GREAT
DRAUGHTSMEN
from
PISANELLO
to

PICASSO

GREAT DRAUGHTSMEN

from

PISANELLO

to

PICASSO

JAKOB ROSENBERG

HARVARD UNIVERSITY PRESS

Cambridge, Massachusetts

1959

Distributed in Great Britain by
Oxford University Press
London

Library of Congress Catalog Card Number 59–7661
Printed in the United States of America

To

PAUL J. SACHS

in gratitude and friendship

PREFACE

The content of this book was presented as a series of eight lectures under the auspices of the Lowell Institute in Boston in January, 1956. The text has been revised for publication but may still suffer from the fact that it was conceived as a sequence of oral presentations with lantern slides, and not as coherent reading matter. (The essay on Rembrandt in its first form appeared in *Daedalus*, Proceedings of the American Academy of Arts and Sciences, Vol. 86, No. 2 [September 1956].)

The choice of master drawings, old and modern, as a subject for public lectures no longer needs justification. The general interest in drawings has steadily grown, certainly in this country, since Paul J. Sachs started to build up a systematic collection for Harvard University some forty years ago — a collection which has maintained the distinction of being one of the finest in the Western Hemisphere. However, for the choice of the eight artists, Pisanello, Leonardo, Raphael, Dürer, Rembrandt, Watteau, Degas, and Picasso, some explanation may be in order. Eight there had to be because of the program of the Lowell Institute. But why *these* eight?

The names of Pisanello and Picasso make an attractive alliteration for the title. However, the choice was dictated by the key positions which these two artists hold at the beginning and the end of the history of draughtsmanship. We do not go back beyond the early fifteenth century because only by then, and through Pisanello in particular, did drawings become an expression of an artist's personal interest; in medieval times they were employed primarily for the working out of traditional motifs.

As for the intermediary periods, from the sixteenth to the nineteenth century — are they properly represented in this program by the other six chosen artists? It may at first seem that the Renaissance is overemphasized with the trio of Leonardo, Raphael, and Dürer, while for the Baroque only Rembrandt is selected, for the eighteenth century only Watteau, for the nineteenth only Degas. Yet no

one of these three Renaissance masters could be omitted without leaving a disastrous gap in the history of European draughtsmanship. It is only regrettable that Michelangelo could not be added. In fact, the choice between him and Raphael was the hardest to make. If the author finally gave preference to the great Umbrian in this contest, he did so reluctantly. Michelangelo was the more powerful artist, but Raphael — and this was decisive in the choice — was the more influential figure in the history of draughtsmanship. The continuous classical trend which carries down to Ingres and beyond, and of which Picasso shows more than a trace, stems from Raphael.

The choice between Rembrandt and Rubens was easier to make, in spite of Rubens' eminence. And as for the eighteenth century, Watteau's precious genius is equaled neither by Tiepolo nor Fragonard, great as they were in their own right. It is different with Goya, who was undoubtedly a towering figure of the profoundest originality and far-reaching effect. The reason for excluding him was an accidental one. The Lowell Institute had sponsored, just the year before, a series of most informative lectures on "Goya the Draughtsman and Graphic Artist" by Philip Hofer. If the present series of eight should ever be expanded, Michelangelo and Goya would be added first, with Rubens following closely.

For the nineteenth century also, the enforced omissions were painful. Both Ingres and Delacroix have a claim to great and original draughtsmanship, and so have Daumier and Manet, van Gogh and Seurat, Cézanne and Toulouse-Lautrec. If Degas was chosen, it was again, as with Raphael, for historical as well as aesthetic reasons. Degas seems to carry on the best of the classical tradition, yet he leads also into contemporary draughtsmanship with a rare and exquisite quality that is almost unequaled.

Thus the final selection was not an easy one to make, but the concentration upon a limited number of great artists may have its advantage for student and layman alike.

The author feels deeply indebted to the scholars from whose basic research he has greatly profited. Without the books of Hill and of Degenhart on Pisanello, of Kenneth Clark and also of Heydenreich on Leonardo, of Fischel on Raphael, of Panofsky and of Winkler on Dürer, of Benesch on Rembrandt, of Parker on Watteau, of Lemoisne on Degas, and of Barr on Picasso, he would have been less safe on the slippery road to critical appreciation. However, a lifelong occupation with drawings has given him the courage to depart here and there from

PREFACE

these reputed authors and to set the accents as he felt necessary. The goal of these lectures was neither a "complete" survey nor the full clarification of all the problems involved, but rather an attempt to bring close to his audience the best and most typical examples and to characterize the achievement of each master in the history of European draughtsmanship.

Finally I want to express my gratitude to the staff of the Harvard University Press for the care they have given to this publication, to Mr. Harold E. Hugo of the Meriden Gravure Company for his expert supervision of the reproductions, and to Miss E. Louise Lucas, Librarian of the Fogg Art Museum, for her great help in providing the necessary photographic material. I feel particularly grateful to Miss Ruth Magurn for her invaluable assistance in bringing the manuscript into final shape. She polished and clarified the text, helping with many excellent suggestions.

J. R.

Fogg Art Museum
Harvard University
October 1958

CONTENTS

ILLUSTRATIONS

ILLUSTRATIONS

PISANELLO

ILLUSTRATIONS

PISANELLO

LEONARDO

ILLUSTRATIONS

LEONARDO

ILLUSTRATIONS

RAPHAEL

ILLUSTRATIONS

RAPHAEL

DÜRER

ILLUSTRATIONS

DÜRER

ILLUSTRATIONS

REMBRANDT

ILLUSTRATIONS

REMBRANDT

WATTEAU

ILLUSTRATIONS

WATTEAU

ILLUSTRATIONS

WATTEAU

DEGAS

ILLUSTRATIONS

DEGAS

ILLUSTRATIONS

PICASSO

ILLUSTRATIONS

PICASSO

ILLUSTRATIONS

The following illustrations are reproduced from the works cited: figs. 4, 34a, 67b, 94, the Vasari Society, *Reproductions of Drawings by Old Masters*, New York: Oxford University Press, 1905–1935; figs. 5, 6, 9, 16, 17, 22a, 27, George F. Hill, *Drawings by Pisanello*, Paris: Van Oest, 1929; figs. 7, 11, 15, 18b, 19, 20, 22b, 25, 26, 28, 29a, Jean Guiffrey, introd., *Les Dessins de Pisanello . . . conservés au Musée du Louvre*, Paris: Société de Reproductions des Dessins de Maîtres, 1911–1920; figs. 74, 78, 80, 87a, 91, 92, Oskar Fischel, *Raphaels Zeichnungen*, Berlin: Grote, 1913–1941; fig. 83, Carl Frey, *Die Handzeichnungen Michelagniolos Buonarroti*, Berlin: Bard, 1909–1911; fig. 90, Oskar Fischel, *Raphael Santi-Ausgewählte Handzeichnungen*, Berlin: Propyläen Verlag, n.d.; figs. 93, 96a, Ulrich A. Middeldorf, *Raphael's Drawings*, New York: Bittner, 1945; figs. 102, 107, 114b, 115, 117, 119, 124a, Friedrich Winkler, *Die Zeichnungen Albrecht Dürers*, Berlin: Deutscher Verein für Kunstwissenschaft, 1936–1939; fig. 122, F. Lippmann and Friedrich Winkler, *Drawings by Albrecht Dürer*, Berlin: Grote, 1883–1929; fig. 128, Karl Giehlow, ed., *Kaiser Maximilians Gebetbuch . . .* , Munich: F. Bruckmann, 1907; fig. 130a, Lionel Cust, *The Chatsworth Van Dyck Sketchbook*, London: George Bell and Sons, 1902; figs. 141, 142a, 142b, 149, Otto Benesch, *The Drawings of Rembrandt*, London: The Phaidon Press, 1954–1957; figs. 147, 153, F. Lippmann and C. Hofstede Groot, eds., *Original Drawings of Rembrandt Harmensz van Rijn*, The Hague: M. Nijhoff, 1910; figs. 162a, 163a, 164a, 173, K. T. Parker and J. Mathey, *Antoine Watteau*, Paris: F. de Nobele, 1957; figs. 170, 172, 174, 180, 188, K. T. Parker, *The Drawings of Antoine Watteau*, London: Batsford, 1931; fig. 175, *Zeichnungen alter Meister im Kupferstichkabinett der k. Museen zu Berlin*, Berlin: Grote, 1910, vol. I; figs. 195a, 209, 211, *Degas-Vingt Dessins 1861–1896*, Paris: Boussod, Manzi, Joyant et Cie, 1898; fig. 196b, P. A. Lemoisne, *Degas et Son Oeuvre*, Paris: P. Brame et C. M. de Hauke, 1946; figs. 203b, 204, 207, 210, 212, 222, 224, Henri Rivière, *Les Dessins de Degas*, New York: Demotte, 1922; fig. 227, Wilhelm Boeck, *Picasso*, Stuttgart: W. Kohlhammer, 1955; figs. 234, 238, 239b, 243, 248, 249, 250, 252, 253, Christian Zervos, *Dessins de Pablo Picasso (1892–1948)*, Paris: Editions Cahiers d'Art, 1949; fig. 235, Waldemar George, *Picasso Dessins*, Paris: Editions des Quatre Chemins, 1926; fig. 242, *Catalogue of Loan Exhibition of Picasso Drawings*, Princeton: The Art Museum, Princeton University, 1949; figs. 244, 245, 246a, 246b, *Cahiers d'Art*, Paris: Editions Cahiers d'Art; figs. 254, 255, *Suite de 180 Dessins de Picasso*, Paris: Verve, 1954, vol. III, nos. 29 and 30.

PISANELLO

PISANELLO

The name of Pisanello instantly brings to mind his exquisite animal drawings with their long elegant lines, highly stylized and delicate in their graphic treatment. A Gothicizing lyricism seems to merge with the fresh naturalism of the early Renaissance. But one thinks also of the master's medals, so perfect in their graceful clarity. In Pisanello's own time, however, he was best known as a painter, not as a draughtsman — and he himself stressed this part of his activity by signing his medals "Opus Pisani Pictoris." The large number of extant Pisanello drawings coming from the Codex Vallardi and now in the Louvre may raise the question whether, as historians, we do not overrate his draughtsmanship, since so few early fifteenth-century drawings, other than his, have survived. For this reason they may now seem more outstanding than they were in the artist's own time. This assumption does not hold, however, because Pisanello was highly thought of in his day; moreover, his drawings reveal an "absolute" quality, so to speak, which stands every comparison with master drawings of later periods.

Before undertaking a survey with selected examples, we may consider briefly the difficulties that beset an adequate critical appreciation of Pisanello's draughts-manship. One is that our knowledge of the artist's life as well as his artistic career is rather spotty. Only approximately can we piece together the whole, and serious gaps remain. Another difficulty lies in the question of authenticity. There are still a number of drawings, and also paintings, on whose attribution the authorities disagree. However, we have enough uncontested works, particularly among his drawings, to gain a clear idea of the artist's style and achievement. These we shall consider first, before attacking the problem of the doubtful attributions.

As for biographical data in relation to Pisanello's work, a few facts must be kept in mind. Pisanello — whose real name was Antonio Pisano — was born in Pisa before 1395, the son of a clothmaker. His mother was from Verona, where she returned soon after her husband's early death (about 1395). Here the boy

received his training and displayed his first independent activity. Degenhart stresses the fact of the artist's central Italian origin and recognizes traces of it in Pisanello's style. They can be explained, however — and Degenhart does not overlook this — by the influence of Gentile da Fabriano, the important Umbrian master whose art Pisanello first encountered in Venice (between 1415 and 1422). Both artists worked on frescoes in the Ducal Palace there and later in Rome, where Pisanello completed Gentile's unfinished frescoes at the Lateran Basilica in 1431–32. Unfortunately none of these works have survived. But if we compare the one major fresco by Pisanello still extant in Sta. Anastasia in Verona — "The Departure of St. George for the Fight with the Dragon" dating about 1435 — with Gentile's most famous composition, "The Adoration of the Magi" (1423) in the Uffizi, we see a connection between the younger and the older master. Something of Gentile's courtly splendor and decorative richness has passed on to Pisanello, and not merely a single motif here and there. Gentile was an adherent of the "International" style which, as a late flower of the Gothic, originated in France rather than in Italy and tinged the Umbrian master's work more strongly than did his central Italian tendencies. And Pisanello's style — in spite of the interval of one generation — still shows similar Gothic implications in his lineament as well as in his decorative character.

In regard to the northern flavor in Pisanello's art, he was deeply indebted to his Veronese background. In north Italy — through its proximity to France and the Germanic countries — the picturesque naturalism and lyricism of the Gothic, the love of flowers and animals and fanciful costumes, also the fairy-like mood in religious as well as in secular subjects, persisted much longer than in central Italy where a more virile and tectonic feeling prevailed and initiated the classical revival. Roots of Pisanello's art in north Italy may be traced back to the late fourteenth century through the sketchbook of Giovannino de' Grassi (preserved in Bergamo). Here we find an abundance of animal drawings almost equaling, in their variety, Pisanello's later production. Giovannino de' Grassi's style, however, retains the schematic character of medieval pattern books, while Pisanello's drawings outgrow this early form through their sensitive naturalism. And as for his Veronese background we must name Stefano da Verona, the artist whom Degenhart and others assume to have been Pisanello's teacher. Stefano's paintings, like the "Madonna of the Rose Garden" in Worcester (fig. 1), clearly reflect the lyricism and stylized naturalism of the International style in the northern coun-

tries. So also does his "Adoration of the Magi" (1435) in Milan. Pisanello's painting "St. Eustace" in the National Gallery in London (fig. 2), which can be dated in the mid-thirties and is close to the St. George fresco mentioned above, is still similar in spirit to Stefano's works. The same love of animals, flowers, and picturesque costumes prevails, and in this delightful panel the artist lays less stress upon the action, the drama of the conversion of the young nobleman at the sight of the miraculous stag with a crucifix between its antlers, than upon the colorful display of the most varied natural phenomena in a dark forest landscape. Also the splendid costume of the young knight and the trappings of his horse are most prominently displayed. G. F. Hill says very aptly about this painting: "Here the naturalist has overweighted the artist in his laudable desire to provide us with a complete compendium of forest life" — and we may add the assumption that this character prevailed in many of Pisanello's lost works.

A similarity between Stefano da Verona's drawings and those of Pisanello can also be used as an argument for the close relation of the two masters, at least in Pisanello's early period. One of the latter's rare sketchbook sheets with compositional studies (fig. 5) — among which a Madonna with four saints is most prominent — shows the same loose and scratchy graphic treatment and long flowing lines found in Stefano's studies like the "Seated Prophet" in the British Museum (fig. 4). And the other type of Stefano's drawings, more finished and dry and characterized by a broad and uniform parallel shading (documented by a signed drawing of battling horsemen in the F. Lugt Collection), is also reflected in some of Pisanello's early sketches. The younger artist's work, however, is distinguished by a more sensitive graphic treatment, by a finer shading, and less robust contours.

After his Veronese period which seems to have ended in the late thirties, and even during this time, Pisanello moved about a great deal among various courts of northern and central Italy. He is repeatedly mentioned at Mantua, Ferrara, and Milan. Thus he came into close contact with those Italian princes — the Gonzagas, the d'Estes, the Visconti — whose residences became centers of humanism. While this classical trend found expression in Pisanello's medals, the majority of his drawings reflect the manifold activities of a court artist who provided his patrons with more than merely portraits or interior decorations. He designed elegant costumes (fig. 16), armor, embroideries, and jewelry and the like (fig. 9), while his natural curiosity was amply rewarded in the menageries and

stables of these princes, or even at their hunting parties. That Pisanello's repu-
tation as a court portraitist was already established in the early thirties can be
concluded from his portrait of the German Emperor Sigismund who visited
Italy in 1432. Studies from life for this portrait still exist (figs. 10 and 11). And
the artist's first medal, representing the Byzantine Emperor Johannes VIII Pale-
ologus who had come to the Council of Ferrara to seek aid against the rising
threat of the Turks, dates from 1438. Various sketches show us studies done on
this occasion. In one of them (fig. 23) the Emperor is seen on horseback — as
he appears on the medal — and the same sheet includes fugitive sketches of
figures from his suite. The large Kufic inscription across the top Pisanello may
have copied from some tent decoration. The Italian text in the center of the page
contains color notes by the artist referring to the Emperor's garment. Thus there
are many indications of Pisanello's keen interest in this historic event which
attracted him by the exotic richness of the Byzantine court.

Finally in 1448 Pisanello took up residence in Naples at the court of Alfonso
of Aragon. His activities in the service of this powerful and splendor-loving prince
were again manifold. We have not only medals of Alfonso and of persons in his
entourage, but many decorative designs, of cannons, embroideries, jewelry, which
the artist provided for the princely household or the arsenal. Whether Pisanello
died while still in Alfonso's service or on a trip to Rome, as has been assumed, is
a matter of conjecture. He is last mentioned in 1450, and in 1455 we hear about
him as deceased.

For our survey we turn first to two datable drawings of convincing authen-
ticity, in order to explore both the characteristics of Pisanello's style and his artis-
tic development. For this purpose we have chosen the head of the princess
(fig. 6) which relates to the St. George fresco and can therefore be dated near
1438, and the portrait study of Alfonso of Aragon (fig. 7), done for his medal of
1448. In both heads much emphasis is given to the contour, as is natural with
profile views. In that of the princess the outlines have more of a calligraphic
swing and show a fondness for large curves in the Gothic tradition. However,
it is no longer the rather flat calligraphy of the medieval artists. The line has a
descriptive and modeling function in addition to its decorative charm. Outline and
inner shading are related and reveal a sense of structure, although the modeling
by fine parallel strokes is still delicate and the indication of texture, here in the
headdress, is equally important.

4

PISANELLO

The slender elongated proportions of Pisanello's figures are felt even when he draws the head alone. His is a refined and precious monumentality, different from the more weighty grandeur of the contemporary Florentines. This head of a woman shows more a type than an individual. It is the courtly type of a fashionable beauty. The features are overrefined, the forehead tautly curved to meet the high swing of the coiffure. A sophisticated artificiality sets the tone for this fashion, and Pisanello's naturalistic curiosity, so strongly evident in his animal drawings, has little outlet here.

Yet it would be a mistake to assume that this head, highly stylized as it is, bears no relation to life. The artist did not create this type at once. More naturalistic studies (figs. 8a and b) preceded this rather finished formulation. Done with a light pen over very sketchy chalklines, they betray a spontaneous grasp of form and expression in a living model. In these preliminary sketches Pisanello studies both sides of the head, with a different headdress on each. Only the finished drawing shows the coiffure of the fresco head. The fact that the princess appears in reverse in the drawing need not disturb us because artists in those days easily transferred a view from one side to the other as the occasion required. What we learn, then, from these three drawings is that the stylization comes in gradually, and this explains also why Pisanello's finished drawings are imbued with a maximum of life and expression.

The head of Alfonso of Aragon (fig. 7) shows stronger Renaissance features, although Pisanello's style of draughtsmanship has not basically changed at this late period. The head is thrown into more vigorous relief through the shadowing of the background where it meets the profile, but also through a broader and more intense shading in various areas. The lineament in general seems more simplified and less florid. The form is built up with a more pronounced tectonic feeling into a firmer and more monumental composition. However, the graphic character retains a certain refinement and is not too remote from the delicate shading of the surfaces and the subtle textural animation in the head of the princess.

Thus we cannot assume a very decided change in Pisanello's style toward the end of his career, when the classical tendency became so evident in his medals. However, his love of Gothic lineament has receded in favor of a rectangular tendency with more forceful plastic accents. And the expression of personality seems bolder and less generalized than before.

PISANELLO

Turning back from the head of Alfonso to the early head of Emperor Sigismund (fig. 10) which can be dated 1432, we find the same contrast as with that of the princess. Like her head, Sigismund's portrait shows more of a Gothic tendency and the delicate treatment of Pisanello's early draughtsmanship. And here again we have evidence that a fresher study from life (fig. 11) — this one done in quick, light chalk strokes — preceded the highly stylized final drawing which served as model for the Emperor's painted portrait now in Vienna. The inscription by Sigismund's beard reads: "più canuta" ("more white hair"). Another inscription is cut off in this reproduction; it relates to the gray color of the Emperor's eyes.

Studies of heads are not infrequent among the surviving Pisanello drawings and show his superb gift as a portraitist within the restrained style of his period. The more finished and highly stylized ones were — as we can assume from the previous and other cases — preceded by fresh, light sketches from life. Two more of these surprising first sketches are reproduced here: the head of a monk, rather jovial and fat (fig. 12a), and that of a bearded gentleman (fig. 12b), the first one in light chalk strokes without further execution, the second in short pen strokes with a light chalk sketch underneath. We have to keep in mind this vivid, spontaneous quality of the artist's studies directly from life and also the degree of finish and stylization which he develops in the final stage in order to gain a clear idea of the range of his authentic graphic expression.

Owing to the nature of the medium a more finished character prevails among Pisanello's rare and precious silverpoint studies of heads. But here too the precision of the final lines is — as a closer look reveals — always preceded by very light, more tentative strokes (in the same medium) with which the artist creates a basis for the tighter final lineament. A superb example is seen in the head of a Mongolian archer (fig. 13), which the artist used in the St. George fresco and which is combined with other less finished portrait studies on one vellum sheet in the Louvre. We see here that Pisanello's repertoire in this category was not limited to the rather archaic profile and frontal views. The three-quarter view occurs as well, and the theory that this was introduced into Italian art by the example of van Eyck's portraits can no longer be maintained.

From Pisanello's portrait studies we may turn to his drawings of whole figures. Although these are not numerous, two categories are outstanding: his costume sketches and his nudes. Of the first we reproduce here a splendid sheet in

6

Chantilly (fig. 16). Others are to be found in Oxford and Bayonne; their technique is the same — pen and watercolor on parchment. In the Chantilly sketch we see a lady and a cavalier displaying their magnificent robes in three-quarter rear view while the heads are set in profile. They appear to be the creation of a costume designer rather than studies from life, and the artist's pleasure in the rich ornamentation and flowing lines of these heavily embroidered robes is quite evident. Pisanello seems to rival here the splendid display of courtly costumes in the calendar pages of the Duc de Berry's famous *Book of Hours* in which the brothers Limbourg set the fashion for the International style at its peak. The latter, however, are more delicate and ethereal, true products of French sophistication, while the Italian master brings a more bodily fullness into the robes. But he is clearly an enthusiastic adherent of the courtly Burgundian fashion.

Of an artist so closely affiliated with the Gothic tradition one would not expect any intense study of the nude. Where nudes occur, as in the "Allegory of Luxury" in the Albertina or in the fascinating sheet of studies in Rotterdam with four nude women in the foreground and a light sketch of the Annunciation above (fig. 14), they are still imbued with the elemental qualities of the International style. The slender proportions, elaborate headdresses, and the affectation of the gestures reflect this — as does the ornamental sweep of the lines, which are already combined with sharp angular turns. Yet there is no doubt that a great deal of observation is implied in the way these figures walk, in the modeling of their bodies, and even in the attitudes of their hands. So we may assume that studies from life (perhaps in a bath house) preceded this rather conscious arrangement. In any case, these female nudes breathe the whole charm of Pisanello's Gothicizing early style and are precious examples of his consummate penmanship.

Some stimulus to deal with the problem of the nude must have come to the artist by the example of classical sculpture. This we assume from his various studies after Roman sarcophagi, of which one from the Codex Vallardi is reproduced here (fig. 15), showing a Hercules swinging a club and a Venus (hastening toward Adonis, as the still extant sarcophagus in Munich indicates). Even in such outright copies of classical models Pisanello's predilection for Gothic slenderness and angularity is seen, as well as the refinement and delicacy of his personal style.

To this group of figures, both costumed and nude, we may add Pisanello's extraordinary studies of hanged men which he used for the gallows in the back-

ground of the St. George fresco (fig. 17). Here he shows an almost Leonardesque curiosity or scientific interest in the decay of the corpses, as we see in the two lower figures which exhibit an advanced degree of deterioration. With a naive detachment Pisanello fills the lower corner of the sheet with the two enchanting figures of a lady and a boy.

One wonders whether it is accidental that by far the largest proportion of Pisanello's drawings which have survived represent animals. It may be that this category was indeed of primary interest to the artist, but we do not know. If one surveys the tremendous range there is from domestic to wild beasts, from native to exotic ones — and even reptiles and fish are not lacking — one cannot help feeling that Pisanello's curiosity went much further than the actual requirement for such subjects in his paintings or medals. Even a partial enumeration will give an idea of the wide variety in this category and the almost universal interest in the animal world. We encounter leopards and bears (fig. 28), cows and dogs (figs. 22a and b), wolves and foxes (fig. 29b), camels, crocodiles, and buffaloes (fig. 29a), mules (fig. 24), horses (figs. 25 and 32b), eagles, cocks, ducks, turtles, goats, mice, and monkeys (fig. 21), peacocks (fig. 20), and deer, a lizard, a rabbit, a porcupine, a wild boar, and so on. If Pisanello ever planned to produce a bestiary it would not have been of the medieval type where all kinds of moral implications and fabulous tales provided the chief reason for representing the animals. He looked at them with the observing eye of an enthusiastic naturalist. Therefore he was not content with a profile view only, or the simple formulas we find in Giovannino de' Grassi's pattern book. Pisanello observed the beasts in various characteristic postures. He grasped their typical movements even though, as an early *quattrocentist,* he was not always in full control of the foreshortening and tended to give some overemphasis to the front plane. We find him also studying details, such as the animal's physiognomical expression, and these are very telling, whether he deals with an eagle's piercing glance, a wild dog's rapacious jaws, or a horse's strong and patient mouth. Pisanello's tireless curiosity becomes most evident when he portrays dead animals which he has previously seen alive. This is found in two drawings of what appears to be the same dog — one showing the animal standing, the other lying on the ground as a corpse. We observe similar studies among Pisanello's drawings of horses. One hesitates to speak of the artist's preference for certain animals because our knowledge is, after all, incomplete. But it seems no accident that the studies of horses, both full-figure

and details (with special concentration on their mouths, teeth, and trappings), form the largest group.

As in the case of his human portraits, Pisanello's many animal drawings show different degrees of execution, and in their first stages are always done with a delightful spontaneity one would hardly expect on seeing the finished products which are carried out with a fine brush on parchment. The fact that even in these Pisanello started out with easy chalk lines or light pen strokes is shown in some of the half-finished watercolors. The gouache technique in particular lent itself to an elaborate textural characterization of the fur, with close attention given to almost every single hair. Yet one does not feel that he lost sight of other essential aspects, and the coordination of the textural effect and the total design is always satisfactory.

From this rich treasure of Pisanello's animal drawings we can reproduce here only a small selection, but perhaps enough to indicate the artist's variety of technique as well as variety of subject. The recumbent cat (fig. 18a) is done in silverpoint on parchment and combines delicate textural treatment with a clear display of the silhouette. The latter, however, was not achieved without some deficiencies in the foreshortening, such as we often find at this early stage of the *quattrocento*.

The sketch of a stag lying on the ground and seen from behind (fig. 18b) is a splendid example of Pisanello's penmanship before he goes into detailed execution. The animal's body is fully relaxed while its neck is erect, forming a sharp vertical crossed by the horizontal accent of the ears. The drawing is a masterpiece both of observation and of stylization.

The two studies of the head of a wolf or wild dog (fig. 19), in pen and some wash on reddish paper — the bodies are only slightly indicated — are keen physiognomical renditions of this ferocious beast and rather dramatic in their frontality. The foreshortening is more successful here than in other cases, especially in the lower head with the jaws closed. The contrast created by the dark holes of the nostrils and the slight superposition of the snout in front of the eyes are responsible for this foreshortening. But also in the upper head the sharp white teeth protrude distinctly and threateningly before the dark open mouth.

The sheet with various studies of a peacock (fig. 20) belongs to the category of fresh pen sketches in which the artist quickly notes down characteristic postures of a species. Of course the profile view with the full length of the bird's

tail and the curve of its back claims his chief attention. But he shows the bird both walking and standing in this position. The three frontal or near-frontal views which he adds are no less lively and prove the master's facility in catching very momentary poses.

The sheet of monkeys (fig. 21) is carried out in pen and some watercolor over a light first sketch in chalk. Here Pisanello revels in the long lines and the furry texture of the exotic animal, and he characterizes superbly its gait and peculiar expression. There are a number of other monkey studies from the Codex Vallardi, some less finished and stylized but showing an amazing grasp of this animal's supple mobility.

Dogs, of course, interested the court painter almost as much as horses. The drawings stress the elegant lines of the greyhound type (fig. 22a) which was obviously favored as a hunting dog. The animal here represented in pen and watercolor seems to be — as mentioned above — the same dog which the artist shows lying dead in another drawing (fig. 22b), executed in chalk. The corpse is already beginning to shrivel. The animal may have been the victim of a hunting accident, since its hind quarters show a wound.

The pen drawing of two saddled mules (fig. 24) can be dated about 1438, when Pisanello saw the Byzantine Emperor and his entourage during their stay in Italy. The nostrils of the Byzantine horses — as we observe also in the sheet of studies including the profile view of the mounted Emperor (fig. 23) — are strangely slit. This operation was performed to allow easier breathing when the animals were under great strain (a custom also reported in Iceland, Turkestan, and some parts of Africa). This drawing of two mules is remarkable both for its liveliness and its firm stylization. While not overfinished, it gives a rather final effect in its energetic linear character.

Among the numerous sketches of horses' heads, we reproduce one (fig. 25) in which the artist's interest centers on the half-open mouth. A bit presses against the tongue, and even the animal's eye — although only lightly sketched — expresses its nervous reaction.

Most enchanting is the pen sketch of an egret (fig. 26), which Pisanello has placed on the paper with consummate skill. We are not surprised that this exotic waterbird attracted the artist repeatedly by its elegant long lines and curious postures. On one sheet (fig. 27) he sets down no less than fourteen egrets, each with unfailing finality. They show a wide variety of poses, walking or standing,

with some of the birds set off against reeds that are enlivened by touches of green watercolor.

The massive bulk of a full-grown bear we see in two profile views in a chalk drawing (fig. 28). In contrast, the silverpoint drawing on parchment of two buffaloes, yoked and belled (fig. 29a), shows sharper linear definition. There is some modeling with the brush on the bull in front, but the total image is primarily pressed into the silhouette so that its flattened relief could easily be used for a medal.

We see a superb example of Pisanello's finished watercolor drawings on parchment in the profile view of a wolf walking to the left (fig. 29b). The artist has expressed here, with equal mastery, the nature of this predatory beast, its slinking movement and rapacious character, as well as the textural beauty of its fur, the latter so thoroughly that every single hair seems rendered. Yet the drawing does not suffer from overelaboration.

Only after close scrutiny of a number of exquisite and convincing drawings by the master do we feel prepared to tackle the problem of authenticity in some of the less striking works which, although close to Pisanello's manner, lack his full quality. The Pisanello literature does not yet offer satisfactory answers in all these cases. I select here only two drawings for closer discussion, but they are somewhat symptomatic of a larger group in the Codex Vallardi that seems to be the work of pupils. If I disagree here with Bernhard Degenhart, I am in other cases much indebted to this author for his substantial clarification of the Pisanello *oeuvre*.

One of these drawings represents the bust of a man with an ornamented tunic (fig. 30), the other the study of a horse's head (fig. 32a). In the man's head the rather hard and pedantic execution by pen arouses serious doubts about the authenticity, even though Degenhart accepts this drawing as a late work of the master. The dryness and stiffness of the lineament, its mannered character, has no parallel among Pisanello's originals, early or late. We miss here all those qualities which we admired before: the sensitive character of the line, the delicate modeling, the subtle yet lively interpretation. But a closer look reveals a lighter chalk drawing underneath which is freer and could well be Pisanello's own. So we have here, and in a number of related drawings coming from the Codex Vallardi, the not infrequent case that the drawing by a master, done in a soft medium which began to deteriorate or fade, was worked over in pen by a

later hand, most probably that of a pupil, in order to preserve a precious invention. How Pisanello's authentic portrait sketches looked in the very first stage we can observe once more in the impressive head of a bearded man (fig. 31), which may represent a person from the Emperor Sigismund's entourage. (It has been suggested that this is the portrait of the Emperor's Chancellor, Kaspar Schlick.)

The drawing of a horse's head (fig. 32a) which I ascribe to a pupil's hand also shows a conspicuous inferiority in its pen lines, compared with convincing studies by the master (fig. 32b). These are always as grand in concept as they are sensitive in execution. Pisanello's modeling and his delicate textural characterization seem unfailing whenever he centers on these aspects. And in the doubtful drawing we again find a light chalk sketch underneath that is freer and could be by Pisanello's own hand.

These observations do not shake the confidence that the majority of the Codex Vallardi drawings must originally have come from Pisanello himself. It is not unnatural that later hands interfered with such a treasure, either to restore or to correct some sheets or even to add other items here and there. Some later owner of the Codex Vallardi lot, for example, added a number of Leonardo School drawings.

Even the small selection of Pisanello's works which has been discussed makes it clear that he was indeed one of the great draughtsmen of all time. Pisanello still stood in the late medieval tradition but began, by his efforts, to break through its limitations. While he kept alive the Gothic feeling for line and its ornamental charm, as well as many other aspects of the courtly International style, he was among the first to represent natural forms — whether human, animal, or floral — with a fresh vision. Pisanello's expressive portrait studies anticipate much of Renaissance portraiture, and his many animal drawings convey the delight in the phenomena of this world that flavors the art of the *quattrocento*.

LEONARDO

LEONARDO

Turning from Pisanello's draughtsmanship to that of Leonardo, we come about two generations closer to our own time. The late medieval flavor is gone, the approach to nature and reality considerably intensified, and a high degree of spontaneity enlivens Leonardo's drawings, particularly in his youth, before the classical ideals press his forms into more conscious abstraction. The range of interest has also widened with Leonardo, whose scientific curiosity embraced almost everything. He was a more full-fledged Renaissance personality. In addition he possessed one of the most astonishing minds that Europe has ever produced.

Pisanello was a worthy forerunner of this great genius and his interests had reached out toward many subjects in which Leonardo became a supreme master. Even the insatiable scientific appetite of Leonardo, who studied skeletons with the same eagerness as he did living beings, was somewhat foreshadowed in Pisanello's rare drawings of corpses.

But while many relations can be found between the two, Leonardo's genius can hardly be measured by the artistic yardstick alone. In Leonardo the inquisitive mind of modern man finds perhaps its first and at the same time one of its greatest representatives. We cannot undertake here to follow to any extent the mighty process of Leonardo's scientific thinking and research. We can only briefly indicate the extraordinary range and importance of his achievements. Our justification is that many drawings accompany his manuscripts which survive in about 3500 densely written pages. These drawings are often remarkable as a type of scientific illustration which, by selective accentuation, clarifies complex phenomena much better than photography can do. Leonardo's fields of interest were: anatomy, botany, biology, geology, cartography, optics, mechanics (both applied and theoretical), hydraulics, and dynamics — to mention only the most

important. It is a frightening range for one man's life which the illustrated manuscripts reveal.

Leonardo could not, of course, attain the standards of modern science. His findings were based upon observations and experiments, and not upon mathematical thinking or theoretical principles. But his method was revolutionary in his time and enabled him to make many surprising advances beyond the barriers and prejudices of medieval scholastic science. It has often been said that Leonardo's most spectacular contribution, for modern man, was his search for the construction of a flying machine, based upon the observation of the flight of birds and his research into aerostatics and aerodynamics. But in other fields, too, his advances were equally astonishing. In his anatomical studies he came close to the discovery of the circulation of the blood; and by his comparative method and his search into the growth of organic life he was well on the way to the modern science of biology. Or, if we consider his geological studies, his notion of the history of the earth and the essential role of water in the formation of its surface was most progressive for his time. He refused, for instance, to accept the then common belief that fossils of sea creatures and shells found in mountains far inland were deposited there by the Biblical Flood. Instead he realized quite accurately that the presence of such fossils was proof that ocean waters once covered these mountains.

Considering his vast and intense scientific activity, we are not surprised to hear from Leonardo's contemporaries that his artistic production was slow and that few of his major works came to completion. This is true of the "Adoration of the Magi," his most important early painting of 1481–82, now in the Uffizi, and of his famous mural for the Town Hall of Florence, representing the "Battle of Anghiari" (1503–1506), which we know only from copies; also of the two great sculptural projects which he undertook — the equestrian statue of Francesco Sforza for which he worked in the late 1480's and the nineties, and the equestrian monument to General Trivulzio (1511–12). Even the "Last Supper" (1495–1498), in Sta. Maria delle Grazie in Milan, his most famous work, never reached a satisfactory completion because here the artist experimented with oil on dry plaster and the painting quickly deteriorated.

This unfinished character of Leonardo's work makes it hard to realize his full significance as an artist. But here the drawings help us considerably to become acquainted with his artistic projects, visions, and ideas, and to trace his develop-

ment. Draughtsmanship came naturally to Leonardo; he could express himself in this medium with an ease and a charm that is almost unequaled.

The story of Leonardo's life provides few answers to the enigma of his personality. From all accounts he was endowed with physical beauty and strength, with gracious and charming manners, and not only with an unusual intellectual and artistic talent. Yet in spite of these gifts Leonardo remained somewhat aloof from human contact and appears to have been an elusive and even mysterious character. In his very extensive notes, in which daily events are also recorded, we never hear an affectionate word about any human being with whom he came in touch. In fact, in his treatise on painting he advises the young artist to seek solitude because only when alone, he says, is one fully capable of contemplating the things one has seen and thus of making the right selection. Leonardo's illegitimate birth (in 1452) has been overemphasized as a clue to his character. We know that his father, a respectable Florentine lawyer, provided an excellent education for the gifted boy and saw that he was apprenticed to one of the most reputed artists of Florence, the sculptor and painter Andrea Verrocchio. With this experienced and many-sided artist — for he was also a musician, a mathematician, and a skilled mechanic — Leonardo remained beyond the normal training period (from about 1467 to 1472), for four more years as an assistant in Verrocchio's studio, and it is quite possible that he had by then a substantial share in his master's works. Soon Leonardo developed his own talents as an engineer and inventor, gifts which made him as attractive to princely patrons as did his rich artistic talents. Thus began a period of service which was to last for nearly two decades — from 1482 to 1499 — for Lodovico Sforza, Duke of Milan. It was a most fruitful period, terminated only by the war with France, when the French Army entered Milan and expelled the Duke. Leonardo himself left the city and moved from place to place for some time. In 1502 he served Cesare Borgia as military engineer. In 1503–1506 he was back in Florence, devoting most of his efforts to the great fresco in the Town Hall representing the "Battle of Anghiari" or, more specifically, an episode from that war between the Florentines and the Milanese (in 1441): the "Battle for the Standard." Leonardo did this composition in a kind of competition with Michelangelo, who was commissioned to decorate the other side of the wall with his "Battle of Cascina." After a second stay in Milan (1508–1513) during the French occupation there, Leonardo went to Rome on the invitation of the Medici Pope Leo X and finally, in 1517, he an-

swered the call of the young King of France, Francis I. The artist was then sixty-five years of age. Little is known about his activities during these last years when he lived in Amboise. In 1519 Leonardo died, leaving his extensive scientific and artistic material to a faithful pupil, Francesco Melzi, who had accompanied him into the foreign land.

We shall now turn to a close analysis of Leonardo's drawings, in an attempt to realize not only their rare and even unique quality, but also his development as a draughtsman. This ranges from the late *quattrocento* to the height of the Renaissance and even beyond, because Leonardo's mature works often show some anticipation of Baroque power and drama.

All writers on Leonardo agree that his early drawings, like the sheet of studies in London of a Madonna with a Christ Child fondling a cat (fig. 33a), are among the most attractive and also the most amazing masterpieces in the whole history of draughtsmanship. Indeed such a judgment is hardly exaggerated, and we can discover here some characteristics which mark the best of Leonardo's drawings throughout. First of all there is a freshness and freedom of touch that would be surprising in any period, even in modern times. The line is versatile, varied in accent, and highly suggestive in its definition of form. There is a sparkling effect of light and shadow. The movement of the figure is complex yet graceful, displaying the dynamic energy in the body, whether human or animal. Leonardo's many sketches of cats reveal his keen interest in the feline nature. He closely observes and captures the cat's peculiar clinging quality, its supple yet tense and wiry movements. There is an articulate compactness in the grouping of his figures, and in addition even such early pen drawings as these show Leonardo's feeling for both sculptural and pictorial qualities, for linear charm as well as painterly brilliance.

If we look back at the rare pen sketches of Leonardo's master, Verrocchio, such as the sheet in the Louvre with *putti* (fig. 33b), we notice a kinship. Verrocchio's light scribbles with the pen already grasped the form in movement — as did the equally rare sketches of the great Pollaiuolo. But there is not yet the compactness and elasticity of Leonardo's figures, not yet the sparkling effect of light and dark, not the human intimacy of the younger artist. We realize, nevertheless, that both the style of draughtsmanship and the type of Leonardo's chubby Christ Child are derived from his teacher.

Another version of the Madonna with the cat, also in London (fig. 34a),

brings us close to one of the few generally accepted early paintings by Leonardo, the so-called "Benois Madonna" (fig. 34b), which has been dated in the years just after he left Verrocchio's workshop. The qualities mentioned above are here even more pronounced. The spontaneity of touch could hardly be greater. The chiaroscuro, or in Leonardo's case we had better call it the *sfumato* effect — that is, the contrast and the gradation of light and shade, softened by air and atmosphere — is most lively and seems to anticipate Rembrandt's draughtsmanship. But here the painterly treatment remains strictly in the service of a clear relief effect, which Leonardo, in harmony with the style of his period, considered the most vital quality in painting. He says so in his *Trattato della Pittura,* which provides directions for the painter and states many of Leonardo's aesthetic concepts. He himself was left-handed, and one sees how the diagonal shading in this London drawing runs from the lower right to the upper left, in contrast to the usual direction. The line varies so quickly from thick to thin, from the powerful to the delicate touch, that we are hardly aware of the conscious order of tones in the interest of the aforesaid relief effect. This is not so clear in the lower part of the figure because the artist experimented here with two different positions of the legs. Leonardo never hesitated to exploit his drawings for such experimentation of positions. In his writings too he advises such a flexible method in sketches. The artist should not, he says, consider every line that he has set down as final and unchangeable.

In the painting of the "Benois Madonna" (fig. 34b) we feel a slight hardening of those qualities which delight us so much in the sketch. The painting required a more finished, and with it a more labored effect, according to the standards of the time. The closeness to Verrocchio is still felt in type and style, but there is here more human sweetness and refinement, a freer and more complex movement than in the Madonnas of Leonardo's teacher.

While Leonardo seems far ahead of his time in the almost impressionistic freshness of his early pen sketches, this is not quite so true of his silverpoint drawings, such as the beautiful study of female hands, in Windsor (fig. 35a), and the profile bust of a warrior in fanciful armor, in London (fig. 35b). In their more finished character they show a closer relation to Verrocchio's style and to the late *quattrocento* in general. These drawings are modeled with superb plastic feeling and the lines have a grace that Verrocchio's never possessed. The bust of the warrior may have been planned for a relief; a similar

type appears in Verrocchio's silver altar in the Opera del Duomo in Florence. And the hands served as a study for the portrait of Ginevra Benci, now in the possession of the Prince of Liechtenstein. Although this painting is cut off in its lower part, the position of the hands in the lost section is proved by a Lorenzo di Credi portrait which imitates Leonardo's "Ginevra Benci."

Early in his career Leonardo set down on paper his favorite types of human faces, and revealed an interest that was to be lifelong in the most diverse physiognomies, from the youthful to the aged, from the beautiful to the grotesque and the deformed. Such heads we find on a sheet of studies in Windsor (fig. 36) where the artist formulates, so to speak, his ideal types and their counterparts. His line is easy, sure, and playful, delightfully crisp and melodious. He arranges the heads in three diagonals, each of which contains contrasting and varying physiognomies. On the central diagonal the most prominent is a beautiful youth's head, which is set against the furrowed face of an older man — the warrior type which often appears later in Leonardo's work. And at both ends we see two variations of the boy's head, with slight transformations which take away his extraordinary charm. The lower diagonal shows the half-figure of a girl between two other profile heads of girls with minor variations. The relation of the ideal male and the ideal female youth is close. Both occupy the central axis of the sheet and are larger than the rest of the sketches. They seem to be personifications of youthful charm in the two sexes as Leonardo envisaged them, with a slight preference given to the boy's head.

Also in his sketches of nudes the young Leonardo shows a consummate skill, as, for instance, in the drawing with studies for an "Adoration" (of the Magi?) in Cologne (fig. 37). Both Pollaiuolo and Botticelli are brought to mind by Leonardo's penmanship here. Pollaiuolo in particular was a spirited draughtsman of nudes and exerted a strong influence upon the younger generation. His little pen sketch of "Hercules and the Hydra" in London shows us his line as similarly both crisp and groping, yet more tentative in the accentuation of muscular forms. Botticelli's pen drawings, for instance, those in the illustrations for Dante's *Divine Comedy*, have a smoother ornamental flow than Leonardo's and less crisp animation of details. The young Leonardo surpasses both masters in the ease and articulation of his line, in its control of the whole form. There is a perfect coordination between movement and expression, and a wealth of gestures beyond the reach of the older artists. Leonardo's figures also seem to be bathed

in light and air, a quality which is suggested by the intermittent character of his line. With Pollaiuolo this intermittent line was more exclusively conditioned by his groping for form.

From 1481 to 1482, the end of Leonardo's first Florentine period, dates the "Adoration of the Magi" now in the Uffizi — the only major painting of his youthful phase. Although unfinished, it gives promise of all that we consider great in Leonardo's later work. It was commissioned by the monks of San Donato, and when the artist left Florence for Milan they waited patiently for fifteen years before asking Filippino Lippi to paint another Adoration. (This second painting is now also in the Uffizi; it is of equal size, but of course less inspired than Leonardo's extraordinary composition.) In Leonardo's work we discover the steps which the artist took, upon entering manhood, to reach out beyond the *quattrocento* style to classical grandeur and even to pre-Baroque power. This painting can also lead one to understand why Leonardo was reluctant to finish a work whose preparatory stage was so full of spontaneous life and expression, of fresh draughtsmanship and rich chiaroscuro, that any finishing touches would imperil its peculiar charm. There are passages in the figure of the Madonna, in the adoring crowd, in the group of horsemen in the rear which delight a modern eye by their sketchy quality, by the bold touches of light and dark. One would not wish to have these suggestive lines carried any further. We know, moreover, from various remarks by Leonardo (which E. Gombrich has recently assembled in an illuminating article) [1] that he himself was fully aware of the peculiar opportunities which sketching offers to the inventive spirit before the final execution of a work. And in Leonardo's treatise on painting he states that the use of light and shade is more important for the creation of form than is the addition of color.

From various drawings we can determine the gradual development of the "Adoration" composition. A pen sketch in Bayonne shows what may be the very beginning of his occupation with the theme. At this time it is still an "Adoration of the Shepherds" (not yet of the Magi) and it is carried out in a much simpler form. The drawing in Cologne of the nudes (fig. 37), just discussed, may belong to the preparatory phase of the Uffizi painting. The bold movements in the adoring crowd are somewhat anticipated in these figures. But the sketch in Paris (fig. 38) is the first to relate quite directly to the final composition, particularly in the foreground where the group surrounding the Madonna is taking shape in

a similar triangular formation. Similar background motifs occur also, but not yet in the positions they assume later. The entire middle distance with the band of angels and two trees behind the Madonna is not yet there, and the background is less populated.

The drawing in the Uffizi (fig. 39) is closer to the painting. It deals only with the architectural setting and is a precise perspective study — an early evidence of Leonardo's thorough control of this science. Agitated figures, particularly horsemen, move about on this stage with the two great staircases and arcades as they appear in the painting. The camel resting in the foreground is omitted in the picture; its place is taken by the band of angels mentioned above. Leonardo packs into the final composition an enormous amount of action and exuberant life. Dramatic motifs like the rearing horses of the background will reappear in his later work, not more lively but with greater knowledge of form and a higher discipline and order.

We are told that Leonardo went to Milan in 1482 and remained until 1499. His first known work there was his so-called "Madonna of the Rocks" now in the Louvre (fig. 40b). (A later version, only partly by his hand, is in the National Gallery in London.) The Louvre painting dates from 1482 and shows a romantic composition with the youthful Madonna, Christ Child, and St. John, and a kneeling angel pointing to the adoring St. John, all within a dark, rocky cavern. The bright opening in the distance with mountain crags in a bluish atmosphere is a typical bit of Leonardo fantasy.

The Metropolitan Museum in New York possesses a sheet with sensitive little sketches (fig. 40a) in which the central group of the Madonna kneeling before the two children looks like a preparation for the Louvre painting. In the drawing the Christ Child is not seated, but half-reclining on the ground, and the attendant angel with the pointing finger has not yet appeared. The drawing is still close to Leonardo's first Florentine period, and the variations of the Madonna and Child motif which surround the central group are reminiscent of earlier Florentine painters, particularly Fra Filippo Lippi.

In the silverpoint study for the head of the angel (fig. 41), in Turin, we come closer to the classical phase. The element of movement — an individual quality of Leonardo — is still implied, as is his pictorial sensitiveness, evident in the fine tonal accents. But these features are restrained in favor of a more balanced and controlled treatment. Other classical aspects are the simplifica-

tion of the lines, the increased power of the contours, and a plastic intensity
which begins to predominate over the pictorial trend. As before, the rounding of
the form is brought out by a system of parallel shading, but more summarily and
subtly. A slight change of the spiritual content is also noticeable in the gravity
of mood which replaces the intimate human warmth of the earlier period. Much
has been written about the inscrutable charm of Leonardo's faces, their mysteri-
ous smile or sensitive gravity. Here we have a perfect example of how the artist
has transcended reality by endowing a countenance with extraordinary profund-
ity of expression. He has combined outward beauty with inner sweetness and
strength.

In Leonardo's first Milanese period appear sketches of grotesque physiogno-
mies of which the one in Windsor with five heads (fig. 42) is the most famous.
These studies manifest the artist's interest in the monstrous forms nature can
produce, and he tries to create these from his own imagination. In the center
we see the same rather classical type which appeared earlier (fig. 36). The fur-
rowed face in profile is beardless and toothless, crowned with oak leaves, the bust
wrapped in a toga-like costume. The four heads surrounding this one show more
pronounced deformities in their features and they vary also in expression. One
is grinning, one shouting, two are brooding. The group therefore represents
studies of facial expression as well as of physiological monstrosities. Yet while
dealing with the "ugly" as a theme, beauty is still inherent in Leonardo's draughts-
manship, in the graphic charm of his line, in the delicacy of his shading.

This is also true when he deals with anatomical subjects such as the two
profile views of the section of a skull (fig. 43), where he combines accuracy
with extreme sensitiveness of touch. The intensive anatomical studies carried
on during Leonardo's first Milanese period are shown in a number of drawings
of equal refinement now preserved in Windsor.

One major task awaiting Leonardo in Milan was the creation of a colossal
bronze monument to Lodovico Sforza's father, the great *condottiere* Francesco
Sforza. Like so many other works of the artist, this never saw completion. He
had trouble with the casting because of the innovation which he brought into
this motif representing the rider on a prancing horse over a fallen foe. This
prostrate figure provided insufficient support for the animal's forelegs, and so
Leonardo had to revert to the traditional pose of a sedately walking horse as in
the great monuments of Donatello's "Gattamelata" and Verrocchio's "Colleoni."

Only the model of his second version was finished; this was much admired, but when the French invaded Milan it was destroyed.

The beautiful drawing in Windsor, in silverpoint on a blue ground (fig. 44), shows the bold idea of the first draft as it was planned in 1488. However, the prancing of the horse is less exuberant here than we saw it in the background of the "Adoration" painting. A classical restraint prevails in this wonderfully balanced design in which the profile expresses the animal's peculiar beauty. Leonardo was as much interested in the representation of horses as he was in that of men, and his studies of proportion embraced both. There exist a number of marvelous sketches of horses from that period — also of details such as legs and heads. On some of them Leonardo has indicated the measurements. The drawing which we reproduce (fig. 45) gives a front, rear, and side view of a perfectly shaped animal and we see again how Leonardo's draughtsmanship in this first Milanese period reaches the height of clarity and economy. There are remarkable drawings of horses by Pisanello (fig. 24), but the earlier master could not yet fully control the foreshortening of the forms. If we seek a comparison in the history of draughtsmanship, it is only Degas who will approach Leonardo's perfection in this genre.

While in Lodovico Sforza's service, Leonardo designed many military machines of complicated mechanism. Very few, if any at all, were built and tried in practice, but their intricate operation is always clearly demonstrated in Leonardo's drawings. How lucidly he could describe such a device is best seen in his drawing of an arsenal (fig. 46) where, by means of a giant block and pulley, a large cannon is being raised onto a gun carriage. It is clearly shown how dozens of figures go to work at strategic points to put this mighty machine together.

The fresco of the "Last Supper" in Sta. Maria delle Grazie is generally considered the prototype of classical composition and represents Leonardo's full achievement in the High Renaissance style. It dates from 1495 to 1498, which means a decade before other masters, with the sole exception of Perugino, had reached this stage. To analyze this famous work will be unnecessary; suffice it to say that the scene represented is the moment following Christ's fateful words, "Verily, verily I say unto you that one of you shall betray me." The concentration of the composition upon Christ, through perspective lines, and the wave of movement that goes through the apostles and flows to the center and back on

both sides, have often been stressed as the key to its unity and drama. Even in its ruined condition the fresco still conveys something truly moving and powerful.

Very few studies for the "Last Supper" have survived, and they give no clear idea how this great composition developed in the master's mind. An early stage, still far from the centralized power of the final version, is seen in the red chalk drawing in Venice (fig. 47). It represents a grouping of Christ and the apostles in which the arguing among the individual figures is studied, rather than any coherent movement going through the whole. Judas still sits apart from the others, on the opposite side of the table, according to the traditional scheme, and Christ reaches across to offer him a morsel. The sheet of paper was not large enough to display the whole table, so four of the apostles are added at the lower right corner.

Sketches of some individual heads are preserved in Windsor, which is by far the richest of all the Leonardo collections. We reproduce here the red chalk drawings of St. James Major (fig. 48) and St. Bartholomew (fig. 49). They give an idea how expressive these heads must have been in the fresco before its deterioration. The bust of St. James is very lightly sketched with all emphasis given to his facial expression. His left hand rests on the table, not outstretched as it appears in the painting. In the lower left corner we see an architectural study in pen, obviously for the towers of the Castello Sforza. This is one of the few signs of Leonardo's activity as an architect at the court of Lodovico.

The head of St. Bartholomew (fig. 49) shows a profile of Roman grandeur and classical simplicity. He seems identical with the apostle who stands at the extreme left end of the table, bending over to form a group with the next two. Here again the economy of draughtsmanship is superb and the sensitive *sfumato* with which Leonardo models creates a full relief and a lively surface. The phenomenon of reflected light is subtly applied along the line of the throat. From now on Leonardo often uses the soft medium of red or black chalk, to create the double effect of modeling and of atmosphere around the form.

As indicated above, the wide range of Leonardo's genius not only embraced the classical style but even foreshadowed the Baroque. This he showed after his return to Florence when he set to work upon the "Battle for the Standard" for the Town Hall (now Palazzo Vecchio), in about 1503. We learn that owing to the experimental nature of the pigments he used, the original painting had already deteriorated by the mid-sixteenth century. A number of copies still exist,

of which the one by Rubens in the Louvre (fig. 50), although not the earliest, is the most effective. The Baroque elements in this composition of a fierce and heroic fight must have appealed to Rubens. He may have slightly increased these qualities, as he usually did, yet we know from older copies of the composition that the essence of the Leonardo group is there.

Leonardo himself, of course, did not live into the Baroque period and the progressive elements in his mature style always remain within classical limitations. Thus the figures in the "Battle for the Standard" are developed exclusively within the front plane, in the mode of relief; the space is not opened up into depth — but the dynamic power of movement, the massing of contorted forms, the configuration of clashing diagonals, are definitely of a Baroque flavor.

Various small scribbles are preserved which indicate preparatory stages before the final composition took shape. We owe to Günther Neufeld an illuminating article [2] on the origin and development of the total plan which began with diverse motifs and grew gradually into a much more extensive representation. But Leonardo finally concentrated on one motif and carried out only the fight for the standard, as we see it in Rubens' copy. A pen sketch in Windsor (fig. 51) shows us the intensity and power in Leonardo's studies of horses about this time. We see, facing the figure of a prancing horse, five heads of horses and a lion's head above the profile of a man, all very fierce in aspect. No doubt Leonardo wanted to compare different physiognomies, animal and human, at the height of emotion. At this stage of the artist's development we observe, in the horse on the right, an increased roundness gained by a new type of shading with curving parallels which follow the form of the body. And the bodies, in general, now have greater suppleness and tension, corresponding well to the dramatic intensity of expression.

A study in Budapest (fig. 52a) shows the head of the central horseman in the "Battle for the Standard" — the one who swings his sword. The plastic power of this head is immediately impressive. The face is deeply modeled with a clear distinction of planes, with vigorous accents, and smooth transitions. A sensitive aerial perspective is brought out by the soft medium of the chalk, producing both form and enveloping atmosphere.

It might be informative at this point to bring in a pupil's drawing of this type (fig. 52b), for closer comparison as to quality. Here we miss not only the master's depth and power of expression. The form is much weaker both in its total

roundness and in surface modeling. There is only a low relief and little existence in space. The outline of the man's profile appears hard and inflexible. Moreover, a critical passage such as the region around the neck and the shoulder, so sure and telling in the master's drawing, as for organic structure, movement, and tension, seems flat and lifeless in the pupil's work.

As his anatomical research progressed, Leonardo was able to grasp the human form in his drawings with intensified knowledge. We see this in the nude studies done at the time of the "Battle of Anghiari," such as the pen sketch in Turin (fig. 53a). A similar intensity of modeling marks Michelangelo's drawings, which, however, lack the scientific, analytical trend that Leonardo stressed here. The red chalk drawing in Windsor of a nude seen from the rear (fig. 53b), also from this period, shows more of the synthetic power of Leonardo's modeling. Outline and inner shading cooperate here; a truly classical feeling produces a clear, articulate, and balanced image of a male nude. Such a mature drawing has a more powerful plastic life than the graceful nudes of Leonardo's youth (fig. 37).

In 1508 Leonardo returned to Milan, which was then firmly in the hands of the French. For the next three years Charles d'Amboise, the French Governor, was his chief patron. Once more Leonardo became as active as he had been under Lodovico Sforza — not only as painter and decorator, but also as military engineer and architect. The only painting that can be placed in these years is the "Madonna and St. Anne" now in the Louvre.

Upon the death of Charles d'Amboise in March 1511, the government passed into the hands of two generals, Gaston de Foix and Gian Giacomo Trivulzio. The latter entrusted to Leonardo the execution of his equestrian monument, of which a sketch in Windsor (fig. 54) shows some first drafts. Unlike the Sforza monument, the horse and rider were this time to be only life-size, but placed on a high classical base which would enclose the sarcophagus of the deceased. The corners of the base were to be ornamented by figures of bound prisoners, as we see them indicated in the darker lower sketch. On another sheet (fig. 55), Leonardo contrasted the motif of the prancing horse trampling a prostrate foe with that of a walking horse. It was the latter which he finally chose. These sketches are distinguished from the earlier ones done for the Sforza monument by a more vigorous expression of weight and volume in Leonardo's mature technique, with the shading lines following the roundness of the form instead of being straight diagonals. But the movement is also intensified, as we have seen already in the "Battle

for the Standard." Horse and rider now form one plastic unit, and the contrasting movements of the two do not loosen the compactness of the group, but rather enhance its dramatic power.

Leonardo's anatomical drawings from his second Milanese period also exhibit the broad and vigorous touch of his late draughtsmanship. In his dissections he studied not only the muscles, bones, and arteries, he explored also the mystery of the growth of human life, as we see in his famous drawing of an embryo within an opened womb (fig. 56). It is an illustration which is still used in modern handbooks of anatomy, because of the accurate rendering of the embryo's position.

The same quality of clear demonstration marks a skeleton seen from the rear and showing the system of muscles which connect the head with the vertebral column (fig. 57). Here as in the previous drawings Leonardo has taken the liberty of deviating from what we would call a photographic rendering in order to bring out certain points more clearly. Thus he separates the compact muscle of the back into single strings, to allow a full view into the interior structure which supports the skull.

Leonardo's representations of landscape deserve special consideration. Although limited to background scenes in his paintings, as in the "Madonna of the Rocks," the "Mona Lisa," the "Virgin and St. Anne," they seem to be conjured up as visions of primeval nature, and to possess a romantic and a mysterious significance. One feels that his rocky crags were formed by the erosion of ages, and the all-powerful role of the waters in the earth's history is strikingly pictured by deep river valleys between these fantastic mountains. Leonardo the scientist joins Leonardo the romanticist in his landscape creations, and the drawings embrace the full range of his extraordinary visions.

The early pen drawing of the Arno Valley (fig. 58), dated 1473 (at the time he served as assistant to Verrocchio), is often held up as a landmark in the history of European landscape. It shows some relation to earlier representations, such as those of Piero della Francesca and above all Pollaiuolo, who, in the backgrounds of his paintings already displayed such panoramic views seen from above. Leonardo, however, adds a freshness and brilliance unknown to the older master. Light and air become tangible elements in this drawing. They permeate the wide space and lend vibration to the strokes. The scheme of the composition is still traditional, but the touch is new, and even some aerial perspective is felt. On this

phenomenon Leonardo later made astute observations in his treatise on painting.

Thirty years later, in the landscape with a storm in the Alps (fig. 59), we reach Leonardo's second Florentine period. The drawing probably dates from the time when he was working on the background of the "Mona Lisa," shortly before he embarked upon the "Battle of Anghiari." Here the dramatic atmospheric phenomena of the sky are of greater interest than the vast country below, which is only slightly sketched. Sir Kenneth Clark, Leonardo's biographer, is reminded of Turner in the way in which a complex panorama is compressed into a few square inches. But Clark rightly adds that the grasp of formal design in the Leonardo makes every Turner look rather diffuse. This drawing is done in the softer medium of red chalk which, from the time of the "Last Supper" on, Leonardo often favored.

The more we advance in Leonardo's career, the fewer are the signs of artistic activity. The scientific work predominated in the later half of his life, and his thinking too, as Heydenreich has convincingly shown, was governed by it. It is exceptional to find a significant human subject, such as the "Seated Old Man" (fig. 60) — we may call him a philosopher — among Leonardo's scientific illustrations. He broods at one side of a page whose other half is filled with studies of swirling water. These demonstrate, as explained by the text in Leonardo's hand, the inner structure of the water's motion which the artist compares to the motion of hair. Leonardo gave a great deal of thought to this problem in hydrostatics and hydrodynamics, and the philosopher — who certainly shows a resemblance to the old artist — may represent an image of himself pondering on the laws of nature. In any case, his mature style of draughtsmanship appears here at its best. As always with Leonardo, posture and expression are well coordinated to indicate the character of his subjects and their inner mood.

A female subject appears in his later period in his "Leda" designs, which are dated at the time of the "Battle of Anghiari." He created a standing Leda which is known from a pupil's copy (a painting in the Borghese Gallery) and also from a drawing by Raphael after it. The study of a kneeling Leda, in Rotterdam (fig. 61), shows an intensification of the movement in the powerful interaction of the forms, but also of emotion, in the affectionate turn of both woman and swan. Leonardo never became a mere formalist. In fact it is one of his great points in the *Tratatto della pittura* that physical motion should always express the inner life of a figure.

LEONARDO

Among Leonardo's latest works are his strange visions of cosmic catastrophes, often called "apocalyptic," which show various types of geological disasters in the form of tremendous outbursts of clouds, deluges, and devastating storms, as if the entire universe were in a state of upheaval. Gigantic rock formations collapse and toss about in the flooding waters (fig. 63). There are earlier drawings (fig. 62) which show Leonardo's close attention to the phenomenon of the stratification of rocks. In other sketches, such as the one mentioned above with the seated philosopher, he investigated the motion of water, just as he also studied the motion of the air in his observations of the flight of birds and of atmospheric phenomena. He finally came to imagine a universe governed by the boundless forces of nature which once had formed the earth and which would — at some point in the remote future — bring about its destruction. Such thoughts must have lain behind his late drawings of deluges. These are the aged Leonardo's version of the end of the world, his contribution to the apocalyptic trend of his time, although utterly different from the strictly Biblical scenes by Dürer, Signorelli, and Michelangelo. His are purely geological disasters. In the drawing reproduced here (fig. 63) we see a mountain falling on a town engulfed by a deluge. In the foreground one discerns a row of tiny trees bent by the fierce winds. But in all this chaos there remains an aesthetic order, a handsome ornamental control in the motion of the water, in the swirl of the rocks, not only because Leonardo the artist could not help bringing order into his designs, but also because he realized the laws governing even a natural catastrophe of cosmic dimensions.

It might be appropriate to conclude this brief survey of Leonardo's draughtsmanship with a self-portrait drawing of the old master (fig. 64). Some doubts have been expressed in former years about its authenticity. At present the Leonardo specialists are inclined to accept it as genuine. I do not feel so certain. The drawing lacks something of the powerful plastic energy, the refinement and animation of form which Leonardo's early work already showed and which grew stronger in his mature years. However, it is at least a good pupil's faithful copy after an authentic self-portrait. We have reason to see in it the undistorted image of the master at about the time he moved to France. It is without doubt an awe-inspiring face, and something of the depth and mystery of Leonardo's personality can be seen in the shadowed eyes that speak of unfathomable wisdom, and in the determined mouth that is not free from bitterness.

RAPHAEL

RAPHAEL

Leonardo — Raphael — Michelangelo are three inseparable names in the history of art. For a long time they stood for everything great, since the High Renaissance, which these artists created, was considered the climax of European art and culture. In this trio Raphael personified the most complete realization of the classical ideal, while Leonardo was considered its pathmaker; Michelangelo's overpowering genius, full of tragic and dynamic implications, seemed to push it to the utmost limits and beyond.

This concept of Raphael as the most perfect representative of classical art was also applied to his draughtsmanship, and for centuries his drawings were regarded as the unsurpassed examples of linear beauty. Even Delacroix dared not openly challenge Raphael's role, when he confided to his journal in 1851: "Perhaps one day it will be discovered that Rembrandt is a far greater painter than Raphael. I write this blasphemy — one that will make every school-man's hair stand on end — without coming to an absolute decision in the matter." [3] And even during the later half of the nineteenth century, when art historical criticism became more active, the traditional acceptance of Raphael as the supreme classical linearist impeded an unbiased investigation of this master's draughtsmanship. One hesitated to admit other than pure pen lines of the most perfect kind as works of his hand, and in doing so not only underestimated the range of Raphael's technical flexibility, but also failed to realize his development.

The more realistic view on the part of twentieth-century criticism culminated in the work of Oskar Fischel, to whom we owe the standard publication of Raphael's drawings (eight volumes, Berlin, 1913–1941). In its present form, however, it is incomplete, owing to the author's death. Three more volumes were planned. Thus, for the last and most controversial phase of Raphael's draughtsmanship we do not have the benefit of Fischel's opinion, except for those cases

mentioned in his general monograph on Raphael (two volumes, London, 1948) which appeared after his death, compiled from his notes.

Though Raphael is no longer the principal idol of the art world, his true importance has not been diminished by a sharpened criticism and by the clarification of his authentic work and development. However, problems still remain, concerning both the beginning and the end of his career. We now realize more distinctly the borderline between Perugino's work and the earliest of Raphael's, yet a *consensus omnium* has not been reached in all cases. For his late period the uncertainty is far greater, because Raphael by then entrusted the final execution of his work, and even some of the preparatory drawings, to his assistants, among them the talented Giulio Romano. A clear distinction between the master's hand and those of the pupils is consequently rather difficult. Therefore it is all the more important to realize the unique qualities of Raphael's draughtsmanship; this alone can lead to more certainty about the controversial cases, for a genius of Raphael's caliber and sensibility is really inimitable. There have never been united so impressively in one man's draughtsmanship grandeur and grace, clarity and beauty, the heroic and the serene — and a higher economy of line has never been attained.

Raffaelo Santi was born in Urbino in 1483, the son of the painter Giovanni Santi who had served the Duke Federigo da Montefeltro. After being initiated into the craft by his father, Raphael entered the workshop of Pietro Perugino in Perugia, some time before 1499, and remained there until 1504. He then moved to Florence, where he was active for four years. Probably late in 1508 he went to Rome, and there he was asked by Pope Julius II to decorate the papal apartments in the Vatican. The frescoes of the Stanza della Segnatura, with the famous compositions of the "Disputà" and the "School of Athens," were finished in 1511. Then followed the Stanza d'Eliodoro, completed in 1514, and the Stanza dell' Incendio, finished in 1517. The Medici Pope Leo X, who succeeded Julius II in 1513, favored Raphael with an even greater extension of his duties. He worked also as an architect, a tapestry designer, and an archaeologist, making plans, as the Pope's Prefect of Antiquities, for the reconstruction of Ancient Rome. This enormously widened range of the artist's activities explains the increase in pupils' participation. Raphael died in 1520 of a malignant fever, at the early age of thirty-seven years, and was buried with the highest honors in the Pantheon.

Raphael's career is thus divided into an Umbrian period at Perugia from about 1500 to 1504, a Florentine phase from 1504 to 1508, and a Roman one

from 1508 to 1520. And each of these periods shows the influence of another artist upon Raphael's work. Perugino, his teacher, naturally dominated his style during the Umbrian years, Leonardo became a powerful influence in Florence, while the impact of Michelangelo left its mark primarily in the early Roman period. But Raphael's own personality was strong enough to prevail and to find its full expression, even before he entered the years of manhood. It was the great commission of Pope Julius II which challenged all his powers so early.

Although some doubt exists about the exact date and the identification, I am inclined to believe, with Fischel and many others, that the fine portrait study of a youth, in Oxford (fig. 65a), is a self-portrait of Raphael at the age of about sixteen. In any case there is hardly a more sensitive drawing to introduce the draughtsmanship of the young artist while he was still close to Perugino. The teacher's melancholy sweetness is there, the musical swing of his lines as we notice it in the metalpoint sketch of the head of a young woman, in London (fig. 65b). But the young Raphael adds to his drawing something of his own. The expression is more personal than Perugino's, the form less schematic, the lines bolder and of greater modeling power. The future grandeur of Raphael is forecast but still bound up with Peruginesque gentleness. This portrait has often been compared to the amazing self-portrait in the Albertina of the young Dürer at the age of thirteen (fig. 97a). Raphael's drawing naturally shows a greater maturity and sureness of touch. Also Raphael's early feeling for the monumental and the economy of his draughtsmanship come out strikingly when seen beside the late Gothic constraint of the young Dürer.

Perugino's influence on the young Raphael was something more than the ordinary outcome of a teacher-pupil relation. Whether it was Raphael's sympathetic personal disposition or the common Umbrian background of the two, the older master struck a note of deep congeniality with his lyrical art. His Umbrian sense of spaciousness and his deep colorism had an appeal to the young Raphael which outlasted the years of his apprenticeship. Characteristic differences, however, are noticeable from the beginning, in the studies of whole figures as well as of heads. The Umbrian tradition was not to study the figure in the nude — as the Florentines did — but rather in the tight-fitting costume of the period. This is seen in a typical Perugino drawing of a youth with a staff (fig. 66a) from the Museum in Oxford — a sketch for the "Adoration of the Magi" in Città della Pieve. Perugino's flowing line is combined here with his characteristic sweetness

35

of expression, and one can understand why the young Raphael was captivated by these qualities, by his master's lightness of touch and melodious rhythm. Yet he must have felt early a slight structural weakness, a lack of vitality, because his own drawings of the Umbrian period, like the study in Oxford for a "Resurrection" (fig. 66b), show a new quality. It is a silverpoint sketch on grayish ground for two of the guards at the Holy Tomb, and dates from about 1502. There is no doubt that the metalpoint line is freer here, the plastic quality increased, the movement and the foreshortening of the figures brought out with more vigor than we ever see in Perugino.

Whether he draws in metalpoint, chalk, or pen, Raphael follows at first his master's draughtsmanship in all these techniques, with only slight yet noticeable deviations. There is in Oxford a delightful pen sketch for a Madonna painting (fig. 67a), similar to the "Solly Madonna" in Berlin. On the verso are two landscape studies for the background of this composition. Like the Berlin painting the drawing is intensely Peruginesque, but freer in the more crisp use of the pen with more vivid formal and psychological accents. And there exists a silverpoint drawing in London (fig. 67b), either for the head of the "Solly Madonna" or for the Virgin in the little "Annunciation" in the Vatican — the two are very similar in expression — which shows the young Raphael as an accomplished master in this fine technique. Here also he departs from the rather flat oval of Perugino's Madonna heads. The forward inclination of this head, which corresponds well with the tender downward glance, is brought out by a sensitive foreshortening such as Perugino never achieved.

The "Coronation of the Virgin" of 1503 (fig. 68) and the "Spozalizio" of 1504 are the two major paintings from the latter half of Raphael's Umbrian period. In these works one again sees the young artist slowly freeing himself from his master's style, while still deeply indebted to him. For the "Coronation" we have a number of drawings of superb quality, like the study for the head of St. Thomas, in Lille (fig. 69a), and the large chalk drawing in London of the head of St. James (fig. 69b). These rise far above everything Perugino ever attained in ecstatic expression or monumental linework. St. Thomas' hands which hold the girdle of the Virgin are separately sketched on the same sheet, below his head, with extreme sensitiveness. It is true that his upward gaze is still an inheritance from Perugino's saints, but without their sentimentality. Again the success of the

foreshortening in the upturned face is remarkable for such a young artist, as is the controlled brevity and accentuation of the lines.

The larger head of St. James (fig. 69b) is no less expressive, and exploits fully the broader medium of the chalk for a monumental effect. This drawing is what Fischel aptly called an "auxiliary cartoon," which means that after the cartoon for the whole composition had been finished, the drawing was created in order to improve this figure. Some grains of charcoal powder are noticeable in the outlines, indicating that they had been pounced through, and the size of the head corresponds precisely to the one in the painting. Raphael maintained this habit of improving his cartoons by added studies also later in his career. He was indeed tireless in his efforts to fill his compositions with a maximum of expressive details.

Raphael was only twenty-two years old when he arrived in Florence. He must have looked with awe at the cartoons of Leonardo ("The Battle for the Standard") and Michelangelo ("The Bathing Soldiers"), which were created at this time for the Town Hall and exhibited there, causing great enthusiasm all over the city. A new concept of the human figure in its full organic life, an heroic and dynamic spirit of movement alien to the lyric stillness of his master, must have deeply stirred the young Umbrian whose sense of grandeur and clarity we saw awakening early, but who had not yet met the challenge of the great Florentines. It is an impressive spectacle to see, in Raphael's drawings of these years, how he reacts to these powerful experiences. Leonardo moves him profoundly. He adapts the free sketchiness of the older master, his articulate modeling, and the dynamic movement of Leonardo's groups. Yet Raphael remains Raphael in refusing to become overarticulate and analytical, in maintaining largeness of forms and grandeur of outlines. The impression of Michelangelo was at first less pervasive, but we shall see that in Raphael's early Roman years this artist, too, had much to contribute to the heroic ideal of the Umbrian's mature art.

A sheet of studies in Oxford, in silverpoint on cream-colored ground (fig. 70), clearly dates from the Florentine years when Leonardo's "Battle for the Standard" was to be seen, because a small sketch in the left upper corner reflects an acquaintance with this great work, or at least with some preliminary sketches for it. Also the profile head of an old man, on the same sheet, is a derivation from Leonardo, though somewhat broadened in appearance. Most conspicuous on this sheet is the fine head of a young monastic saint and two studies of hands. They are preliminary sketches for the figure of St. Benedict in the fresco of the "Holy

Trinity," which both Perugino and Raphael painted for San Severo in Perugia. As shown by the Leonardo motifs in the drawing, Raphael's contribution to this fresco was made only after he had moved to Florence. This head of a young saint personifies much of Raphael's greatness and his ideal mood. The Perugino flavor is not entirely gone. Something of the lyric quiet of the valley of Umbria is still reflected in the monk's expression. But it is raised to a higher plane, to an heroic austerity that signifies or at least foreshadows the classical style of Raphael's mature art. The draughtsmanship is firm and more vigorous than before, the oval shape of the head brought out with intensive roundness. The halo is only slightly indicated, but is essential for the heightened spatial effect.

Many Madonna studies show Raphael's preoccupation with this sacred theme during the Florentine years before he was favored with official commissions. The Leonardo influence is evident in the increased animation of the motif by vigorous *contrapposto* movements and in the groping, sketchy character of his lines, while occasionally Michelangelo's ideas are also introduced, as in the sheet of studies in London (fig. 71). Here the lowest group is a sketch for the "Bridgewater Madonna," in which the Child's position seems to be derived from Michelangelo's marble *tondo* of 1503, now in the Royal Academy in London. The group on the right is made for the "Madonna of the Casa Colonna," while the one above shows the "Tempi Madonna" motif in reverse. In all of these the spirit of his draughtsmanship is strongly Leonardesque in its bold sketchiness and in the dynamic movement of the groups. We have seen similar features in Leonardo's pen sketches for the "Madonna with the Cat" (fig. 33a); his stroke, however, was still *quattrocentesque*, more refined, pictorial, and sparkling, while Raphael tends toward a more vigorous simplification of the forms, as in the way he reduces the Madonna heads to elementary ovals.

Another instance of a strong Leonardo influence can be seen in the pen sketch (fig. 73) for the portrait of Maddalena Doni (now in the Palazzo Pitti together with the companion portrait of her husband, Angelo Doni, both dated about 1506). The sketch clearly reflects the composition of Leonardo's "Mona Lisa." But again Raphael translates the motif into his broader, more monumental touch and brings in a greater architectonic quality through the columns framing the background. The expression, too, has little of Leonardo's mysterious sweetness. It is more generalized, yet the deep, dark accents of the eyes convey an impression of girlish freshness.

RAPHAEL

It is interesting to see in comparison the drawing of a young woman (fig. 72), now in London, a study for a female saint from Raphael's Umbrian period. This drawing is done in black chalk over a stylus sketch, a traditional technique frequently used by Raphael. Like many early works, this one gives a foretaste of the artist's later grandeur of style; but in type and touch, also in mood, it is still Peruginesque, only fuller in form and bolder in line. The Florentine sketch shows a new vividness of accentuation, a more dramatic contrast of light and dark, that is derived from Leonardo.

It is rather natural that under the powerful new impressions gained from Florentine art Raphael's study of the nude expanded and took a new turn toward the more organic, heroic, and dynamic. But the artist was not willing to give up his Umbrian fondness for large contours and he had to struggle for some time before his drawings of the nude fully reflected what he had learned from the Antique, from Donatello and Pollaiuolo, from Leonardo and Michelangelo.

A study of four warriors in Oxford (fig. 74) and a sheet with a horseman fighting two nude soldiers, in the Academy in Venice (fig. 75), are two leaves from the so-called "large Florentine sketchbook," which had been dispersed and was tentatively reconstructed by Fischel. The central figure of the first drawing is a free version of Donatello's "St. George"; the right-hand figure is derived from an ancient relief now in the Museo delle Terme. Raphael brings these motifs together in a freely handled group, stressing the relief effect but leaving enough space for an easy position of the front figures. His outlines model forcefully while the interior drawing is slight; his broad parallel shading creates coherence, also light and atmosphere. There is a new tendency toward idealization and heroic proportions.

The other sheet, with the man on horseback fighting two foot soldiers, seems to be inspired by Leonardo's "Battle for the Standard." Here Raphael goes boldly into dramatic action and tries to master a complicated group in full motion. Again he works primarily with the contours. His control of the anatomy is not yet complete, but he gives vigor to the swelling of the forms in the contour lines and in this way stresses the action of the muscles.

For one major painting, "The Entombment" (fig. 76a), now in the Borghese Gallery and dating from the end of the Florentine period (1507), a large number of drawings of special interest have survived. The painting is not considered one of Raphael's greatest masterpieces. It has a slightly academic or formalistic touch,

39

and Raphael's eclecticism of these transitional years — he relies here upon motifs of both Mantegna and Michelangelo — is perhaps too evident. It is, however, a work which reveals the artist's effort to overcome the Peruginesque lyricism of his youth by a more heroic pathos. The drawings give us full insight into this significant development before the final version in the painting is reached. In addition they teach us a feature of Raphael's which characterizes his entire production: namely, the thoroughness of his preparation. His procedure involved not only the traditional phases of a draft for the whole composition and studies of details until the cartoon could be made as the basis for the painted work. He seems to have multiplied these processes by introducing ever new ideas at each phase, constantly balancing the whole and the details. We have seen that he even added studies (fig. 69b) after the cartoon had been finished. Michelangelo said of Raphael that he achieved his work largely by diligence. This remark has a malicious undertone, but it is true, nevertheless, that Raphael's thoroughness was a natural part of his genius, often forgotten when one sees the ease and the grace that distinguish his final work.

The commission for "The Entombment" went back to the years in Perugia, where the painting was destined for the Church of the Franciscans. But Raphael was able to finish it only in Florence, just before he moved to Rome. There are two scenes united, of which one is the bearing of the body toward the tomb, with the unusual motif of the Magdalene holding Christ's hand. In this part of the composition the influence of Mantegna's famous engraving of "The Entombment" is evident. The other part represents the swooning Virgin attended by three holy women. In this group the kneeling figure in front, with her *contrapposto* movement, reflects the posture of the Madonna in Michelangelo's *tondo* painting of "The Holy Family" now in the Uffizi.

The early draft in Oxford (fig. 76b) is still far from the final version. The theme here is a "Pietà," not yet an "Entombment," and it reminds one of Perugino's painting now in the Uffizi, dated about 1495, which Raphael must have seen. Of course there are changes. A new, powerfully unifying swing goes through the composition, which is simplified and freed of the staccato rhythm of the *quattrocentro* painting.

For the right-hand group of this first draft Raphael made a special study. It is a beautiful pen drawing in London (fig. 77a), which comes close to Raphael's Roman masterpieces. The forms of St. John and the kneeling Magdalene have

an heroic fullness, the lines flow with the greatest ease, and light and air lend more charm to Raphael's draughtsmanship here than we find in the somewhat hard, sculptural effect of the painting.

Another draft in London (fig. 78) brings us closer to the composition in the painting and shows the decisive change from the "Pietà" motif to the action of "The Entombment" under the influence of Mantegna's print. Mantegna's heroic style impressed the Florentines of the High Renaissance, but the Paduan master, on his part, owed a great deal to the most powerful Florentine sculptor of the *quattrocentro*, to Donatello.

This version, however, did not yet satisfy Raphael. As we see in the drawing in the Uffizi (fig. 77b), which deals only with the left half of the final composition, he decided to give the figure of Mary Magdalene greater prominence. She is now raised and appears in full bust and in profile as she gazes at Christ's face and tenderly holds His hand. This is not yet the final draft, but comes close to it. The woman on the right, behind the Magdalene, will be eliminated and the faces of the left-hand figures will be changed.

But the greatest alteration was made in the group on the extreme right, in order to gain greater dramatic effect. We see this in still another drawing in London (fig. 79a), in which the Virgin is collapsing, supported by the three holy women. This change is equally in line with Raphael's new Florentine tendencies. And finally a study of this last group, also in London (fig. 79b), shows the figures of the swooning Virgin and the woman behind her as skeletons. This is definitely a reflection of the Florentine practice from the time of Pollaiuolo on — a practice which made the thorough anatomical study of the human body a prerequisite for an artist. Still more drawings related to Raphael's "Entombment" are known, but the ones just discussed demonstrate the correctness of Fischel's remark that in the development of this composition Tuscan drama gradually replaced Umbrian lyricism.

The sequence of Raphael's Madonnas did not break off in his Roman period when so much of his time was taken up by the great fresco work in the Vatican. It culminated in the most famous of all, the "Sistine Madonna," but for this painting no drawings exist. A delightful sketch for the "Alba Madonna" in red chalk, in Lille (fig. 80), belongs in the early Roman years. Some smaller sketches are added on the same sheet, preparatory to the later idea of the "Madonna della Tenda." In the Alba sketch the aftereffect of Leonardo's style still lingers in the

vigorous rounding of the composition, in its dynamic movement and impetuous sketchiness. All of this is transposed into the grandeur of Raphael's Roman style which, as this sketch shows, succeeds in combining freshness and ease with monumentality. It seems that the Madonna at first held a book in her right hand, but that this motif was replaced by the raised arm of the Christ Child who grasps the staff of the young St. John's cross.

A pen drawing in Vienna, with the Madonna sitting on the ground reading and two cherub heads in the upper corners (fig. 81), goes still further in the delightful ease of line. The old Umbrian qualities of spaciousness and airiness, of pictorial softness, seem to return and are united with features of the artist's later style. The contorted *contrapposto* motif of Michelangelo's Madonna in the "Holy Family" *tondo*, which once impressed Raphael so forcefully in a study for the Bridgewater Madonna (fig. 71), has now lost its manneristic twist and is reduced to greater naturalness and a monumental simplicity in this triangular group. The drawing can be dated about 1513, not far from the time of the "Sistine Madonna."

In Raphael's first Roman years, when he was working on the frescoes of the Stanza della Segnatura, Michelangelo's influence is felt particularly strongly in his studies of nudes. An example like the red chalk sketch of "Fighting Men," in Oxford (fig. 82), which was done for the "School of Athens" and used for the relief on the base of the Apollo statue in that composition, shows, in its incisive anatomical treatment, that for a while Michelangelo impressed Raphael even more than Leonardo did. Raphael holds to his emphasis on the outline and tries to coordinate with it an intensified interior modeling. Michelangelo's nudes, even when drawn with the pen (fig. 83), have sharply chiseled muscles, and Raphael's figures show this influence in an increased vigor and articulation.

With his work on the Vatican frescoes Raphael's style blossomed into full maturity, and the beauty of his drawings must have assured Pope Julius II that the youth to whom he had entrusted this important commission gave the highest promise of great achievement. Whether sketches for the ceiling figures, for the "Parnassus," the "Disputà," or the "School of Athens" in the Camera della Segnatura, all breathe the same spirit of grandeur and serenity, and the technical range is wider than ever.

A pen study of the "Melpomene" in Oxford (fig. 84) was done for the "Parnassus" and represents the muse of Tragedy, but not quite as she appears in

the left-hand group in the fresco. A Marcantonio engraving reproduces an earlier version of the composition, and the drawing is closer to the "Melpomene" there. Its intentional incompleteness gives the impression that the muse is floating in the air. The figure traces a curve that is beautifully echoed by its flowing garment, and the contrasting movements of head and arm are essential for the rhythmical animation. While the drapery lines swirl in graceful curves, the body and its movement are clearly suggested through the garment, an achievement which Raphael owes to his intensive studies of both Florentine art and ancient sculpture.

The study with a standing Apollo figure and a bearded man crowned with leaves and holding a book (fig. 85) is not definitely connected with any of the frescoes. Since the verso of the sheet shows studies for the "Disputà," the same date (c. 1508–1510) is feasible. But for stylistic reasons also the drawing belongs to Raphael's early years in Rome. It is fully characteristic of those sketches of both nude and draped figures which he then produced with such superb lightness and control of form. In the Apollo figure one can still see a reflection of Leonardo's early pen sketches, which have a similar sparkling brightness and grace. But Raphael's nude is more muscular and shows the heroic fullness which the still young master achieved in his Roman years.

For none of the frescoes in the Stanza della Segnatura do we have every phase of their development clarified by drawings. But in the case of the "Disputà" an unusual number, altogether forty-five, have survived, giving a fairly clear idea how the composition gradually developed and how skillfully and thoroughly Raphael prepared the individual motifs, down to such details as hands, feet, and draperies. The flexibility and range of his technique is also evident from these drawings, among which we find examples in pen, in black or red chalk, in silverpoint, and in brush. Only a few reproductions can be shown here to illustrate all these points. It is hardly necessary to describe the famous fresco (fig. 86) explicitly. It is well known that the scene represented is the disputation on the mystery of the Eucharist, which occupies the center. The participants on earth, among whom St. Peter, St. Paul, and the Church Fathers are prominent, form a semicircle, while in the sky representatives of the Old and the New Testament, seated on clouds on both sides of the Holy Trinity, form a corresponding curve. A third, but smaller semicircle is formed high above by angels, large and small, on either side of God the Father. While the background seems to be all air and sky, the figural setting has the effect of a great piece of architecture, more specifi-

cally of a half-dome or a large apse which shelters the altar. The movement in the crowd below, which flows from both sides toward the center, reminds us of Leonardo's "Last Supper," but here it is strongly linked with the heavenly sphere which has its center in Christ and the Holy Trinity.

An early sketch for the composition — as Fischel rightly recognized — is the brush and silverpoint drawing in Windsor (fig. 87a). Raphael chose this technique, so suggestive of light and air, as the most appropriate medium for the preparation of the fresco effect. Only the left half of the composition is seen. Three circular rows of figures are already apparent, but they are less coherent and less articulated than in the final composition. Here they are framed by an architectural setting, while in the fresco a firmer effect is achieved without the use of architecture. The young man who later appears so prominently in the foreground at the extreme left seems to be prefigured in the motif of the girl who has a certain prominence at the extreme left in the drawing.

Additional intermediary phases in the development of the composition can be traced in two more brush drawings, in Oxford and Chantilly, which show further steps in the evolution of the three principal rows of figures. We reproduce here (fig. 87b) the last of the known compositional sketches, one which is considerably closer to the final version. This is in London; it is done in pen and brush and deals with the left-hand group on earth. Figures have been added which make the crowd fuller and, above all, the movement toward the center is now effectively worked out. But the finished fresco will bring still more changes and will articulate this movement further by breaking the multitude into small groups. An arresting accent will be added by a standing figure seen from the rear, in front of the three kneeling youths.

A powerful example of Raphael's preparation of single figures may be seen in the black chalk drawing of a seated male nude (fig. 88) which served as a model for the figure of Adam, the second in the row of heavenly figures on the left. In the fresco he differs from the drawing in appearing bearded and half-draped; his position also is slightly changed. A reflection of Michelangelo's heroic nudes of the Sistine Chapel is quite evident here, yet no one would confuse this drawing with a Michelangelo because of its broader, more generalized modeling, its softer touch and more lyrical mood. It is Raphael through and through, but strengthened by a knowledge of the art of the great Florentine.

Another study, perhaps after the same life model but done in pen (fig. 89),

was used for the seated figure of Apollo in the "Parnassus." He is playing the viol and a detailed drawing of his left hand with the instrument appears separately to allow a full exposure of the nude. The difference between this figure and that of the "Adam" seems to be conditioned by the sharper medium of the pen, which tends to a more incisive outlining. But it is also possible that in the Adam, Raphael had made some progress in overcoming an unduly sharp anatomical treatment by a more summary and painterly modeling.

Finally, we show an example of Raphael's precious silverpoint sketches for the "Disputà." It is the sheet in the Louvre (fig. 90) with the figure, the head and the hands of the so-called "Sectarian" who in the fresco appears leaning over the balustrade in the foreground at the extreme left. Raphael remained fond of the medium of silverpoint throughout his career. Here, in the preparation of the frescoes, he uses it for more intimate details. The character of the old man — sometimes called Bramante — is superbly expressed in this refined technique. Compared to the silverpoint sketch of the Florentine period with the head and hands of St. Benedict (fig. 70), the modeling is now less tight, the line more vibrating, with an increased effect of light and air that is so vital in the fresco.

The cartoon for the "Disputà" has not survived, but that for the "School of Athens," at least its lower part with the figures but without architecture, is preserved in the Ambrosiana in Milan. We reproduce here a detail (fig. 91) from the group of geometricians in the right front corner. In spite of some damages, Raphael's hand is clearly visible in the bold directness of the contours and the powerful summary shading which provides a forceful modeling and a vivid overall tonality, yet maintains a remarkable transparency.

For the Stanza d'Eliodoro, which was finished in 1514, we have very few drawings. In these frescoes Raphael becomes a dramatic composer ("Expulsion of Heliodorus from the Temple") as well as a dramatic chiaroscurist ("Liberation of St. Peter"). And in the Stanza dell' Incendio, which was finished in 1517, the participation of the pupils was so great that a division of the hands is extremely difficult.

It is from about 1512 on that one can speak of Raphael's late style of draughtsmanship. His stroke has broadened and softened in a pictorial sense, both in his nudes and his draped figures, yet they do not lose, but rather gain in monumentality. The outlines, although still important, are more subdued to allow a more massive effect of form, with a sensitive tonal shading of summary breadth

that shows Raphael's painterly touch at its height. The study of a nude soldier blinded by light (fig. 92) — a figure which Fischel related to a "Resurrection," but which was also used, although in reverse, for the "Liberation of St. Peter" — is reminiscent of Signorelli's powerful nudes, with their massive quality, dramatic animation, and tonal breadth. This great Umbrian may have figured in Raphael's experience when the artist saw his frescoes in Orvieto on the way from Florence to Rome. Or Raphael may have come in touch with Signorelli's drawings, as Michelangelo obviously did later. In any case, Raphael embraces Umbrian features once more, and seems to have left the analytic Florentine trend behind.

If we look at the majestic study for the planet Mars and an angel (fig. 93), done for one of the mosaics in the cupola of the Chigi Chapel in Sta. Maria del Popolo and therefore datable in 1516, we gain a clear idea of Raphael's late nudes, so impressive in their form and pathos, so broad in their painterly touch. Beside these figures the nudes of the early Roman years look rather harsh. Even the study for the "Adam" (fig. 88) exhibits a more pressing plastic power derived from Michelangelo. The memory of his art is not eliminated in the late work, but the Michelangelesque flavor is now only remotely felt in the equally grand yet softer language of the fully mature Raphael.

Similar impressions are gained from his rare authentic female nudes or draped figures, such as the kneeling woman in red chalk from Chatsworth (fig. 94) and the study for the Phrygian Sibyl (fig. 95), also in red chalk, in Oxford, done for the fresco above the entrance to the Chigi Chapel. The latter, therefore, can be dated in 1514. The pose of the figure is considerably changed in the fresco, and so the drawing may belong to an earlier stage of the composition, for which we have no record. Its beauty has often been admired, and in its marvelous expression of form beneath the garment, it may be considered a worthy sister of the Elgin marbles.

The kneeling nude (fig. 94) also deserves highest praise. Fischel connects it with the "Mass of Bolsena," Popham, and more plausibly, with the Psyche frescoes in the Farnesina. In any case, we have here a work of striking authenticity in Raphael's late style, which ought to make it possible to distinguish the master's hand from even that of his most gifted pupil, Giulio Romano.

A Giulio Romano drawing (fig. 96a) with two male nudes, done for the "Transfiguration," shows this pupil's harsher style, although Raphael may have retouched it. Giulio has derived from his master as much as he could: the pro-

portions, the broad and luminous treatment, and even something of the beauty, but Raphael's touch is both more sensitive and more monumental, and his pathos is not fully attainable to his followers.

Even in a work as late as the "Transfiguration," which was finished by Giulio Romano after Raphael's death, the master supplied detailed studies like the magnificent sheet in Oxford (fig. 96b). It represents heads and hands of the apostles John and Peter, as they appear in the center of the composition. These are "auxiliary cartoons" of the type we have already mentioned, since they agree precisely, in size and form, with the painting, and their outlines have been pounced. A wonderful calmness, together with an heroic grandeur, emanates from these faces. The emotion is restrained, but not at the expense of inner life. Here again is a level of quality unattainable to Giulio Romano, who tends to exaggerations and who lacks the tonal breadth and beauty found in these late works. Few drawings can be claimed with any certainty for the hand of Raphael in his late years, but these few are perhaps enough to round out the development of his draughtsmanship and to clear his authentic work from degrading attributions.

DÜRER

DÜRER

As Raphael is considered the most perfect representative of the Italian Renaissance, so Albrecht Dürer is generally credited with being the greatest artist and draughtsman of the north at this period. The contrast between the two masters is very revealing. Raphael's art and personality not only impress us as unusually harmonious, but his development leads smoothly to the High Renaissance style for which his forerunners, Perugino and Leonardo, had laid such a firm foundation. Dürer, however, had to struggle hard in order to reach the new classical ideal; the obstacles in his path seemed almost insurmountable because he had to overcome so many tendencies that were rooted in his own German, late Gothic beginnings.

When seen from the height of the Renaissance, it may appear that Dürer's development was split by the year 1500 into two antagonistic phases. But such a sharp division does not do justice to Dürer's personality in which both trends were to be found — the northern Gothic one by inheritance, the new classical one by disposition. His career was marked by the gradual integration of the two, with an increasing predominance of the classical trend. The fact that Dürer was unable to cast off completely his German heritage bears witness to the strength of his native qualities — qualities which are manifested in his devoutness, in his love of nature, in his expressive and detailed realism, or in the ornamental charm of his graphic works. However, Dürer's disposition toward the classical point of view was also strong, rising from an innate sense of moderation and refinement, a yearning for clarity of formal expression and its rational foundation. This classical bent was more pronounced in Dürer than in any of his northern contemporaries. Moreover, from an intellectual standpoint he was a true Renaissance personality and had much in common with Leonardo; both for his theoretical efforts and his many-sidedness he approached the great Florentine. Dürer not

only studied perspective as a science, and the vexing problem of ideal proportions in an effort to reestablish the lost canon of classical Antiquity, he also wrote substantial treatises on these subjects. Furthermore, he rivaled Leonardo as a specialist on fortifications, as his publication on this subject shows.

Erwin Panofsky, in his brilliant monograph on Dürer, has stressed this tension that goes through the artist's life, "the constant struggle between reason and intuition, generalizing formalism and particularizing realism, humanistic self-reliance and medieval humility," and he says that it caused in Dürer's development "a certain rhythm comparable to the succession of tension, action and regression in all natural life." [4]

Albrecht Dürer's biography gives us some insight into his artistic growth and we learn a great deal about it from his own writings as well as from the remarks of his contemporaries. Three times he traveled into foreign lands — twice to Italy and once to the Netherlands — and each of these journeys played a significant part in his development. He was born in Nuremberg in 1471, the son of the goldsmith Albrecht Dürer the Elder who had come from Hungary and married the daughter of his Nuremberg master. The boy was initiated by his father into the goldsmiths' craft and at the age of fifteen was apprenticed for three years to Michael Wolgemut, a respectable Nuremberg painter who operated a large workshop. According to Dürer's own remarks this was not a happy time in his life, since the older apprentices treated young Albrecht rather roughly. But Dürer respected his master and owed to him the introduction to the art of woodcutting, in which he was soon to excel. In 1490, at the age of nineteen, he started on his travels (*Wanderjahre*), visiting Colmar in Alsace in 1491, where he hoped to meet Martin Schongauer, the renowned late Gothic engraver. He arrived too late; Schongauer had died the year before. Dürer then went to Basel and Strasbourg during the years 1492–93. In 1494 he returned to Nuremberg and married Agnes Frey, daughter of a coppersmith. It does not appear that the marriage was a happy one — in fact, he soon left home on a trip to Italy. If we can believe his friend Pirckheimer, Agnes often plagued him, later in his life, by her excessive thrift, forcing him to work when he was ill.

The first Italian journey occurred in the fall of 1494. Dürer went to Venice, but the contact with the art of the south did not yet initiate a full-fledged classical trend in his own art. It simply gave a kind of heroic impulse to his draughtsmanship, which still retained its late Gothic mode of expression.

DÜRER

In 1505, when Dürer was a man of thirty-four, he again left Nuremberg for a second trip to Venice. This time he was received as a prominent master, since his prints had gained for him an international reputation. He was also better prepared to absorb the point of view of the Italians and some of the qualities of Venetian painting. It was with reluctance that Dürer returned to Germany in 1507. A famous passage in a letter he wrote to Pirckheimer from Venice sounds like the perennial yearning of the northerner for the beauty of the south. "How I shall freeze after this sun! Here I am a gentleman, at home only a parasite." [5]

However, Dürer's situation in Germany improved following the Venetian journey. He received orders for large paintings and in 1512 the Emperor Maximilian honored him with a number of important graphic commissions. Although he never earned a great deal, Dürer became the foremost artist of Germany.

When Dürer was forty-nine, in 1520, he left Nuremberg once more, this time on a journey to the Netherlands. He wished to obtain from the new Emperor Charles V a renewal of his small pension. This journey provided much stimulation for the aging artist. The traditional realism of Flemish art and the new impressions gained from the wealthy culture of Flanders — where he was received as a famous visitor — refreshed his mind and his style. However, on an excursion to Zeeland, where he went to see a whale which had been washed ashore, he contracted a malarial fever. This undermined his health and caused his death seven years later. He died in 1528, at the age of fifty-seven.

It has often been said, and we hear this even from his Italian contemporaries, that Dürer's genius expressed itself more easily and more successfully in his drawings and graphic art than in his paintings, which the Italians found lacking in coloristic harmony. The artist resented this judgment and considered himself as much a painter as a draughtsman. Nevertheless, it was most natural for him to express his feelings, his ideas, and observations by linear means, and his drawings show from the beginning a rare sensitiveness of form and an extraordinary ornamental charm. There still exist about 900 sheets by his hand, for the most part in the museums of Berlin, Vienna, London, and Paris. These are well reproduced in Friedrich Winkler's standard work on Dürer's drawings (four volumes, Berlin, 1936–1939). Since Dürer's art always enjoyed the highest reputation, by far the largest part of the drawings came early into the great European collections. Comparatively few have found their way to the Western Hemisphere, and of these the Morgan Library owns the most substantial group.

DÜRER

A feeling for his own worth and his place in history must have led Dürer, late in life, to make specific biographical or documentary comments on a number of his earlier drawings. Thus he wrote on the early self-portrait (fig. 97a), a silverpoint sketch in the Albertina, which represents him at the age of thirteen or fourteen: "Dz hab Ich aus einem spigell nach mir selbs Kunterfet Im 1484 Iar Da ich noch ein Kind was Albrecht Dürer" ("This I have drawn of myself from a mirror in the year 1484 when I was still a child"). It is a highly interesting document of Dürer's precocious talent — done, of course, in the conventional style of German late fifteenth-century portraiture, but with clear signs of his individuality both in appearance and in artistic skill. The slight squint of his eyes, the aquiline nose, the full-lipped, rather sensuous mouth, the long, flowing hair, the emphasis on his nervous hand — these are the same features that appear in Dürer's later self-portraits, but done with a boyish constraint and understandable shortcomings. The feeling for form and sensitiveness of line are remarkable, and it is not difficult to relate this work of a child to much that follows in Dürer's manhood.

The step, however, from this drawing to the self-portrait drawing of the twenty-year-old Dürer, in Erlangen (fig. 97b), clearly shows what an enormous development the young artist has gone through since the days of his apprenticeship with Wolgemut. His *Wanderjahre* have just begun, but he does not seem to be setting forth in the carefree mood of an adventurer. The burden of his genius appears to weigh upon him. We are struck by the directness of expression in his glance, by the freedom of his pen which now reveals a master's touch. The vivid naturalism and the twisted arrangement are clearly late Gothic. No Italian artist would have placed his hand so prominently in front of his face. He would have considered such a gesture undignified, if not ugly, preventing a clear frontal or profile display of the features. But the young Dürer enjoyed such superpositions and the interpenetration of forms. The line still depends upon the vocabulary of Schongauer's graphic style, with its vivid shading by means of little hooks and cross-hatching, the latter beginning to follow the curves of the contours. We can admire Dürer's sensitive modeling and recognize more clearly certain personal traits that were forecast in the earlier self-portrait.

The large pen drawing in Berlin of a "Holy Family in a Landscape" (fig. 98) can be dated 1492–93 and strongly represents Dürer's late Gothic style during his *Wanderjahre*. The slender type of the Madonna with flowing curly hair and

delicate hands, the cascade of angular, crumpled folds in her drapery, the restless play of light and shade — one may call it flamboyant — which is brought about by dense cross-hatching and little hooks, all these features are derived from Dürer's forerunners, from Martin Schongauer in particular. A comparison with a Schongauer Madonna (fig. 99), also a pen drawing in Berlin, will show both this dependence and the young Dürer's amazing individuality. The older master's design, while more disciplined, seems hard and archaic beside his. A new vitality and freedom of line crop up in Dürer's graphic language. The modeling is both more nervous and more intense, enlivening the organic character. Of course the Madonna's body is still largely hidden, in the late Gothic fashion, under a mass of crumpled drapery, but Dürer's new feeling pervades both animate and inanimate forms. The landscape reflects a fresh, naturalistic vision. It has depth and a delightful airiness, and is therefore quite different from the severely stylized and somewhat schematic backgrounds of Schongauer's engravings. The impression of a continuous spatial depth is achieved not by a correctly integrated foreground and background, but largely by the unifying quality of a pervading light and atmosphere. In the surface composition the vertical tendency and sharp diagonals still predominate.

In the same stylistic phase as the "Holy Family" belong the drawings of a "Young Couple Walking," in Hamburg (fig. 101), and a "Female Nude" in Bayonne, dated 1493 (fig. 100). Thus both genre subjects and nude studies were already in Dürer's repertoire during his *Wanderjahre*. A few years later, in 1496–97, he engraved the motif of a young couple on a walk, known as the "Promenade," adding in the background the figure of Death lurking behind a tree and holding up an hourglass. A genre subject is thus transformed into a moral allegory. In the drawing the figures are somewhat intertwined, while both step forward in a diagonal direction. The drapery of the young lady is sharply crumpled, still in the Schongauer manner, which we also detect in the type of shading. The line is as crisp and vibrant, and the light as brilliantly flickering as we have seen in the "Holy Family." Most remarkable, again, is Dürer's vigorous modeling, and the subtle and lively characterization of the young people reveals something of the artist's own personality, whether or not the youth can be considered a self-portrait, as some authors will have it.

In the late Gothic period the study of the nude was almost nonexistent. It became important only in the Renaissance. Dürer, however, as the drawing in

Bayonne (fig. 100) proves, took an interest in the nude early, even before he came in contact with Italian art. This drawing shows a complete lack of classical standards. There is no clear expression of weight in the stance, nor is the structure of the body fully grasped. Nevertheless we are charmed by the peculiar stylization which the artist brings into the figure. It seems as if the shape of this body has been determined by the late Gothic costume, with its narrow waist, and its emphasis on slenderness and elegant fragility. The young Dürer's vitality and freshness of vision are felt in this unusual subject.

Dürer's genius for decorative designs is also evident before his first trip to Italy. The impressive coat of arms with a man behind a stove, and surmounted by a bird resembling a pelican, in Rotterdam (fig. 102), clearly belongs to the *Wanderjahre*. It fairly bursts with vitality in the luxuriant foliage and densely intertwined tendrils surrounding the humorous motif on the shield. The bird perched on the helmet is seized by the same violent, rhythmical movement that animates the ornamental parts. Throwing its head back and raising one claw, the creature seems to emit a loud cry from its sturdy beak. Schongauer's engravings show some fine foliage-and-bird designs, but they look tame beside the young Dürer's dramatic creation.

From the artist's first trip to Italy (1494–95) we have comparatively few drawings. Some copies after Mantegna and Pollaiuolo show that he tried, at that time, to learn from the heroic nudes of these leading *quattrocento* masters, and something of Mantegna's virile art goes over into Dürer's most powerful production following this trip: the woodcut series of the "Apocalypse." A drawing of a "Women's Bath" dated 1496, in Bremen (fig. 103), may illustrate how Dürer's interest in the nude had grown since his first contact with Italian art, and how his style progressed toward a fuller and more competent modeling, and also toward a clearer perspective. Elements of the late Gothic style still persist, however. Winkler assumes that Dürer intended this drawing as a kind of "academy" of female nudes in various positions — a convincing suggestion, although the actual subject of a bathhouse gives the representation also a genre character. It is unusually finished, as if to serve as a model for an engraving. A kindred motif of various nudes in an interior occurs one year later, in 1497, in the engraving called "The Four Witches." This print shows the subject stripped of its genre character and transformed — as in the case of the "Promenade" engraving — into a moral allegory. Moreover, the strong late Gothic tendencies of the

drawing are almost eliminated in the print. These tendencies in the bathhouse scene are most evident in the rear figures who turn and twist their bodies in the act of washing themselves. Most conspicuous is the corkscrew movement of the woman on the right who flourishes a kind of whisk broom. The kneeling one in front, about to scrub the back of a fat old woman, seems more acceptable to classical standards. Altogether it is a well integrated composition full of lively details. One such detail in the background, easily overlooked, is the man peeping in through the narrow opening of the window on the left. In the graphic treatment we notice a lighter touch than in the Bayonne drawing (fig. 100), in addition to a better understanding of the human body.

Perhaps the most striking result of Dürer's first Italian journey was his discovery of landscape as an independent theme in art, although he did not exploit it later in his life (in the classical concept, man, rather than landscape, takes first place). A number of beautiful watercolors like the "View of Trent," in Bremen (fig. 105), make us regret that Dürer did not follow up this discovery. Whether the first impulse to represent mountain scenery came to him on the spot, or whether he was stimulated by the landscape backgrounds he had seen in Venetian painting, it is clear that Dürer was struck by the beauty of the Alps and showed amazing competence in attaining a wide and coherent spatial effect in their portrayal. He used the medium of watercolor for sensitive aerial perspective, as well as for balancing the masses with an almost Cézanne-like feeling for the colors' bearing on the position in space and on the harmony of the whole design.

If we look back from these Alpine watercolors to an earlier pen drawing of a rocky landscape with a castle in the distance, belonging to the Albertina (fig. 104), we see Dürer still steeped in the Wolgemut tradition in the sharp separation of foreground and background, and the angularity of the rock formations. The drawing does not lack indications of Dürer's sensitiveness in the airy distance, but the spatial effect has the violent abruptness of late Gothic landscape backdrops.

The period from 1500 to 1504 we call transitional because in these years Dürer made decisive advances toward the classical style without breaking with the past. There are works like his great series of woodcuts on the "Life of the Virgin," and also engravings such as the "Great Fortune," the "St. Eustace," the "Adam and Eve," where an effective balance is struck between the old and the

new trends, between northern intimacy and southern clarity, between late Gothic ornamentalism and Renaissance formalism.

A few sketches for the scenes from the "Life of the Virgin" are preserved as precious documents of Dürer's preparatory work with the pen for this great woodcut series. The study for the "Birth of the Virgin" (fig. 106) looks like a fresh first draft concentrating on an interior with a few figures around the childbed in the center. In the woodcut many more persons are brought in; it becomes a real crowd of visitors, while the bed is moved to a rear corner and an angel hovering over clouds fills the upper half. The sketch definitely has its merits in the spirited penmanship, with the briefest yet adequate indication of a fully-furnished interior, and showing few but essential figures in vivid momentary action.

The draft for the "Visitation" (fig. 107) is much closer to its woodcut version and may have been used as a basis for the final drawing on the block. There are still changes to come, particularly in the landscape background, which becomes one of the most beautiful passages of the whole series. This drawing, like the previous one, is of the fast and very sketchy type. The figures, however, have a more emphatic relief than the rest of the scene, as if they alone were meant to serve as models for the final draft.

Dürer never ceased creating portraits with the greatest ease and with striking characterization. A pen sketch of his young wife (fig. 108) — he inscribed it "mein Agnes" — may date back to the year of his marriage, 1494. Its vivid, instantaneous quality gives a foretaste of Rembrandt's draughtsmanship.

But in turning to the powerful charcoal portrait (fig. 109) of Dürer's friend Willibald Pirckheimer, of 1503 — the year in which he for the first time exploited this medium in a number of portrait drawings — we are struck by the monumental finality, by the vigorously tectonic composition with a classical emphasis on the profile. It has been suggested that this drawing was made as a model for a medal, but the profile view can be sufficiently explained by Dürer's growing taste for the Italian style. Moreover, he may have done it to please the sitter who, as a wealthy patrician and man of culture, collected ancient coins among other things. Dürer, in venturing into the new style, does not lessen his realism. Pirckheimer's personality is fully expressed. An almost brutal vitality is felt, and a certain sensuousness combined with intellectual keenness. Pirckheimer favored the artist with a lifelong friendship; he advanced him the money

for his second trip to Italy. The two men exchanged many letters and it was largely due to this relation that Dürer was everywhere given access to the world of the humanists and the wealthy. In their correspondence both showed extreme frankness, as Dürer did also in his portrait, making no effort to beautify the fleshiness of his friend's features. But the drawing has decorative grandeur and simplicity that can hardly be surpassed.

Dürer's search for the secret of classical beauty begins in this transitional period when drawings of nudes as studies of proportion first occur. It seems that Jacopo da Barbari, a Venetian painter and graphic artist who worked in Germany, raised the Nuremberg master's high hopes of finding the key to classical perfection in a definite formula of proportion. Whether the "Apollo and Diana" drawing in London (fig. 110) — which went through various transformations by the artist himself — was inspired by an engraving of the same subject by Jacopo da Barbari, or by the "Apollo Belvedere" (which had recently been discovered), or by a Mantegna figure from one of the Bacchanal engravings (as Winkler suggests), the central figure was used by Dürer in a number of studies of proportion. His engraving of the subject of Apollo and Diana dates from a few years later (c. 1504) and shows very different positions in the two figures. It seems, therefore, that the drawing in London was made before the plan for the engraving materialized. In any case, it is a handsome example of Dürer's growing classicism which is here enlivened by the freshness and delicacy of his penmanship.

There is no doubt that the nudes in Dürer's famous engraving of "Adam and Eve" of 1504 represent the result of extensive studies of proportion during these years, and that the Adam is related to the Apollo figure in the previous drawing. The beautiful preparatory sketch in the Morgan Library (fig. 111) served as a model for the figures in the print. It is by no means accidental that the artist chose this Biblical subject to express his ideas of perfect beauty. Since, as a Christian, he believed implicitly that perfection was lost through the fall of man, he attributed it only to Adam and Eve before that fateful event. So Dürer applied his knowledge of ideal proportions — as classical authors and classical art had taught him — to man's first ancestors. The figures in the drawing look somewhat constructed because the artist had labored hard before finding an acceptable formula. Yet their handsome outlines, their graceful gestures, and their human characteristics are not destroyed. And in the engraving, as is well known, Dürer

added all his mastery of natural detail in the thicket behind the figures and the animals around them. The graphic treatment in the drawing, with little dots and hooks, still relates to the somewhat restless shading of his earlier style. The effect, however, is more transparent than before, and the extreme finesse seems dictated by the model character of the drawing.

Any account of Dürer's draughtsmanship would be incomplete without mentioning his many studies of costumes at home and abroad. Some pen sketches of Venetian ladies are among the few documents from his first trip to Italy. The watercolor of a "Nuremberg Lady Going to a Dance" (fig. 112) — as Dürer's inscription tells us — is dated 1500 and while more than a mere costume design, the artist has here elaborately described all the details of a fashionable dress for a townswoman. We find similar figures and costumes in the "Life of the Virgin" series on which the artist was working during these years. The style is now broader than in the earlier sketches of this kind. The late Gothic slenderness, the flamboyance, and slightly forced elegance have given way to greater naturalness and simplicity. And there is even a touch of monumentality in this figure which is not found, for example, in the pair of lovers taking a walk, of c. 1492 (fig. 101).

While Dürer now turns more and more to the serenity of classical art, he is still haunted at times by the apocalyptic mood to which he had once given such powerful expression in his famous woodcut series. This was, after all, the age of the "Dances of Death." The subject was painted on the walls of charnel houses and even cathedrals. It was a time when the plague broke out overnight and took its toll from the population. There was, in fact, such an outbreak in Nuremberg just before Dürer left for his second trip to Italy. Thus death was ever-present and the people were admonished through *memento mori* representations to save their souls in time. This is clearly the meaning of Dürer's vigorous drawing of 1505, now in London (fig. 113). We see Death with a crown on his head, using his scythe to spur his emaciated horse on to new ventures. Dürer's line has here a gripping power. The composition with the clear profile display of horse and rider shows the artist's classical taste, while the highly emotional content relates the drawing to his Gothic past and equals Grünewald and other German expressionists in intensity.

Dürer's second journey to Italy is well recorded in his letters to Willibald Pirckheimer, from which we have already quoted one famous passage (p. 53). Many of his visual experiences on this trip are reflected in his drawings. Among

these the majority are studies from life in preparation for paintings which he carried out in Venice. The largest commission, a painting of the "Feast of the Rose Garlands" for the church of S. Bartolommeo, came from the German merchants whose residence or clubhouse, the Fondaco dei Tedeschi, had just been built. Other important works were the "Christ among the Doctors," now in the Thyssen Collection (formerly in the Palazzo Barberini), the "Madonna with the Siskin," now in Berlin; also single portraits of Venetian ladies, one now in Vienna, another in Berlin. Dürer's mastery in details, which he always prepared by careful studies, was much admired by the Venetians. Of these studies a number have survived, including heads, hands, draperies, and half- and full-length figures, done in a new technique derived from the Venetians, that is, with the brush in dark gray, highlighted with white, on blue paper. This Venetian paper was colored in the fiber during its manufacture, and its natural grainy texture appealed to Dürer as a drawing surface. The German method was to add the color after the paper had been coated with a ground of bone meal, making a smooth, opaque surface to receive the drawing. The superior painterly taste of the Venetians made an impression upon Dürer, but he did not adopt the breadth of their technique; he rather combined, in an original way, his own linear finesse and tonal sharpness (brought in by highlights) with the new painterly technique of brush drawing.

The "Christ among the Doctors" (fig. 114a) was perhaps inspired by a composition of Leonardo's which is reflected in a Luini painting. But Dürer's work differed considerably and became an exhibition piece of expressive physiognomies and hands. His drawings for it may well have charmed the Venetians more than the final picture. The study in the Blasius Collection (fig. 114b) shows two pairs of hands, each holding a book; one of them was taken over into the painting. As always with Dürer, these hands show personality, vigor, and refinement in the way they grasp or relax. Dürer's sense for organic life is evident here and he combines, at this stage of his development, precision of observation with beauty of presentation, through tonal harmony and transparency. The tones, however, are more vivid and detailed, in the interaction of light and shade, than is ever found with the Venetians. It seems little short of a miracle how subtly Dürer suggests the phenomenon of reflected light by his method of linear shading.

For some time Dürer held to the Venetian technique of brush on blue paper. But when he returned to Germany he had to use grounded paper, as we see

from his studies for the so-called "Heller Altar" of 1508, of which we reproduce the drawing of the feet of a kneeling apostle (fig. 115). The painting, which represented the "Assumption and Coronation of the Virgin" and was ordered by a wealthy citizen of Frankfort, was destroyed by fire and is known to us only by an old copy. Fortunately a number of Dürer's studies (fig. 116 also) have survived.

The sole of the foot is not often observed in detail, yet structurally it is one of the most interesting parts of the human body. Dürer's attention was drawn to it by earlier representations of kneeling apostles (most prominent being the figure in Schongauer's engraving of the "Death of the Virgin"), but only now does the motif assume a truly organic character. We feel the integration of muscles and bones, and the skin seems as vital a part as the flesh and the skeleton underneath. We also learn a great deal about the coordination of heel, sole, and toes in this position of the foot. Moreover, the drawing has both an expressive and a calligraphic attraction.

There are heads of extraordinary beauty among the Venetian studies, like the one of a young woman (fig. 117), also in brush and on blue paper, in the Albertina. Dürer used a similar type for his "Madonna with the Siskin," but the face in the drawing seems grander in its proud erectness and noble features. One is tempted to see here an idealized type, but Dürer's intense and accurate rendering of details — even to the reflected light playing so subtly over the features and so minutely observed at the side of the mouth and the nose and in the corner of the eye — betrays, I believe, direct observation from life. His brush lines work with an incredible finesse to build up the form with perfect roundness and to produce, at the same time, an intimate surface animation.

Again we see the Venetian brush technique coming back in the "Head of an Apostle" for the Heller altar of 1508, this one on grounded paper (fig. 116). Here one may assume an invented type; it seems to be an ideal head which is only remotely based on earlier studies from life. The calligraphy is even more perfected, the plastic power intensified, and the character boldly deepened, but still with naturalistic sharpness. It seems that Dürer has here for the first time formulated one of those apostle types which are to become prominent in his late work.

A "Female Nude Seen from the Back," in Berlin (fig. 118), also belongs to the Venetian period and is surely done from life, unlike the majority of his

nudes done in Venice which are constructed figures and pen studies of proportion. In a work as early as the engraving of the "Four Witches" of 1497 we encounter a nude seen from the rear and showing similar stance and proportions. It was one of the early manifestations of Dürer's awakened interest in a fuller study of the nude, which resulted from his first contact with Italian art. He now shows a much firmer grasp of the structural qualities in the human body. The figure is set effectively against a darker tone, and the light which plays over the surfaces helps to create an impression of full existence in space. It is by no means an academic exercise, but one pulsating with life and of a refreshing directness, yet not without an intense formal discipline.

While Dürer's style in the Venetian brush drawings and in those for the Heller altar is still a little tight, it loosens in such pen drawings as the "Adam and Eve" of 1510 in Vienna (fig. 119) or the "Rest on the Flight into Egypt" of 1511 in Berlin. A new brightness and economy of line dominate the graphic expression, which is now of a superb lightness and transparency. The concept is here more realistic, not to say sensuous, than it was in the ideal "Adam and Eve" of the 1504 engraving. Dürer used the main motif of this drawing in his woodcut series of the "Small Passion" which originated at about this time. The aftereffect of the Venetian years can be recognized here in the pleinairistic charm and open manner, while the penmanship shows a steady increase in ease, delicacy, and suggestive brevity.

In the years 1513 and 1514, Dürer must have given his best thoughts to the three so-called "Master Engravings" ("Knight, Death, and Devil," "St. Jerome in his Study," "Melencolia I"). He poured the essence of his philosophy into these three famous prints which, for profundity of content and graphic perfection, rank among the masterworks of all time. Only a few drawings have survived that are directly connected with these prints, among them the forceful pen study in the Ambrosiana representing "A Knight on Horseback" (fig. 120). It is well known that Dürer here revised an earlier study, his horseman of 1498, changing only the position of the horse's legs and head. In the early representation the animal was quietly standing, now it is smartly pacing. In this form the horse bears a definite similarity to Leonardo's draft for the Sforza monument which became widely known. It would not be the only case where Dürer learned from the great Italian. Like Leonardo he studied the proportions of horses, and some construction lines are noticeable in this drawing. Thus it is far from being

a sketch from life, but rather a carefully thought out study derived from two different sources. As for animal studies from life, and plant studies also, it is well known how superb a naturalist Dürer could be, from his "Little Hare" and his "Great Piece of Turf," both in the Albertina.

In the same year in which Dürer created his "Master Engravings" he drew one of his most impressive portraits, that of his sixty-three-year-old mother, now in Berlin (fig. 121). Dürer made some touching remarks about her in his short autobiography. She was a hard-working woman who had given birth to eighteen children, of whom only three survived. After her husband's death her son took her into his house and she made herself useful by sitting in the market places selling his prints, until illness overcame her. The artist represents his mother here two months before her death, as we learn from the inscription he added later in pen. The realism of this drawing is overpowering, and its objectivity remarkable. The subject is enriched and ennobled by the expressive quality of its decorative lines.

The Madonna theme appears throughout Dürer's work as one of his most favored subjects, and one which he endowed with all the grace and human intimacy of his art. In this subject, too, the influence of Venetian art made itself felt, both in arrangement and in treatment, even long after his second journey to Italy. The drawing of 1519 in Windsor (fig. 122) still shows the motif of a music-making angel at the feet of an enthroned Madonna as Dürer had found it in Giovanni Bellini's St. Zaccaria altar. The fullness of form has increased over the years, as has the dignity of expression. These features, too, bring his style closer to the best of Italian art. Dürer's penmanship has now achieved a beautiful breadth and openness. A sunny brightness bathes the figures and permeates the landscape, forming an adequate correlative to the monumentality and clarity of his late style.

Even with tragic and emotional subjects such as the study of five nudes (fig. 123) for a "Resurrection"(?), these qualities of lightness and brilliance, as well as the vibrancy of the lines and their extreme economy, lend a rare attraction to Dürer's late sketches. As far as his draughtsmanship is concerned, there was no lapse into classicistic coldness or academic rigidity, such as sometimes occurred in his late paintings and engravings.

On his Netherlandish journey in 1520–21, Dürer eagerly sketched people, monuments, places, animals, costumes, and whatever aroused his interest, as the

surviving sheets of two sketchbooks show. The smaller one contains silverpoint studies (fig. 124a) and pen drawings (fig. 124b), the larger one, portrait drawings in chalk. The latter he often produced on his journey, for a small fee (one guilder), and now they are numbered among the greatest art treasures of the world. The head of a young man, in London (fig. 125), is a superb example of this group. Although slightly cut along both sides and on top, the decorative breadth of the arrangement is still clear and the expression of inner life — as so often with Dürer — is vividly brought out by the glance of the young man. He gazes dreamily into the distance as imaginative persons sometimes do. It has been suggested that the Flemish court painter Barent van Orley is portrayed here. We have no certainty about this identification, although it is quite credible that an artist is represented.

Dürer's use of the silverpoint in his Netherlandish sketchbook may have been influenced by the preference of Flemish artists for this delicate medium. However, it was familiar to Dürer from his boyhood (fig. 97a); he had obviously learned the technique from his father, who had been trained — as the artist tells us — "by the great masters" in the Netherlands. Now Dürer applies this fine technique with the breadth and transparency of his mature style, yet it seems more appropriate than ever to his intimate description and characterization. The sheet with heads of two women, a young and an old one (fig. 124a), bears the artist's inscription above the young head: "zu pergen." Early in December 1520, Dürer arrived in Bergen op Zoom and he wrote in his diary: "Ich habe conterfet . . . die Magd und die alt Frau (im Haus des Jan de Has) mit dem Steft in mein Büchlein" [6] ("I have portrayed . . . the maid and the old woman (in the house of Jan de Has) with the silverpoint in my little book"). The Flemish headdress caught his interest as well as the individual character of both subjects; they became unforgettable portraits, which can stand the competition of any Memling or van Eyck.

In the pen drawing of the harbor view of Antwerp, in the Albertina (fig. 124b), the artist depicted simply the row of boats drawn up at the quay which leads diagonally to the edge of the city wall with its towers. Yet the spatial effect is a bold one, defined by the open foreground and a few well-spaced horizon lines. Although the drawing is merely factual, its suggestive open manner and economic penmanship lend it considerable charm.

The large painting of the "Four Apostles" now in Munich, dated 1526, was

Dürer's gift to the city of Nuremberg and has often been called his testament to the German people. The high religious ethos of the Reformation, to which the artist adhered in his late years, emanates from these mighty figures. Dürer was deeply disturbed about radical excesses in the Protestant movement, and he wished to warn the rulers of Nuremberg "not to accept human seduction for the Word of God," as the inscription originally under this painting (and now preserved in Nuremberg) tells us. It includes four quotations chosen by the artist from the writings of the four holy men represented and all refer to the same idea: that we should beware of false prophets. The figure of St. Paul is perhaps the grandest of the four, and the metalpoint sketch in Berlin for his head (fig. 126), although no longer in perfect condition, gives the full impact of the character which Dürer has created with this type.

Themes of the Passion also occupied the artist in his last decade as intensely as ever. A silverpoint drawing of the "Lamentation" in Bremen, of 1522 (fig. 127), may be chosen to convey the power of some of his late compositions. Here again he is both an expressionist and a classicist. He rivals Grünewald in emotional strength, yet also preserves the restraint and dignity, the monumentality and clarity which he had attained in his long struggle to incorporate the achievements of the Italian Renaissance into his own style.

Even a brief survey of Dürer's draughtsmanship cannot omit an example of his delightful marginal designs for the prayer book of Emperor Maximilian which the artist carried out in 1515. Their inventive spirit, delightful humor, and ornamental fantasy exhibit one side of Dürer's genius that has earned him much popularity and shows, like his other works for the Emperor, his importance as a decorative designer. These drawings were models for woodcut illustrations in colored ink, to be printed around the text which is printed in black. The Emperor intended to distribute this prayer book — which as a printed work never came to completion — among the distinguished members of the Order of St. George. Other reputed German artists like Cranach, Altdorfer, and Burgkmair also made contributions, but Dürer's part was the largest and most important, and it set the pattern for the whole.

In the page reproduced here (fig. 128) we see on the right a nude man with a club, at his feet a dead lion. He is Hercules, whom Dürer the humanist introduced here as "the champion of Virtue and conqueror of evil in all shapes and forms." Hercules is contrasted with a scene of vice below, where we notice, to

quote Panofsky again, "a drunkard too lazy and self-indulgent to fight off the attack of a spoonbill goose." Dürer represented here "the victory of spiritual forces over the dangers and temptations of the world — by way of mythological allusion." [7] Closer scrutiny reveals a snake crawling down the fancy tendril on the left, and above it a mask and a bird's head coming out of the coiling branches. This is the side which leads to the evil represented below.

We can repeat here the statement we made at the beginning of this essay, that even in Dürer's mature art the classical trend remains integrated with the artist's Gothic past. It is evident that the marginal designs of medieval manuscripts, with their drolleries and tendrils, are the true forefathers of these illustrations of Dürer's. However, he has enlivened them with his humanist spirit and with an ornamental fantasy that seems inexhaustible. No one who followed him could equal Dürer in the musical charm of his line, not even Holbein, who took up the classical trend of the northern Renaissance and carried it to its highest point.

REMBRANDT

REMBRANDT

The attraction of Rembrandt's drawings is steadily increasing. Their appreciation owes a great deal to the period of Impressionism. It was the Impressionists who sharpened our eyes to the charm of sketchy and spontaneous representations in art, such as drawings can most easily produce. The Impressionists were opposed to overdetailed and highly finished styles. They rejected all laborious techniques and processes which might lessen the freshness and spontaneity of a work of art. Only when these qualities are preserved, they believed, can the spectator come into close contact with the artist's personality and participate in his creative sensations.

There is little doubt that Rembrandt's drawings satisfy such impressionistic demands. But it is not only the spontaneity and directness that attract us. There are many more features implied, such as his striking grasp of form and character, his strong suggestion of space and atmosphere, the originality and expressive power of his graphic language, and last, not least, the intimacy and profundity of his human interpretation. These are qualities which Rembrandt's drawings exhibit even more than his etchings and paintings, and which go beyond the range of Impressionism.

However, Rembrandt the draughtsman was as unusual in his own century as he is when set beside the Impressionists. There was no other artist in the Baroque period who could compare with him for range, variety, and expressiveness, although the seventeenth century abounded in graphic talent and even genius. If we consider Rubens, the greatest representative in northern Europe before Rembrandt, we must admit that the Fleming's drawings hold their own in vigor, directness, and pictorial attraction. But it is undeniable that drawing did not mean as much to Rubens as it did to Rembrandt, who cultivated it as an art for its own sake. For Rubens, drawing had only a subsidiary function in relation

to painting. This was the Italian tradition in which he had been brought up. In the Italian Renaissance, and still with Rubens, drawing served primarily to prepare pictorial compositions. It furnished a quick draft of the whole, or detailed models for later execution in painting, as the drawing of the "Girl Bearing a Jug" (fig. 129a) served as a model in a painted "Adoration of the Shepherds." Drawing was seldom practiced for its own sake. For Rembrandt, on the other hand, there was sheer pleasure in the art of draughtsmanship; it served as a favorite means to study life in its diverse aspects, and beyond that, to express imaginary subjects, often independent of any later execution in another technique.

Rembrandt's position as a draughtsman is also unique in relation to other Flemish or Dutch masters of the seventeenth century. There were some to whom he was indebted for his youthful style, with its electrifying vivacity. Among these forerunners was van Dyck, whose impulsive and angular pen drawings, like the sketch after a Titian composition of "The Arrest of Christ" (fig. 130a), give a premonition of the young Rembrandt's penmanship. Also Adriaen Brouwer, the ingenious founder of the lowlife genre in Dutch and Flemish painting, may be named among Rembrandt's forerunners. Brouwer's vivid impressionistic sketches of peasants and tavern scenes (fig. 130b) were obviously known to Rembrandt and seem to have influenced him. And finally his teacher, Pieter Lastman, as in his sketch "Young Man with a Staff" (fig. 129b), left some traces of his Baroque draughtsmanship in Rembrandt's work. But none of these earlier draughtsmen extended the range of their activity beyond the traditional boundaries. With them, drawings, in general, still served primarily a preparatory function or were confined to a highly specialized category such as landscape, genre, or historical compositions.

It is not necessary to carry this comparison further, either with Rembrandt's contemporaries or with modern draughtsmen. It will be sufficient to state that it was Rembrandt who raised the art of drawing to a principal form of artistic expression, with the widest possible range and with a considerable independence from his painted or etched work. From Rembrandt's drawings, as in "Studies of Heads and Figures" (fig. 131a), we learn the vivid experiences of his daily life, his human contacts, his artistic sensations — at home, on the street, and in nature. And beyond this they reflect the creative activity of his mind in purely imaginary representations, like the scene from Rembrandt's mature period, with

St. John and St. Peter healing the cripple at the door of the temple (fig. 131b). Rembrandt was so organized that he could not abandon any thread he had once taken up. This growing productiveness of his mind, this constant development of favorite subjects, with an ever-deepening interpretation, are reflected in his drawings because only there, rather than in the more laborious techniques of etching or painting, could he materialize this overflow of vision with the necessary speed. Therefore it is justifiable to say that one does not know the whole Rembrandt if one does not know his drawings. Indeed it is his drawings that give perhaps the most intimate insight into the complexity of his genius and his artistic procedures. From them we learn that nature and life were a constant source of inspiration to his art; from them we also learn that the invisible, spiritual world of the Bible never ceased to nourish his imagination. The borderline between these realms, the actual and the imaginary, fades to such a degree that his Biblical scenes seem to be real, while his studies from life are filled with the spirit of his inner world.

In the self-portrait of about 1629, an oil painting in the Royal Gallery at The Hague, we see Rembrandt at the age of twenty-three (fig. 132a). The young artist's energetic and sensitive character is brought out, also his romantic taste in the way he dressed up as an officer with a steel collar. The illumination strikes us as very dramatic; we notice also a detailed, almost minute, execution in parts — in the hair, the breastplate, and elsewhere. It was some time before Rembrandt was able to overcome this laborious character in his painting technique.

Turning to a drawing of the same period (fig. 132b) — it seems to be a preliminary study for the previous painting — we meet with a bolder and freer touch, a greater directness and suggestiveness. There is the same dramatic chiaroscuro, that is, contrast of light and dark for the sake of a vigorous pictorial expression. The design is organized in three values: deep darks, half darks, and lights, with some transitions between them. The surety of accents is amazing, also the ingenious use of pen and brush and their intricate cooperation. In his speedy execution the young Rembrandt remains quite selective, omits a form here (the ear), stresses another there (the curl on his forehead), yet the general impression is that of a most spontaneous creation, in contrast to the painting of the same year.

When we look at one of Rembrandt's earliest etchings, representing St. Peter

and St. John healing the cripple at the door of the temple (fig. 133a), we find a rather coarse use of this technique, with some failures in the biting of the acid into the plate, noticeable in the dark diagonal streaks across the composition. It is an unusual attempt to express his bold early draughtsmanship in etching, which in this case was unsuccessful due to his technical inexperience. There exists the preliminary sketch for the figure of St. Peter, which appears reversed in the print. It is a chalk drawing belonging to the Museum in Dresden (fig. 133b), and here again we can appreciate the surety of the young Rembrandt's touch, a quality which his draughtsmanship showed from the beginning. It is a vivid sketch from life, with dramatic accentuation on movement and expression. The bowing gesture of the old man in his ragged garments (the model may have been a beggar from the streets), his hands, so markedly spread out, the intense glance — all of these features are strikingly set down in a speedy sketch which already has the characteristic organization of Rembrandt's drawings: in these vital points (head, hands, back) the draughtsmanship is sparse and placed with great economy, while the strokes are massed only in the shadows of the garment where the figure bends. The easing up of the touch toward the contours gives the suggestion of light and air surrounding the figure, and the vivid angular strokes lend a strong momentary life to the appearance of the old man.

We introduce one prominent example of Renaissance draughtsmanship — Dürer's sketch of a seated woman holding a flower (fig. 134) — in order to realize, by contrast, the strong Baroque features inherent in Rembrandt's early drawings. With Dürer the line serves primarily to define form in its plastic entity. With Rembrandt there are more vigorous contrasts of light and dark, a bold omission of line here and there, to indicate light and atmosphere playing over the surfaces. There is a greater immediacy of touch, and stronger emphasis on movement and psychological content — altogether a more exciting momentary effect.

With the drawing in red chalk of a seated old man, dated 1630 and belonging to the Rosenwald Collection (fig. 135), we have another confirmation of the brilliant Baroque qualities of the young Rembrandt's draughtsmanship. Again we find active movement expressed, even in a seated figure, a strongly pictorial character, by a vivid interplay of lines and tones. The contrast of light and dark is vigorous yet softened by fluid transitions; the expression dominates and is brought out with a sensitive lightness of touch in the face. Rembrandt's

fondness for old people is a peculiar feature of his art from the beginning. He was attracted by the richness of inner experience visible in their lined faces. It may be that such fondness was implanted during Rembrandt's childhood by his Bible-reading elders, and resulted from the impression made upon his imagination by the patriarchs of the Old Testament.

After stressing the Baroque features of Rembrandt's draughtsmanship, one must also emphasize how far ahead of his time he was, compared to other Dutch artists. In the drawing of a sick woman in bed (fig. 136) by Frans van Mieris, a respectable genre painter of the mid-seventeenth century, we meet with certain rather common qualities of the Dutch: a detailed realism, an almost photographic description with an equal emphasis on all surfaces, whether hands, bed-cover, or objects on the table. There is nothing suggestive or imaginative in this type of draughtsmanship. It does not go beyond an accurate and rather dry, although competent, rendering of visual reality.

When we turn to a similar subject among Rembrandt's drawings — a pen and brush drawing representing Saskia in bed, attended by a nurse (fig. 137) — we realize that Rembrandt has much less interest in the complete rendering of mere matter, that he is highly selective in his accentuation. With his far more flexible touch he creates dramatic relations in space, as well as psychological tension. He boldly omits part of the composition in order to give added force to the vital points, and his graphic touch ranges from very forceful, broad strokes to the most delicate and thin lines, while the tonality too embraces a wide scale of values, from brilliant lights to deep darks. There is no hesitation, only a striking immediacy, in spite of the intricate organization. Here again light-and-dark contrasts serve as a brilliant means of spatial definition, relating distant planes at will, but also focusing the interest on the essentials: the mood of the sick woman.

A charming little sketch in silverpoint (fig. 138) represents Saskia at the time of her engagement to Rembrandt, in 1633. There is an air of happiness surrounding her, and we realize how much she meant in the artist's life. Saskia came from a patrician family, while Rembrandt was of humbler origin. Thus, at her marriage, she brought him a considerable fortune, and may also have helped Rembrandt to make contacts among the upper circles in Amsterdam. There are more prosaic sketches from the time after the marriage, but none of them lack vividness and directness. For example, in the drawing of "Saskia Asleep" (fig. 139b) we even seem to hear her breathing. The sheet shows two

sketches of her with a slight but noticeable variation. In both the completely re-
laxed attitude of a sleeping person is strikingly brought out; in the lower study
the body is more contracted, she has sunk into the pillows and seems to breathe
more deeply through her open mouth.

Rembrandt also observed closely the growth of his children. Another pen
sketch (fig. 139a) records two successive moments in the feeding of the new-
born. The artist observes and describes how eagerly the infant sucks at the bottle:
in the upper sketch leaning back and half asleep, and in the lower one rising a
little, with an increased effort. We admire the rare economy of strokes in these
pen sketches. Speedy as they are, they grasp the decisive features.

In a chalk sketch in London (fig. 143b), we see two women — it may be
mother and grandmother — teaching a baby to walk. The date is close to 1640,
in other words, Rembrandt's middle period, when his draughtsmanship gains a
tectonic quality, when the forms are more firmly built and their cubic character
is emphasized. Wonderful is the rendering of movement in the two women, the
younger one, on the left, bending over with ease, the other obviously stiff with
age. The focal interest in the child is maintained by sharper delineation in this
area. The drawing is a brilliant example of the suggestive power of Rembrandt's
quick sketches.

While the typical Dutch genre painters like Terborch, Metsu, and others
chose only the more appealing moments of daily life for their representations,
Rembrandt had an eye for all vital reactions, as we know from his drawings. His
babies are often naughty, the mothers shown as tired from their exhausting
maternal duties or quick-tempered in dealing with their problems. This is the
case in a pen and brush drawing belonging to the Morgan Library (fig. 140).
The boy seems reluctant to leave the house, the mother has grasped him ener-
getically and walks down the steps. We see again a dramatic use of chiaroscuro,
with a light silhouetting of the group against the open air. But the drawing is
not only pictorially striking; the mother-child relationship is sharply characterized.

A drawing in the Louvre (fig. 141) is perhaps a study of Rembrandt's second
wife, or we may say, companion, Hendrickje Stoffels, looking out of a window. It
belongs to his later period, to the mid-fifties of the seventeenth century, when the
tonal treatment shows a softer and richer character. The light is brilliantly ren-
dered around the head with most sensitive gradations. The features are effectively
set off against the square form of the shutter with fine and incisive lineament.

The broad areas of shadow show a velvety depth and are more luminous than the reproduction indicates.

Hendrickje fallen asleep, leaning against the arm of a chair (fig. 142a), is shown in a pure brush drawing of powerful breadth such as Rembrandt often produced in his late work. (One can well imagine that Renoir, in his late period, was fascinated by such sketches, by the compactness of form as well as the brilliant suggestion of light and atmosphere.) The reflected light on the hair creates a special pictorial attraction, between the massive dark accents of the foreground and the more hazy chiaroscuro of the background. The open character of the foreground is very suggestive. The diminishing width of the strokes indicates the recession in space.

In the delightful chalk study (fig. 142b) which Rembrandt used for the figure of Susanna in his painting of 1647 in the Kaiser Friedrich Museum, the sensitive impressionistic character recalls Degas, rather than Renoir. The model seems to be the young Hendrickje shortly after she had joined Rembrandt's household as a maid. In his middle period Rembrandt shows himself particularly receptive to atmospheric effects, as we know also from his landscape drawings. It is with the utmost delicacy that light and air here play around the youthful nude shoulders; the accents on head and hand could hardly be more telling.

Turning to other daily-life motifs, which the artist encountered on the streets rather than at home, we find a sheet of studies of beggars and an old woman with a crying child behind her (fig. 143a). This sketch brings us back to the thirties, as is evident from the Baroque character of the line and the vivid instantaneousness of the gestures. In spite of the very momentary character of every figure, they seem to be interconnected by the arrangement in two parallel diagonals running across the sheet. This formal feature the artist may have brought in instinctively, but it lends to the diverse sketches a charming decorative coherence on the page.

A pen study of a beggar woman (fig. 144a) which comes closer to the middle period could well be a preliminary study for the "Hundred Guilder Print," although it differs from the mother-and-child motif finally used in the center of the famous etching. Rembrandt was exceptional in his sympathetic understanding of the poor and destitute, deeply human but never sentimental. The expression of exhaustion, of motherly care, in this drawing is magnificently rendered.

REMBRANDT

The pen and brush study of an Oriental in turban and wide coat (fig. 144b) dates from about 1655 and shows Rembrandt's rich late style of draughtsmanship. The form seems to glow as much from within as it is illuminated from without. The graphic sharpness of Rembrandt's early line is now abandoned in the interest of a broader and softer painterly touch.

Rembrandt is also unsurpassed in his studies of animals, of wild and exotic beasts that he was able to see in the traveling zoos which visited Amsterdam. A chalk study of a lioness eating a bird (fig. 146a) shows an amazingly quick and powerful grasp of the creature's structure and rapacious character. While she crouches holding her prey between her outstretched paws, the potential strength of her wiry body is marvelously expressed with a few decisive strokes.

In 1637 Rembrandt saw and sketched an elephant (fig. 145). It is quite obviously an open-air study. The black chalk does justice to both the massive frame and the curiously wrinkled surface of the giant creature. The artist must have felt that this was a rare opportunity, because he added here — as he seldom did in his drawings — his full signature and the date.

A crouching lion in Amsterdam (fig. 146b) may belong to the late fifties; in other words it is in Rembrandt's mature style. The animal is seen in a majestically relaxed pose, yet watching with an alert glance. Rembrandt made use of such studies in his Biblical compositions. An elephant, for instance, appears in his etching of "Adam and Eve," dated 1638, a year later than the drawing. Lions appear in a sketch of "Daniel in the Lions' Den" (fig. 147), where the artist stressed the contrast between the praying young prophet and the ferocious beasts. The latter are superbly characterized in their different attitudes, varying from fiercely threatening to almost affectionate movements.

Landscape drawings as dramatic as the one in the Albertina (fig. 148) showing cottages against a stormy sky are rare. Rembrandt usually reserved this type of romantic illumination for his paintings. It is a comparatively early drawing, perhaps from the end of the thirties, when the Baroque quality was still strong. Emphatic diagonals and contrasts of dark and light animate the composition and lead the eye into the distance, lending to the picture a vivid, dynamic quality.

At the time of Saskia's illness around 1640 — she died in 1642 — Rembrandt often strolled in the environs of Amsterdam making many sketches of the Dutch countryside like the "House among Trees on a Canal" (fig. 149). They are highly sensitive, unassuming studies of nature, expressing the wide spaciousness,

the seaside atmosphere, the simplicity of the Dutch landscape, always with a delicate touch of the pen and the brush and ingeniously exploiting the white of the paper as a source of light. The landscape drawings of the fifties grow bolder, like the sketch of a similar motif, "Cottage among Trees," with the curve of a road in the foreground (fig. 150). Rembrandt now stresses more forcefully the structural features. He is also more summary in his technique. The atmospheric quality is retained and enriched by stronger value contrasts. The wide sweep of the road leads vividly into the distance and we feel the sunlight as well as the breezy sea air.

A sketch from his early maturity shows a view of London, dominated by the old Cathedral of St. Paul's (fig. 151). While this study (not done on the spot but probably based upon an old engraving) appears to be the work of a few minutes, it combines monumentality with sensitiveness of touch. We are drawn into the distance by the powerful contrast of dark and light. Yet there are subtle transitions and at no point is the sequence of planes interrupted. In the bright and hazy distance the building retains its structural clarity and is bathed in sunshine.

Coming finally to Rembrandt's Biblical subjects, we show a drawing from his early period, about 1633, representing "Christ in the House of Mary and Martha (fig. 152). We know from his paintings and etchings that Rembrandt was from the beginning a vivid storyteller. This episode from Luke 10 emphasizes the value of a contemplative life. Christ had entered the house of Martha and, as the text expresses it: ". . . Martha was cumbered about much serving, and came to him, and said, Lord dost thou not care that my sister hath left me to serve alone? bid her, therefore, that she help me. And Jesus answered and said unto her, Martha, Martha, thou art careful and troubled about many things. But one thing is needful: and Mary hath chosen that good part, which shall not be taken away from her." The three figures in the drawing are intensely related by gestures and glances. Emphasis is given to Christ through the converging lines of the background. Mary appears frontally, with a book on her lap; Martha, the busy housewife, is the closest of the three, but seen from the rear. There is the characteristic diagonal arrangement of the Baroque, leading the eye from the foreground into the middle distance, where the interest focuses on the figures of Christ and Mary. We see the same vivid and flexible use of line, for both expressive and pictorial purposes, as in Rembrandt's early studies from life. He

masses the lines with dense strokes in some areas, while in others he opens them in a more widely spaced shading. There is still the graphic sharpness of his early style, without a finer tonal softness.

This tonal softness is apparent in a Biblical scene from his middle period, about 1640, representing "Jacob's Dream" (fig. 154). Jacob has fallen asleep on the stone which served him as a pillow, "and he dreamed, and behold a ladder set up on the earth, and the top of it reached to heaven. And behold the angels of God ascending and descending on it," according to Gen. 28. Here Rembrandt shows only two angels looking tenderly down on the sleeping Jacob. The ladder is omitted. Rembrandt took liberties with the Biblical text when it served a more concentrated expression of deeper meaning. In fact, through the reduction to a few figures and the spatial limitation, the artist makes us intensely aware of the inner relation between these divine messengers and the sleeping wanderer. The delicate tonal treatment with pen and brush helps to create a transcendental atmosphere and relieves the scene of any obtrusive realism. The human intimacy expressed is a general feature of his art in this crucial middle period after the illness and death of his wife Saskia.

As in his landscape studies, so in his Biblical scenes, the simplicity of his compositions increases in his later work, and to the sensitiveness of touch is added more power and depth of expression. In the scene representing Christ, followed by some apostles, healing a sick person (fig. 153), the group of Christ and the apostles is taken together into one square block, while the figures around the sick person form a triangle. The two groups are closely related. These formations are far from being geometrically rigid: light and air permeate everywhere and lend vibrancy to the lineament and the tonal play. One feels a great spaciousness around the figures, and atmosphere in a double sense, physical and spiritual. Rembrandt's style has now reached the highest point of economy and selectiveness. The dignity of the Christ figure equals that of the great Renaissance masters. One thinks in particular of Titian.

The last example in this survey also belongs to the period of about 1655 and may come close to 1660. It represents St. Peter praying before the raising of Tabitha (fig. 156). The subject is taken from a passage in Acts of the Apostles 9, where we hear that Tabitha, a pious woman who "was full of good works" had died, and that the disciples of St. Peter sent after him for help. "When he was come," the text says, "they brought him into the upper chamber: and the

widows stood by him weeping, and shewing the coats and garments which Dorcas [Tabitha] made, while she was with them. But Peter put them all forth, and kneeled down, and prayed; and turning him to the body said, Tabitha, arise. And she opened her eyes: and when she saw Peter, she sat up. And he gave her his hand, and lifted her up, and when he had called the saints and widows, presented her alive."

It is not accidental that Rembrandt has chosen here the moment when St. Peter was alone at prayer. Not the outward action, not the miracle as such interested him primarily, but man's innermost contact with the Divine, as the real source of his power. From Rembrandt we learn that this contact occurs in absolute stillness, when man turns inward in humility and awe. In his drawings the artist, as we have seen, was receptive to all spheres of life, at home, in the streets, and in nature. But it is in the sphere of religious experience that he tells us the most profound things. While his late paintings of such subjects are perhaps grander in their size and the extraordinary use of color, Rembrandt was able to express the essence of his credo also in pure draughtsmanship. The composition in this drawing is again of a noble simplicity. Pen and brush are used with utmost delicacy and economy.

This is as far as I can go here in discussing the character and range of Rembrandt's drawings and their significance in the history of draughtsmanship. But with this master it might help to add a brief consideration of the problem of authenticity — a problem which exists in a similar way with all the other artists, but is, in the case of Rembrandt, particularly pressing because of the immensity of his production and the large body of drawings closely related to him.

The key question in this problem of authenticity is, of course, whether our judgment has an objective basis or whether it is founded only on subjective impressions. Here we have to admit at once that, except for a few cases where drawings are signed by the master's hand (the drawing of the elephant, for instance, was one of these rare cases), we have no absolute proof, but only a reasonable certainty about the authenticity. And this reasonable certainty comes about by what may be called cumulative evidence.

There is first the judgment of the so-called expert or connoisseur — let us say in a more modest way, specialist — who is thoroughly familiar with the material and has proved his competence over the years by exposing his judgment to professional criticism.

There is secondly the *consensus omnium,* the general approval by all the experts, adding certainty to the judgment of the individual.

And there is finally — and this is not unimportant — something that we may call the test of time, that is, the judgment not only by one generation of connoisseurs, but by successive generations of active and critical specialists. This is, in fact, what has been going on during the last fifty years.

The first comprehensive catalogue of Rembrandt's drawings was published in 1906 by the Dutch scholar Hofstede de Groot, who listed altogether 1613 drawings by Rembrandt. To some of them, however, he added question marks.

In the next generation there followed, in the mid-twenties (1926) and the early thirties (1934), a new publication by W. R. Valentiner which was not carried to completion but included at least two-thirds of Rembrandt's total work. (The volume on landscape and genre scenes has never appeared.) Valentiner in these two volumes of the *Klassiker der Kunst* series rejected many attributions of Hofstede de Groot but added many new ones.

Finally, in 1954–1957 there appeared a standard edition of Rembrandt's drawings in six volumes by the Austrian scholar, Otto Benesch.

In this succession of three generations, from Hofstede de Groot, to Valentiner, to Benesch, we observe altogether an advance, both in knowledge and in criticism, by the combined effort of many scholars. Of substantial help have been the special catalogues of Rembrandt's drawings in the great European collections, that is, in London, Paris, and Amsterdam, by Arthur M. Hind, Frits Lugt, and Max Henkel respectively. The present writer is responsible for the catalogue of the Berlin collection. In summing up the results statistically, and limiting our consideration to those drawings that are now generally agreed upon, one can say that since the time of Hofstede de Groot about one-third of his attributions has been eliminated as doubtful, but this loss has been balanced by an equal number of new discoveries.

In spite of this general progress, we are still far from a *consensus omnium,* if we may take Benesch's publication as a basis for such judgment. And this is owing to the fact that, while the common knowledge has grown from generation to generation, the discriminating faculties of the individual scholars continue to differ.

Of the questionable material that has been eliminated, three groups can be distinguished: old copies, pupils' drawings, and forgeries.

REMBRANDT

As for old copies, it is understandable that previous generations have been deceived when encountering them without knowing the originals. Superficially, there is enough of Rembrandt's style and even spirit reflected in such an old copy as the "Lamentation" in Stockholm (fig. 157a) to engage our interest and to let it pass as his work. But once we have become more intimately familiar with authentic drawings, and have, in addition, an opportunity to compare the copy with the original (fig. 157b), we feel a certain thinness, emptiness, a mechanical and abrupt use of the line, a lack of fine tonal gradations. The true sketchiness of Rembrandt's real drawings, the atmosphere, the subtlety of accents, both formal and psychological, are missing. If we look, in the copy, at the main group of Mary embracing the dead Christ at the lower left, or the play of hands in the center, or the two faces above (of St. John and one of the Marys) — and compare these passages, as well as the total impression, with the original — we are lifted to a higher plane of artistic performance in Rembrandt's authentic work. The touch is infinitely finer and more lively, there is a more complete suggestion of form in space. Yet the copy, which is in the old royal collection in Stockholm, was for a long time considered an original.

As for drawings by Rembrandt's pupils which have often passed as the master's work, the example of "Jacob's Dream" may serve our purpose. A beautiful drawing of this subject by Rembrandt's own hand (fig. 154) has already been discussed. There we saw Jacob fallen asleep on a stone, and two angels appearing above on the left. We admired the delicate tonal treatment, which created, with a minimum of means, an atmosphere of wonder and even transcendence. The pupil's drawing can be ascribed to Ferdinand Bol (fig. 155). He is certainly sketchy, but overdoes this quality by massing lines into heavy darks and losing all the finer points of Rembrandt's draughtsmanship, with its superb sensitiveness and economy, its wide yet highly articulated range of accents, its clarity and simplicity.

And finally, for the third and most vexing group — that of the forgeries, which we must be prepared to face in ever new and ingenious versions — I show one of the oldest known examples (fig. 158), which pretends to be a preparatory sketch for a painting by the master representing the "Adoration of the Magi" (now in Buckingham Palace). This drawing along with many others — equally false and also in Munich — goes back to the eighteenth century, when a wave of enthusiasm for Rembrandt drawings started and the demand for them

83

made a forger's activity profitable. It was then that this whole "Munich" group was acquired by the Count Palatine and thus came finally into the Bavarian State Collection. The puzzling thing about the drawings is not only their comparatively early date (they may go back to the first half of the eighteenth century, after the French critic Roger de Piles had expressed a high appreciation for Rembrandt drawings and himself brought together a considerable collection), but also the fact that even today a Rembrandt expert can consider them authentic.[8] In the drawing reproduced, this early forger cleverly suggested a draft for a known Rembrandt painting; this relation obscured the inherent weakness of the drawing, and proved deceptive. The weakness becomes evident upon closer comparison with a convincing drawing of this late period, such as the "Arrest of Christ," in Stockholm (fig. 159). We will then realize the confusion in the crowd above the Madonna, and in the spatial organization. The lines, moreover, in their exaggerated dashiness are often meaningless. Forgers in general are apt to exaggerate a few aspects of a master's style but are unable to control all the other essential features that belong to it. This one lost not only the clarity of form and of spatial coherence, but also the all-embracing atmosphere and the gradations of tone. In the Stockholm drawing there is also a foreground crowd; but how clear, how articulate, how integrated is every figure, in spite of the sketchy character of the whole. And how wonderfully the whole reads, by a distinct order of accents.

I hope that the inclusion of doubtful material in this discussion will not create the impression that Rembrandt's drawings are still controversial and that one had better keep away from them, letting the experts quarrel about their authenticity. No, we have gained considerable ground in our certainty about the authentic material, but must continue to draw valid criteria from the fully convincing drawings.

In conclusion we reproduce a fine self-portrait by Rembrandt (fig. 160), which conveys the full power of his personality. It can be dated in the fifties and is similar in pose to the painted self-portrait of 1652 in Vienna.

WATTEAU

WATTEAU

From Rembrandt to Watteau is a tremendous step that seems even wider than that from Dürer to Rembrandt. Dürer and Rembrandt, although representatives of two different periods, the northern Renaissance and the northern Baroque, had substantial things in common: their genius in graphic art, their devotion to Biblical subjects, and their sincere humanity. This last — it is true — went much further with Rembrandt in the expression of man's innermost life.

It seems impossible to link Rembrandt and Watteau by any such bonds. Watteau, although also a draughtsman of rare genius, has — on the surface at least — little in common with the great Dutch artist. Watteau's was not the world of suffering mankind, as it was with Rembrandt, but the world of pleasure, of the theater, music, and the dance, of elegance and lightheartedness. These are the aspects of Watteau's art which a first impression of his paintings, and their typical subject matter, will convey. But there are deeper implications, and when we turn with close attention to his drawings, we find ourselves brought closer to Watteau the man, and to the foundations of his art.

One might say that the historical circumstances in Watteau's time provided him with a mission, and this was to open up, after the pompous and ponderous style of the Louis XIV period, a new era of elegance and gaiety, the dream world of the Rococo. This he really achieved, although his temperament seems ill-suited for the carrying out of such a mission. He was not a lighthearted person, but of a very complex nature, burdened with inhibitions. He had endured much hardship in his early life, and shortly after attaining fame contracted a deadly illness which allowed him only a few years of intense productiveness at the height of his power. His misanthropic disposition made it difficult even for his devoted friends, like de Julienne and Gersaint, to make his situation easier. They realized the artist's lovable qualities, his genius, his rare sensitivity, and sincerity of character. Yet with all their generosity they could not really help him.

WATTEAU

Watteau himself found a compensation for his adversities in the world of his art, which was, so to speak, the imaginary fulfillment of a deep yearning for the beauty and grace that were denied him in reality. Thus while art and life, with Watteau, seemed to be at opposite poles, there was a tense inner relation between the two — not the ordinary one of the conventional eighteenth-century painter, but one that made Watteau's creations infinitely more sensitive and expressive than theirs.

Another remarkable fact about Watteau's art is that the visual foundation of his dream world was — at least in his mature phase — an intensely realistic one. We discover this in his drawings, of which a large number have survived. Most of them were taken from life, and show close adherence to the model, yet they are imbued with his artistic feeling and sense of beauty. In fact, Watteau was more at ease when drawing than when painting, and he considered his draughtsmanship superior to his painted work. On this point the well-informed Gersaint, art dealer and close friend of Watteau, wrote: "I give great preference to his drawings over his paintings. Watteau thought the same in this regard; he was more satisfied with his drawings than with his paintings, and I can confirm that in this respect vanity did not conceal any of his faults from him. . . . I have often seen him vexed with himself because of what he could not render in paint — the spirit and the truth which he knew how to give to his crayon." [9]

The reconciliation of the two seemingly contradictory facts — namely, his passion for drawing in close contact with real life and the predominantly imaginary character of his painted work — provides one of the most interesting features of Watteau's artistic production. He made hardly any preparatory sketches specifically for his paintings; instead he drew upon the rich treasure of life studies in his sketchbooks, using them in ever new combinations. We hear explicitly about this from Count Caylus. "Most of the time," Caylus says, "the figure which Watteau drew from life had no defined purpose. For he never made a sketch for any of his paintings. His custom was to draw his studies in a bound book, so that he always had a great number of them at hand. . . . He chose the figures that suited him best for the moment. He formed groups of them, most often in consequence of a landscape which he had conceived or prepared. It was rarely that he deviated from this practice." [10] There are in fact few exceptions to these working habits, and on the whole Caylus' statement is borne out by the material we know.

WATTEAU

While these various bits of information from reliable contemporary sources throw some light on Watteau's character, his artistic disposition, and his methods, they do not solve the problem which faces us here: to attain a full appreciation of his draughtsmanship and for that purpose to clarify his development until he reached his full stature. This development was slow, and for a long time the artist seems to have been more receptive than creative. But during his last five years the flowering of his genius was amazing.

If we look closely, however, we find that the transition from Watteau's youth to his maturity was by no means abrupt and that his long period of receptivity turned gradually into creativity. His contact with nature grew closer at the same time. His development was in fact continuous yet complex, and one which cannot be traced step by step. A few salient facts stand out. While Watteau's growing contact with nature, that is, his reliance upon living models, played a definite part in the unfolding of his artistic personality, a strong stimulus came from the art of the old masters also, from Rubens in particular. The great Fleming's example fired Watteau's imagination and gave him the courage to seek a freer and bolder self-expression. Although Rubens' influence upon him was by no means as exclusive as, for instance, that of Raphael upon Ingres, it released a hidden energy in Watteau's genius. And in the fire that it kindled, Flemish sensuousness was happily fused with French elegance and grace.

Antoine Watteau was born in 1684 in Valenciennes, the son of a tiler. Since his native town had belonged to Flanders until 1677, it is not surprising to find a Flemish vein in his art. We know little of Watteau's early years in Paris, where he made a meager living by copying pictures of saints and the like for a dealer on Pont-Notre-Dame. He was liberated from this drudgery when he entered the workshop of Claude Gillot about 1703. It was Gillot who opened up to the young artist the world of the theater which was to remain a favorite theme in his art. After several years in Gillot's studio, Watteau worked for Claude Audran (from about 1707 to 1709), a reputable decorative painter and engraver who had his residence in the Luxembourg Palace. Here it was that the artist came into contact with Rubens' famous series of paintings on the life of Marie de' Medici. He copied these repeatedly in drawings, and also began to make landscape sketches in the Luxembourg Gardens. After a short visit to Valenciennes, where he painted military subjects, Watteau returned to Paris in 1710. He stayed this time at the house of the art dealer Sirois, who purchased his pictures. Through him the artist

gained the friendship of Sirois' son-in-law and successor, Gersaint. Contact with the wealthy manufacturer and patron Jean de Julienne was also made during these years. Thus Watteau began to be known in the art world of Paris.

In the years 1712–1717, which we may define as the transitional period, Watteau's style gradually attained independence. Toward its end he created the "Embarkation for Cythera," which gained him admittance (in 1717) to the Academy with the title *Maître des fêtes galantes*. Since 1715 he had had a permanent invitation to the residence of Pierre Crozat, and he spent much time there eagerly copying drawings from the famous collection of his host. Crozat's salon was the meeting place of the prominent Parisian artists and connoisseurs.

A last period may be dated from 1717 to 1721 and included such paintings as the "Gilles" now in the Louvre and the "Signboard" for Gersaint's art shop. Watteau had then been living for some time in Gersaint's house, and paid his debt of gratitude by the latter masterpiece. Like the "Gilles" it shows a broader style. There is no longer any trace of the influence of the Flemish and Dutch "Little Masters," like Teniers and others, who had once impressed the artist on his first contact with de Julienne's collection. In 1719 Watteau undertook a trip to London to improve his financial situation. He was successful with his paintings, but the London climate aggravated his illness and he had to return to France early in 1720. He went into the country, to Nogent-sur-Marne, in the hope of finding some relief there, but it was too late. After a few months he died, in July, 1721. His loyal friend Gersaint attended the artist in his last hours.

In the first volume of the comprehensive catalogue of Watteau's drawings by K. T. Parker and J. Mathey, 182 drawings are ascribed to the artist's early period, many of them hitherto unknown or going under the name of Gillot. The dependence of the young Watteau upon the older artist was quite heavy, and a few examples can easily confirm this relation. The red chalk drawing in Stockholm showing a group of comedians (fig. 161b) is such a case of a former Gillot attribution. Parker and Mathey have given it to the young Watteau because of its stylistic closeness to a large number of similar drawings now authenticated as Watteau's work. Some differences from Gillot can be found. The gestures are less bizarre, the movements a trifle more elegant. One may also notice a little more verve in the strokes and vividness in the expression than in a typical Gillot drawing such as the theater scene, in the Louvre (fig. 161a). These differences, however, are minute and the general similarity remains very close. The young Wat-

teau's fantasy functions in terms of Gillot's superficial sketchiness. The figures are marionettes with little bodily existence, and a few easy formulas for faces, hands, and gestures suffice for endless combinations.

In the juxtaposition of a Gillotesque figure, a red chalk drawing in the Louvre (fig. 162a), with one of Watteau's mature period, a *trois crayons* drawing in Rotterdam (fig. 162b), one can visualize the tremendous range of his development. The early drawing is dry and flat, the graphic treatment schematic and cursory; the late one sparkles with vitality, with plastic and pictorial life. Stance and posture are firm yet relaxed; elasticity and verve have come into Watteau's strokes. The *trois crayons* manner — that is, chalk drawing in the three colors of red, black, and white — allows a brilliant display of light and atmosphere on and around the figure. The difference between these drawings is almost too great to assume the same authorship, yet both attributions are well founded.

If we compare the study of two pilgrims to the land of Venus (fig. 163a) which can be dated about 1710, because of the relation to the early painting of the "Island of Cythera," with a study for the late "Embarkation for Cythera" of 1717 (fig. 163b), we experience the same vivid contrast. One shows a petty, timid manner, with no indication of Watteau's later daring and forcefulness, as shown in the other. In the early drawing the figures are again carefully outlined but have little articulation. Their faces are doll-like, their gestures conventional; whether standing or seated they are completely weightless. The mature drawing is full of spirited movement, the action vigorously expressed in a bold and highly economical draughtsmanship. The dry graphic character is replaced by a brilliant pictorial treatment in which again the *trois crayons* manner helps substantially. One naturally asks: how was it possible for Watteau to go this long way, from meticulous detail to the most ingenious sketchiness, within less than a decade?

We have heard that a decisive impulse to this amazing development came from the art of Rubens, which Watteau first encountered when working for Claude Audran at the Luxembourg Palace. From his red chalk drawings of motifs from Rubens' Medici series we show the sketch of three figures, Ariadne, Bacchus, and Venus (fig. 164a), which form one group at the upper right in the "Government of the Queen." Watteau's line here seems inspired by his model. It shows greater ease and force than before. He deepens the shadows, he heightens the lights, he brings out more roundness of form — yet in all this he is only faithful to the original.

Another sketch after Rubens (fig. 164b) shows three groups — two of a mother nursing her baby and one of a wildly dancing and caressing couple — copied from the "Kermesse" in the Louvre. In this drawing Watteau's stroke seems still bolder and his graphic treatment broader. One might argue that since the model was a much later work of Rubens than the Medici series, this fact was responsible for the difference of style between the two drawings. But it seems more probable that Watteau made the second sketch a few years later, when he had access to the King's collection (the "Kermesse" then belonged to Louis XIV). Thus we have an indication that the influence of Rubens extended over a number of years and kept pace with the advancement of Watteau's own style almost to its full maturity.

It was not only Rubens the painter, but also Rubens the draughtsman who inspired Watteau. It is generally assumed that he learned the *trois crayons* manner from the great Fleming, who favored this technique for his portrait drawings and costume studies. Watteau must have seen examples in Crozat's collection. In the head of a young woman in the Kramarsky Collection (fig. 167), Watteau copies a Rubens drawing now in London (fig. 166). Here, however, he prefers to transpose the black chalk and brush of Rubens' original into the *trois crayons* manner. There are other minor changes and a more ornamental touch that is Watteau's own, as well as the typical short accents on the mouth, the ear, etc., which chisel out the form with elegant precision. But these changes may have been introduced unconsciously. In any case Watteau's drawing is clearly not an early performance, but shows the advance characteristic of his middle period.

It is in this transitional phase that most of his copies after old masters can be placed, and many of them belong in the year 1715 when Watteau stayed in Crozat's house. We find among them drawings after van Dyck, after Dutch masters such as van de Venne, Rembrandt, and Metsu, after Le Nain and the Venetians (Bassano, Veronese, Titian, Campagnola), although the Rubens copies are in the majority. Of the Veronese copies we reproduce two sheets with various motifs, mainly heads (figs. 165a and b). Watteau seems less free here than in his copies after Rubens' "Kermesse." Still, the drawings do not appear to be early. They show Watteau's maturing manner of draughtsmanship with the strong accentuation and ornamental trend of his line, particularly in the draperies. A slight dryness may result from his effort to approximate the style of the mid-sixteenth-century master. The influence of Veronese on some of his paintings can

be reconstructed if one consults the engravings after lost works of Watteau's middle period. The noble and exotic types of the Venetian master had a certain appeal to him, but Watteau also adopted something of Veronese's arrangement of figures before a decorative landscape background.

Among Venetian drawings the landscapes of Titian and Campagnola made perhaps the deepest impression upon Watteau. This is an influence which left a lasting mark on his art and was second only to that of Rubens. Landscape cannot be said to play an independent role in Watteau's work, but it became a substantial part of his compositions. In an early drawing called "Le Meunier Galant" (fig. 168), which an etching of Boucher reproduces with some differences of detail, the Gillotesque character is still evident both in the figures and in the landscape with its curly and schematic foliage. A sensitive tonality, however, indicates something of Watteau's native gift.

After this type of superficial background landscape which consisted largely of parallel shading and schematic shrubbery, Titian's and Campagnola's drawings must have come as a revelation to the artist. In the landscape with two youths (fig. 169), he faithfully copies a Titian drawing now in the Albertina, except that whereas his model is done in pen, Watteau again prefers red chalk. There are other minor differences. He omits Titian's scribbles in the figures and draws them with the more clear-cut accents which have become a characteristic element of his style.

Titian's influence makes itself felt in Watteau's own landscape drawings such as the one in Bayonne (fig. 171). Whether this is a motif from Crozat's estate near Montmorency, where Watteau made sketches, or from the bank of the Marne on the property owned by de Julienne, has not been established. The latter seems more probable. In any case, it is a striking drawing by the mature Watteau, with his forceful stroke and an obvious application of the Titianesque shading.

The drawing of "A Vista down an Alley of Trees" (fig. 170) can with more certainty be called a view of Crozat's estate, since a similar scene by Watteau, engraved by Caylus, defines the location in an inscription. Here Watteau's manner is different, light and rather impressionistic in the treatment of the masses of foliage, with a subtle vibration of tones and a delightful atmospheric effect. One wishes that more of such drawings were preserved which show Watteau as a forerunner of Gainsborough and Constable as well as of Fragonard. But a point of

great interest here is that while Watteau was eagerly copying Titian's and Campagnola's drawings and deriving inspiration from them, he was at the same time making his own independent studies from nature, rare as they are among the surviving works.

In following the trend of Watteau's development we have traced the many influences which had a bearing on the formation of his art. This has led us to the threshold of his mature period. One category, however, in which the young Watteau followed the path of his employer Claude Audran has not yet been mentioned: that of ornamental design. It seems that in the collaboration of the two men Watteau followed the schemes of Regency decoration which the older artist provided, but embellished them with his own more graceful line and filled the oval or circular medallions with figural motifs. A drawing formerly in the Hermitage (fig. 172) shows such a case. Watteau's full authorship is acknowledged in some very delightful arabesque designs which were engraved by Huquier. Two of them are in the Groult Collection and one is reproduced here (fig. 173). In these arabesques Watteau's line plays with the ease and charm of a Mozart melody, and one regrets that his productivity as a decorative designer did not continue. Only two sketches in this category are known from his mature period, one in Rotterdam and one in the Uffizi (fig. 174), and they show the master's more forceful touch in his late years as well as a wonderful ornamental sweep.

Before turning to Watteau's mature period with its full range of subject matter, we may cast a glance at the military figures which he drew from life at the time when he painted such subjects in Valenciennes (about 1710). He had just left Audran's workshop, giving as his reason that he wanted to go home. A modest success with a military painting may have induced him to concentrate on this genre for a while. Valenciennes seemed the right place for the project since the town had remained a military stronghold following its capture by the French. There was little else that attracted Watteau's interest and in fact he soon returned to Paris. Going through his studies and the paintings in which they were used, one gains the impression that Watteau spent a great deal of time in and around military camps studying the soldiers in the most varied activities — at rest, on the march, exercising, or maneuvering. But in fact, as Parker and Mathey rightly observe, he used only one model which he must have directed to pose in a great many attitudes typical of military life. In the drawing in Berlin (fig. 175), we see this young man both standing and walking away. The style is more forceful

than in the Gillotesque period. Watteau clearly renders all the details of the uniform and equipment, but without pettiness, and seems well on his way toward a firmer grasp of form and a richer pictorial treatment. The close contact with the living model, then, invigorated his style no less than the example set by the old masters.

In discussing now Watteau's draughtsmanship at its height we turn first to a category which rightly enjoys great fame and seems best suited to epitomize Watteau's mastery: namely, his studies of heads. They are done in the *trois crayons* manner. The red is used mainly for the flesh tone — it appears in our reproductions as a light-middle value — the white is added for highlights but is sometimes omitted when the white paper makes it superfluous, and the black defines the principal lines and produces the shadow accents. Thus these drawings are much more colorful in reality than they appear in the black and white illustrations.

Watteau liked to vary the position of a head on one and the same sheet. With the variation of posture there is always a variation of expression and even a change in the artist's station point. In the beautiful drawing in London (fig. 176) with four female heads, one observes that the two lower heads are seen at about eye level with the model, while the two upper ones are seen from above. Each position shows a slightly different inclination of the head. Watteau wished to know his models from many angles. His types are very French and always somewhat refined even though they may have been simple servant girls. They have the grace, the alertness, and the sensitiveness of their nation. But we can also assume that the artist's own exquisite taste and rhythmical feeling were in some way imposed on his models. While Watteau gave close attention to details — an ear, a mouth, a nostril, an eyelid drawn by him are not easily forgotten — the coordination of all these details into an engaging and convincing total impression is never lacking. In his women we see an emphasis on the neckline and a wonderful, organic connection between head and bust, a passage which so often defeats minor artists. Like the neckline all the other features of gracefulness are stressed, but the facial expression is always as important as the elegance of form. The two are inseparable. The forms are infused with character and spirit, but there is no excessive emotional stress to disturb the serenity of atmosphere which prevails even where we detect a slightly melancholic undertone. Watteau is sparing with his lines and his accents; they are precise and pointed, elastic and clear-cut. He avoids long drawn contours and favors a brilliant light in which his very personal ac-

centuation produces colorful surfaces. All in all, his draughtsmanship seems the most perfect equivalent, on the visual side, of the charm, the wit, and the spirited accentuation of the French language when spoken by a lively Parisian tongue. We certainly should expect such speech from the woman sketched here.

Heads or busts are often combined with other motifs on a single sheet, as we see in the drawing from the H. N. Strauss Collection in New York (fig. 177) where the figure of a flute-player accompanies the head and the bust of a woman. The model is the same as in the previous drawing and here her bust in three-quarter view is set against a sketch of her profile. In both a frill is placed around her neck but her costume varies. The discrepancy in scale on one and the same sheet — the flute-player's scale is about one-third that of the woman — was not disturbing to Watteau. He did this quite often without caring for spatial relations among the various parts. It was a matter of economy and he perhaps adopted this method when copying motifs, particularly heads, from older masters' paintings, as we saw in his drawings after Veronese (figs. 165a and b).

Watteau shared with his century the taste for oriental and exotic types. The "chinoiseries" in tapestries, porcelain, and wall decoration manifest this wide-spread fashion to which the artist made his own contribution in ornamental designs preserved mainly in the form of engravings. In the justly famed drawing in the Louvre (fig. 178) showing three studies of a Negro boy's head, we are struck both by the deep human quality and by the rich coloristic treatment which is achieved simply by the *trois crayons* technique. The boy's dark skin glows with reflections and the expression of slight sadness is most remarkably brought out, as are the racial characteristics. Here again the scale of the three heads varies, but less obviously than in the previous example, and the *mise en page* has a pleasant effect.

Watteau's drawings of children are most engaging. Like those of van Dyck, whose sensitive, nervous nature resembled his own, his representations of children excel by an appealing expression of the child's naiveté and inner charm. The drawing in the Morgan Library with two studies of a little girl (fig. 179) is a fine example. Watteau again varies the position and the expression in a significant way. As if his subject had induced a special tenderness of treatment, strong accents are avoided and a silvery middle tone prevails, while the highlights produce brilliant reflections on the girl's skin and headdress.

The studies of hands are as famous as Watteau's studies of heads. The

brothers de Goncourt, who revived the artist's fame in the mid-nineteenth century, after long neglect during the period of classicism, made some telling remarks on this feature. They wrote: "The hands of Watteau! Everyone knows them, these tactile hands, so finely elongated, curving so provocatively around the handle of a fan or a mandolin, whose nervous life was lovingly drawn by the master — hands, Heinrich Heine might have said, which seem to possess the faculty of thought." [11] In the study from the Marquis H. de Ganay Collection (fig. 180), Watteau represents nine single hands of a man in different positions. It is assumed that the model was the actor La Fourillières. In any case the artist has chosen an elegant and individual hand that speaks, in its various attitudes and gestures, with an almost vocal eloquence. Admirable also are his many studies of musicians' hands. No artist has been more articulate in expressing the fine, nervous movement of such hands on various instruments, whether guitar (fig. 181), flute, or 'cello.

Watteau would not have been a genuine eighteenth-century personality had he not been intensely interested in elegant and precious costumes, and in this category, too, his mature sketches show authority, strength, and grace. In a drawing of a seated woman in Chantilly (fig. 182), his bold strokes characterize well how the stiff and glittering material of her dress stands out from the body here and there, or breaks into angular folds. Yet figure and costume are one inseparable unit and the movement of the body is closely felt in this complex design of almost abstract beauty. The rhythmical organization of the various shapes and strokes centers about the point where the figure bends to form an angle and the drawing becomes more delicate.

In the sketch in the British museum (fig. 183) of a woman seated on the ground and seen from the back, a costume of a softer tissue is studied. Its narrow stripes are delicately followed by Watteau's lines, yet the posture of the figure is subtly expressed through the full folds of her garment. Her small right hand gives just enough support to make her position comfortable and convincing. Here the artist withholds the stronger accents, as he sometimes does for special reasons. Probably he wished to avoid breaking the flow of the parallel pattern and to maintain the impression of an allover brightness.

Count Caylus' discourse on Watteau (1748) contains the following remarks on the artist's nudes: "Indeed, since he had no knowledge of anatomy, and had almost never drawn from the nude, he was unable either to comprehend or ex-

press it." [12] This statement has to be modified considerably to make it acceptable. In the first place, we know a number of drawings from the nude, at least from Watteau's mature period, and there may have been more, since the artist is known to have destroyed his drawings of free subjects at the end of his life. And furthermore the surviving nudes belong among Watteau's most brilliant creations, in spite of Caylus' academic criticism. They are surprising, however, in the informality and intimacy of approach — qualities which charm us and lead Watteau's work directly into the realm of modern art.

A comparatively early nude is the study for the figure of "Spring" (fig. 184); it was done for one of the "Seasons" which were painted for Crozat in 1715. The artist seems more academic here than later. Although he brings a graceful tension into the different parts of the body, its coherence is not fully successful.

The half-length nude who raises her right arm (fig. 185) belongs to the late group. The position is chosen to emphasize the graceful curve which leads over the back into the raised arm, and to reveal the woman's breast in a foreshortened view — here more successfully rendered than in the previous drawing. The modeling is soft yet convincing, and the covering of the face by the raised arm creates an interesting configuration.

With the study of a reclining figure sleeping on a chaise longue, in the Kramarsky Collection (fig. 186), and that in London of a seated woman pulling her garment over her head (fig. 187), we reach the height of Watteau's draughtsmanship in this genre. The latter is a sketch for the painting in the Wallace Collection called "La Toilette." In both drawings the nudes are exposed to brilliant light and the soft crayons model their forms with tenderness, surrounding them with air and atmosphere. The step from here to Degas is not far, while the heroic nudes of Titian and Giorgione, so much admired by the academicians, are left behind. Only a genius like Watteau, with his freshness of vision and extraordinary sensibility, could break through a long-standing convention and open up a new approach to an age-old subject.

Watteau is perhaps least known as a portraitist. Yet his drawings reveal a rare capacity in this field too. The portrait study of "A Man on Crutches" (fig. 188), in the Fitzwilliam Museum, Cambridge, is said to represent a friend of the artist, Antoine de la Roque, who was wounded in the battle of Malplaquet, and there is a distinct resemblance to a portrait of this man engraved by Lepicié. We see Watteau's characteristic accents enlivening an unusual subject. It is a straight-

forward representation of the crippled man whose personality seems outspoken in spite of his physical handicap.

A similarly forceful directness marks Watteau's portrait study of a seated Oriental, in Haarlem (fig. 189). The artist's interest in exotic types we have seen in his splendid "Studies of a Negro Boy" (fig. 178). Here he portrays a Turk, in his rich late style. The position of the figure seems well chosen for the expression of the man's character and costume. The profile view often prevents a lively representation, but here it is ingeniously connected with a full suggestion of the sitter's stout frame and exploited for a powerful rendering of his exotic appearance and temperament.

It is true that Watteau, with his definite taste for elegance and refinement, never treated the cruder aspects of life, but he had a certain liking for popular types, as his repeated studies of Savoyards, monks, street boys, sellers of curiosities, and the like indicate. He may have planned a whole series of street criers, so-called *cris de Paris*, such as Boucher and Bouchardon produced later. The drawing of two bootblacks, in Rotterdam (fig. 190), is a good example of this category, and we see that here, too, Watteau favored a combination of contrasting positions of the models. The style is clearly that of his mature period. The same can be said of the man with the peep show, also in Rotterdam (fig. 191). Here we meet a favorite model of Watteau's, a bearded old Savoyard who appears in various sketches. In one he is seated with his arm resting on the voluminous peep-show case, in another he has it shouldered and stops for a moment looking toward the spectator. In the drawing shown he displays it on the street and Watteau contrasts the richly drawn figure in red and black chalk with the lightly sketched façade of the peep show in grayish black. It is a colorful and brilliant study and the artist characterizes in a masterly fashion the old man's professional pleasure in his exhibition.

The range of the mature Watteau's subjects in draughtsmanship was wide, and we cannot attain completeness in this short survey. His studies of animals should at least be mentioned as being of great interest and quality. We prefer to select here, as a last example, one of Watteau's rare compositional sketches for a painting. We have heard from Caylus that such sketches were the exception in Watteau's work. But there are a few, and they all show a more fugitive execution than the majority of his drawings. It is therefore quite possible that others once existed, but that the artist did not consider them worth preserving after they had

served their purpose. In the sketch reproduced here (fig. 192), which prepares the composition of "Les Plaisirs d'Amour" in Dresden, we see in a park setting, with a statue of Venus on the right, an arrangement of groups of lovers in the foreground and in the middle distance. The swiftness of Watteau's line seems here to transform his draughtsmanship into pure rhythm, and once again the association of Rococo music comes to mind.

For a final word on the master's drawings, I should like to quote his close friend Gersaint in a passage from the "Notes sur Watteau" which was printed in the *Catalogue du feu M. Quentin le Lorangaire*. After more than two centuries the words still have validity as a true and considered appreciation. "As for Watteau's drawings," Gersaint wrote, "when they are of his best period, that is to say, after he had left M. de Crozat, there is nothing superior in this genre; finesse, grace, lightness, correctness, facility, expression, they leave nothing to be desired, and he will always be considered one of the greatest and best draughtsmen that France has ever produced." [13]

DEGAS

DEGAS

In the history of painting, the nineteenth century holds a very special position. It was a most turbulent period. In its first half there occurred a quick sequence of Classicism and Romanticism which seemed to repeat, with an accelerated tempo, the European development from the Renaissance to the Baroque. But in all of this, and even more in the second half of the century, with the consecutive styles of Realism, Impressionism, and Post-Impressionism, there gradually developed a tendency toward new modes of vision and expression. Modern art was, so to speak, in the making. With Impressionism in particular many traditional boundaries were broken down and a new form of vision as well as new aspects of reality were discovered. During the course of the century stimuli came from sources other than that of the European tradition — from exotic and primitive art, primarily from the Japanese woodcut and the art of the South Seas. Still another significant phenomenon was the artist's new autonomy. He gained increasing independence, both from his patrons and from the cultural demands of his environment. Through the *l'art pour l'art* principle he became his own master and a kind of dictator in the realm of aesthetics. In discovering new artistic sensations he cast off age-old standards. The twentieth century continued this process and carried it to a much greater extreme. The artist even departed from man's natural vision and created an abstract language of his own, in Cubism and Abstract Art, in order to attain the height of independence from both tradition and reality.

Such historical considerations may not be superfluous when we try to realize the significance of Edgar Degas in the broad realm of modern art. Degas' work embraces a wide span in the sequence of styles, reaching from the last phase of Classicism to the verge of twentieth-century art. Unlike his contemporaries Manet and Monet, Renoir and Pissarro, he cannot be called an outright Impressionist,

close as he was to this important movement. He went beyond it and thus became an adored model for the young avant-garde, for Toulouse-Lautrec, his follower, and Gauguin, his admirer.

This wide range of Degas' development was an outcome both of his training and of his innate gifts. Brought up in the Ingres tradition, he never defied this heritage; he showed a consistent inclination toward linear expression with emphasis on form as well as coherent design. His problem became that of combining the best of Impressionism — its vivid rendering of light and atmosphere, its brilliant reaction to instantaneous life, and its new use of color in bright, vibrant effects — with the traditional fundamentals which he had learned from Ingres and the old masters. Degas was able to achieve this only by rejecting certain features of Impressionism. He disapproved of painting directly from nature in the open air. ("After all," he said once, "painting is first of all the product of the imagination, it ought never to be a copy. . . . The air one sees in the painting of the masters cannot be breathed.") [14] Thus he was in a way closer to twentieth-century art, in emphatically stressing the intellectual effort which is needed for the creation of a work of art. Moreover, he disliked the concept of spontaneity as a primary quality. ("No art," he said, "was ever less spontaneous than mine. What I do is the result of reflection and study of the great masters; of inspiration, spontaneity, temperament I know nothing.") [15]

Yet one of the great achievements in Degas' art is the suggestion of spontaneous movement and instantaneous life which he creates away from nature, as a result of intensely thought-out artistic devices. Both the Japanese woodcut and the camera snapshot gave him a lead in this direction. The former, in particular, taught him how abrupt representation can be combined with a coherent, decorative design. With these aids he was able to break the conventions of the classicistic tradition and to attain a maximum effect of life or convincing "truth" in his art. While, on the one hand, Degas rejected the copying of nature and laid all emphasis upon intense mental activity, he was, on the other hand, uncompromising in his effort to approximate reality and to master those aspects which fascinated him most: graceful forms in movement, whether of women or of horses. Degas turned to the ballet dancers, the women bathing, the racetrack, and a few other favored subjects for purely aesthetic reasons, and he was almost inhuman in excluding psychological or sympathetic reactions. ("They call me painter of dancers," he once said, "not understanding that for me the dancer has been a pre-

text for painting beautiful fabrics and rendering movements.")[16] Only at the end of his long life did Degas confess to a friend that he was perhaps wrong in considering woman too much as an animal — a rather significant admission.

It would be a serious error, however, to doubt Degas' capacity for deep psychological insight. When he concentrated on this aspect, as he did in his portraiture, which belongs largely to the first half of his activity, he was a most sensitive interpreter of human character. It was therefore a self-imposed limitation to specific artistic problems when, later in his work, psychological interest or human sympathy were much less in evidence.

There are many seemingly contradictory factors in Degas' art, whether we think of the contrast between the traditional and the revolutionary in his style, between his pronounced aristocratic prejudices in private life and his preference for lower-class subjects, or between his highly intellectual approach and the impression of spontaneity which his art conveys. These contradictions can only be explained by the uniqueness and complexity of his personality. We have given some reasons for these phenomena, and they affect in equal measure his attitude as a painter and as a draughtsman. As for his draughtsmanship, it needs no justification that we have chosen Degas as the outstanding figure of the nineteenth century, perhaps the only one who can follow Watteau without giving us a feeling of decline.

Hilaire Germain Edgar Degas was born in Paris in 1834 of well-to-do parents. His father was a banker, but the young Degas showed no inclination to follow this career. He began to draw early and in 1854 entered the studio of Louis Lamothe, an Ingres pupil through whom he came in touch with the art and the draughtsmanship of the great neoclassical painter. He frequently visited the Louvre and copied the Italian masters, also Clouet and Holbein. Between 1856 and 1859 he spent much time in Italy, where he deepened his knowledge of the Italian Renaissance painters. Botticelli, Mantegna, Leonardo, and others attracted his interest by their linearism and fine relief effect, and Degas copied them eagerly. Upon his return to Paris he embarked upon the production of historical paintings in the Ingres manner. These form the least impressive part of his entire work, while his drawings done at the same time (figs. 193b, 194, and 195a) are already outstanding. He soon began to draw horses also (fig. 216), and to paint the spectacle of the racetrack.

It was about 1865, when Degas was thirty years old, that he made contact

with the naturalist painters and novelists who frequented the Café Guerbois, and among whom Manet and Zola were leading figures. Degas then abandoned historical painting and turned primarily to portraiture. But in the seventies, after the Franco-Prussian War, in which he served in the artillery, he took up the new subjects of dancers, washerwomen, nudes, etc., which remained from then on his chief interest. The ballet, the opera, the racetrack, the café-chantant, became the main sources of his motifs. In this decade an impressionistic touch, or we may say a more painterly treatment, is noticeable in his art and draughtsmanship. He exhibited repeatedly with his Impressionist friends, but tried to insist that they change their name to "Independents." In the 1880's, when Degas had passed his fiftieth year, his failing eyesight began to trouble him. His style broadened and he began to prefer the pastel technique to oil painting. With pastel he could both draw and paint simultaneously. Color took on a primary role in his late work. In drawing he had turned to chalk and brush in the seventies; later he favored charcoal, with which he swept powerful forms on large sheets of paper until blindness overcame him.

All his life Degas cared little for public success. He was financially fairly independent and worked primarily for his own pleasure, storing his large output at home. He had to give up painting about 1909, and this was the time when his works began to bring high prices. But Degas remained indifferent. When, in 1912, one of his paintings: "La Danseuse à la Barre," which he had sold for 500 francs, brought the sensational price of 435,000 francs (about $100,000) at the Rouart sale, he remarked, with his usual sarcasm: "I feel like the horse which, having won the Grand Prix, receives merely his ordinary feed of oats." [17]

Degas died in 1917, at the age of eighty-three. Among the few friends who came to see him in his last years was Jean-Louis Forain, a former pupil and himself a spirited draughtsman. Degas once told him that he wanted no funeral oration. "If there has to be one," he added, "you, Forain, get up and say, 'He greatly loved drawing. So do I.' and then go home." [18]

We have mentioned that Degas' first independent activity, apart from portraiture, was in the field of historical painting, where he followed more or less in the Ingres tradition. Among his subjects are such themes as "Semiramis Building the Walls of Babylon," "The Daughter of Jephtha," "Spartan Boys and Girls Exercising," and the like. In his drawings, too, as our first examples show, he was closely attached to Ingres' style in that master's fine neoclassical pencil or chalk

sketches. But one realizes, even at this early stage, Degas' sensitive individuality in contrast to Ingres' more monumental and generalizing form and line. If we compare a study of a kneeling nude (fig. 193b) for the "Semiramis" composition of 1861 with an Ingres nude (fig. 193a), a study for the Iliad in the "Apotheosis of Homer," Degas seems more a descendant of Botticelli than of Raphael, who was Ingres' revered model. Degas' line is of an exquisite delicacy, yet not without a trenchant quality. It clearly defines forms and a relief effect is added by subtle tonal shading. Also the figure is given an inward mood which is different from Ingres' heroic pathos.

A costume study (fig. 195a) for the same "Semiramis" painting shows equal subtlety of lineament and shading, not found in Ingres' costume sketches (fig. 195b). There is a difference not unlike that between Greek refinement and Roman fullness, or between Leonardo's precious early drapery designs and those of Raphael. In any case, the intimate study of *quattrocento* art was not lost on the young Degas, and his closeness to Ingres is far from slavish.

The same qualities are present in a reclining nude, a pencil sketch in the Louvre (fig. 194) for the painting "Les Malheurs de la Ville d'Orléans." The Louvre owns twenty drawings for this work, which dates from 1865 — among them nudes of extraordinary beauty. The Ingres influence is still felt, but the distance from his more classical concept has widened. The diagonal placing of the figure, its bold foreshortening and swift lines go beyond the style of the older master. A tender light flows over the nude and Degas' pencil accentuates the contours here and there with a fine sharpness. He knows now how to combine structural firmness with a sensitive atmospheric effect.

Portraiture was one of the first subjects of Degas' own choosing. In the late fifties, in Italy, he tried to learn from the stylish simplicity of the Renaissance masters. He copied them in a very personal manner, with a fine reduction to essentials and a characteristic lightness of touch. In a few cases, such as the handsome Pontormo portrait of a lady, in the Uffizi, he made both a drawing and a painting after the original (figs. 196a and b). The drawing, in pencil, belongs to the Museum of Modern Art in New York, the painting, to Mr. and Mrs. R. W. Finlayson, Toronto.

Already in his early twenties Degas began to portray himself and members of his family. The drawing in the John Nicholas Brown Collection (fig. 197) shows the neoclassical style of the 1850's, with emphasis on line and form. But through

the softness of touch — it is done in red chalk on cream-colored paper — the line seems to turn into tone and the psychological content is arresting. Young as the artist is, his full character is felt: his veracity and sensitive haughtiness. Camille Mauclair, one of Degas' biographers, observes in the Louvre portrait for which this drawing served as a study: "reticence, obstinacy, disdain and restrained violence." [19] This amazing work can take its place beside the early self-portraits of the old masters, as we have seen in the cases of Dürer (fig. 97a), of Raphael (fig. 65a), and of Rembrandt (fig. 132b).

The portrait of Degas' sister, Thérèse de Gas, who married her cousin the Duke of Morbilli in Naples, is represented in a drawing in the Boston Museum (fig. 198), which also owns the impressive double portrait of the Duke and Duchess, painted in 1867 (fig. 199). The drawing is earlier and still very like Ingres. Degas' ancestry was French only on his father's side, though the father was born and brought up in Naples where Degas' grandfather had moved at the time of the French Revolution. His mother was from a Creole family which had come from New Orleans and settled in Paris. These rather international ties meant something to Degas. He often visited his relatives in Italy, and once (1872) even those in the New World. Whether his sister, with her large dark eyes, represents more the southern strain in the Degas family is hard to say. But she looks like an Ingres Madonna in this drawing, and the almost Roman grandeur of draughtsmanship is more pronounced here than Degas' usual subtlety. The sketch must date from the year of Thérèse's marriage (1863), as does the Louvre portrait for which it was made. In the Boston painting she appears older and the characterization is more personal and interesting.

The drawing of "Mme. Julie Burtin" (fig. 201), in the Paul J. Sachs Collection of the Fogg Art Museum, shows Degas' draughtsmanship on a higher level. It is a study for the portrait listed as "Femme en Robe Noire" of 1863, in the first Degas sale. We find here the refinement of characterization, the freedom and sensitiveness of touch which mark Degas' best portrait drawings. The artist still uses Ingres' pencil technique, here slightly enriched by some white chalk in the face and the hair, but goes beyond Ingres (fig. 200) in many ways. Posture, gesture, and facial expression characterize the woman's individuality in the most delicate way. In the composition we notice how diagonal accents and a geometrical trend begin to be essential in Degas' style. And these formal elements are more subtly integrated with the expression of the sitter's character than is ever found

with Ingres. One realizes also that Degas, at this phase, prefers a restrained relief effect, as he had learned it from *quattrocento* art, to the plastic roundness and fullness of Ingres' forms.

With the famous drawing of "Mme. Hertel" (fig. 202) — a study for the "Woman with the Chrysanthemums" of 1865 in the Metropolitan Museum — we reach a definite height in Degas' development. It is the height of his early style in which line rather than tone is the dominant factor. This is the time of Degas' contact with Manet and his group at the Café Guerbois, but the drawing shows no deviation, as yet, from the artist's personal line as he had developed it out of Ingres' style. There is still Ingres' pencil technique, and even the posture of the woman, the easy way she supports her head with her hand, is one favored by Ingres in his late female portraits. But the informality and naturalness of this gesture are here much greater, as is the masterly foreshortening of the hand, with only two fingers clearly outlined. (The older artist usually felt obliged to display all five.) Furthermore Ingres' subjects looked at the spectator, which was more or less the classical rule. Degas' deviation from this convention leads to new possibilities of intimate characterization. The woman's glance to the side, that goes so well with the relaxed and personal gesture, gives us a remarkable insight into her intelligent personality, shown in Degas' superb delineation of her eyes. In the painted portrait the woman is placed at the extreme right of the composition, looking out of the picture, while a giant bouquet of chrysanthemums fills the center. This arrangement therefore shows the beginning of an unexpected shifting of accents as Degas had learned it from the Japanese woodcuts. It offered a new means of suggesting the casual and the momentary by the use of surprising angles of vision.

In the spirited sketch for the portrait of James Tissot in the Fogg Art Museum (fig. 203a) — the painting belongs to the Lewisohn Collection in New York — Degas goes further in his innovations, inspired by Japanese woodcut design. The sitter was a friend of Degas and himself a painter; the two shared the experience of having been pupils of Lamothe. The drawing is to be dated 1868, a date which fits its advanced style. Degas here combines with geometrical design tendencies an unusual informality of pose that expresses well the casual elegance of this gentleman painter. But also, with his swift and pointed lines and a vibrating tonal effect, he suggests light and atmosphere as well as spatial accents that are not found in the decorative flatness of the Japanese cuts.

Only a few years earlier, about 1865–66, he did the sheet of studies (fig. 203b) for the etching "Manet Seated and Turned Right." Similar stylistic tendencies appear here, with a most engaging freshness. Manet has never been characterized as vividly and sympathetically as in Degas' splendid sketches and the etchings which followed. The two artists had high respect for each other, although their friendship was often disturbed by quarrels. After one reconciliation Degas remarked: "How can anyone be expected to remain on bad terms with Manet?" [20] It did not often happen that Degas was so forgiving, but Manet's personality was too overpowering and engaging, even for him.

Degas' rare portrait studies of the later seventies and early eighties show a broader technique in chalk or pastel, with painterly contrasts of dark and light and a more vigorous expression of mass and form. This can be seen in the remarkable sketch of "Diego Martelli" (fig. 205) in the Paul J. Sachs Collection of the Fogg Museum, for the painting of 1879 in Edinburgh, and in the impressive drawing (fig. 204) in which Degas took Mary Cassatt as the model for his pastel "Chez la Modiste" of 1882. Martelli, a friend of the artist, was a Neapolitan engraver living in Paris. Degas enjoyed his company, partly because he could talk with him in the Neapolitan dialect. Every recollection of Ingres is now gone in this powerful drawing, where the emphasis is thrown on mass and tone rather than on line. The angle of vision, as in most of Degas' work from the late sixties on, is both surprising and revealing, and the expression of character as forceful as ever. One does not doubt that the artist has chosen a typical posture of his jovial friend, one that reveals his good nature and his robust personality in a moment of complete unselfconsciousness, when his eyes are lowered and almost hidden. In fact, Degas often approaches Rembrandt in his insight into a sitter's personality. Most effective here is the broad open shading on the vest, providing an intermediary tone between the grayish white of the sleeves and the deep dark of the hair.

In the study (fig. 204) for the pastel "Chez la Modiste," lights and darks are equally strong and even more brilliantly graded. All attention is given to the woman's action of tying the ribbons of her hat under her chin, before a mirror. It is therefore more of a genre motif than an actual portrait, yet psychological insight is not excluded.

If only the portrait drawings by Degas had survived and nothing else, we should still realize how great a master he was. But there exists much more — all the

varied subjects of his later period, among which the ballet dancers hold the foremost place. In the seventies, in particular, the ballet theme predominates, and numerous drawings show us Degas' intense observation of the dancing girls in many different aspects of their professional life, not so much on the stage as behind the scenes, at their training, when practicing difficult positions or rehearsing for the performance, or even when standing about conversing and snatching a few moments' rest. The description of the human atmosphere of this backstage world given by Camille Mauclair in his brilliant essay on Degas is very graphic and worth quoting, but he treats an aspect which Degas intentionally bypassed, though elements of it are felt here and there. Mauclair writes: "It was not the celebrated, wealthy and fêted ballet girls who interested Degas, but the poor little plebeians of the *corps de ballet*, representing the unknown and sorrowful reverse of illusion. And not only did he pass from the auditorium to the wings, he entered the bare, light and cold rooms where these young girls of the *faubourg* were trained. They came there from their wretched lodgings, sometimes conducted by a 'Madame Cardinal,' such as his friend Ludovic Halévy depicted, sometimes alone, girls already vicious and even devoted to harlotry. Their salaries were poor, their work exceedingly hard. Physical exercise disarticulated their ill-nourished young bodies from which an excessive muscular effort was demanded. A thankless profession indeed! — and one which those adolescent girls chose more in the hope of meeting some serious *entreteneur* than of securing leading rôles in the limelight, and finally attaining to the glory of a 'star.' At the same time as acrobatics they were taught to be elegant, graceful and stylish, for they were of the 'lower orders' and remained so both in speech and manners as soon as they were at rest, as soon as their master had stopped beating time." [21]

Only by close attention can we detect something of this dreary human atmosphere in Degas' drawings; the overwhelming impression is one of youthful grace and movement. The drawing in the Metropolitan Museum of a "Dancer Adjusting Her Slipper" (fig. 206) was used in a painting of 1874 (now in the Havemeyer Collection) and indicates that in the first half of this decade Degas could still remain a linearist. But a comparison with his work in the sixties shows that the atmospheric quality has greatly increased — this is even more noticeable in the ballet paintings, with their beautifully diffused light. The expression of movement in space is also greater, and the problem of balance takes on an exciting aspect. In another drawing, also of 1874, representing a dancer standing and touch-

ing her earring (fig. 207), the swift chalk lines of the skirt are cursory and suggestive while the artist focuses the interest on head and gesture by sharpened accents.

In a brilliant study of 1877 for the "Danseuses à la Barre" in the César de Hauke Collection, a brush drawing on green-colored paper (fig. 208), Degas' touch has become more painterly. Tonal accents are now more important than the contours which tend to vibrate or dissolve in the lighted areas. But through these tonal accents there develops also a more powerful emphasis on mass by means of light and dark contrasts. Color too becomes more prominent, through the brilliant green of the background against which Degas sets his violet and dark gray drawing. As in the case of Watteau, Degas likes to compare or contrast figures in different postures. In this pair, both dancers are seen exercising at the bar; the one on the left has stretched out her leg to a straight horizontal behind her, while the one on the right faces the bar, raising her foot to its level.

From 1882 we have the pastel study of a Spanish dancer with repeated sketches of her arms and legs filling the left half of the sheet (fig. 209). A splendid force is given to the dancer's triumphant stance. The footlights illuminate her widespread skirts and vivid strokes in yellow, red, and orange produce the golden glimmer that radiates from Degas' late pastels.

The artist's inscription on a drawing in black chalk done in December 1878 (fig. 210) tells us that the dancer represented was named Mélina Darde and that she was fifteen years of age. Above the figure are some color notes and specific remarks on her costume. The young toe dancer is absorbed in one of the foot exercises that form a part of her rigorous training, and Degas observes her with the keen eye of a scientist. I believe this is the kind of drawing that was not meant to reach the public (Degas' signature was printed later, before the sale). In fact, the old artist once became furious when he heard of the indiscriminate selling of his drawings, without any regard for their function and degree of finish. This study could indeed be compared, in its scientific precision, to one of Leonardo's anatomical sketches which were also done largely for his own information.

The drawing in crayon and pastel of 1887 shows a ballet girl seen at close range, bending down to tie her slipper (fig. 211). This is carried out to fuller tonal richness and perfection. It is ingenious how Degas balances the masses of light and dark in this unusually posed figure, with full awareness of the

natural course of light which comes from the upper right. With the lines of the girl's arms and shoulder straps he creates a decorative pattern of almost abstract beauty, yet the spatial effect remains convincing. The classicistic world of Ingres now seems far away. He and his followers would have rejected such a posture as ugly, if not repulsive, but Degas proves the contrary with his bold innovations resulting from a tireless search for new aspects of reality and for new means of representing them with a striking design effect.

As is well known, Degas tried his hand at sculpture also, modeling dancing girls and horses in wax, which were later cast in bronze. The three sketches of a nude dancer on a sheet in the Demotte Collection (fig. 212) served as preliminary studies for a statuette in wax which was exhibited at the Sixth Salon of the Impressionists in April 1881 under the title "Dancer of Fourteen Years." They are done with broad crayon strokes in black and white on greenish gray paper and show Degas' unyielding realism and observing power more strongly than ever. He summarizes the form, sharply characterizing the angularity and the wiry muscles of the youthful, trained body. The facial type, with its broad, vulgar features, is no less realistic. Yet the drawing has charm and rhythm in the configuration of the three nudes.

Four studies of a young dancer on a sheet in the Louvre (fig. 213) represent the same girl in her ballet dress as Degas modeled her in the above-mentioned statuette. These also are done with broad crayon strokes, but the stylization seems slightly increased. There begins a tendency to monumentalize the forms, a trend that will grow with Degas' advancing years.

It was not only the dancers, but also the musicians, the full orchestra, the ballet master that Degas studied with attention and rendered in his paintings. A beautiful oil sketch on greenish paper from the McIlhenny Collection (fig. 214) represents the ballet master who is the central figure in the painting of "The Dancing Lesson" of 1874 in the Louvre (fig. 215) and in that of 1876 in the Harry Paine Bingham Collection in New York. Although the oil sketch is dated one year later than the Louvre painting, it seems to have served as the study for it, and therefore we may assume that the artist added the date the year after the sketch was finished. In the two paintings Degas assembled many of his studies to form a remarkably complex design of fascinating brilliance. The drawing is a study of light as well as of form, with the rich tonality that distinguishes his brush sketches from the middle of the seventies on.

DEGAS

As early as 1860–1862, that is, after Degas' return from Italy, there occur a few paintings of the racetrack, and the artist turns repeatedly to this subject up to the late eighties. In the early period we can date the pencil drawing of a saddled horse, in the Fogg Art Museum (fig. 216). With pencil alone the texture and structure of the race horse's body are rendered with infinite care and sensitivity. Compared to Degas' later work, this drawing looks a little photographic in its very detailed realism. However, we should not forget that the ability to abstract form and reduce it to essentials does not come to an artist at once. Careful studies of this kind have to pave the way, even in a master's career, before he can build on his knowledge and display greater artistic power by proper selectiveness.

The fine pencil drawing in the Louvre of a "Lady on Horseback" (fig. 218) is dated about 1865. In style it parallels the exquisite portrait drawings of the mid-sixties, and shows some recollection of the Ingreslike drawings of Degas' youth. Remarkable here is the young woman's lost profile in half shadow, which adds a portrait character and a distinct psychological note to this study of a lady's costume and position on horseback.

A "Gentleman on Horseback" (fig. 219), a brush drawing also in the Louvre, cannot be very far in date from the previous sketch. But whenever color comes in, Degas shows us new effects of luminous tones set against deep dark values — the same device which lends to his paintings of that period a highly individual and distinguished coloristic character.

With the study of a jockey mounted and the sheet showing two jockeys holding their reins (fig. 217), both in broad crayon, we come closer to Degas' late style, when his grasp of form in movement is so remarkable and his line has gained in power. He can now seize and set down the most momentary positions with striking clarity. The drawing of the jockey mounted has its parallels in pastels of the late eighties, while the other motif occurs in paintings of the early eighties. The two studies are thus nearly a decade apart, as their style also indicates.

The subject of nude women at the bath or making their toilet was of unending interest to Degas in the later part of his life. If we think of classical nudes and their long tradition from Giorgione and Titian, through Poussin and Velasquez, down to Ingres and Puvis de Chavannes, we realize how revolutionary Degas was in his unacademic study of the female body in action. On one occa-

sion, when he showed some of his nudes to his friend George Moore, Degas made the following comments: "This is the human animal occupied with herself, a cat licking herself. Hitherto the nude has always been represented in poses which presuppose an audience. But my women are simple, honest creatures who are concerned with nothing beyond their physical occupations. Here is another one, washing her feet — it is as if you were looking through a keyhole." [22] In Watteau's nudes we have already noticed something of this new and more intimate approach, but his was only a timid beginning when compared to Degas' daring studies. Through constant search the modern master discovered ever new aspects and motifs. In these, however, his imagination was as active as his observation, for Degas never failed to transpose reality into art. In another conversation he once said: "It is all very well to copy what one sees; it is much better to draw what one no longer sees except in memory. A transformation is effected during which the imagination collaborates with the memory. You reproduce only what has struck you, that is to say, what is necessary. Then your recollections and your fancy are freed from the tyranny which nature exerts. That is why paintings made in this way by a man with a trained memory, one who is well acquainted both with the masters and with his craft, are almost always remarkable works — witness Delacroix." [23]

When he drew the early nude of a reclining woman (fig. 194) for the historical painting "Les Malheurs de la Ville d'Orléans," Degas was still far from his later approach to the subject. His line was delicate, Ingreslike, and his modeling done in a subtle mode of relief, as he had learned it from the *quattrocento* masters. Also the posture was still fairly conventional, although he was beginning to explore new angles of vision.

In the pastel drawing of a nude on blue paper (fig. 220), dating from the early eighties and belonging to the Georges Viau Collection, no neoclassical recollection is left. It is a bold choice of posture for a nude, with no regard for beauty in the traditional sense. One could not even call it comfortable, because the woman's two elbows are supported on one knee. A closer view reveals that her left foot, the one on which she leans, is resting on the rim of a bathtub. But the artist wanted to explore this unusual position in which the upper part of the body, together with the arms and one thigh, becomes a solid mass, while the legs are widely separated. The result is a plastic motif with a kind of ara-

besque charm, and lights and darks are held together in masses to heighten the monumentality of the graphic treatment.

The powerful drawing of a seated woman after the bath (fig. 221), in black and colored crayon on white paper, belonging to the Paul J. Sachs Collection of the Fogg Museum, dates from about 1885 or later. Here the model dries her neck with a towel, and her movement brings about a mighty curve that encloses her upper body. It heightens the compactness of the motif. The artist lets the towel fall in such a way that the outline of the body is thrown into relief. The summary force of the contour in these late drawings is matched here by the breadth of modeling which Degas produces by wiping the chalk with a stump.

Of equal massiveness and great breadth of treatment is the drawing in charcoal and pastel of a woman washing her neck over a hand basin (fig. 222), in the André Noufflard Collection, Paris. This can also be dated near the mid-eighties. Toulouse-Lautrec followed Degas in depicting such motifs, but his line has more swiftness than the old Degas' forceful simplification. Renoir, in comparing Degas and Toulouse, made the following startling remark: "When one paints a bordello, it is often pornographic but always desperately sad. Only Degas can give such a subject an atmosphere of cheerfulness, and at the same time the aspect of an Egyptian relief. This side, semi-religious and very chaste, which makes his work so noble, is even greater when he deals with the prostitute." [24] Renoir's feeling about the chasteness of Degas' art is rather significant, and one can also understand his reference to Egyptian reliefs.

The arabesque quality found in some of Degas' late drawings seems to reach a height in the black crayon sketch, in the Paul J. Sachs Collection of the Fogg Museum, of a woman standing in a bathtub (fig. 223). She rubs the heel of her right foot with her right hand, while her left one grasps the rim of the tub. The result is a highly interesting configuration. Again the natural and the momentary are brought out in a boldly balanced design with strong spatial effect. Degas' shading is now scratchy and summary, giving a textural charm that is similar to the brittle, vibrating surfaces of his late pastels.

As for subjects other than ballet, racetrack, or bathing women — for example, the milliners, laundresses, performers in the circus or the café-chantant — not many drawings are known. Of the last group, at least, we may show in conclusion a strong example: two studies of a café-chantant singer in charcoal and pastel on grayish paper, belonging to the Wintersteen Collection in Phila-

delphia (fig. 224). It is a drawing of considerable size and possesses that monu-
mental quality which Degas reached in the eighties. The step from here to Ex-
pressionism seems not too far (one is almost reminded of Kaethe Kollwitz in
the left-hand figure). But Degas would have rejected the program of distorting
reality for the sake of heightened expression. With him the expressive power
grew through the intensification of the means, through ever-increasing selective-
ness and accentuation. Degas the realist advanced steadily along with Degas the
stylist, and the drawing of the two singers shows this development at its height.
The physical effort in the act of singing is as forcefully expressed here as is the
women's wholehearted abandon to their task at this moment. Life is enhanced by
the suggestive power of the artist, and the drawing made beautiful by Degas'
rare sense of form, his masterly organization and graphic touch. Degas, after all,
remained faithful to the basic ideals of the old masters, but his artistic genius
brought him close to the art of our day.

PICASSO

PICASSO

There are drawings by Picasso which no one would object to placing at the side of the great European draughtsmen as the last phase of a long and glorious tradition. But there are many others in which no connection or comparison with the European past seems possible. How can we explain this discrepancy in one and the same master's work?

The answer to this question lies in Picasso's unusual many-sidedness — a many-sidedness and a versatility which have no parallel in the past and which can be understood only as the outcome of his extraordinary personality and the unique historical circumstances of our time. The paradox of a traditional vein in Picasso's art along with an intensely revolutionary one has to be accepted. But it is the revolutionary part of his work which is the largest and most conspicuous, as is the case with twentieth-century art in general. The break with the past, in this century, has been so fundamental and far-reaching that an effort is required in order to realize its full significance. If we draw our standards exclusively from the periods and masters we have already dealt with, access to the new character of contemporary art seems difficult, even though the late nineteenth century, as we have seen in the case of Degas, prepared the ground for things to come. Only if we are willing to follow an artist like Picasso on his adventurous path, shall we find an opportunity to realize his intentions and his achievements. But for a final evaluation we may still lack the proper perspective.

From the late Middle Ages the representational arts in Europe have been built on man's natural vision. There were changes of concept from the fifteenth to the nineteenth century, but all these periods had in common a form of vision which we call here "natural" because it was based primarily on man's eyesight and aimed at the illusion of visual reality. Objects were rendered from one station point only, in the perspective view to which the eye's perception is subjected.

PICASSO

The Renaissance artists regarded the discovery of the laws of perspective as the union of science and art, if not the elevation of art to the level of science. But after succeeding periods had exhausted the artistic potentialities of perspective representations, and when photography had demonstrated that "illusionism" has no artistic value in itself, the twentieth-century artists turned away from natural vision in a search for new possibilities of expression.

Their revolutionary ideas possessed a certain logic. The eye, their argument ran, sees an object only from the front, the side, the back, or whatever station point the observer holds; but we know by experience that all those other aspects also belong to the object in its completeness. Thus we assume its full three-dimensionality by a combination of knowledge and vision. Why not, they then asked, increase the role of the mind in relation to that of the eye, break the narrow limits of the perspective view and expand its one-sidedness to embrace a multiplicity of aspects such as can never be attained from one station point only? Why not give full freedom to the artist's imagination and allow him to apply more comprehensive concepts than the mere imitation of reality? The avant-garde of our century took the courage to make this fundamental break with the European past from the art of the primitives, from ancient Egyptian reliefs, where front and side views are combined in one figure, and from whatever digressions from traditional "illusionism" could be found in the remotest parts of the world or of man's history.

Once natural vision had been discarded, and with it the obligation to a coherence of form and of space, the artist's fancy was freed and he began to experiment in many ways: space could be manipulated arbitrarily in every part of the picture, objects — including the human figure and even the face — could be taken apart at will, dissected into planes and solids, as Analytical Cubism undertook to do. Or after such dissection a new synthesis could be made, based exclusively upon the artist's fancy, as in Synthetic Cubism. Even arbitrary distortion of the natural proportions of forms became permissible for expressive, experimental, or other purposes — as Surrealism and, to a more limited degree, Expressionism ventured to do. With all these trends, however, at least a thin bond with reality was retained and a certain reference to nature still implied. Even this slim bond was removed by the strict adherents to the tenets of Abstract Art. They admitted only forms that were wholly products of the artist's imagination and independent of any allusion to visual reality.

PICASSO

With such radical abandonment of natural vision the old content of European art also suffered a complete change. A world of forms was created that looked chaotic from the traditional viewpoint, but was stimulating to those who could follow the modern artist in his frantic search for new means of expression. No law was any longer acknowledged save the barest principle of artistic organization.

What we have said about the fundamental changes which took place in twentieth-century art, after half a millennium of illusionistic painting, and about the conceptual, rather than visual character of contemporary art, applies to a very large degree to Picasso, because he was the initiator of many of these changes and can be called the leader in European art since the beginning of this century.

But Picasso, extraordinary personality that he is, maintained his identity and individuality in all this turmoil, and cannot be held responsible for everything that happened during this revolutionary period. He is unique in many ways, and this fact must be clarified before we can measure his full share in the general development. No other artist displays such a multiplicity of styles — a multiplicity that reflects his exceptionally wide range as well as his high degree of susceptibility and creativity. To be exposed to works of art of widely different periods and styles, and to be susceptible to them, is nothing unusual in this age of the "Imaginary Museum," as André Malraux has termed it. In the case of artists this easily leads to imitation or eclecticism, when they themselves have little to add. Not so with Picasso. Often, however, the many-sidedness of his art has been regarded with suspicion (a renowned psychoanalyst on one occasion even called the artist schizophrenic). But the last twenty years of his production have clearly shown that Picasso's changeability does not transcend the potentialities of a great creative personality. Definite signs of a synthesis of the many different phases of his art have appeared in his mature work, roughly since the time of his great "Guernica" painting.

In another respect, too, Picasso's artistic personality has manifested its coherence and identity in spite of his amazing versatility. For he never adopted the strict tenets of Abstract Art, close as he may have come to it here and there. His vital nature obviously demands, time and again, contact with reality for the inspiration of his artistic fancy. His abstract stylization develops gradually from the image of nature as a starting point. We can follow this process of transformation in a number of cases, and all show the same pattern.

PICASSO

These two points which mark Picasso's individuality: namely, the multiplicity of his styles, building up to a kind of synthesis in his mature work, and the specific relation between nature and abstraction in his art, have also been stressed in Wilhelm Boeck's recent monograph. He goes further than I originally did, in the elaboration of these points, and I am indebted to this writer for his contribution.

Finally, in these introductory paragraphs, a few words may be said about the peculiar role and value of Picasso's drawings, for they are our chief concern here. Picasso's graphic genius is evident at many high points of his production, both in his drawings and in his prints. With him these two forms of art often come so close to one another that there is justification in including a few prints in this selection as samples of his mastery in draughtsmanship. But not every drawing by Picasso can be called a masterpiece. At times they are only quick scribbles, a means of developing a compositional idea to its next phase, without any attempt at artistic effect. Such drawings have not been included in our brief survey, although they may be of interest in showing the genesis of individual works.

Picasso's drawings in general, even if we limit ourselves to more weighty and representative examples, exhibit by no means all aspects of his work. It is only in his paintings that the artist displays the whole range of his momentous search for, and discovery of, new forms of expression. Nevertheless, his art in black and white reveals much of his genius. And in it we find, more often than in his paintings, an adherence to the "classical" style. Particularly in his outline drawings, which are of great beauty, he shows his affinity to the European past, and he comes back to this type of draughtsmanship with a certain regularity; in his paintings the classical creations are primarily the product of one period, that of the early 1920's.

The precocious talent of Picasso was already apparent in his Barcelona period (1896–1900) and on his first visit to Paris (1900). There are a number of portrait drawings in black chalk or charcoal, from the turn of the century, like that of his friend Rocarol (fig. 226) — drawings that are not yet in any way revolutionary but show the young artist's power of characterization. The medium of black chalk is exploited for broad treatment with deep darks and sharp linear accents. It is surprising, in an artist so young, to find no hesitation, but a rare sureness and economy of touch. Picasso took up the current trends, particularly

in Paris, where Toulouse-Lautrec and Steinlen, also Gauguin and van Gogh, had come into fashion following Degas, Renoir, and the Impressionists. The Toulouse character is evident in a very free crayon sketch with heads and scenes from a bar (fig. 225), in the Ivan L. Best Collection in Seattle. Picasso's stroke is much broader than the French artist's sophisticated line. The young Spaniard seems to superimpose an almost barbaric vitality on the refinement of Toulouse, but the latter's acid spirit of caricature is picked up eagerly.

The so-called Blue Period (late 1901 to early 1904) of Picasso, his first independent stylistic phase, in the course of which the artist settled in Paris, receives its name from the striking, somewhat sombre blue that dominates the coloristic impression of his paintings during these years. In keeping with the melancholy undertone of this blue, the subjects too are drawn from the dark side of life: poverty-stricken mothers, weary acrobats, blind or crippled beggars, and the like. Picasso himself, as a newcomer to Paris, suffered from hunger and disappointment. In the drawing of "The Madman" (fig. 227), Barcelona, Museum of Modern Art, and in the study of a mother and child, with four sketches of her right hand on the same sheet (fig. 228), from the Paul J. Sachs Collection in the Fogg Museum, we encounter various characteristic aspects of Picasso's style at that period. A Gothicizing slenderness and a lyric pathos are expressed by long and finely drawn lines which tend to angularity and stress the bony structure of his emaciated figures. Their elongated forms have been called mannerist because they reflect types of the late sixteenth-century Spanish painters, Morales and El Greco, which Picasso must have seen in his own country. Irrespective of such influence, there is individuality in his style and a sensitive and expressive linearism that will remain the artist's own throughout his career. The significance of Picasso's blue is not so much our concern here in dealing with his drawings. Both its melancholic and its idealizing character have rightly been stressed, and a similar feeling can be detected in his draughtsmanship of these years.

The Rose Period, which follows in 1904–1906, brings not only a brightening of Picasso's palette with a delicate rose or terra cotta tonality predominating, but also a less tragic, more positive mood. His figures gain volume and health. We meet with ideal nudes and horses in a landscape, not uninfluenced by the compositions of Puvis de Chavannes and Gauguin, and a kind of proto-classicism appears. This is evident in the etching called "The Watering Place" (fig. 229b), where male nudes and horses are treated with a pure line of re-

markable beauty and economy, and where we discover Picasso's mastery in spacious compositions. The artist, by that time, may also have seen Greek vase paintings, richly represented as they are in the Louvre. In any case, he shows an unusual freshness in this early indication of his classical leanings. There exists a gouache of the same composition in reverse (anonymous loan at the Worcester Art Museum); perhaps the artist had planned a large-scale picture which was never executed. The drawing in the John W. Warrington Collection in Cincinnati (fig. 229a) is a charcoal study for the horseman on the left in the gouache but on the right in the etching. The outlines are more rounded and naturalistic than those of the Blue Period and are stylized in a classical, rather than a Gothic, spirit. The beautiful oil of a boy leading a horse (on loan at the Museum of Modern Art in New York from the William S. Paley Collection) best represents this short phase and special subject in a large-scale painting.

Picasso's first turn from the classical toward primitivism appears late in 1906 after the artist has seen the Iberian bronzes of Oruña exhibited in the Louvre. The breakthrough to Cubism (in its initial phase) is generally noticed in the large painting of "Les Demoiselles d'Avignon," which dates from 1907. This shift from the classical to the Cubist was perhaps the most momentous step in Picasso's development, because within these two extremes all further development was to take place. This period, which is characterized by a peculiar power and daring, therefore deserves our special attention.

The charcoal drawing of 1906 in the Richard S. Davis Collection, representing "Two Nude Women" (fig. 230), still holds to the reality of the forms, but their simplification and vigorous massiveness, also their contracted proportions, indicate the new trend. One might see a trace of Gauguin's primitivism in the exotic faces, but nothing of his flattening design tendency. Plastic power seems to be Picasso's chief concern, and he achieves his goal by narrow bands of shading and the fullest exposure of the bulging parts of the forms to intense light.

With the "Head of a Woman" (fig. 231), in Chicago, of the spring of 1909, we enter the period of Cubism. The drawing, in its prismatic character, goes beyond the "Demoiselles d'Avignon." Sharply cut, tilting planes of geometric shape are set against each other by light-and-dark contrasts. The "sharp-edged facets" into which the surface is broken up resemble those of "a crystal or cut diamond," as Alfred Barr so aptly remarks. The basic natural form of the head is not yet lost, but it is broken and its parts modeled in Cubist terms. The planes

show curved or angular edges, the tonal effect is somewhat checkered. Negro sculpture is still felt as an inspiration (as in part of the "Demoiselles d'Avignon" painting) and the dynamic power of this sketch matches the strongest works of the primitives.

An "analytical" tendency prevails in the following years, during which Picasso's contact with Braque is very intimate. The disintegration of the natural form makes rapid strides, as we see in the drawing of a female nude in the R. S. Davis Collection (fig. 232a) and in another of the same subject in the Metropolitan Museum (from the Alfred Stieglitz Collection, fig. 232b), both of 1910. The figures are completely dissected into planes of geometric shape constantly shifting their direction. Through the modulation of tones and the overlapping of planes, some plastic action, some movement forward and back, is still suggested, but within a very limited picture space. The shifting of direction is often combined with an intentional ambiguity of spatial definition whenever the drawing opens up or runs into white. Guillaume Apollinaire, friend of Picasso and literary defender of this form of Analytical Cubism, spoke of Picasso's "assassinating anatomy with the science and technique of a great surgeon." [25] In any case, the massive character of the previous years is completely dissolved and everything is set into motion; no stability is any longer admitted. The new principles open up an endless variety of abstract formalistic play, and the remoteness from nature often reaches a point not far from complete abstraction. Of the two drawings under discussion, it will be noticed that the vestiges of reality are harder to detect in the Stieglitz sketch (fig. 232b), which therefore seems the later one. Its planes have a more strictly geometric shape, whereas the Davis drawing is still fairly readable as a human figure and retains some modeling in the round.

The study of a "Man with a Pipe" (fig. 233), of 1912, in the Rosen Collection in Baltimore, is another striking example of Analytical Cubism where only with the closest attention can one detect a justification for its title. Some reminiscence of the head's form is retained in its transformation into a triangle. The eyebrows, the ears, the nose, the moustache, the pipe, are still in place, although altered into geometric shapes. The right eye has taken on the form of a cube, the left seems to project. The nose, too, is treated in a geometric fashion. The whole is composed of a number of vertical and diagonal planes that are interlocked in a narrow picture space. Strangely enough, some character is re-

tained in this intensely abstracted image, and this is explained by the fact that Picasso never completely loses contact with the original "experience" of his model, however far he may go toward abstraction. And he knows how to maintain a compositional order in this new language by the proper scaling of forms, by balancing the directions and the tonality, by creating a focal interest that is well related to all other parts of the design.

The second important phase of Cubism has been termed "synthetic." It lasted from the end of 1912 to the middle of the twenties, and within it Barr distinguished a Rococo trend in 1914–15 and a "curvilinear" one from 1923 to 1925. It is somewhat questionable whether the term Cubism, if we take it literally, can be attached as a meaningful label to all those phases of Picasso's art which bear this name. But we have become accustomed to the word and accept it in the broader sense of an abstract formalistic tendency in which the cube is just one, but by no means the essential form. In fact, as we have seen in Analytical Cubism and shall also see in the Synthetic phase, the three-dimensional features are generally subdued in the interest of a more planar effect. And even the geometric trend is not a permanent characteristic, as Synthetic Cubism will show. Alfred Barr's definition may be mentioned here because it is comprehensive enough to embrace all these variations and deviations. He says that Cubism does not depend fundamentally upon the character of the shapes — straight-edged or curved — but upon the combination of such factors as: the flattening of volumes and spaces, the simultaneity of points of view, the disintegration and recombination, and, generally, the independence from nature in color, form, space, and texture without, however, abandoning all reference to nature. It is a complex definition which goes to show that Picasso's arbitrary tendencies move in so many directions that they can hardly be comprehended by one term alone.

As for Synthetic Cubism, it seems that Juan Gris was the initiator of this term (see W. Boeck, *Picasso*). In the beginning the Cubists were much influenced by Cézanne's famous advice to his pupil Emile Bernard: "You must see in nature the cylinder, the sphere, the cone." Juan Gris, however, advised his Cubist friends to go the opposite way — not to transform a bottle into a cone, but a cone into a bottle, and thus to produce "synthetically" objects that were the artist's creation rather than an imitation of nature. In any case, Picasso's desire at this phase to turn from the dissection of objects to their synthesis is

understandable. This synthesis is for the sake of a more coherent decorative effect that could not be attained by Analytical Cubism, with its strong divisional tendency. At the same time it brings about a more readable representation with at least some suggestion of the natural forms.

The crayon drawing of a "Woman in an Armchair," of 1916 (fig. 234), shows the new synthetic quality as well as a clearer readability in its representational aspect. The figural motif is not dissolved, but rather put together in abstract terms of white, gray, and black planes that show a geometric shape. Some spatial effect is retained by the outlined armchair and the prismatic effect of converging planes in the figure. But the flat decorative pattern dominates, and the coherence of the design is no longer threatened by an overintense analytical treatment.

"The Figure in Motion," from a sketchbook of 1925 (fig. 235), one would place in the phase of curvilinear Cubism, which comes toward the end of the Synthetic period and is marked by an abstract decorative quality with curvilinear shapes predominating. The division of the face into two different views — the so-called "simultaneity" of aspects — is a frequent device of Cubism and noticeable also in the previous drawing. The pattern is now greatly enriched by a more active interplay of light and dark shapes and textural charm is added by various types of shading. Space is slightly suggested through the indication of a foreground and a background, yet the three-dimensional effect of the figure is again negligible and the pattern dominant.

In bringing the development of the various Cubist trends up to the mid-twenties we have given only an incomplete picture of Picasso's full range. The decade from 1915 to 1925 shows, in fact, a realistic and classical trend running side by side with the abstract or Cubist one. This is more evident in graphic art than in painting, where only the early twenties can claim a full-fledged classicism. As stated above, this simultaneity of the realistic and the abstract, or the classical and the Cubist, is unique with Picasso and he handles both modes with equal mastery and originality. Obviously he finds nothing contradictory in this bilingual attitude and his choice is dictated by his mood, by the specific problems he is facing, or by the aptness of the technique he employs. The fact that Picasso has favored outline drawings in his graphic production is not surprising. His native ability as a sensitive and expressive linearist we have already noticed in the Blue Period and in the Rose Period which followed.

PICASSO

The portrait drawing of Ambroise Vollard of 1915 shows Picasso more as an Ingres follower and realist than as a revolutionary. It is not a pure outline drawing in the classical manner, but combines contour with delicate modeling and textural animation reminiscent, in this respect, of Renoir. More outspoken on the linear side is the vigorous portrait of Igor Stravinsky of 1920 (fig. 236a). Picasso first came in contact with the composer when the former was working for the Russian Ballet in Rome (1917). It was during this Italian sojourn, particularly on excursions to Naples and Pompeii, that Picasso's taste for the classical was stimulated, while the grace of the Russian dancers may have stirred his enthusiasm to a more naturalistic representation of the human body. The Stravinsky portrait has a forceful expressiveness. The heavy hands, the strong face, the nonchalant air of the Russian composer are well brought out.

Two years earlier, in 1918, Picasso had created the beautiful line drawing of the "Bathers" (fig. 236b) in the Paul J. Sachs Collection of the Fogg Museum, in which the new classicism — or neoclassicism, as Barr calls it — began to manifest itself. In this elaborate composition we distinguish fifteen female nudes in or near the water. The forms are graceful, exhibiting both slenderness and fullness; the design is spacious and rhythmically animated. There is a touch of Botticelli as well as of Ingres in the slight and expressive distortions. Picasso's line, however, is his own in its springy and active character and also in its calligraphic beauty.

From 1920 date the two drawings of "Nessus and Dejanira" (figs. 237a and b). In the first, a pencil drawing carried out on September 12 and belonging to the Museum of Modern Art in New York, the classical line style has reached its full flower. The second, done in silverpoint ten days later, is animated by an intense cross-hatching, and we shall see in other cases, too, that Picasso likes to vary the graphic treatment within the classical style in different versions of the same subject, shifting from pure outline to the application of various types of shading with the pen or the brush. In fact, there exists a third drawing of the Nessus and Dejanira motif which, like the first one, was done on September 12, 1920, but in watercolor with short curly touches that produce a Guardi-like flickering effect.

The massive form of classicism which Picasso adopts in the early twenties — and which has been termed "colossal classicism" — can be seen in a drawing of the bust of a woman with raised left hand (fig. 238). It dates from 1921 and is

executed in black and red chalk. Here Picasso has imbued the human form with a monumental plasticity. His figures of this type seem to belong to a race of giants. In massiveness and intensity this trend equals the early Cubist or Negroid phase. Yet the artist maintains the classical mood and thus creates an heroic style of his own.

In the following years Picasso abandons the colossal proportions and gains more ease, elegance, and naturalness. It is in the course of the twenties and during the early thirties that he does some of the most remarkable line drawings our century has seen. In the sketch of a nude pipes-player beside a reclining nymph (fig. 239a), in the John Nicholas Brown Collection, the bucolic mood is enchanting. A Mediterranean atmosphere of serenity, clarity, and brilliant light prevails and the slightly intermittent lines are applied with the utmost economy and ease. Their lyric quality was never greater.

No less classical in mood and perfection, and of the same year (1923), is the delightful pen drawing of a pipes-player kneeling before a Venus-like nude for whom a boy in a Pierrot costume holds up a mirror while Cupid reclines above (fig. 239b). Here, however, we have one of the frequent cases in which Picasso combines pure line drawing on one side of the sheet with a rich graphic shading on the other. The latter gives prominence and a heightened relief effect to the woman's figure.

In etching Picasso continued to favor the classical outline style during the later twenties and the early thirties. In 1930–31 he did the famous series of illustrations for Ovid's *Metamorphoses*, in 1933 another remarkable set of etchings on the subject of the sculptor and his model, and in 1934 a series of illustrations for Aristophanes' *Lysistrata*. We reproduce here an etching of 1927 representing "The Painter and His Model" (fig. 240) and one from the series of 1933, "The Sculptor and His Model" (fig. 241). Both are masterpieces. The later of the two has a heightened monumentality through its largeness of form and somewhat mythical mood. It also shows a slight graphic enrichment in the treatment of the heads and the landscape background, yet the flow of line is of equal ease and perfection. The earlier etching may be credited with a greater consistency in the application of pure line. All the more admirable is its clear suggestion of form and space and of the painter's psychological intensity while at work. Such examples of Picasso's classical style can easily compete with the greatest draughtsmanship of the Renaissance and of Antiquity.

PICASSO

It was also in 1933 that Picasso began to work on the subject of the Minotaur and did a remarkable set of drawings and etchings on this mythological theme whose motif of the half beast, half man seized his imagination. As usual he took liberties with the original story and treated it according to his own fancy. The dramatic images he created often show a fusion of the classical style with Baroque exuberance and vitality. The sketch in the S. W. Labrot Collection, of "The Minotaur Attacking a Young Woman" (fig. 242), has hardly an equal in plastic power and dynamic animation, even when held beside a Rubens or a Delacroix. The outline style is still inherent here, but enriched by washes of light and dark grays, by tonal modeling and a restrained chiaroscuro.

Once the Minotaur myth had kindled Picasso's fantasy, the bull became a prominent personal symbol of the artist's world, and with it the dying horse. Both motifs, however, had their origin in his early experience of bullfights and their representations. Now they return in his art, more charged with expressive power, in violent compositions and gradually gaining a symbolic significance not easy to decipher. Picasso has been unwilling to make verbal comments on these subjects. He obviously believes the images themselves best convey their meaning, and that words will only dilute it. W. Boeck's interpretation of the bull as the symbol of the virile, aggressive, or evil forces, and that of the wounded or dying horse as a symbol of femininity (it is always a mare), of suffering, and innocence, seems to have much to recommend it. The large, densely shaded pen drawing of 1934 with the wounded bull and the disemboweled horse (fig. 243) is still essentially a bullfight scene, but the additional motif in the upper left corner, of a girl holding a lighted candle, leads over to the symbolism of the large etching of 1935 called the "Minotauromachy," which sums up this theme. The drawing, in its glowing chiaroscuro effect and expressionistic vigor, also anticipates features of the "Guernica" phase. It no longer has a place among the works of the pure classical style which, in fact, recedes for a while after the early 1930's.

In the meantime the abstract trend has made further advances in Picasso's work. From Synthetic Cubism the artist progressed in the later twenties to the "metamorphic" phase, which is marked by abstractions of an amorphous and organic, rather than geometric character. The human figure is completely transformed (hence the term metamorphic) with violent distortions and with an emotional intensity never admitted by Cubism with its merely formal problems. These

grotesque transformations into abstract sculptures — for they are chiefly representations of sculptured figures — are not uninfluenced by the Surrealist movement whose leader, André Breton, had published his first manifesto in 1924. Picasso was acquainted with Breton and had etched his portrait twice in 1923. The charcoal drawing of 1927 (fig. 244) belongs to a sketchbook in which the subject represented — a bather at the beach turning the key of her cabin — is varied in a number of fanciful designs. One would hardly decipher the subject without knowing the title, but soon one discovers that in this strange creature — as in other cases of the metamorphic style — the artist has left some small yet distinct indications of the different parts of the body: in the head one recognizes the eye, the open mouth with the teeth, the nostrils; the torso is marked by the navel and the diagonally placed breasts by the nipples. The arms, the two short stumps on the left, are recognized by the fact that the upper one touches the key. Thus the two remaining large stumps must be the legs, although they terminate differently. What reason lies behind these fantastic transformations which the abstract sculpture of our day has developed still further? Does the artist wish to express his abhorrence of mankind, or to ridicule the idea that man was created in God's image? We do not know, but here we see Picasso's fancy at work in his search for new forms. These creations bring an association of nightmarish ugliness and primitive growth; it is hard to overcome the feeling that a sinister mood underlies them. Yet in their strong sculptural character they have an enigmatic expressiveness.

Like the classical trend, the abstract, or semi-abstract, one continues into the thirties. In the latter half of this decade a new tendency develops which shows an allover and rather geometric ornateness of design. It covers the forms with a kind of basketry pattern and is spun over them like a finely meshed spider web. Both the metamorphic style and rudiments of Cubism are now implied, but the arabesque ornateness predominates. We see this in the portrait drawing of 1938, in Picasso's own collection, representing a woman in an armchair (fig. 245). In this complex figure some of the amorphous features of the previous phase, as well as its sculptural quality, reappear, but even stronger are the traces of Cubism, with the multiplicity of aspects in the face, the body, and the chair, to which an arbitrary distortion of perspective is added. Thus Picasso begins to integrate various former devices with his new ornamental trend. Whether in the latter he was influenced by pre-Columbian textiles, with their fanciful geometrizing

tendency, or by the fantastic late Mannerist inventions of the Italian sixteenth-century painter Arcimboldo (this is Barr's assumption), who created composite figures of woven straw, fruits, and vegetables, is hard to say. Whatever its origin, this arabesque ornateness has come into Picasso's style to stay and we shall find it, again and again, in his late work, combined with other devices of his earlier periods.

The monumental "Guernica" painting of 1937, like the large "Demoiselles d'Avignon" of 1907, marks a decisive point in Picasso's career. It was created as a flaming protest against the cruel destruction of the little Basque town of Guernica by Nazi planes operating for General Franco. The imposing composition, still owned by the artist but on exhibition in the Museum of Modern Art in New York, combines features of Synthetic Cubism (its moderate divisional, flattening, and patterning tendency) with the symbolic and expressionistic trend which we have seen developing during the thirties. Motifs like the bull, the disemboweled horse, the woman with the lighted candle, recur. Others are added, like the woman falling from a burning house, the crying mother with the dead child, the slain soldier clutching a broken sword, to make this great work an outcry of humanity against war's senselessness and far-reaching destructiveness, such as the world has not known since Goya's "Disasters of War."

The expressionistic power that Picasso's draughtsmanship has gained by this time is easily seen in two studies for the "Guernica" — bulls' heads which remind one of the monstrous half-human, half-beast Minotaurs of 1933–1935. In one of them (fig. 246a), Picasso operates with vigorous curved strokes, while in the other he applies a rich ornate shading (fig. 246b) and adds various arabesque formulas for the eye of the bull. Equally violent is the compositional sketch of the wounded horse and the dead soldier lying in front of the standing bull, with the crying mother and the dead child on the right (fig. 247a). The final version of "Guernica" turned out to be quite different and it is interesting to see, from the many preparatory sketches Picasso made, what an overflow of expressive ideas came to him before he decided on the final form of this major work.

It was from the "Guernica" phase on that Picasso began to blend the various styles which he had mastered in his uninterrupted search for new forms of expression. However, he never summed up everything in one work; he drew upon different modes, integrating them vigorously into an original and coherent design. But he could also devote himself to a single trend — Cubist or classical, meta-

morphic or arabesque, expressionistic or realistic. His development never came to rest in a complete synthesis. Picasso's productiveness did not abate at the approach of his sixties; it demanded an enormous range of expressive formulas or modes, to which he could turn at will, reshape in the spirit of the moment, or forge into ever new combinations. For nearly two decades now, Picasso has not created a basic new language, but has constantly invigorated, transformed, or combined the old ones. His spirit of conquest remains active in spite of his frequent reversions to former modes and motifs.

In a drawing of a reclining nude of 1941, in the artist's own collection (fig. 247b), we see the Cubist trend coming back, with its dissecting tendency and simultaneity of different aspects. Combined with these features is a plastic power gained through modeling in the round, and a certain coherence of the body. It seems that here the two antagonistic trends of the realistic and the Cubist have merged into one.

Picasso's portraits, too, from the late thirties on, often show the simultaneous occurrence of these two trends. But one could as well demonstrate, with the famous series of painted portraits of Mlle. D. M. (Dora Marr) how the artist moves very gradually, with one and the same model, from a first naturalistic image to the most amazing abstract transformation of the original impression.

The head of a girl looking down and sewing, of 1937 (fig. 249), done in pen and brush, is fully naturalistic with a Renoir-like softness of tonal treatment, while the crayon sketch of two profile heads of a woman (fig. 248), also dated 1937, is definitely abstract and linear in style. A similar contrast can be seen in two portraits of the late forties. The drawing of "Mlle. Mercedes Arcas," dated September 5, 1948 (fig. 250), does not lack force and moderate stylization, but it must be called naturalistic when compared with the "Head of a Woman," a lithograph done early in 1949 (fig. 251), that has all the disquieting qualities of Picasso's most violent abstractions. Here the different parts of the face — the ridge of the nose, the eyes, the ears, the eyebrows, the lower profile with the mouth, and the hair — are seen from different angles and forged together into an arabesque design that is not without a strong decorative quality.

In 1946 Picasso embarked upon a new venture, creating works for the Picasso Museum in Antibes, an ancient building situated on the Côte d'Azur, near the little town of Vallauris, where the artist had settled. The museum contains many enchanting drawings and paintings with classical motifs in a bucolic mood. Two

of these drawings are reproduced here: a satyr seated near a reclining nymph (fig. 252) and a pastoral entitled "Antipolis," with a nymph between a pipes-playing satyr and a centaur (fig. 253). Both show the classical outline style fancifully treated in a metamorphic spirit. The swift flow of line and the whimsical distortions of the figures well express the bucolic character of the subject and also the gaiety that animated Picasso at this phase. A glance back to the "Pipes-player and Reclining Nymph" of 1923 (fig. 239a) shows the higher dynamics of Picasso's line at this advanced phase and also its more summarizing and abstract character.

Now, in the 1950's, Picasso still plays in all the keys of his rich repertoire with undiminished power and freshness. One major work in draughtsmanship is the suite of 180 drawings which appeared in 1954 under the title "Picasso and the Human Comedy." Here he deals in a number of drawings with a long-favorite subject of his, the artist and his model, but in a new spirit. The artist is represented in most of the scenes as an old man who seems unaware of the odd contrast of his appearance with that of a youthful and alluring model. While she poses in various attitudes, he becomes increasingly ridiculous in his pedestrian seriousness or bloodless senility (fig. 254). But other subjects are woven around the central motif of provocative female beauty. These nudes are also paired with ugly goblins, melancholy Pierrots, patrons and critics, bourgeois admirers and satyrs, even animals such as the monkey and the black cat. The whole world of Picasso's creatures seems to pass before our eyes. In a number of drawings the nude woman plays with a flying *putto* who holds a mask before his face (fig. 255). The mask is a significant motif in a group of drawings in which it produces a strange contrast between face and body in the same figure. (It may be an allusion to man's, and particularly to woman's, deceptive behavior.) Thus the human comedy is played in many combinations. Biting irony and good-natured humor, bitterness and sweetness, charm and ugliness, have their share in this colorful pantomime of Picasso's creatures. The sprightly quality of all these drawings shows the old master's brilliant command of line and tone. An impressionistic touch is often added to classical beauty of line. (In this series Picasso turns abstract only in a few interspersed drawings in colored chalk.) Goya, and even more, Manet come to mind, here and there, as masters of equally quick and suggestive draughtsmanship. But there is nothing eclectic about the style. This suite represents an outburst of Picasso's genius as fresh and significant as any-

thing he has done in former years, in spite of the rather traditional mode he employs here.

In the same year, 1954, Picasso also created lithographs, such as "Le Jeu du Taureau" (fig. 256), in the pure classical line style which he had brought to a high degree of perfection in the 1920's and thirties. In this print we see a young man frightening a group of girls by putting on the mask of a bull. The three female nudes are ingeniously intertwined to form an animated group full of movement and excitement. A vibration now goes through Picasso's lines which we have not seen before. As in his most attractive classical prints of former decades (figs. 240 and 241), serenity and beauty prevail.

There has always been in Picasso — as we have seen in the course of our discussion — something of a Mediterranean sense of form as well as mood, an inheritance from Greece and Rome, but along with it an untamed, almost barbaric ferocity which is a Spanish trait. While this latter side of Picasso has produced more momentous changes in the development of modern art, his creations in the classical vein, which occur in greater numbers in prints and drawings than in paintings, manifest that this greatest of revolutionaries in the history of art has his roots, after all, deep in the past.

REFERENCES

1. Ernst Gombrich, "Conseils de Léonard sur les esquisses de tableaux," *L'Art et la Pensée de Léonard de Vinci* (Paris-Alger: Actes du Congrés Léonard de Vinci-Etudes d'Art Nos. 8, 9 et 10, 1954).

2. Günther Neufeld, "Leonardo da Vinci's 'Battle of Anghiari': a genetic reconstruction," *Art Bulletin*, 31 (1949), pp. 170–183.

3. *The Journal of Eugène Delacroix*, trans. Walter Pach (New York: Covici, Friede, 1937), p. 253.

4. Erwin Panofsky, *Albrecht Dürer*, 2nd ed. (Princeton, 1945), I, 14.

5. Letter from Dürer to Pirckheimer, *c.* October 13, 1506, in William Martin Conway, *Literary Remains of Albrecht Dürer* (Cambridge: Cambridge University Press, 1889), p. 58.

6. K. Lange and F. Fuhse, *Dürers schriftlicher Nachlass* (Halle: Max Niemeyer), p. 141.

7. Panofsky, p. 190.

8. Otto Benesch, *Mitteilungen der Gesellschaft für vervielfältigende Kunst* (Vienna, 1925), p. 37 and *The Drawings of Rembrandt* (London: The Phaidon Press, 1954–1957), V, 295.

9. Quotation from the sale catalog of the Augran de Fonspertuis Collection, 1747–48. See J. Hérold and A. Vuaflart, *Jean de Julienne et les graveurs de Watteau au XVIIIe siècle* (Paris, 1929), I, 141.

10. From an address on Watteau delivered by Count Caylus to the Academy on Feb. 3, 1748. See Hélène Adhémar and René Huyghe, *Watteau, sa vie — son oeuvre* (Paris: Pierre Tisné, 1950), p. 181.

11. Edmond and Jules de Goncourt, *L'Art du dix-huitième siècle*, 3rd ed. (Paris: A. Quantin, 1880), I, 43.

12. Adhémar and Huyghe, p. 179.

13. *Ibid.*, p. 172.

14. P. A. Lemoisne, *Degas et son oeuvre* (Paris: Paul Brame et C. M. de Hauke, 1946), I, 100.

15. Lemoisne, p. 117.

16. Ambroise Vollard, *Degas* (Paris: G. Crès et Cie., 1924), pp. 109–110.

REFERENCES

17. Lemoisne, p. 200.

18. Daniel Catton Rich, *Degas* (New York, 1953).

19. Camille Mauclair, *Degas* (Paris: Hyperion Press, 1937), p. 7.

20. Vollard, p. 86.

21. Mauclair, p. 12.

22. Lemoisne, p. 118.

23. *Ibid.*, pp. 100–101.

24. Vollard, p. 60.

25. Guillaume Apollinaire, *Les Peintres Cubistes* (Paris: Eugène Figuière et Cie., 1913), p. 37.

SELECTED BIBLIOGRAPHY

General Works: de Tolnay, Charles. *History and Technique of Old Master Drawings.* New York: H. Bittner and Co., 1943.

Meder, Joseph. *Die Handzeichnung, ihre Technik und Entwicklung.* Wien: Schroll & Co., 2ᵉ Aufl., 1923.

Rosenberg, Jakob. *The Problem of Quality in Old Master Drawings (on value judgment in the Fine Arts)*, Allen Memorial Museum Bulletin, Oberlin College, Winter, 1951, p. 32 ff.

Sachs, Paul J. *The Pocket Book of Great Drawings.* New York: Pocket Books Inc., 1951.

Watrous, James. *The Craft of Old Master Drawings.* Madison: University of Wisconsin Press, 1957.

Degas: Lemoisne, P. A. *Degas et son oeuvre,* 4 vols. Paris: Paul Brame et C. M. de Hauke, 1946.

Rivière, Henri. *Les Dessins de Degas.* Paris and New York: Demotte, 1922.

Dürer: Panofsky, Erwin. *Albrecht Dürer.* Princeton: Princeton University Press, 3rd edition, 1948.

Winkler, Friedrich. *Die Zeichnungen Albrecht Dürers.* 4 vols. Berlin: Deutscher Verein für Kunstwissenschaft, 1936–39.

Leonardo: Clark, Kenneth. *A Catalogue of the Drawings of Leonardo da Vinci in the Collection of His Majesty the King at Windsor Castle.* 2 vols. Cambridge: Cambridge University Press, 1935.

———— *Leonardo da Vinci: An Account of his Development as an Artist.* Cambridge: Cambridge University Press, 1939.

Heydenreich, Ludwig Heinrich. *Leonardo da Vinci.* 2 vols. Basel: Holbein Verlag, 1953.

Picasso: Barr, Alfred H., Jr. *Picasso, Fifty Years of his Art.* New York: The Museum of Modern Art, 1946.

Boeck, Wilhelm. *Picasso.* Stuttgart: W. Kohlhammer, 1955.

———— and Jaime Sabartés. *Picasso.* New York: Harry N. Abrams, Inc., 1957.

Zervos, Christian. *Dessins de Pablo Picasso (1892–1948).* Paris: Editions Cahiers d'Art, 1949.

Pisanello: Degenhart, Bernhard. *Antonio Pisanello.* Wien: Schroll & Co., 2ᵉ Aufl., 1940.

SELECTED BIBLIOGRAPHY

Pisanello: Hill, George F. *Drawings by Pisanello*. Paris and Brussels: Les Editions G. van Oest, 1929.
———— *Pisanello*. New York: Charles Scribner's Sons, 1905.

Raphael: Fischel, Oskar. *Raphael*. 2 vols. London: Kegan Paul, 1948.
———— *Die Zeichnungen der Umbrer*. Berlin: G. Grote, 1917.
———— *Raphaels Zeichnungen*. 8 vols. Berlin: G. Grote, 1913–41.
Middeldorf, U. A. *Raphael's Drawings*. New York: H. Bittner and Co., 1945.

Rembrandt: Benesch, Otto. *The Drawings of Rembrandt*. 6 vols. London: The Phaidon Press, 1954–57.
Rosenberg, Jakob. *Rembrandt*. 2 vols. Cambridge, Mass.: Harvard University Press, 1948.
Valentiner, W. R. *Die Handzeichnungen Rembrandts*. 2 vols. Stuttgart and New York: Deutsche Verlags-Anstalt, 1925, 1934.

Watteau: Parker, K. T. *The Drawings of Antoine Watteau*. London: Batsford, 1931.
———— and J. Mathey. *Antoine Watteau, Catalogue complet de son oeuvre dessiné*. 2 vols. Paris: F. de Nobele, libraire de la Société de reproduction de dessins anciens et modernes, 1957.

PISANELLO

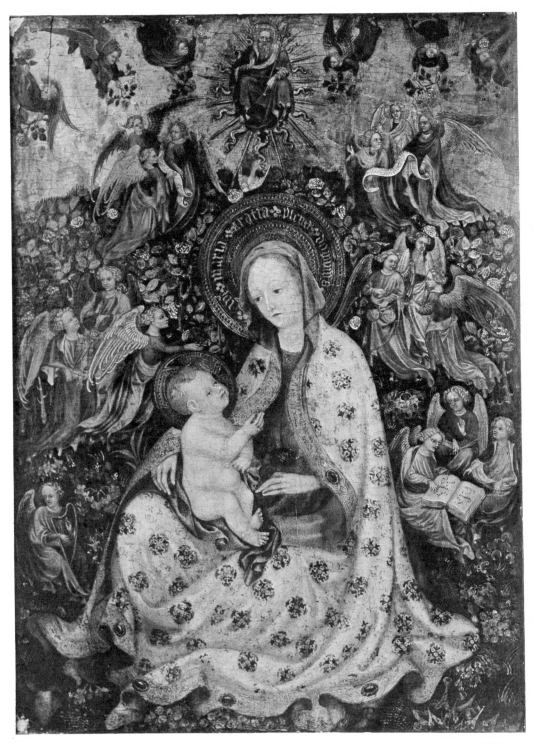

1. STEFANO DA VERONA: Madonna and Child in a rose garden. Worcester, Massachusetts, Worcester Art Museum.

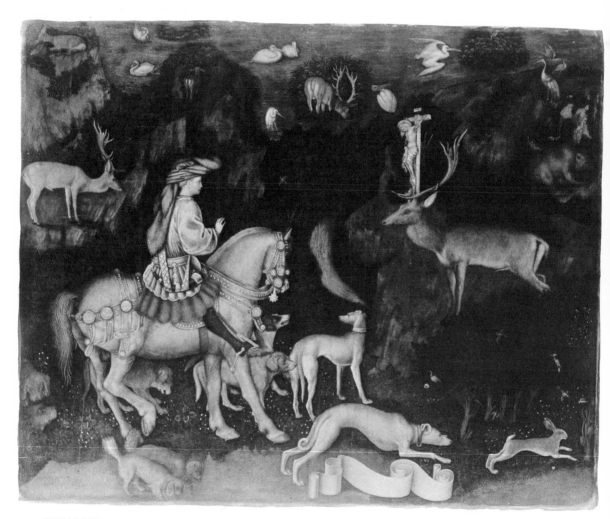

2. PISANELLO: The vision of St. Eustace. Reproduced by courtesy of the Trustees, the National Gallery, London.

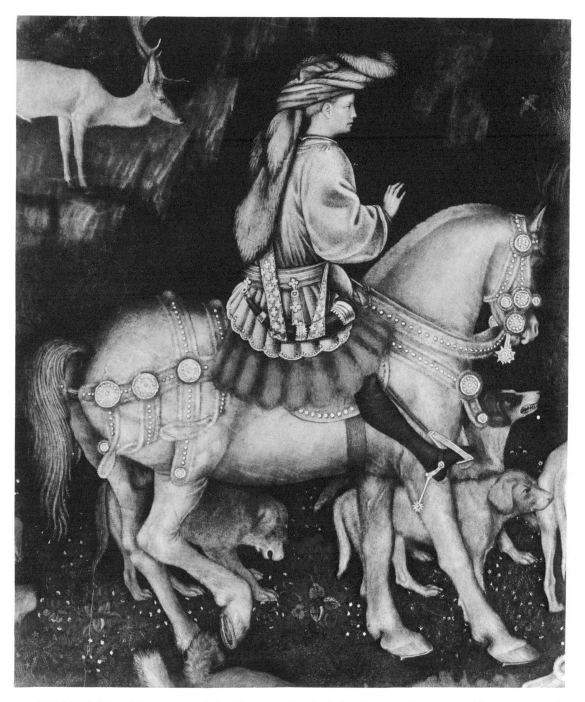

3. PISANELLO: The vision of St. Eustace, detail of St. Eustace. Reproduced by courtesy of the Trustees, the National Gallery, London.

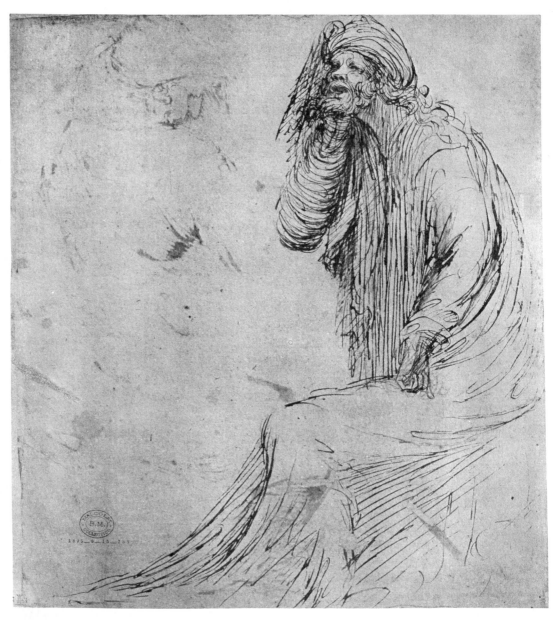

4. STEFANO DA VERONA: Seated prophet. London, British Museum.

5. PISANELLO: Sketchbook page, right side. Paris, Louvre.

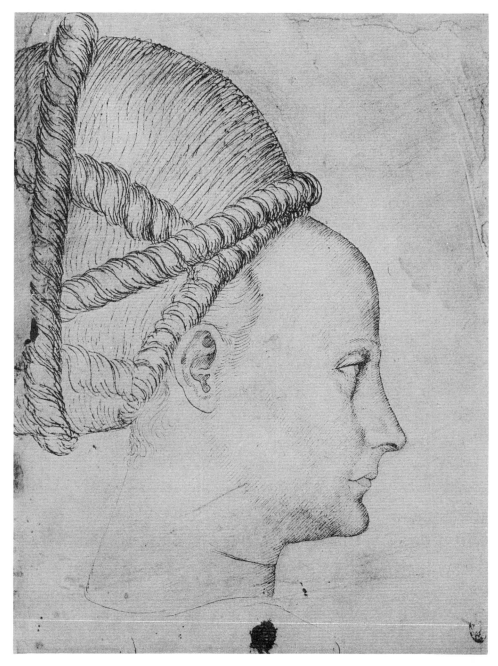

6. PISANELLO: Head of the princess, study for the St. George fresco. Paris, Louvre.

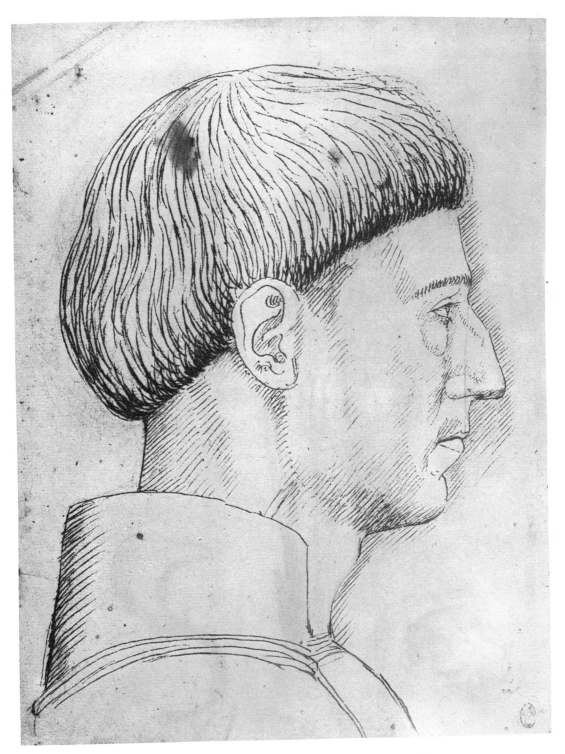

7. PISANELLO: Head of Alfonso of Aragon. Paris, Louvre.

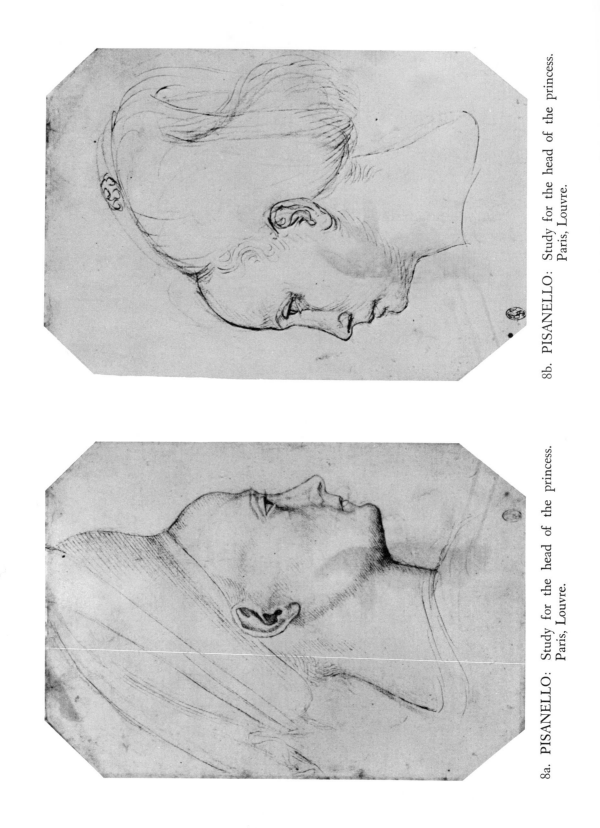

8a. PISANELLO: Study for the head of the princess. Paris, Louvre.

8b. PISANELLO: Study for the head of the princess. Paris, Louvre.

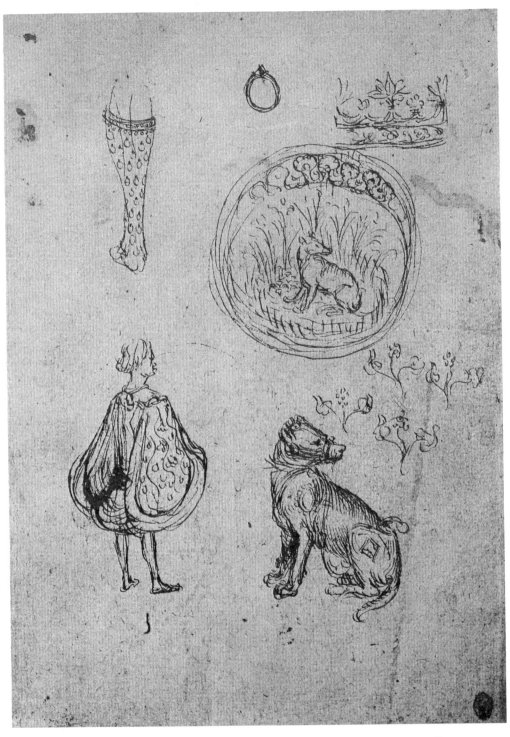

9. PISANELLO: Sketchbook page with cavalier, crown, etc. Paris, Louvre.

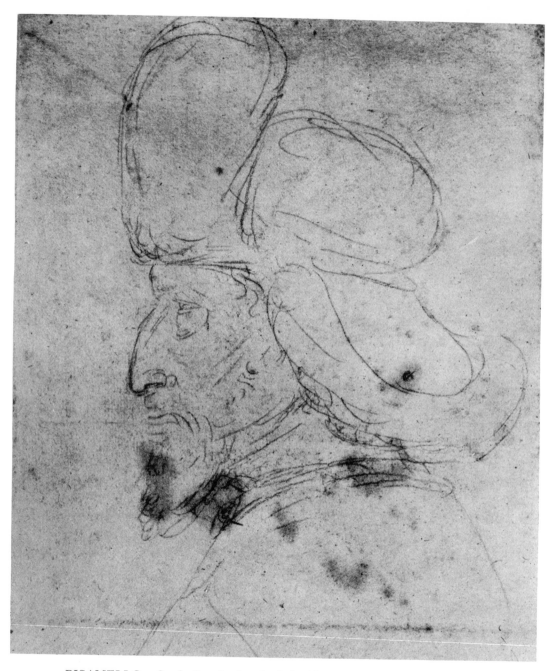

10. PISANELLO: Study for the head of the Emperor Sigismund. Paris, Louvre.

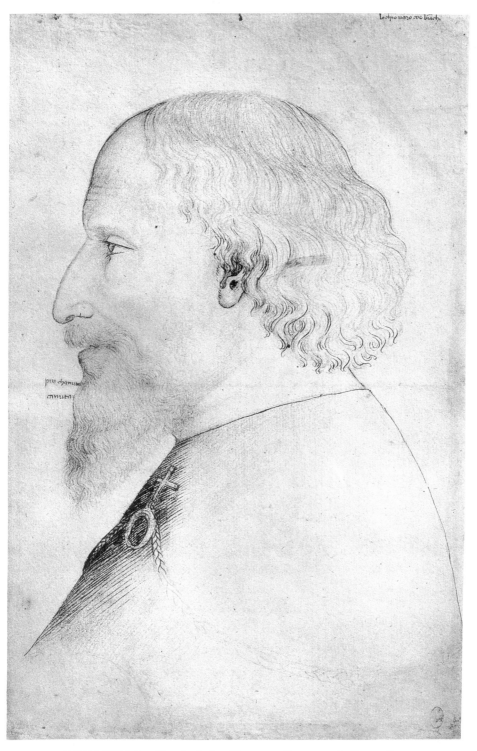

11. PISANELLO: Head of the Emperor Sigismund. Paris, Louvre.

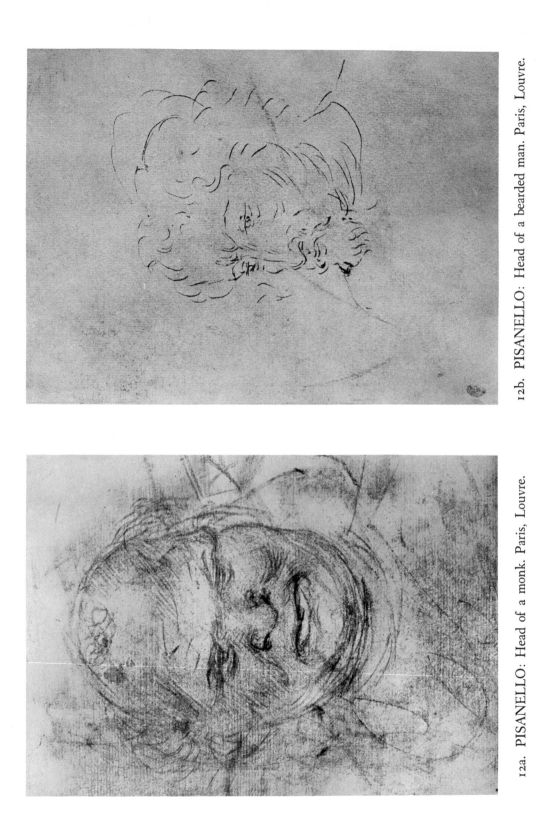

12b. PISANELLO: Head of a bearded man. Paris, Louvre.

12a. PISANELLO: Head of a monk. Paris, Louvre.

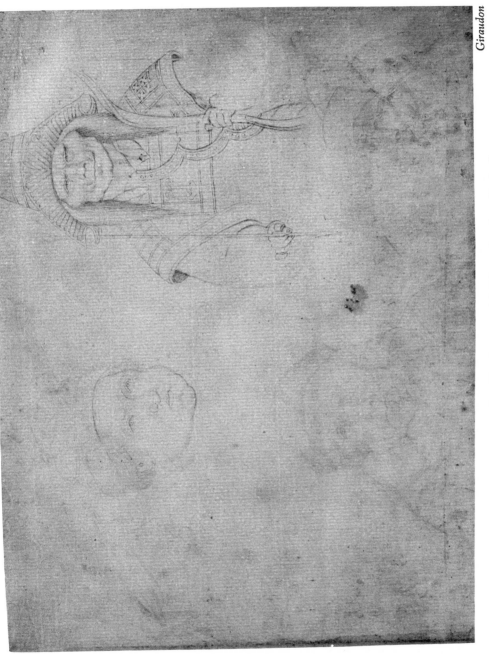

13. PISANELLO: Sketchbook page with Mongol archer. Paris, Louvre.

14. PISANELLO: Sketch with four female nudes and an Annunciation. Rotterdam, Boymans Museum.

15. PISANELLO: Nude figures, copies after ancient reliefs. Paris, Louvre.

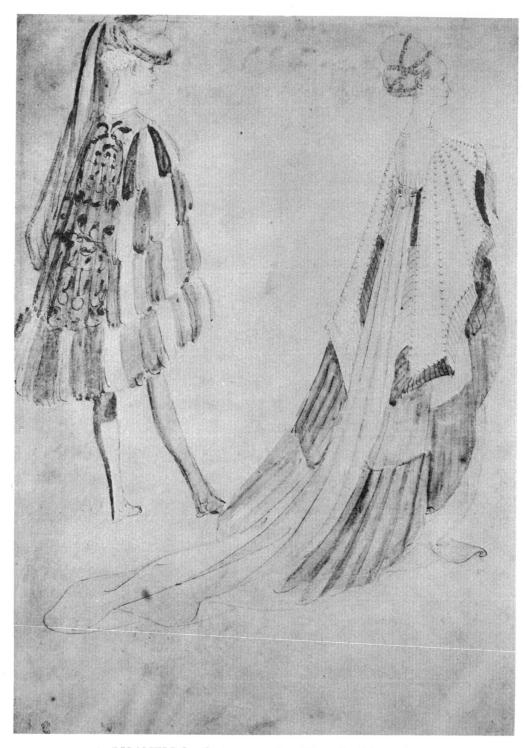

16. PISANELLO: Costume studies. Chantilly, Musée Condé.

17. PISANELLO: Sketchbook page with hanged men. London, British Museum.

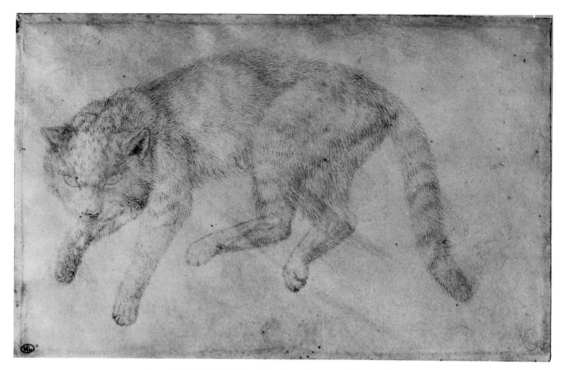

18a. PISANELLO: Study of a cat. Paris, Louvre.

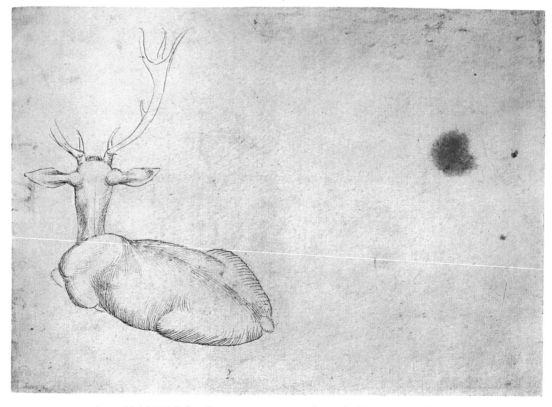

18b. PISANELLO: Stag resting, seen from behind. Paris, Louvre.

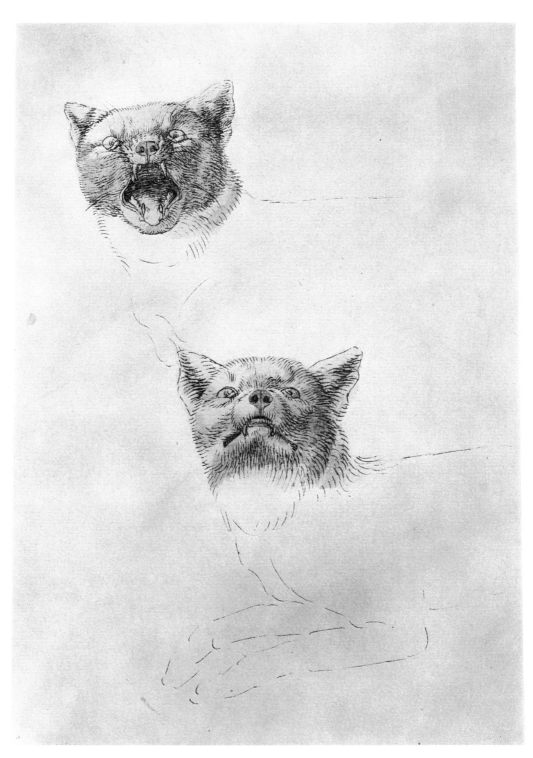

19. PISANELLO: Two studies of a wolf's head. Paris, Louvre.

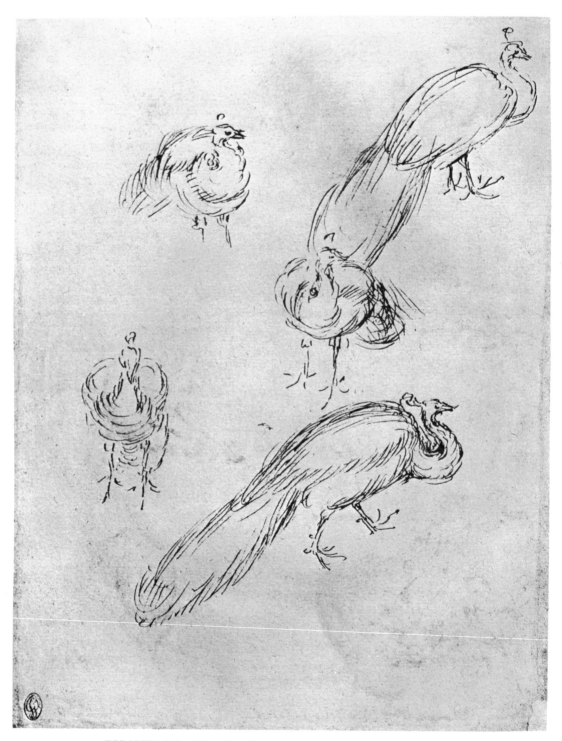

20. PISANELLO: Sketchbook page with five peacocks. Paris, Louvre.

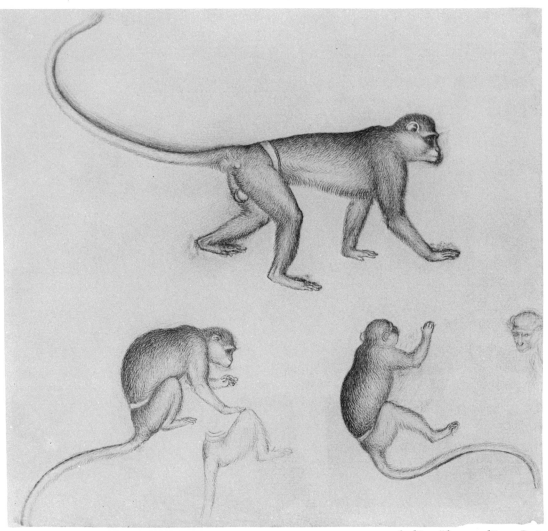

21. PISANELLO: Studies of monkeys. Paris, Louvre.

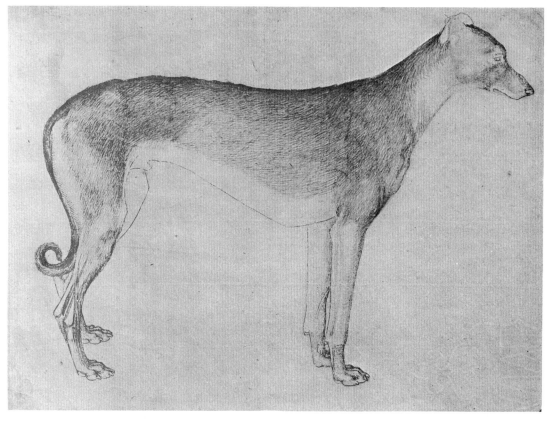

22a. PISANELLO: A dog in profile to the right. Paris, Louvre.

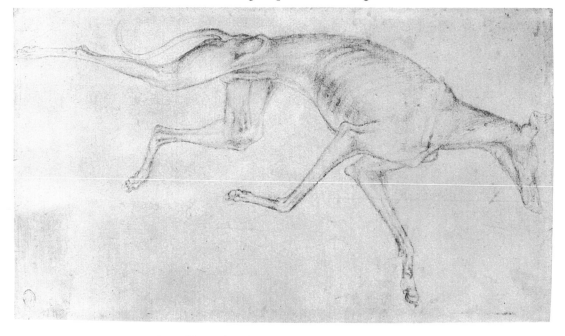

22b. PISANELLO: A dead dog. Paris, Louvre.

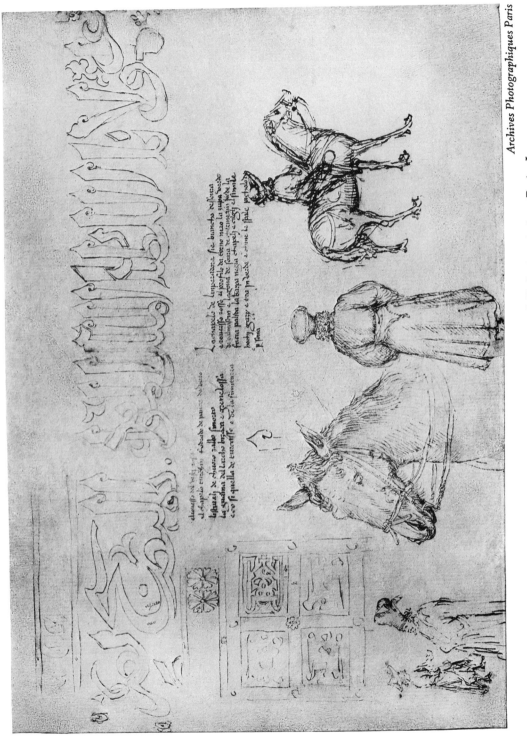

23. PISANELLO: Sketchbook page with figures and Kufic inscription. Paris, Louvre.

24. PISANELLO: Two mules. Paris, Louvre.

25. PISANELLO: Head of a horse, to the left, with open mouth. Paris, Louvre.

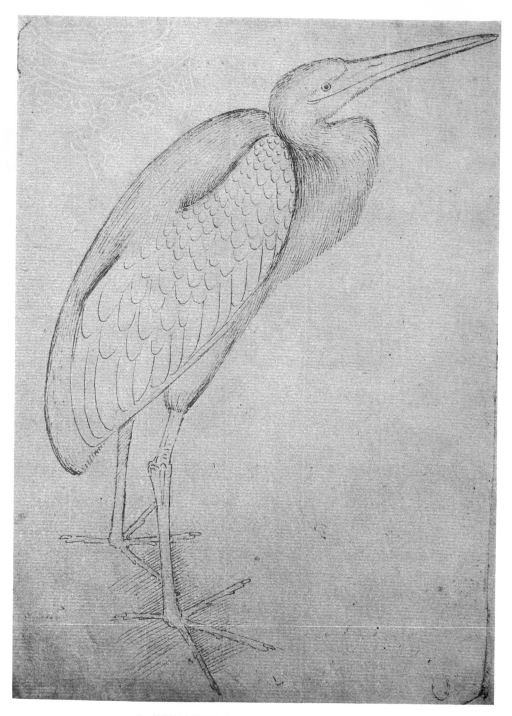

26. PISANELLO: An egret. Paris, Louvre.

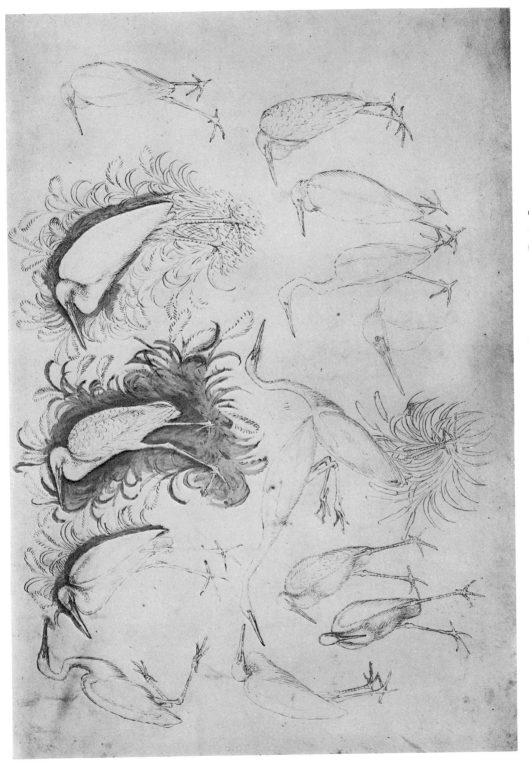

27. PISANELLO: Sketchbook page with fourteen egrets. Paris, Louvre.

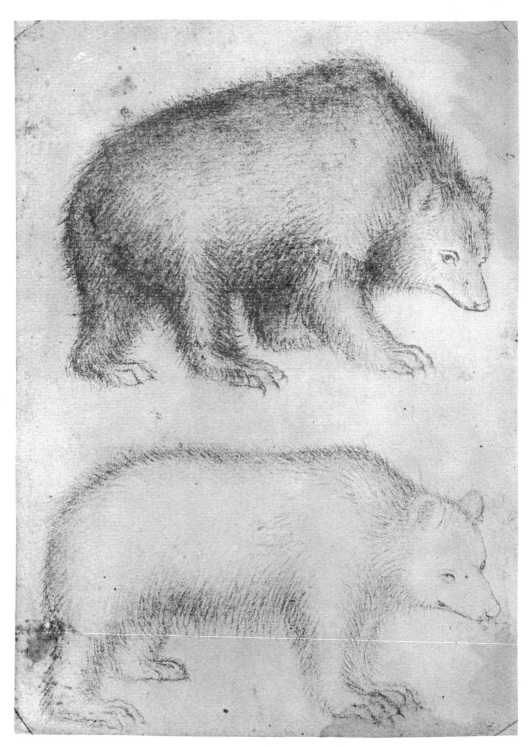

28. PISANELLO: Two bears. Paris, Louvre.

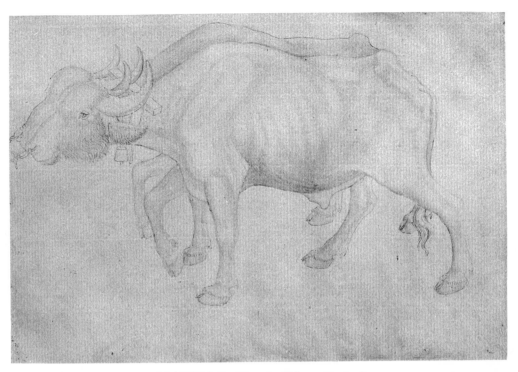

29a. PISANELLO: Two buffaloes. Paris, Louvre.

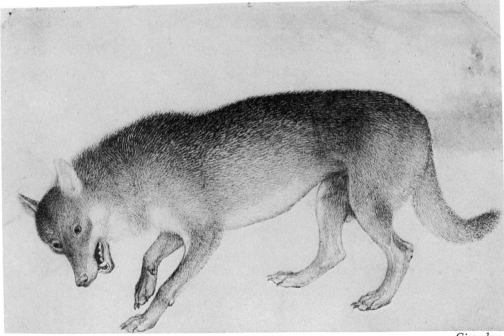

Giraudon

29b. PISANELLO: A wolf. Paris, Louvre.

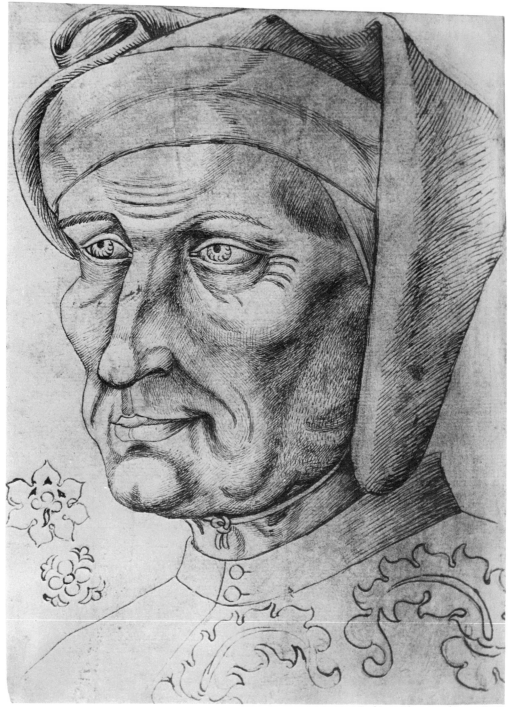

30. PISANELLO (?): Head of a man. Paris, Louvre.

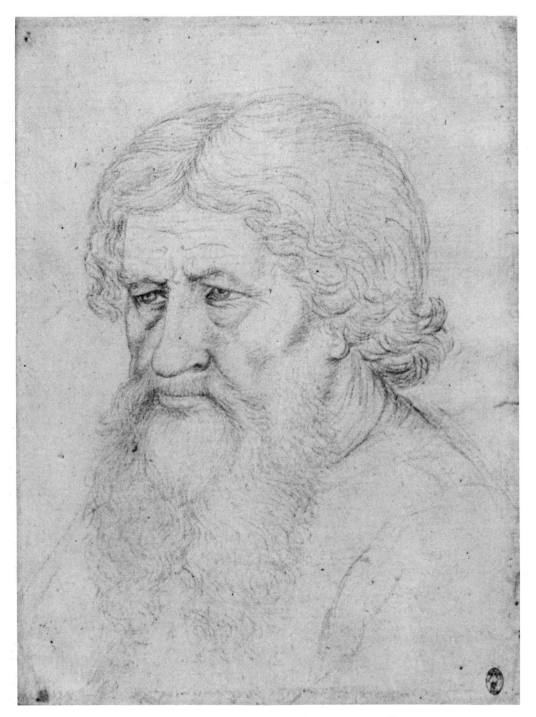

31. PISANELLO: Head of a bearded man. Paris, Louvre.

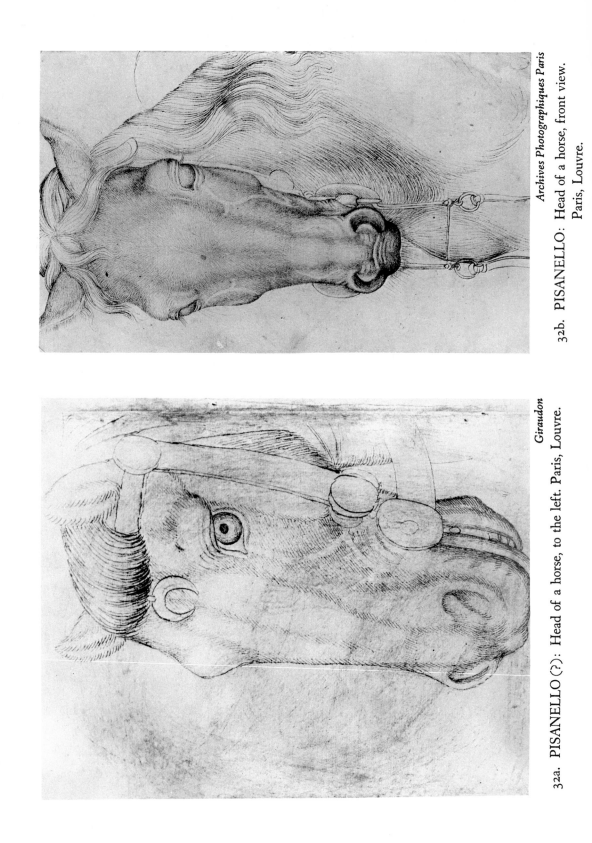

32a. PISANELLO (?): Head of a horse, to the left. Paris, Louvre.

32b. PISANELLO: Head of a horse, front view.
Paris, Louvre.

LEONARDO

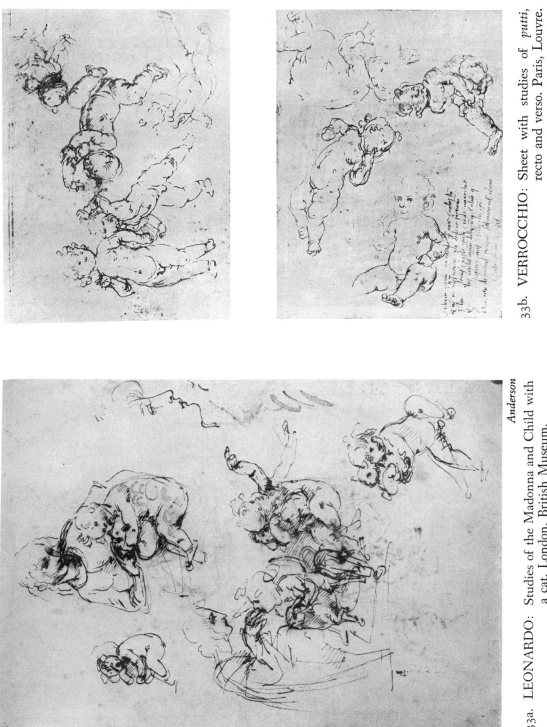

Anderson

33a. LEONARDO: Studies of the Madonna and Child with a cat. London, British Museum.

33b. VERROCCHIO: Sheet with studies of *putti*, recto and verso. Paris, Louvre.

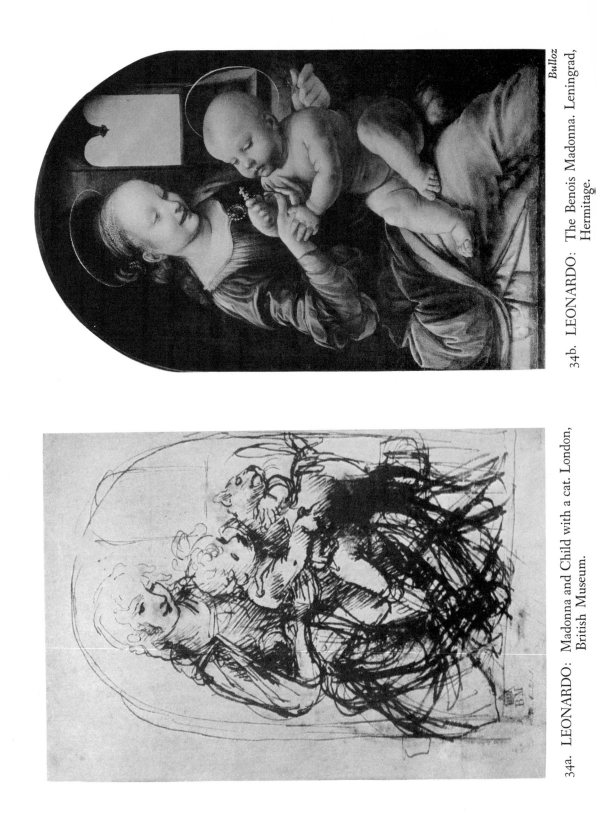

34b. LEONARDO: The Benois Madonna. Leningrad, Hermitage.

34a. LEONARDO: Madonna and Child with a cat. London, British Museum.

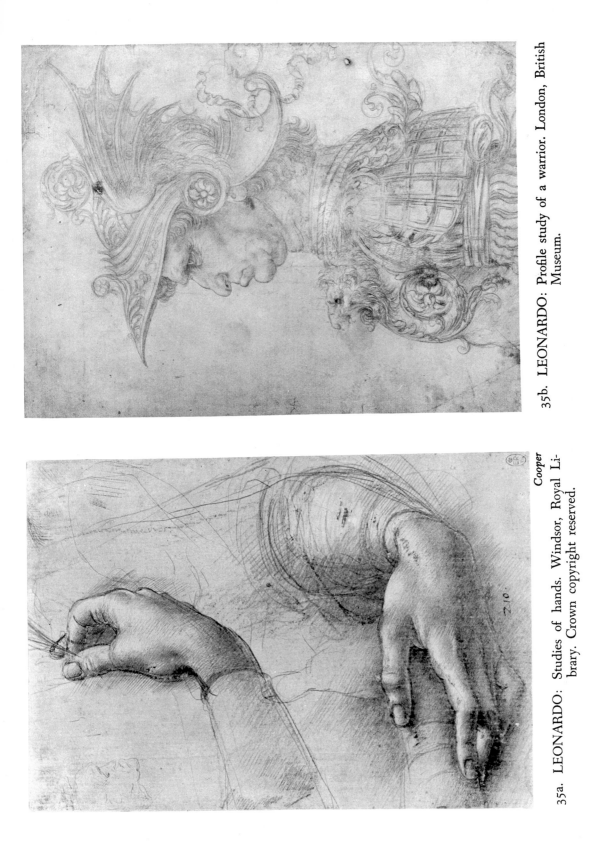

35b. LEONARDO: Profile study of a warrior. London, British Museum.

35a. LEONARDO: Studies of hands. Windsor, Royal Library. Crown copyright reserved.

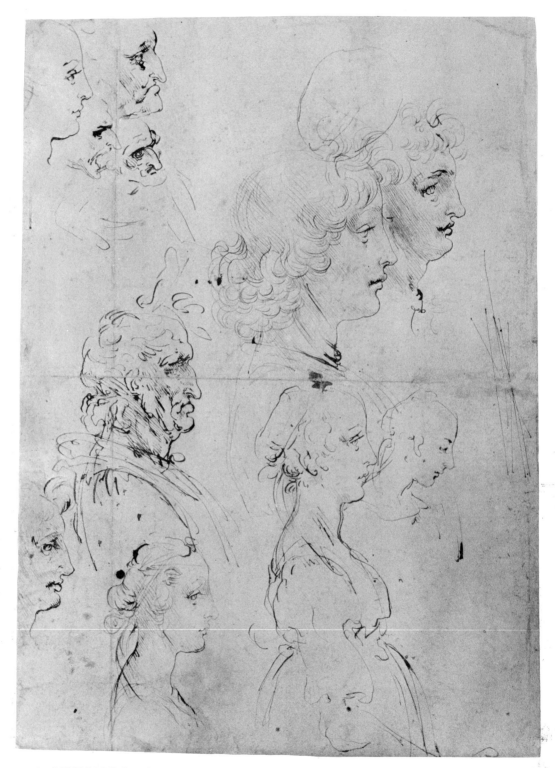

36. LEONARDO: Studies of heads. Windsor, Royal Library. Crown copyright reserved.

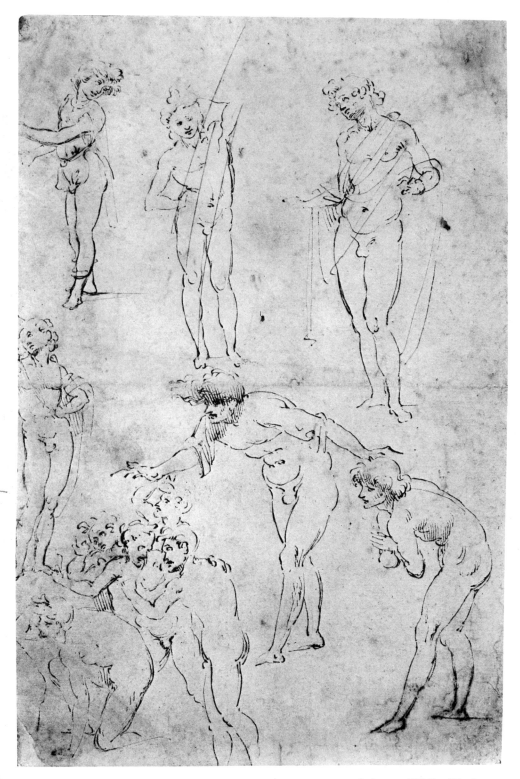

37. LEONARDO: Studies for the Adoration of the Magi. Cologne, Wallraf-Richartz Museum.

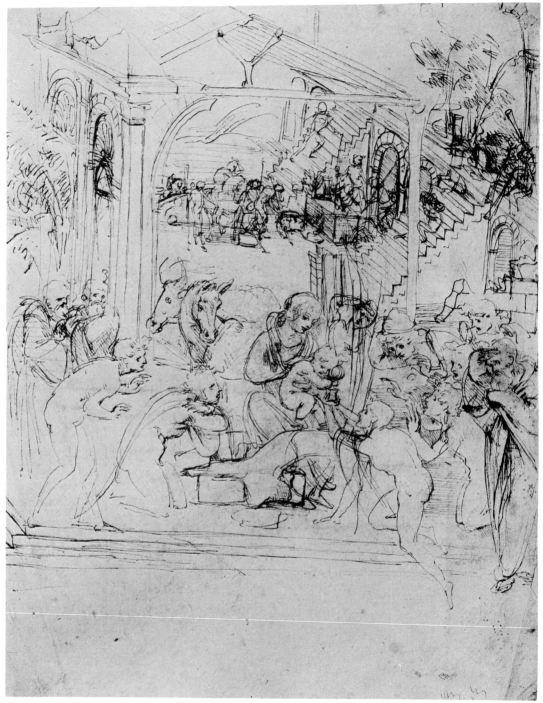

38. LEONARDO: Study for the Adoration of the Magi. Paris, Louvre.

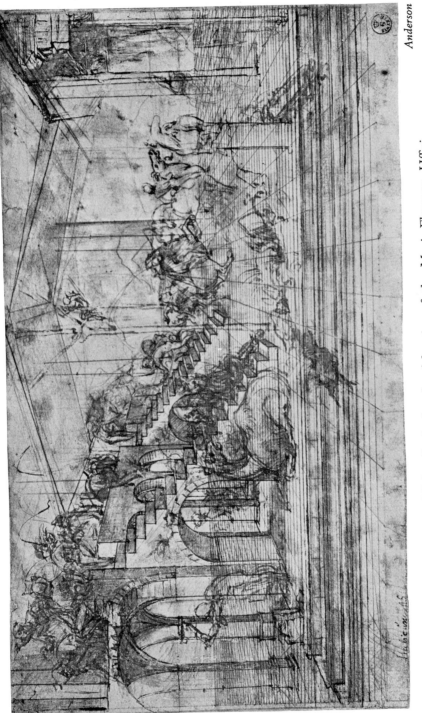

39. LEONARDO: Study for the Adoration of the Magi. Florence, Uffizi.

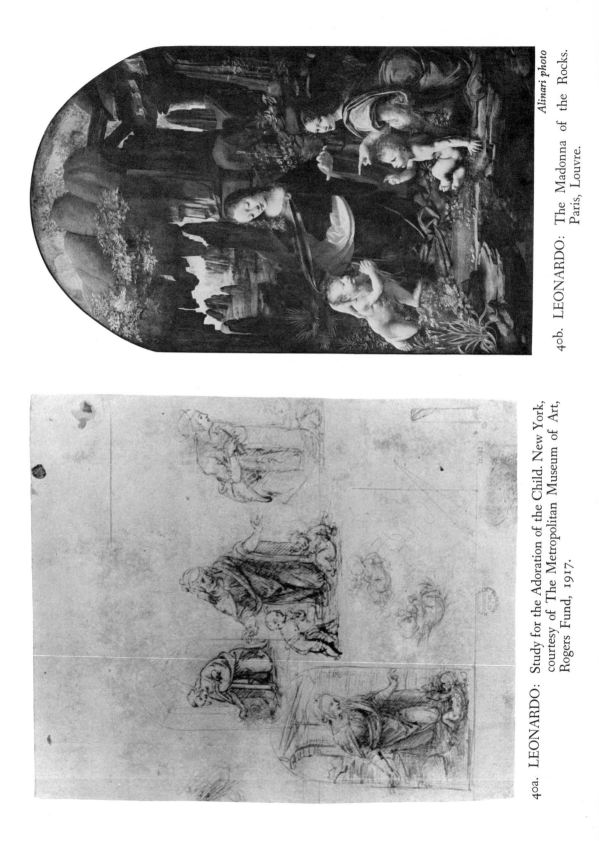

40b. LEONARDO: The Madonna of the Rocks. Paris, Louvre.

40a. LEONARDO: Study for the Adoration of the Child. New York, courtesy of The Metropolitan Museum of Art, Rogers Fund, 1917.

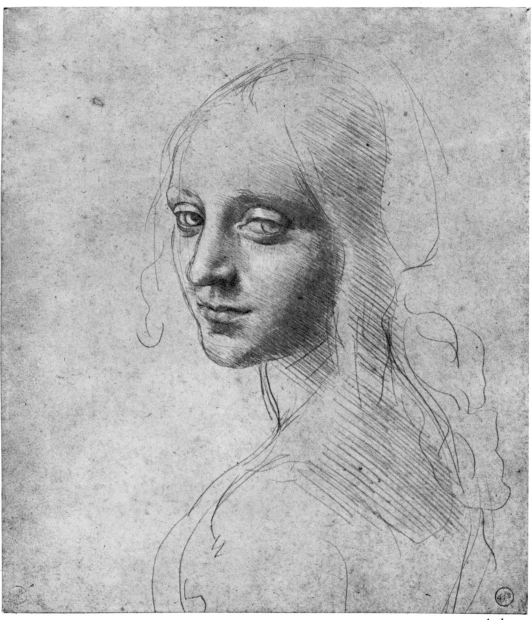

41. LEONARDO: Study for the angel in the Madonna of the
 Rocks. Turin, Biblioteca Reale.

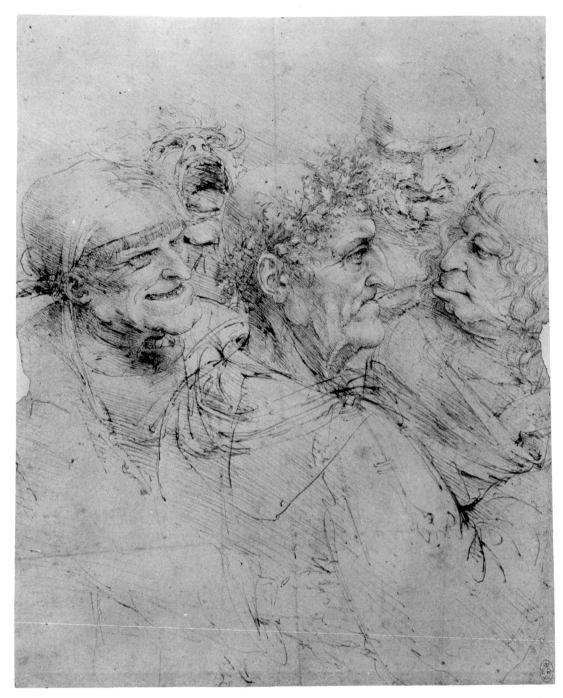

42. LEONARDO: Five grotesque heads. Windsor, Royal Library. Crown copyright reserved.

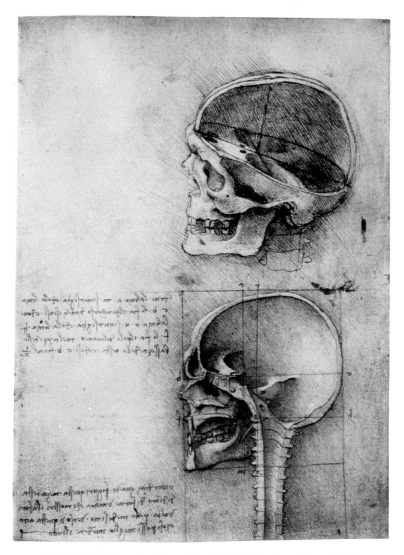

43. LEONARDO: Studies of a skull. Windsor, Royal Library.
Crown copyright reserved.

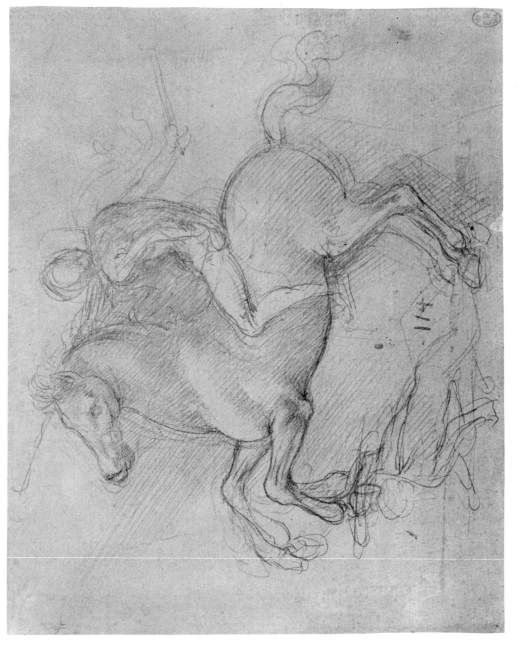

44. LEONARDO: Study for the Sforza monument. Windsor, Royal Library. Crown copyright reserved.

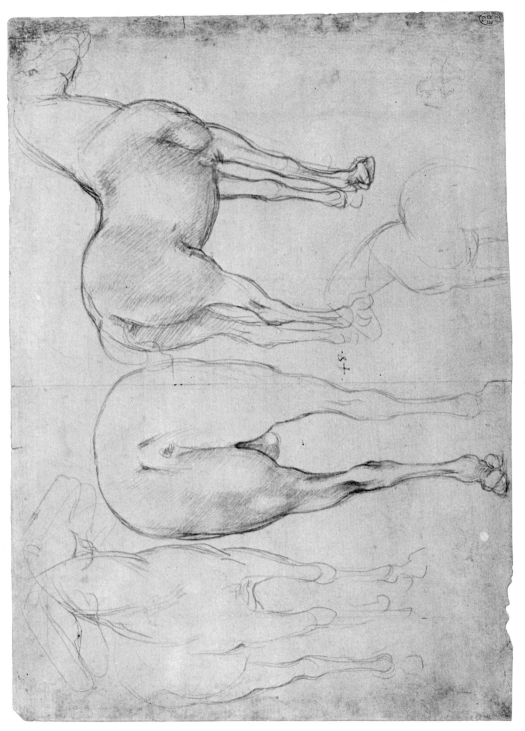

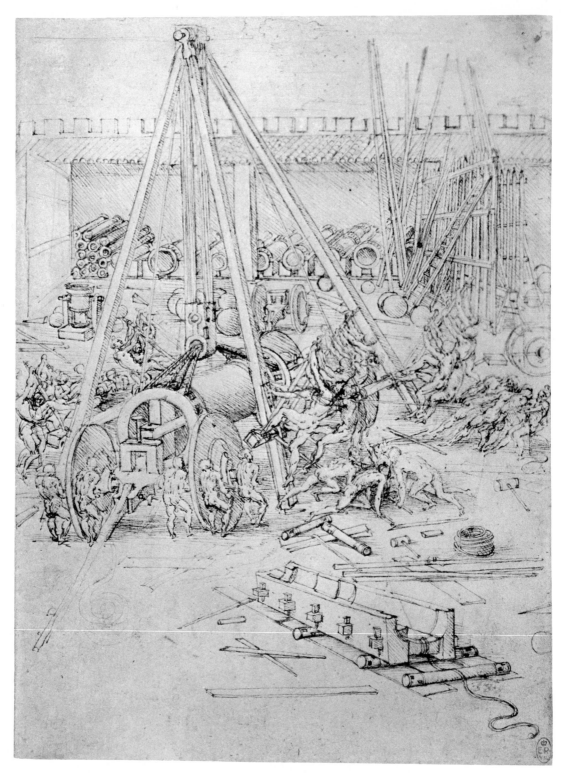

46. LEONARDO: The cannon foundry. Windsor, Royal Library. Crown copyright reserved.

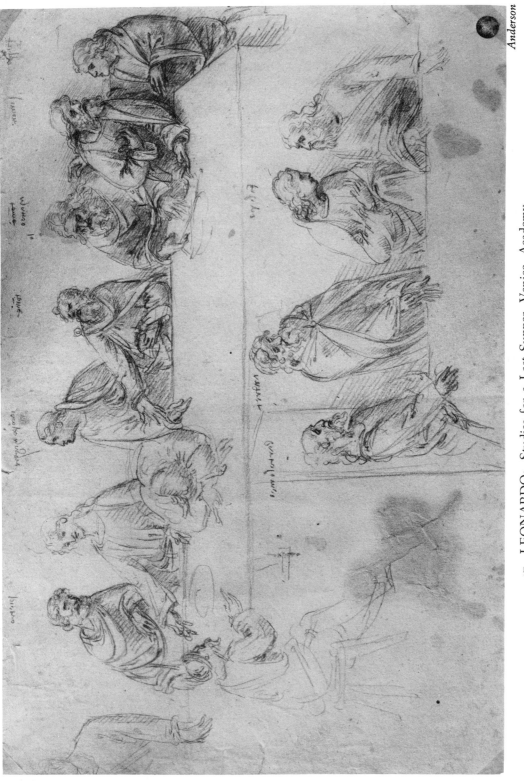

47. LEONARDO: Studies for a Last Supper. Venice, Academy.

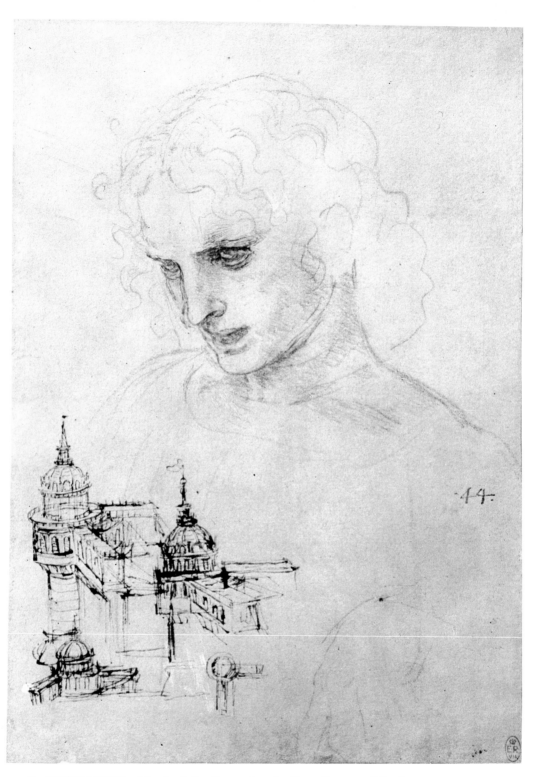

48. LEONARDO: Head of St. James in the Last Supper. Windsor, Royal Library.
Crown copyright reserved.

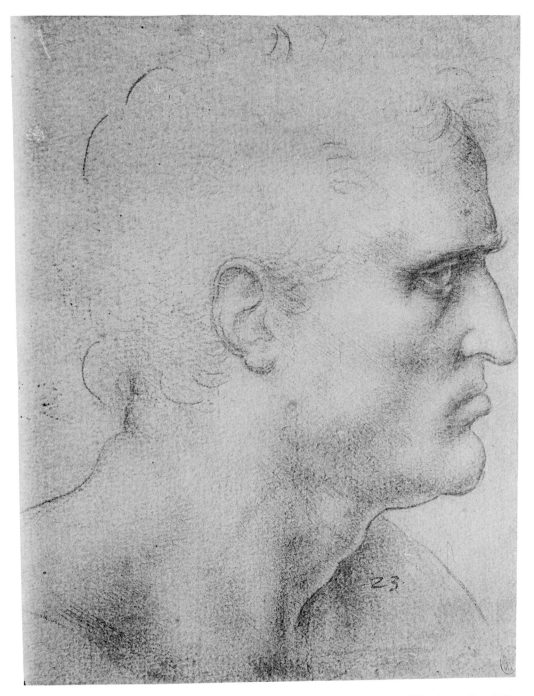

49. LEONARDO: Head of St. Bartholomew in the Last Supper. Windsor, Royal Library. Crown copyright reserved.

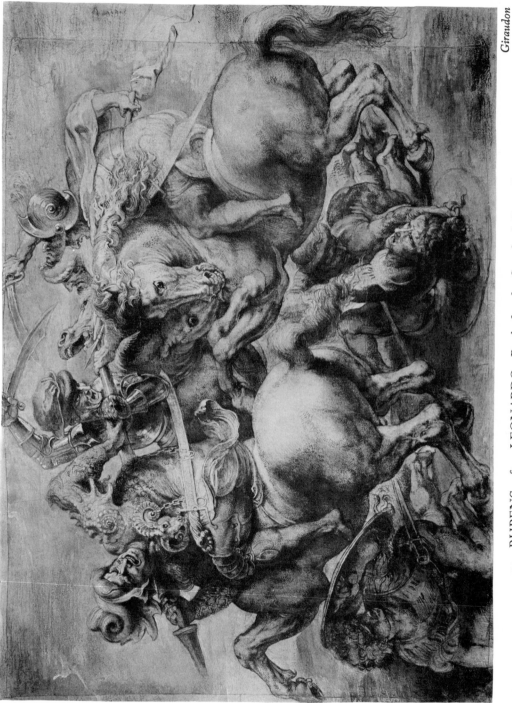

50. RUBENS, after LEONARDO: Battle for the Standard. Paris, Louvre.

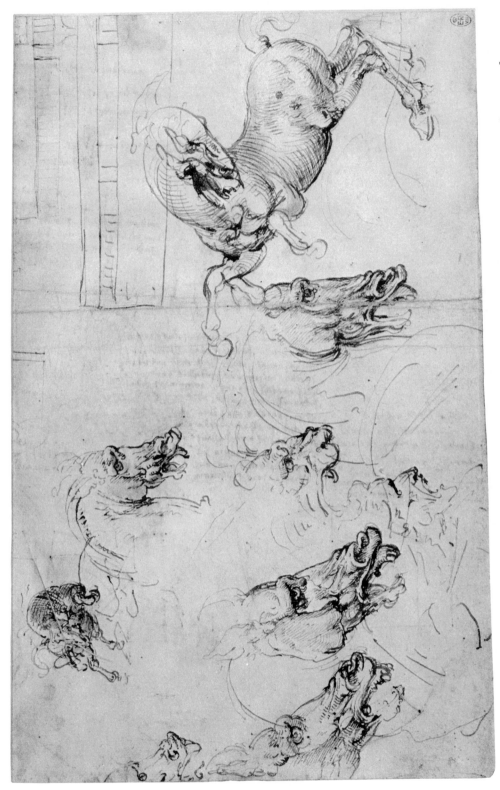

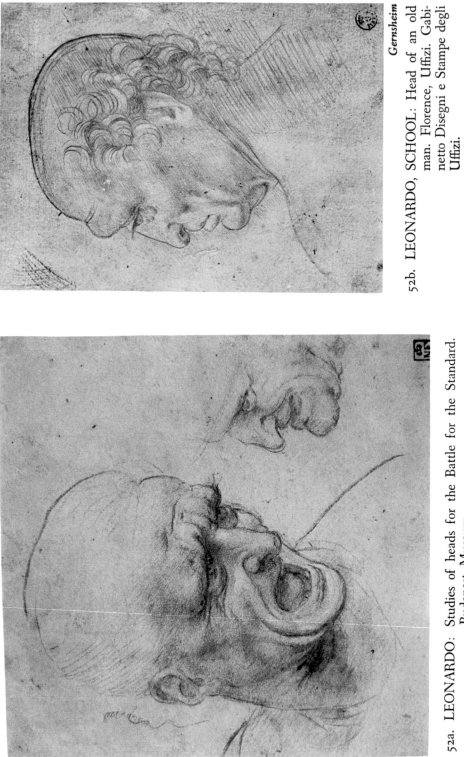

52b. LEONARDO, SCHOOL: Head of an old man. Florence, Uffizi. Gabinetto Disegni e Stampe degli Uffizi.

52a. LEONARDO: Studies of heads for the Battle for the Standard. Budapest, Museum.

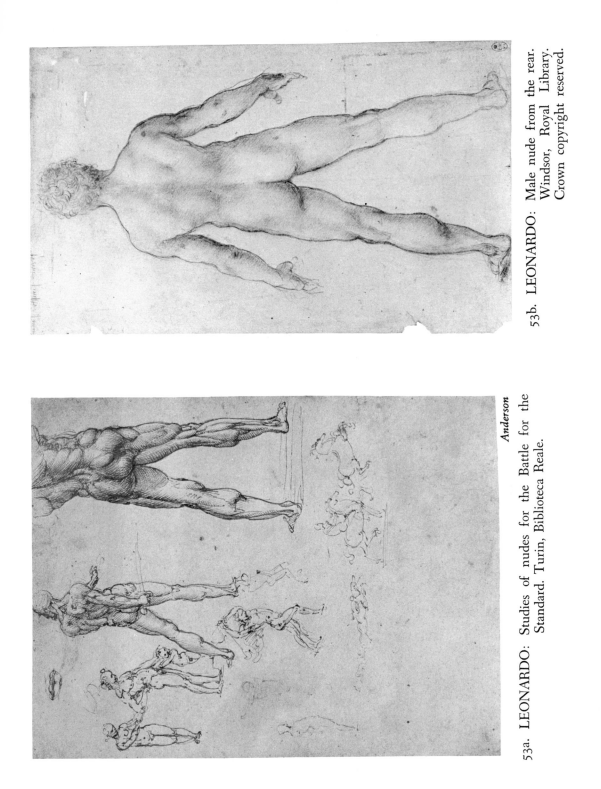

53a. LEONARDO: Studies of nudes for the Battle for the Standard. Turin, Biblioteca Reale.

53b. LEONARDO: Male nude from the rear. Windsor, Royal Library. Crown copyright reserved.

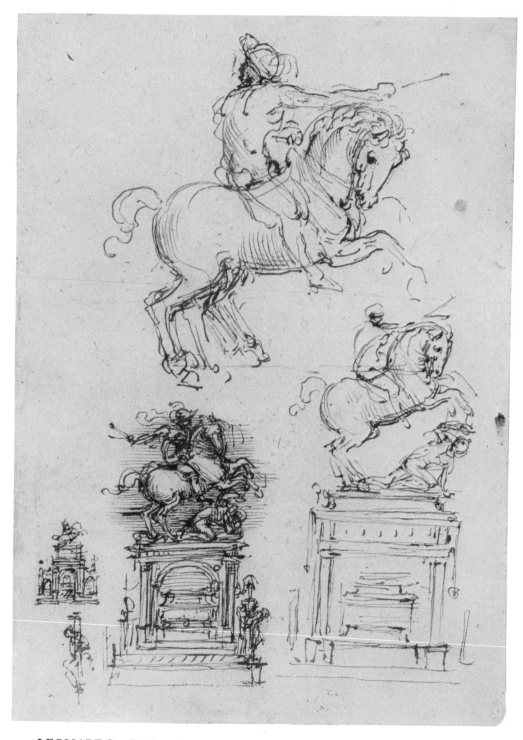

54. LEONARDO: Studies for the Trivulzio monument. Windsor, Royal Library.
Crown copyright reserved.

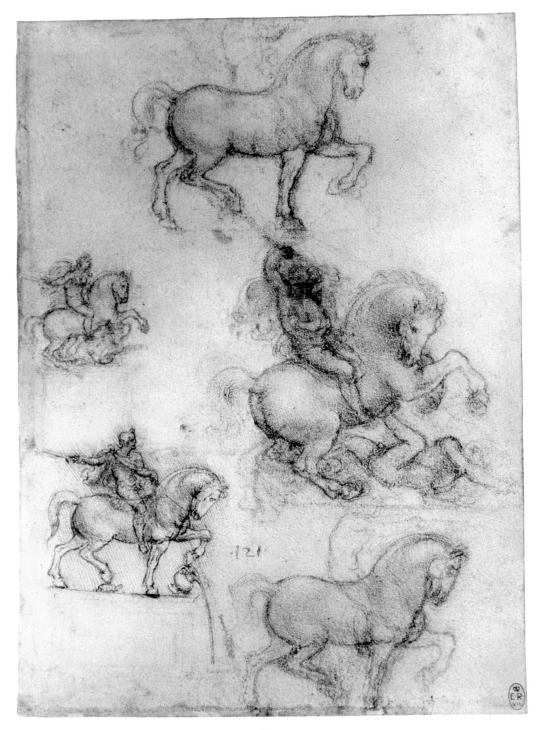

55. LEONARDO: Studies for the Trivulzio monument. Windsor, Royal Library.
Crown copyright reserved.

56. LEONARDO: Page of studies with embryo. Windsor, Royal Library. Crown copyright reserved.

57. LEONARDO: Anatomical study. Windsor, Royal Library. Crown copyright reserved.

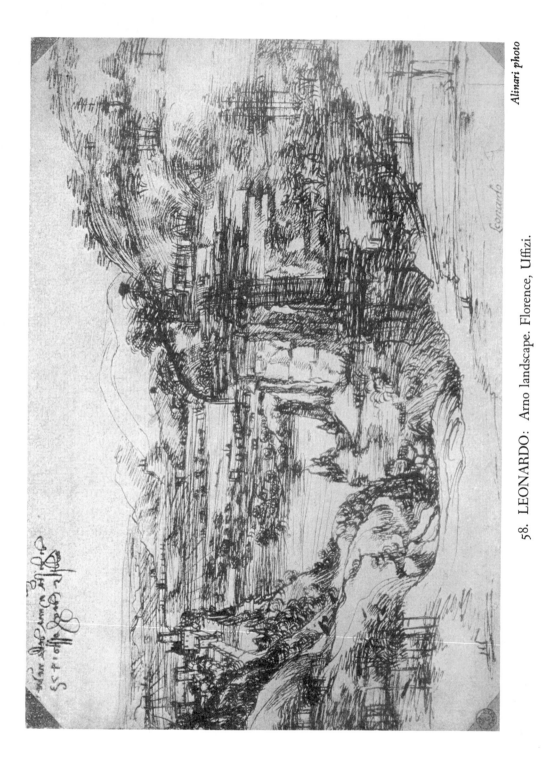

58. LEONARDO: Arno landscape. Florence, Uffizi.

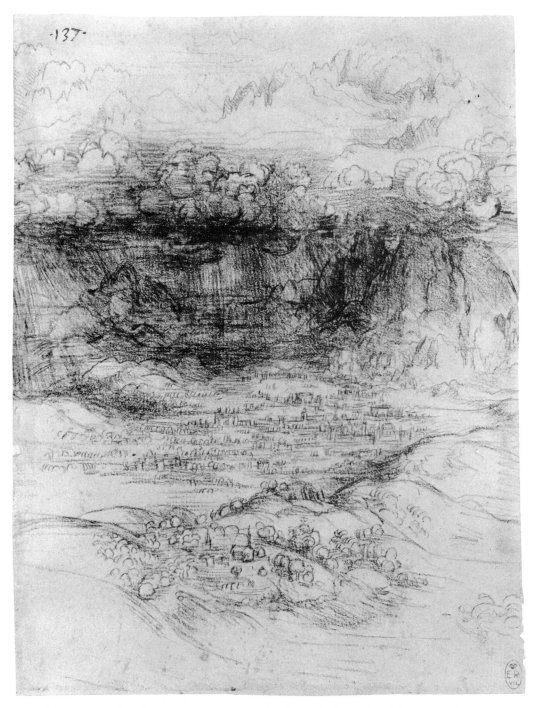

59. LEONARDO: Landscape with rain clouds. Windsor, Royal Library. Crown copyright reserved.

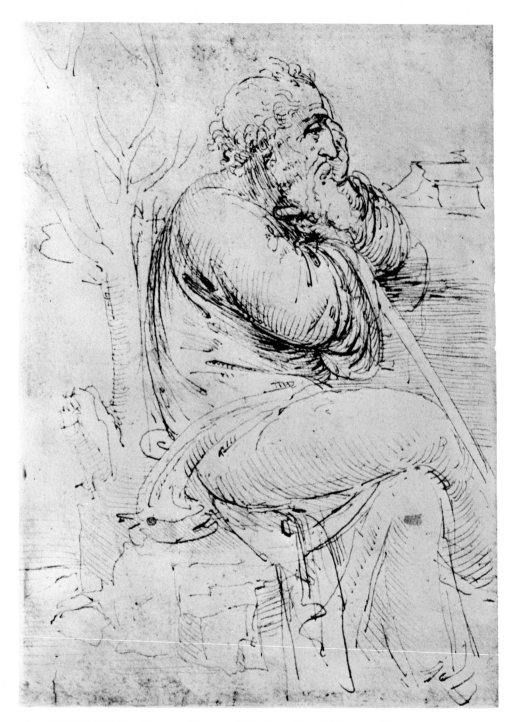

60. LEONARDO: Seated old man. Windsor, Royal Library. Crown copyright reserved.

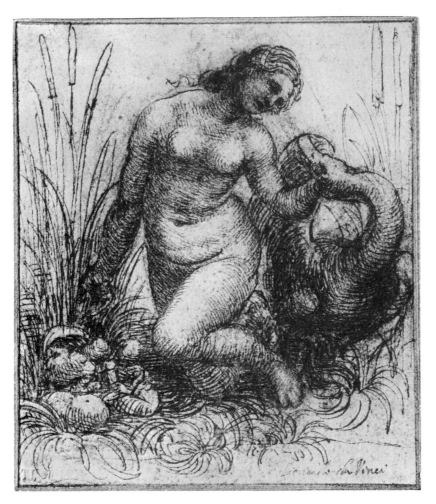

61. LEONARDO: Leda. Rotterdam, Boymans Museum.

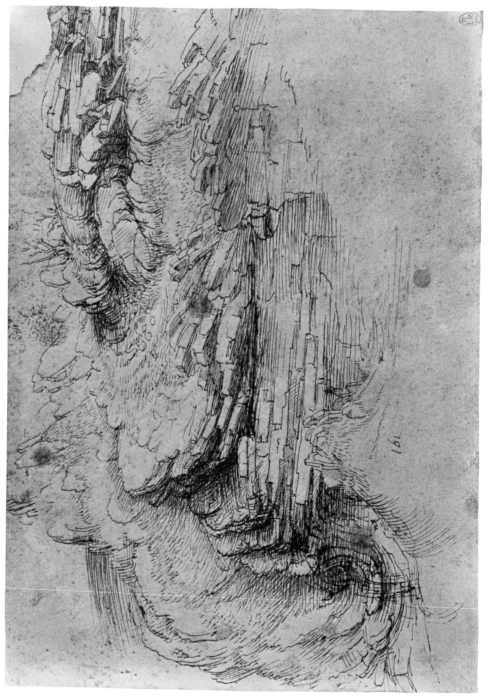

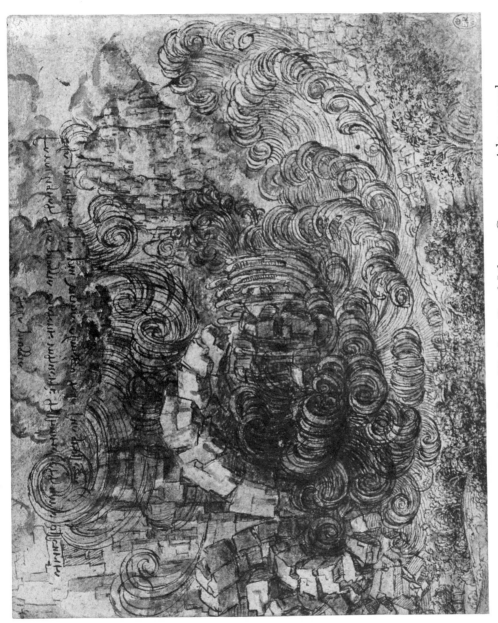

63. LEONARDO: Deluge. Windsor, Royal Library. Crown copyright reserved.

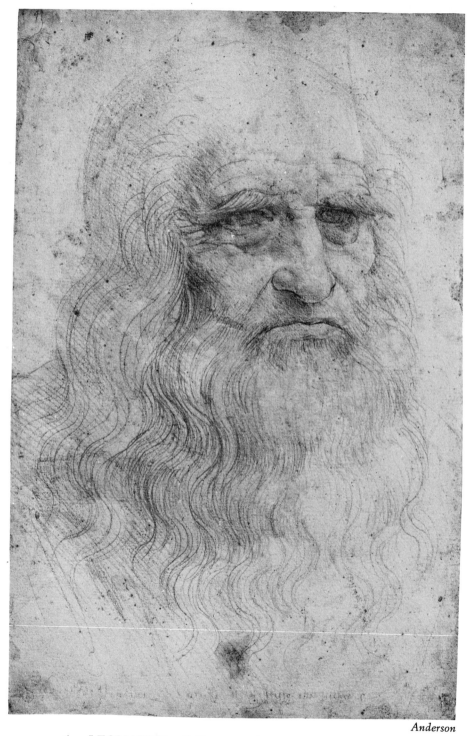

64. LEONARDO: Self-portrait. Turin, Biblioteca Reale.

RAPHAEL

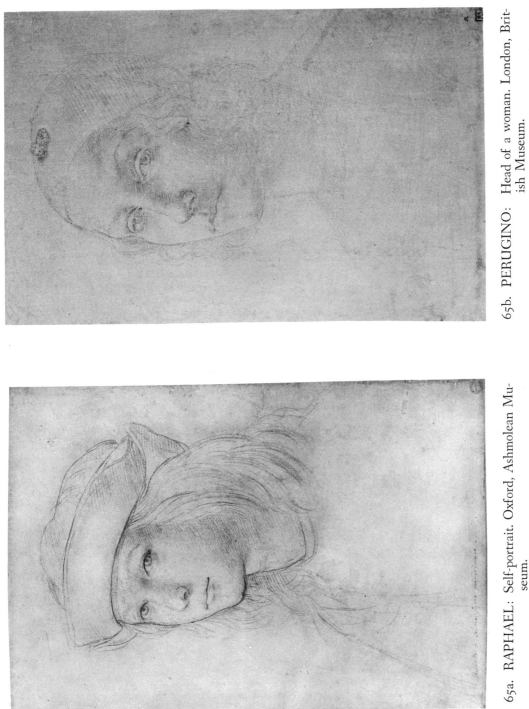

65a. RAPHAEL: Self-portrait. Oxford, Ashmolean Mu-
seum.

65b. PERUGINO: Head of a woman. London, Brit-
ish Museum.

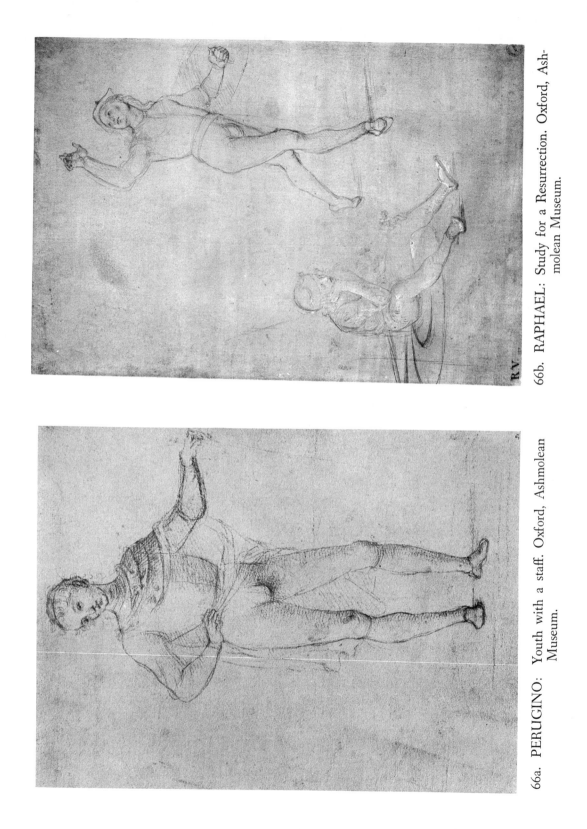

66b. RAPHAEL: Study for a Resurrection. Oxford, Ashmolean Museum.

66a. PERUGINO: Youth with a staff. Oxford, Ashmolean Museum.

67b. RAPHAEL: Head of a Madonna. London, British Museum.

67a. RAPHAEL: Study for a Madonna. Oxford, Ashmolean Museum.

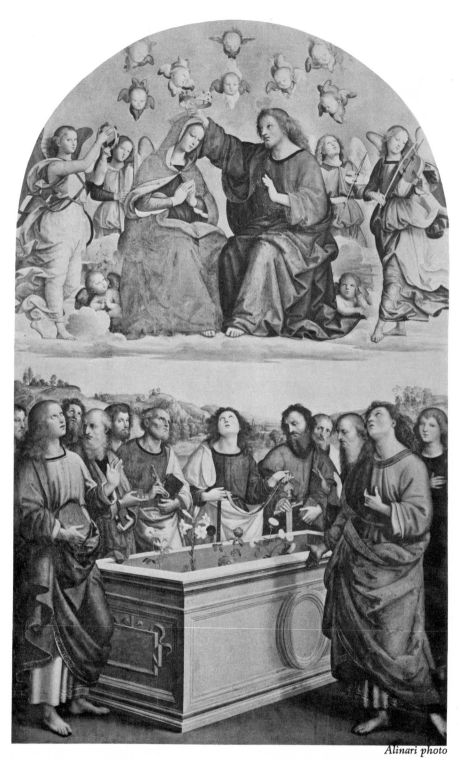

68. RAPHAEL: Coronation of the Virgin. Rome, Vatican.

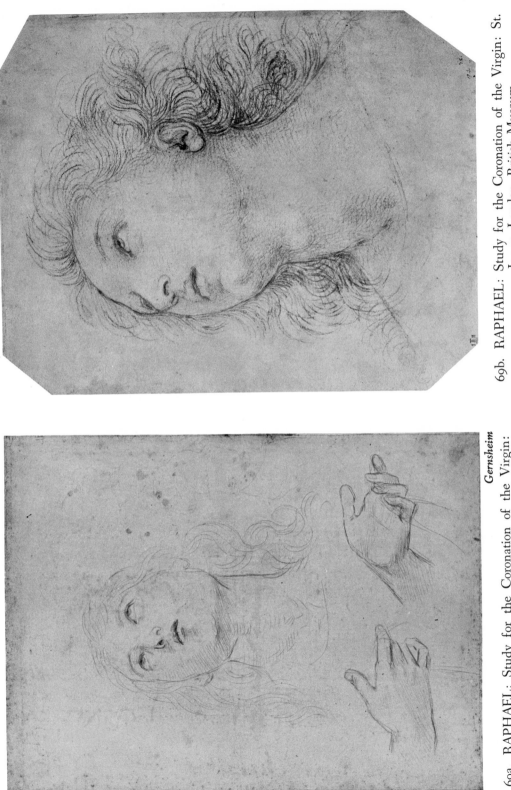

69a. RAPHAEL: Study for the Coronation of the Virgin: St. Thomas. Lille, Musée Wicar.

69b. RAPHAEL: Study for the Coronation of the Virgin: St. James. London, British Museum.

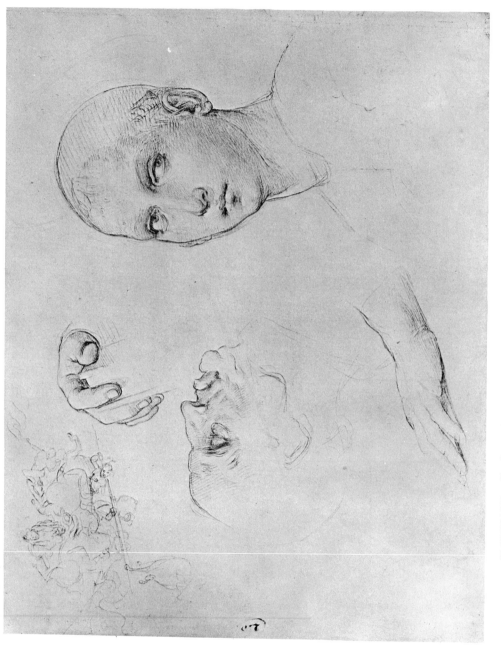

70. RAPHAEL: Studies of heads and hands (St. Benedict). Oxford, Ashmolean Museum.

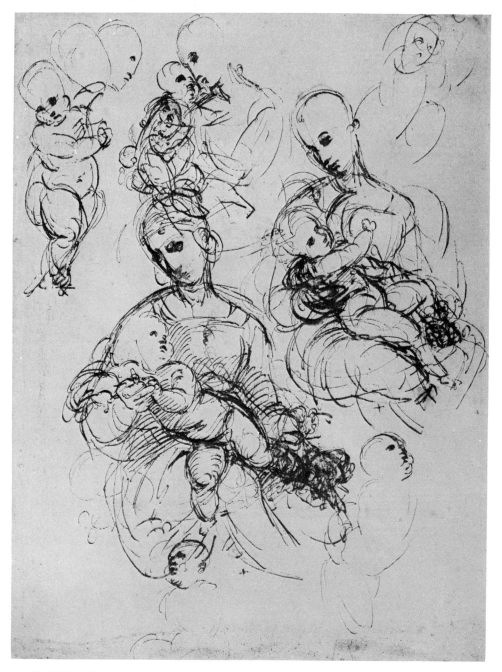

71. RAPHAEL: Study for the Bridgewater Madonna and other studies. London, British Museum.

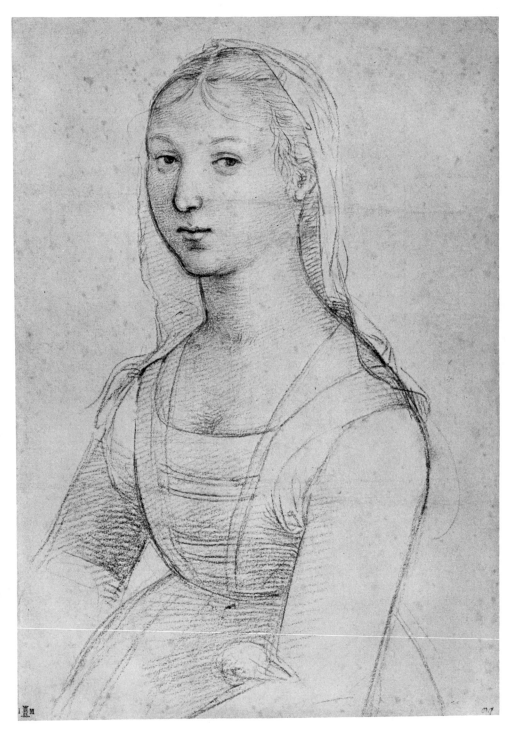

72. RAPHAEL: Bust of a woman. London, British Museum.

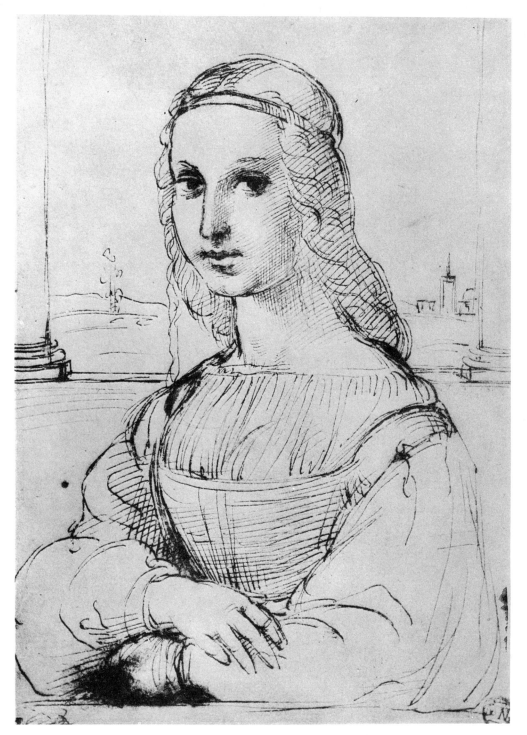

73. RAPHAEL: Study for the portrait of Maddalena Doni. Paris, Louvre.

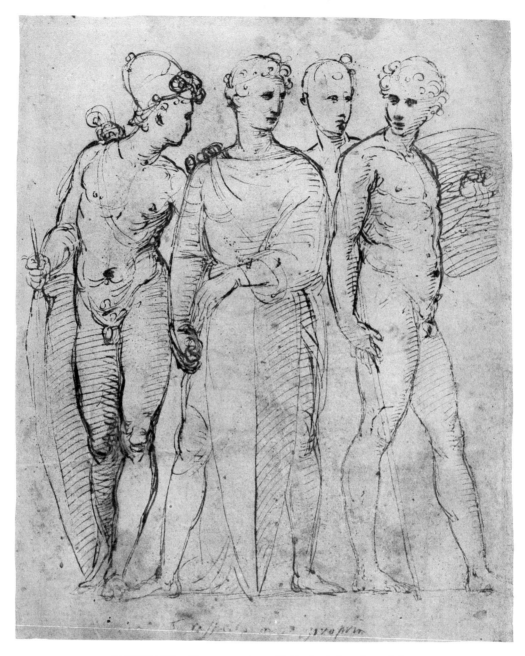

74. RAPHAEL: Four warriors. Oxford, Ashmolean Museum.

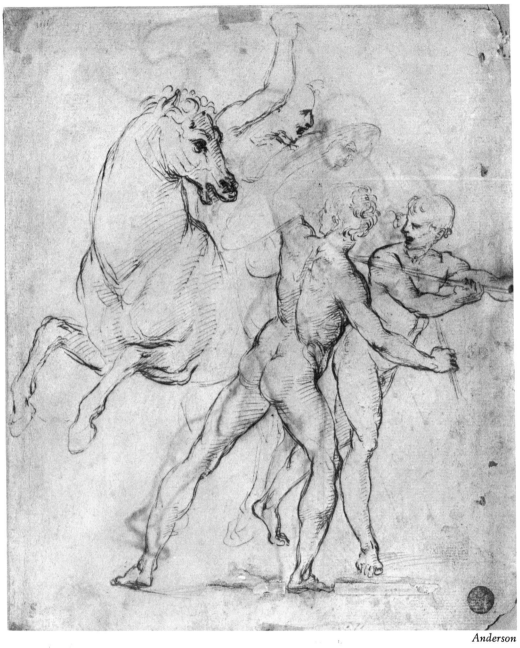

75. RAPHAEL: Horseman and two soldiers fighting. Venice, Academy.

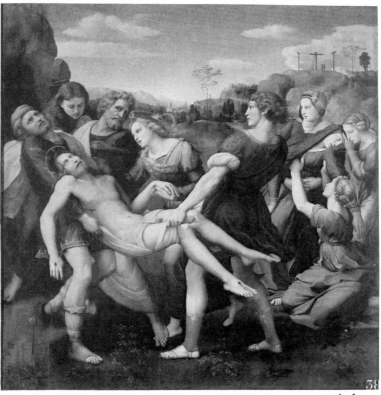

76a. RAPHAEL: The Entombment. Rome, Borghese Gallery.

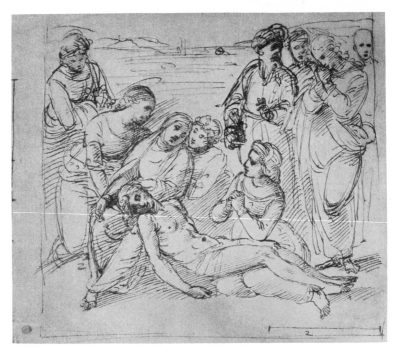

76b. RAPHAEL: Study for the Entombment. Oxford, Ashmo-
lean Museum.

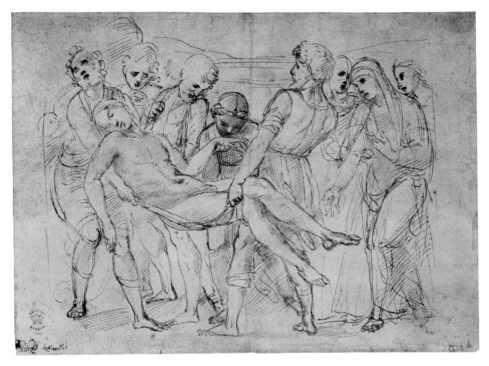

77a. RAPHAEL: Study for the Entombment. London, British Museum.

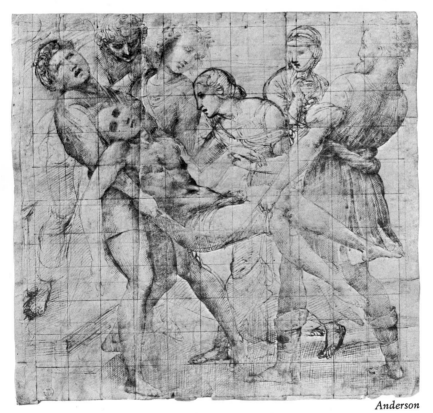

Anderson

77b. RAPHAEL: Study for the Entombment. Florence, Uffizi.

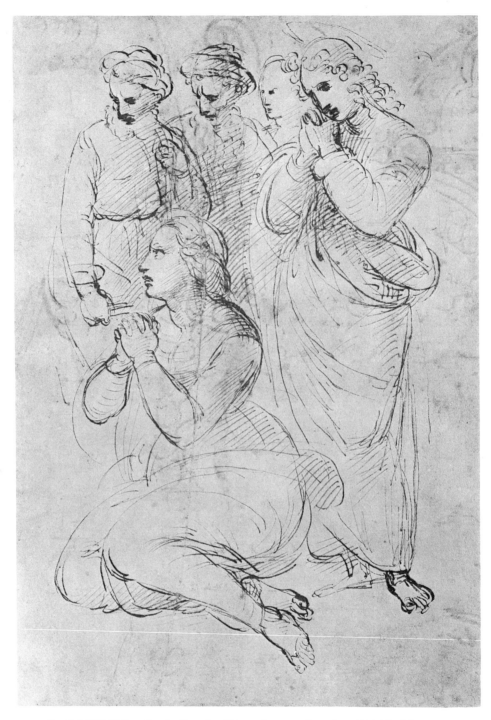

78. RAPHAEL: Study for the Entombment. London, British Museum.

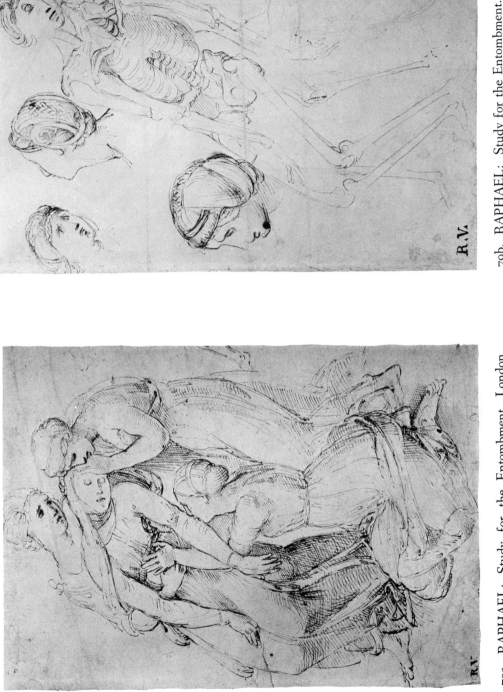

79b. RAPHAEL: Study for the Entombment. London, British Museum.

79a. RAPHAEL: Study for the Entombment. London, British Museum.

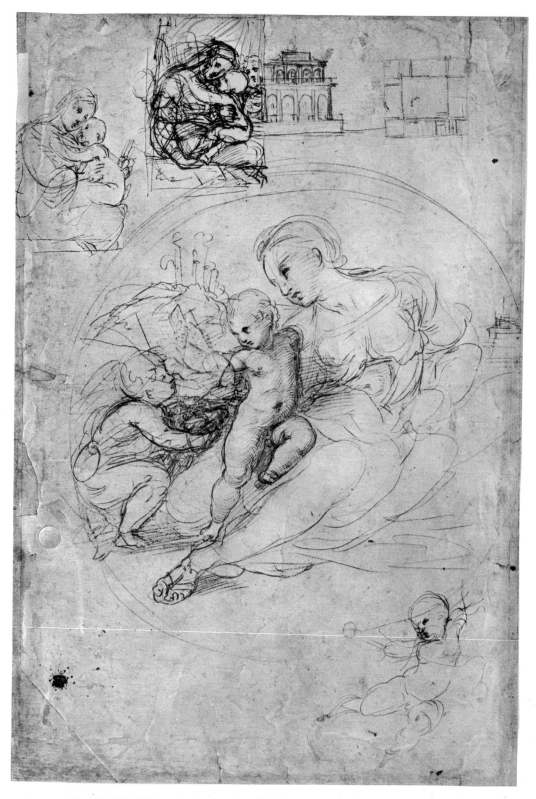

80. RAPHAEL: Study for the Alba Madonna. Lille, Musée Wicar.

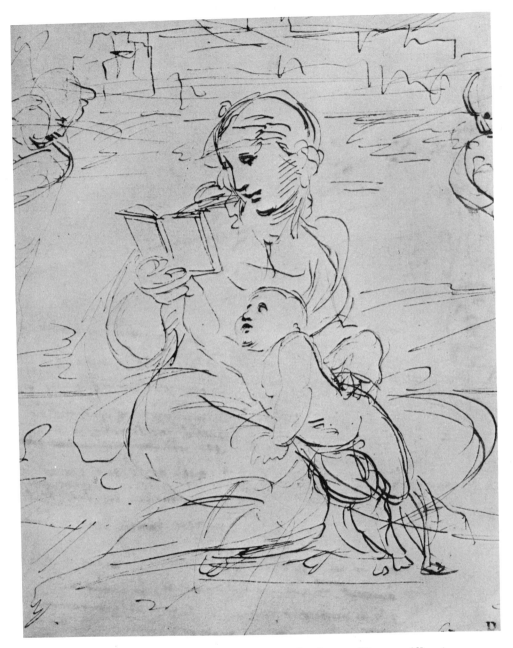

81. RAPHAEL: Madonna reading in a landscape. Vienna, Albertina.

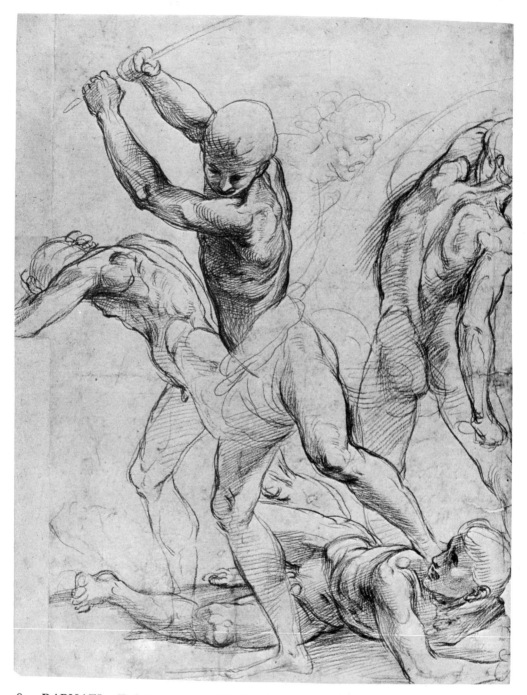

82. RAPHAEL: Fighting men, study for the School of Athens. Oxford, Ashmolean Museum.

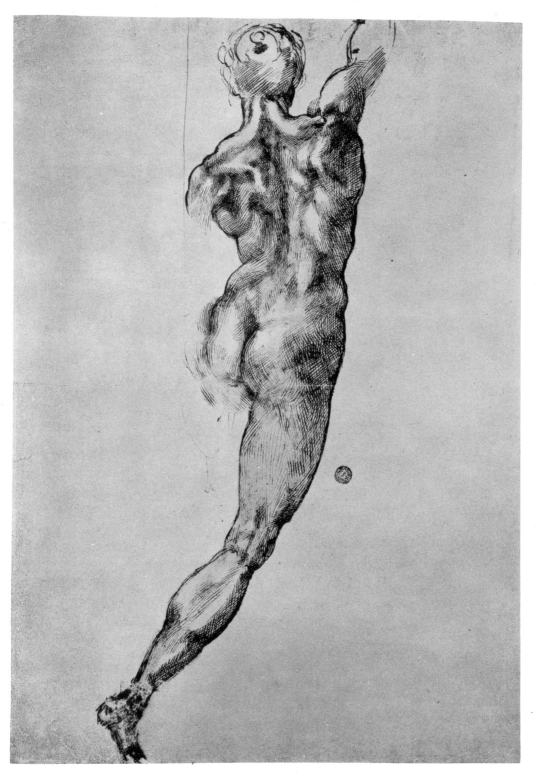

83. MICHELANGELO: Study for the Battle of Cascina. Florence, Casa Buonarroti.

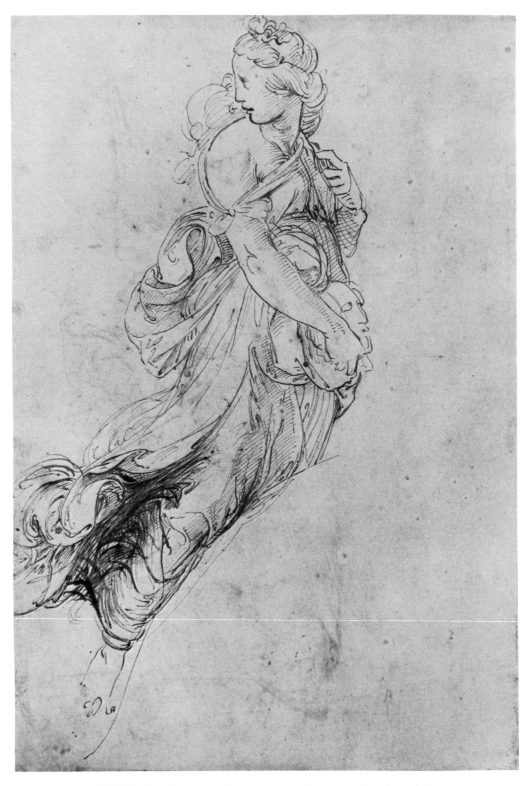

84. RAPHAEL: Study for Melpomene. Oxford, Ashmolean Museum.

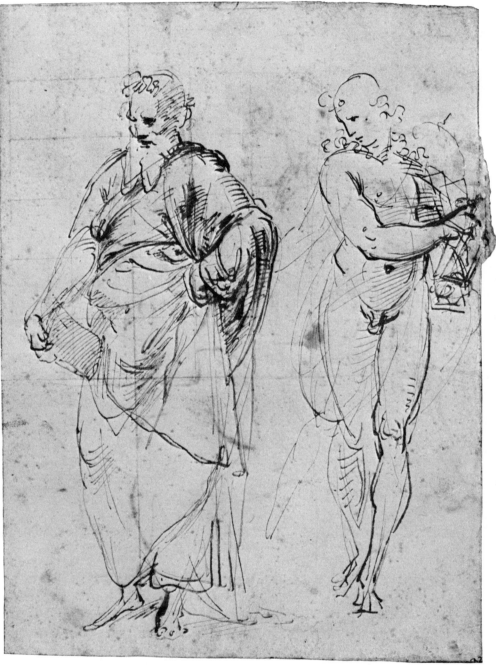

85. RAPHAEL: Study for the Disputà (?), with an Apollo. Lille, Musée Wicar.

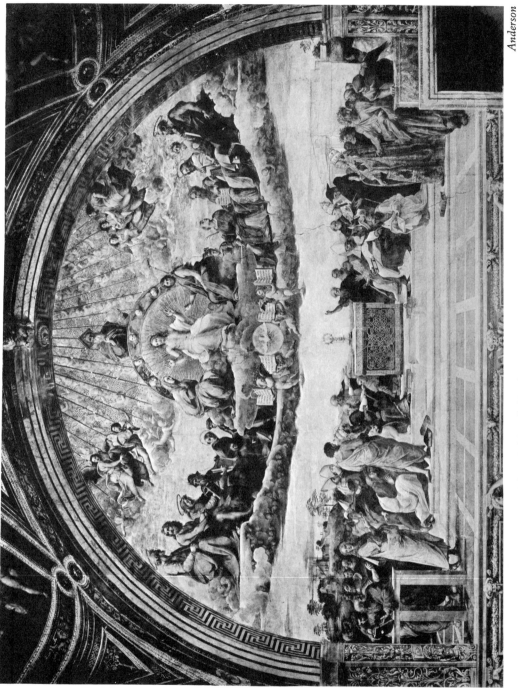

86. RAPHAEL: The Disputà. Rome, Vatican.

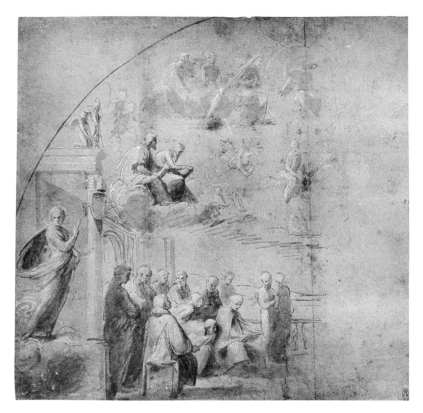

87a. RAPHAEL: Study for the Disputà. Windsor, Royal Library.

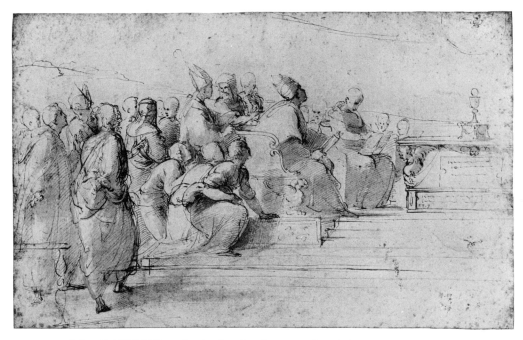

87b. RAPHAEL: Study for the Disputà. London, British Museum.

88. RAPHAEL: Study for the Disputà: Adam. Florence, Uffizi. Gabinetto Disegni e Stampe degli Uffizi.

Brown

89. RAPHAEL: Study for the Parnassus: Apollo. Lille, Musée Wicar.

90. RAPHAEL: Study for the Disputà. Paris, Louvre.

91. RAPHAEL: Cartoon for the School of Athens, detail. Milan, Ambrosiana.

92. RAPHAEL: Study for the Resurrection. Windsor, Royal Library.

93. RAPHAEL: Study for the Chigi Chapel: the planet Mars and an angel. Lille, Musée Wicar.

94. RAPHAEL: Kneeling female nude. Duke of Devonshire Collection, Chatsworth. Reproduced by permission of the Trustees of the Chatsworth Settlement.

95. RAPHAEL: Study for the Phrygian Sibyl. Oxford, Ashmo-
lean Museum.

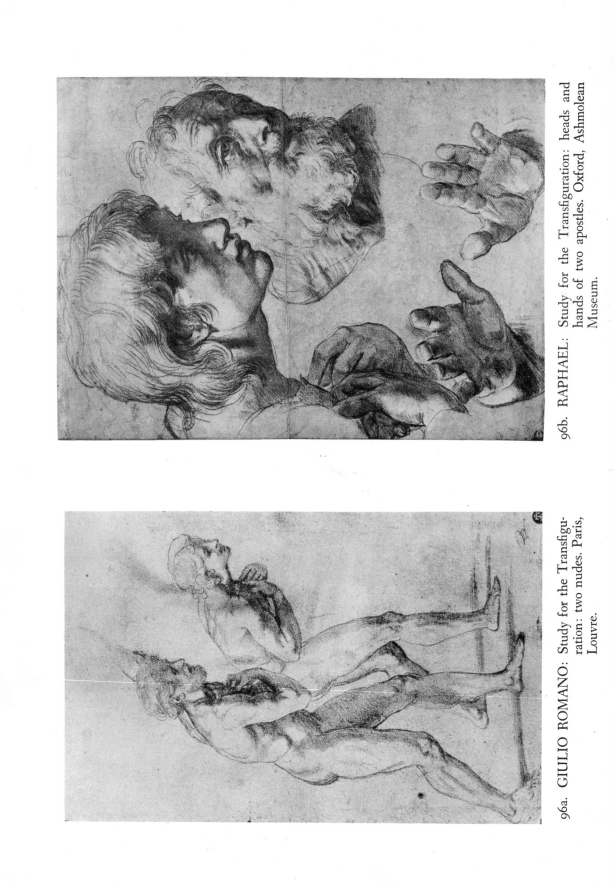

96a. GIULIO ROMANO: Study for the Transfiguration: two nudes. Paris, Louvre.

96b. RAPHAEL: Study for the Transfiguration: heads and hands of two apostles. Oxford, Ashmolean Museum.

DÜRER

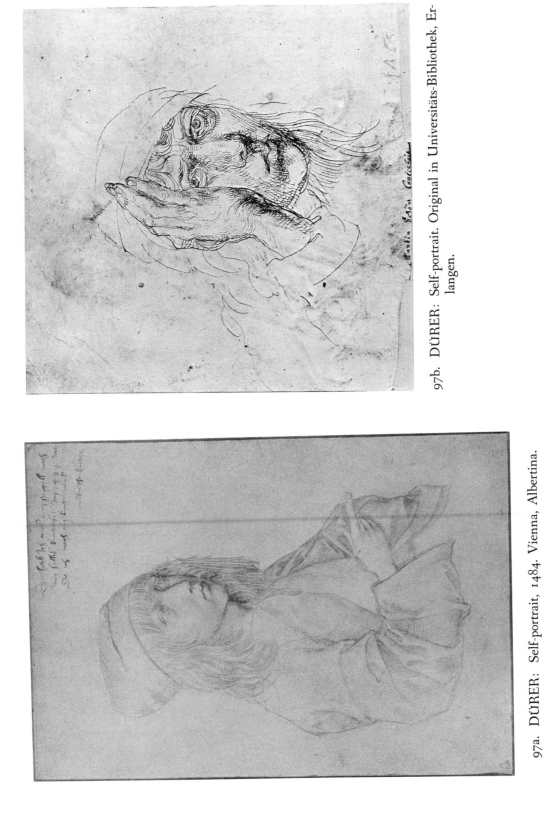

97b. DÜRER: Self-portrait. Original in Universitäts-Bibliothek, Er-
langen.

97a. DÜRER: Self-portrait, 1484. Vienna, Albertina.

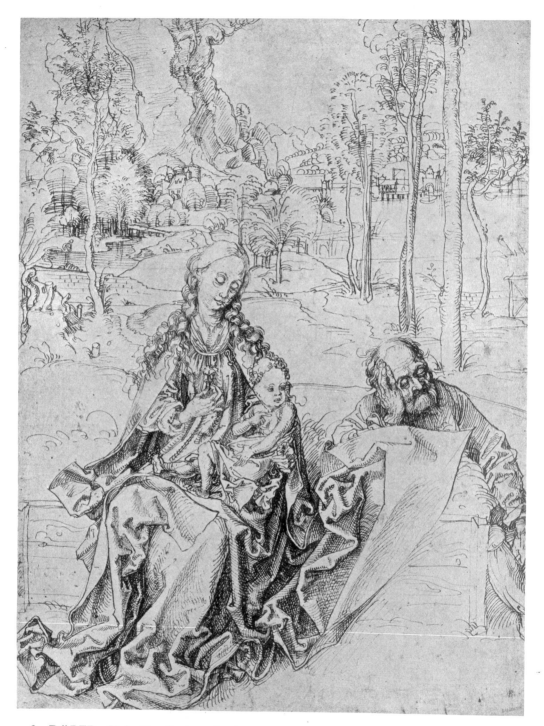

98. DÜRER: Holy Family in a landscape. Berlin, Ehemals Staatliche Museen Berlin, Kupferstichkabinett, Museum Dahlem.

99. SCHONGAUER: Madonna and Child. Berlin, Ehemals Staatliche Museen Berlin, Kupferstichkabinett, Museum Dahlem.

100. DÜRER: Female nude, 1493. Bayonne, Musée Bonnat.

101. DÜRER: Young couple walking. Hamburg, Kunsthalle.

102. DÜRER: Coat of arms with man behind a stove. Rotterdam, Boymans Museum.

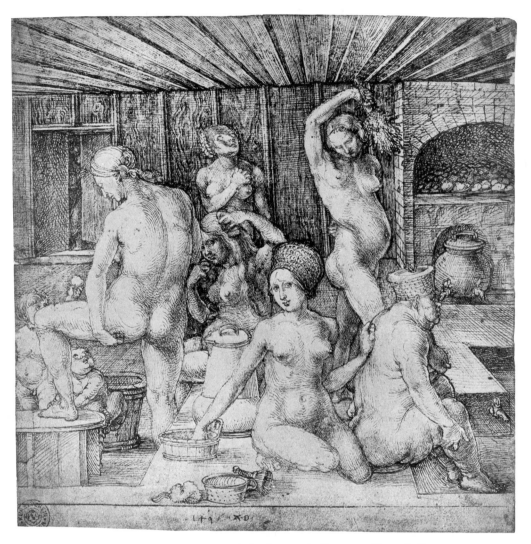

103. DÜRER: Women's bath, 1496. Bremen, Kunsthalle.

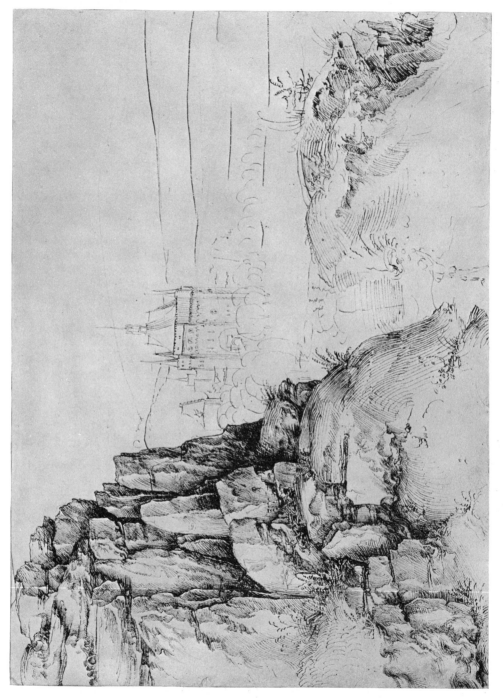

104. DÜRER: Rocky landscape with castle. Vienna, Albertina.

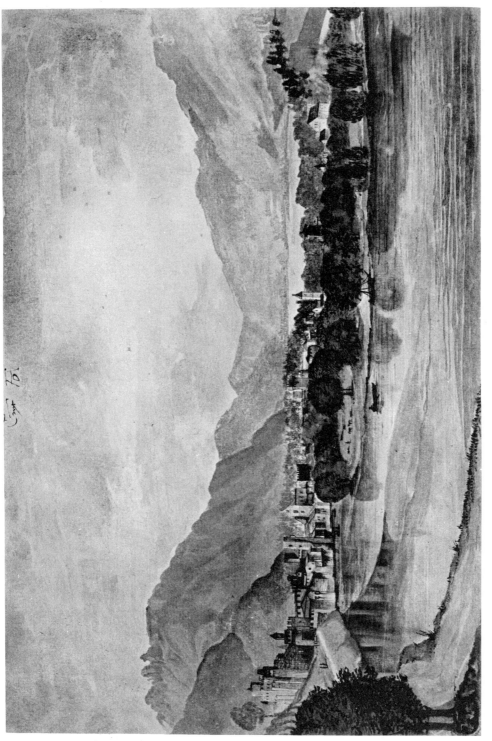

105. DÜRER: View of Trent. Bremen, Kunsthalle.

106. DÜRER: Study for the Birth of the Virgin. Berlin, Ehemals Staatliche Museen Berlin, Kupferstichkabinett, Museum Dahlem.

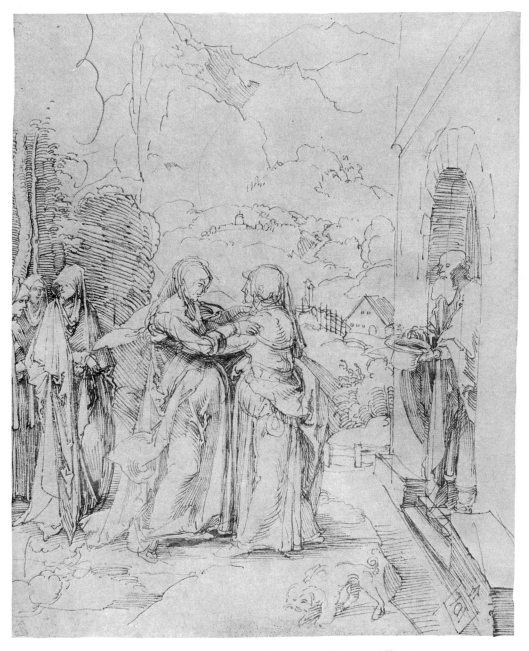

107. DÜRER: Study for the Visitation. Vienna, Albertina.

108. DÜRER: Portrait of Agnes. Vienna, Albertina.

1503·

109. DÜRER: Portrait of Willibald Pirckheimer, 1503. Berlin, Ehemals Staatliche
Museen Berlin, Kupferstichkabinett, Museum Dahlem.

110. DÜRER: Apollo and Diana. London, British Museum.

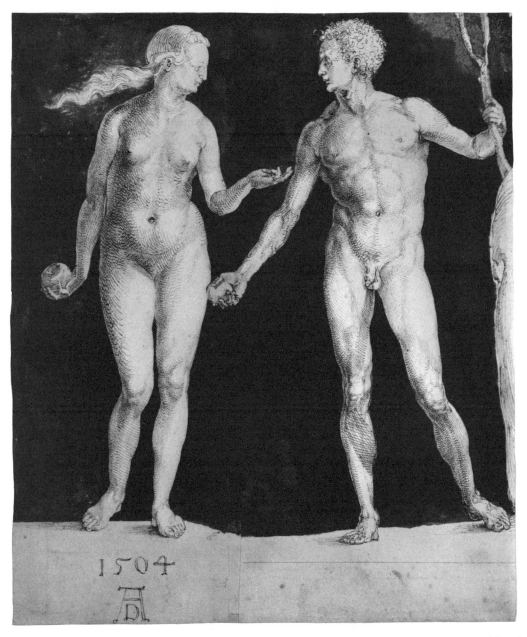

111. DÜRER: Adam and Eve, 1504. New York, by courtesy of Pierpont Morgan Library.

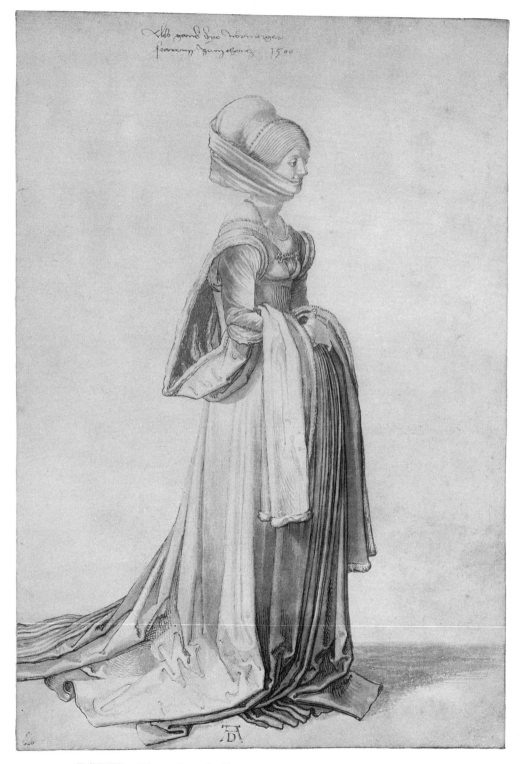

112. DÜRER: Nuremberg lady going to a dance, 1500. Vienna, Albertina.

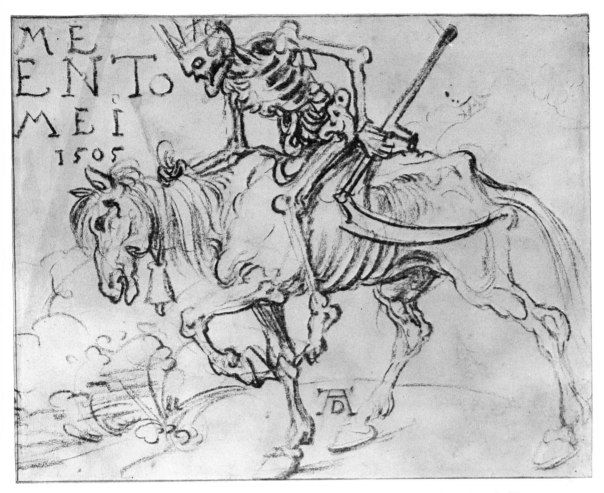

113. DÜRER: Death on horseback (*Memento mei*), 1505. London, British Museum.

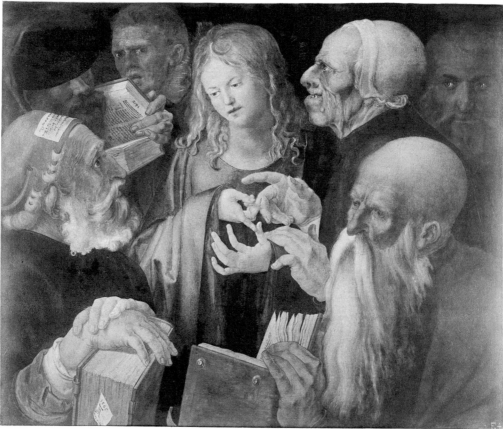

114a. DÜRER: Christ among the doctors. Lugano, Thyssen Collection.

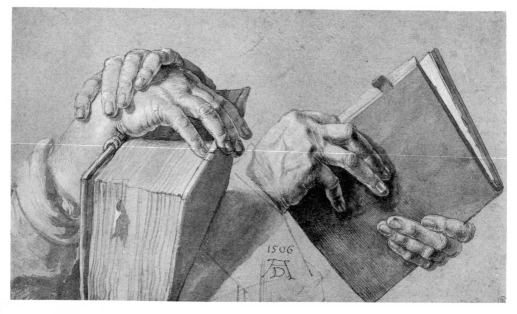

114b. DÜRER: Christ among the doctors: studies of hands, 1506. Brunswick, Blasius Collection.

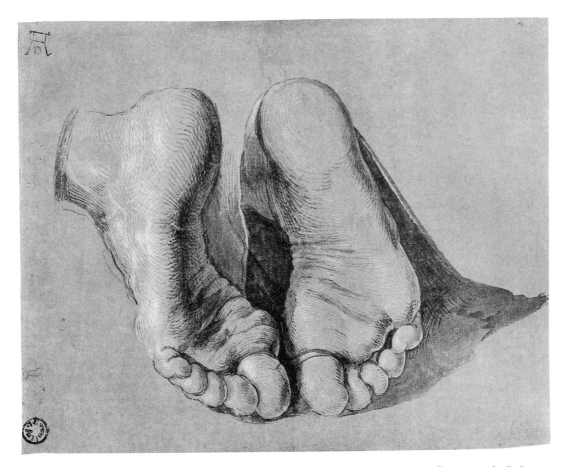

115. DÜRER: Study for the Heller altar: feet of kneeling apostle. Paris, Comtesse de Béhague Collection.

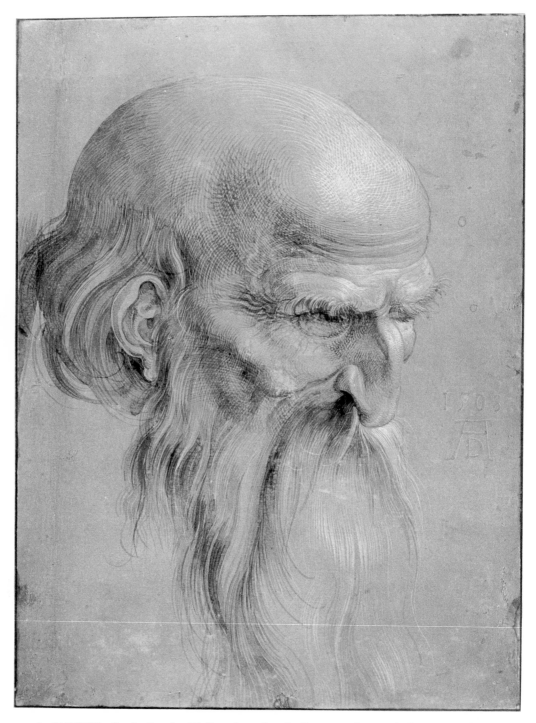

116. DÜRER: Study for the Heller altar: head of an apostle, 1508. Vienna, Albertina.

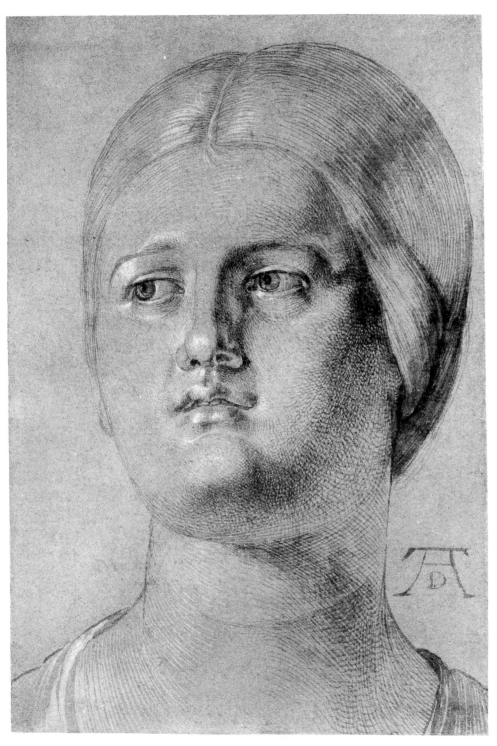

117. DÜRER: Head of a young woman. Vienna, Albertina.

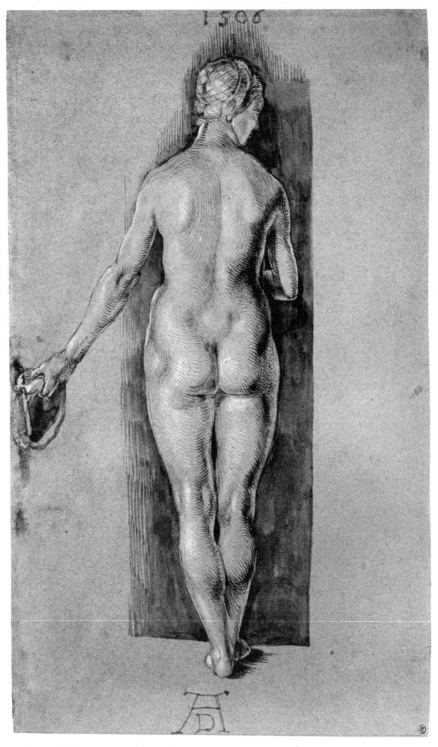

118. DÜRER: Female nude seen from the back, 1506. Berlin, Ehemals
Staatliche Museen Berlin, Kupferstichkabinett, Museum
Dahlem.

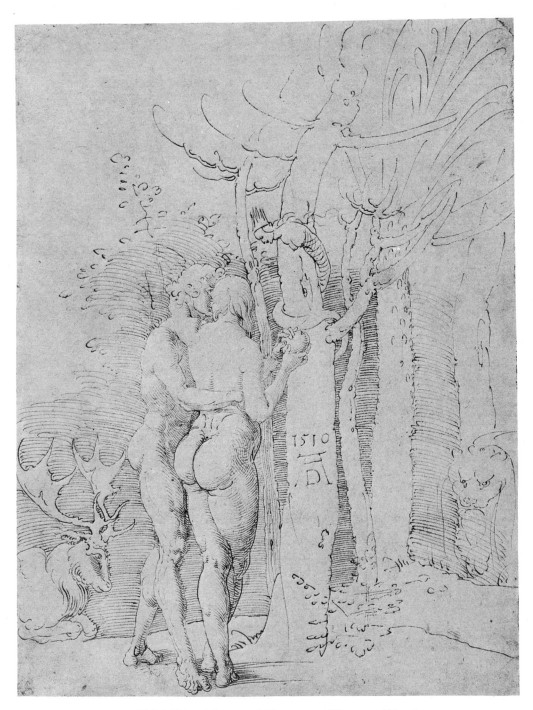

119. DÜRER: Adam and Eve, 1510. Vienna, Albertina.

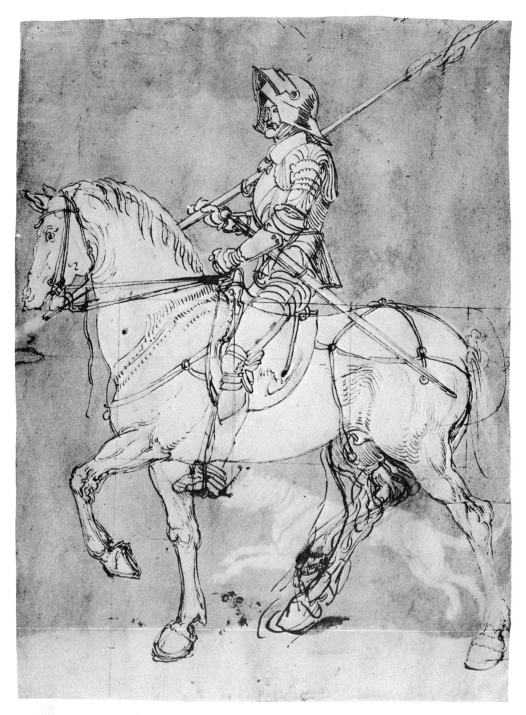

120. DÜRER: A knight on horseback. Milan, Ambrosiana.

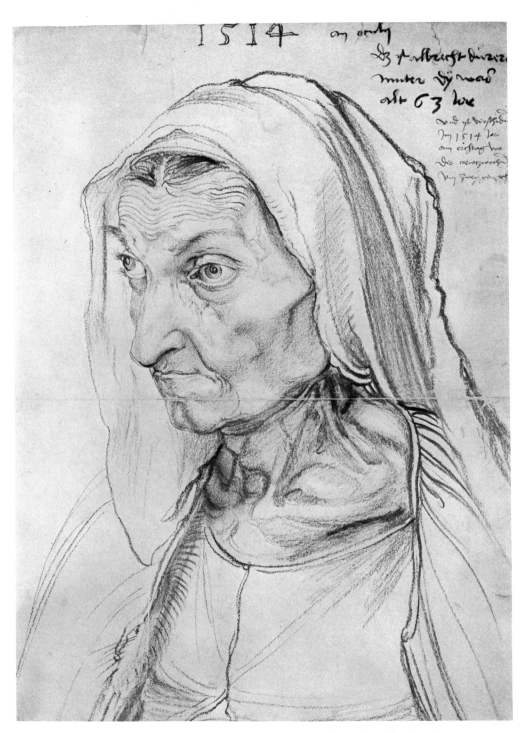

121. DÜRER: Portrait of Dürer's mother, 1514. Berlin, Ehemals Staatliche Museen
Berlin, Kupferstichkabinett, Museum Dahlem.

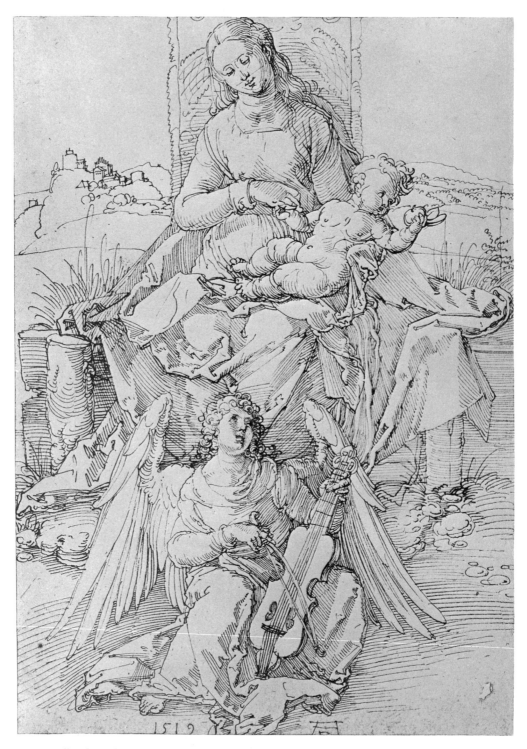

122. DÜRER: Madonna and Child on a grassy bank, 1519. Windsor, Royal Library.

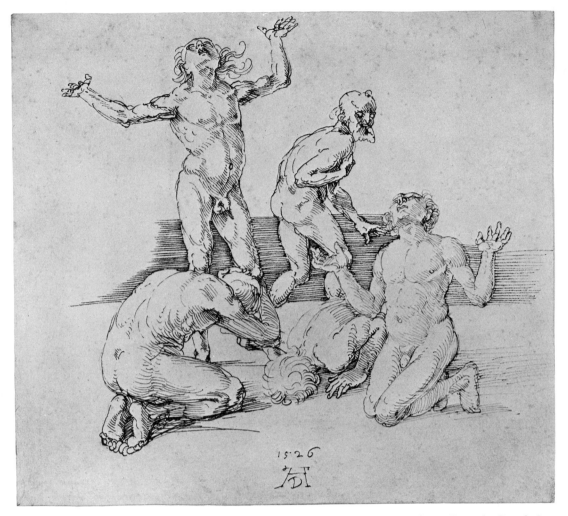

123. DÜRER: Five nudes, study for a Resurrection (?), 1526. Berlin, Ehemals Staatliche Museen Berlin, Kupferstichkabinett, Museum Dahlem.

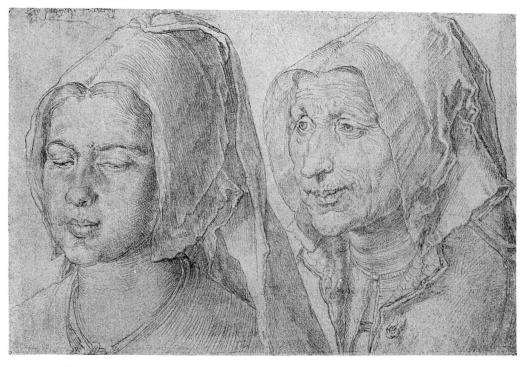

124a. DÜRER: Portraits of an old and a young woman, 1520. Chantilly, Musée Condé.

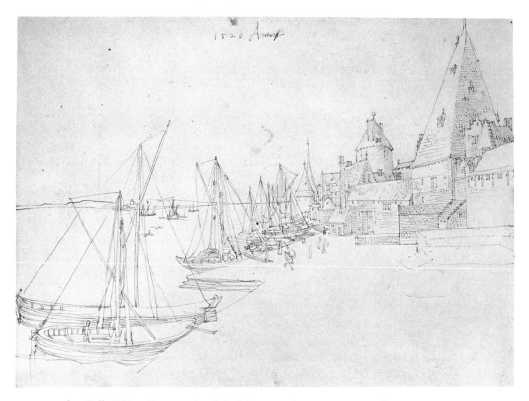

124b. DÜRER: Pier at the Scheldt gate, Antwerp, 1520. Vienna, Albertina.

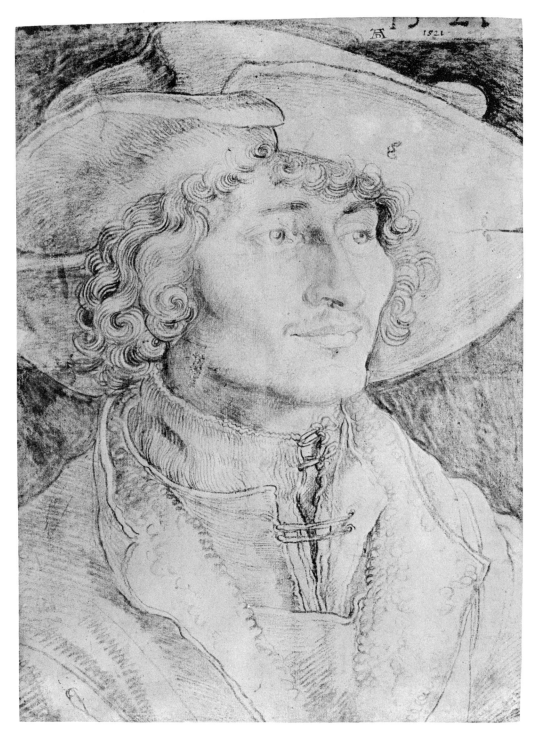

125. DÜRER: Portrait of a young man, 1521. London, British Museum.

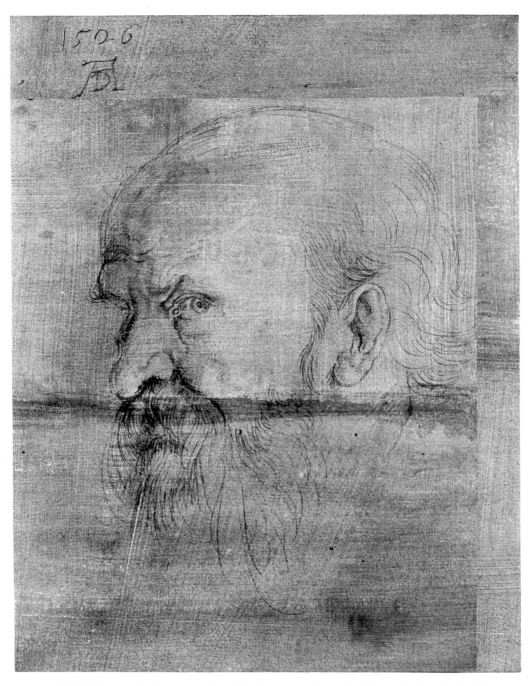

126. DÜRER: Study for the head of St. Paul, 1526. Berlin, Ehemals Staatliche Museen Berlin, Kupferstichkabinett, Museum Dahlem.

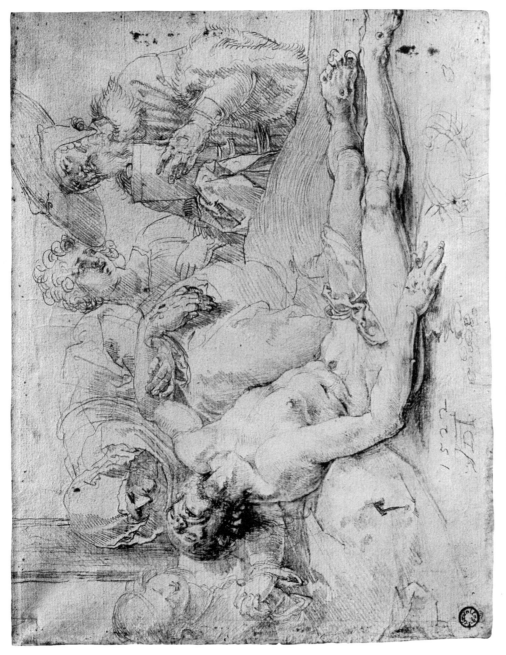

127. DÜRER: Lamentation, 1522. Bremen, Kunsthalle.

te deus in eternum. Pater no
ster. Et ne nos. Bñdictio. Pre
cibus et meritis. vt sequir post
Iste psalmus: et alij duo se
quentes cum suis antiphonis
dicuntur diebus mercurij et
sabbati. Antiphona. Gaude.

Psalmus

Antate domino canti
cum nouñ: cantate dño
omnis terra. Cantate domio
et benedicite nomini eius: an
nunctiate de die in diem salu
tare eius. Annunctiate inter

128. DÜRER: Page from the prayer book of Maximilian, 1515. Munich, Library.

REMBRANDT

129a. RUBENS: Girl bearing a jug. Berlin,
Ehemals Staatliche Museen
Berlin, Kupferstichkabinett,
Museum Dahlem.

129b. PIETER LASTMAN: Young man with a
staff, 1603. Amsterdam,
Print Room.

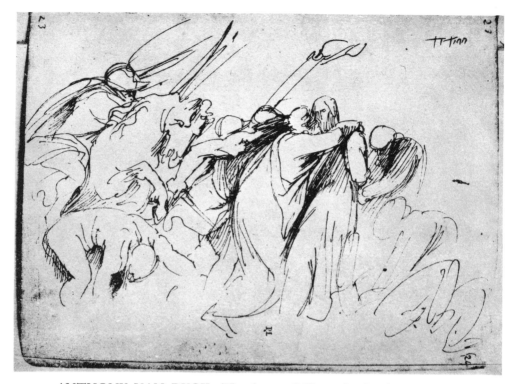

130a. ANTHONY VAN DYCK: The Arrest of Christ. In the sketchbook formerly at Chatsworth, Duke of Devonshire Collection.

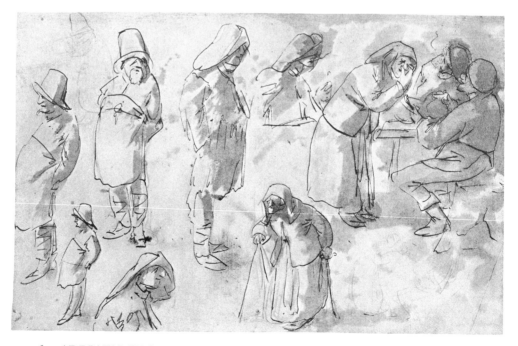

130b. ADRIAEN BROUWER: Studies of figures. Berlin, Ehemals Staatliche Museen Berlin, Kupferstichkabinett, Museum Dahlem.

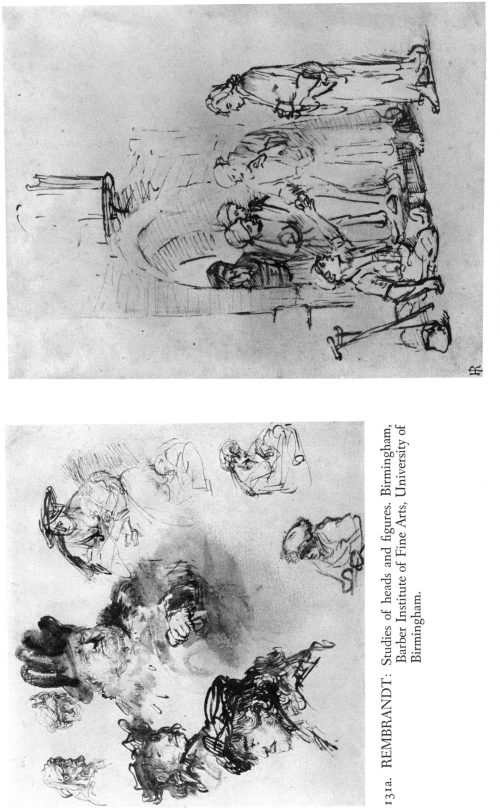

131a. REMBRANDT: Studies of heads and figures. Birmingham, Barber Institute of Fine Arts, University of Birmingham.

131b. REMBRANDT: Sts. Peter and John at the gate of the temple. New York, courtesy of the Metropolitan Museum of Art, Rogers Fund, 1911.

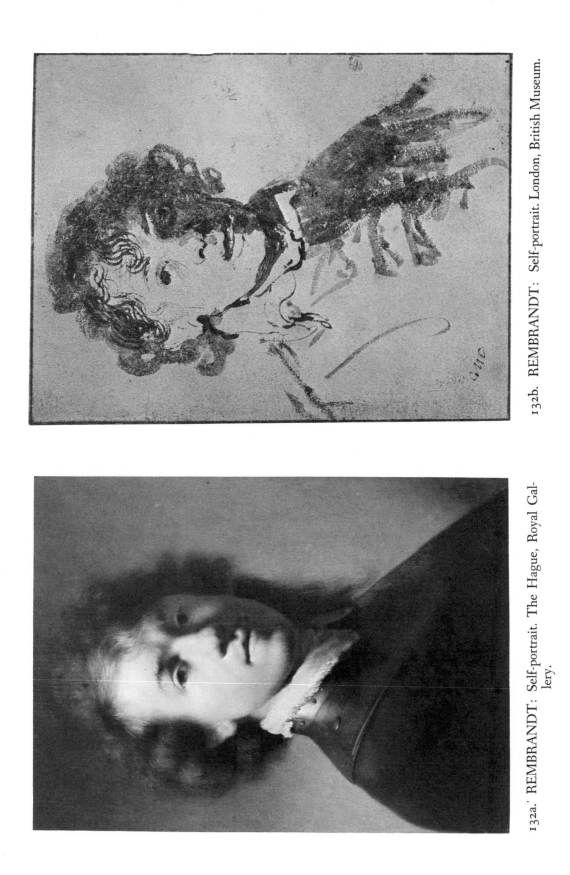

132b. REMBRANDT: Self-portrait. London, British Museum.

132a. REMBRANDT: Self-portrait. The Hague, Royal Gallery.

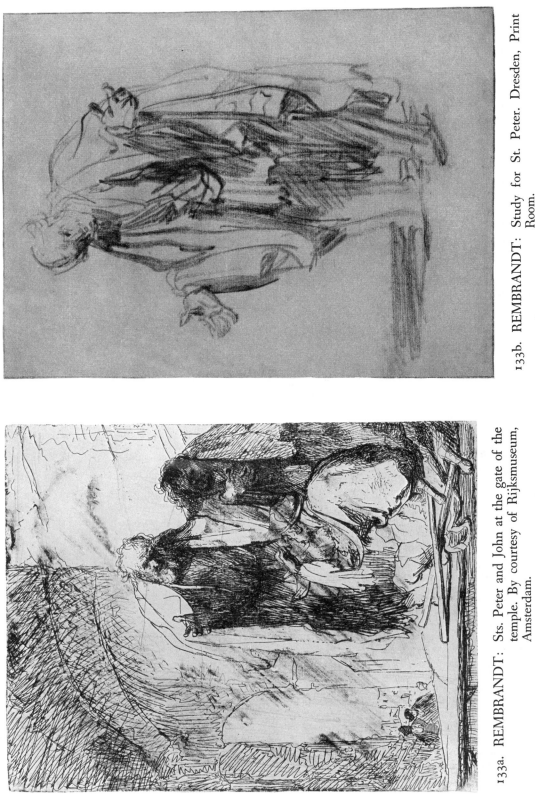

133b. REMBRANDT: Study for St. Peter. Dresden, Print Room.

133a. REMBRANDT: Sts. Peter and John at the gate of the temple. By courtesy of Rijksmuseum, Amsterdam.

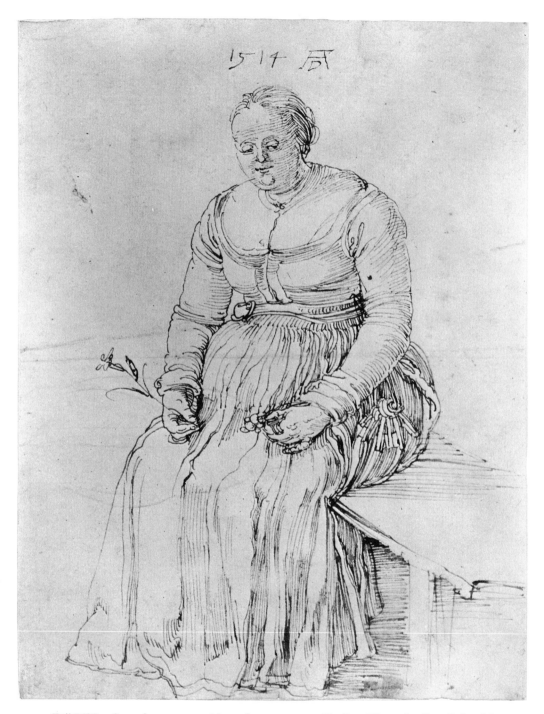

134. DÜRER: Seated woman with a flower, 1514. Berlin, Ehemals Staatliche Museen
Berlin, Kupferstichkabinett, Museum Dahlem.

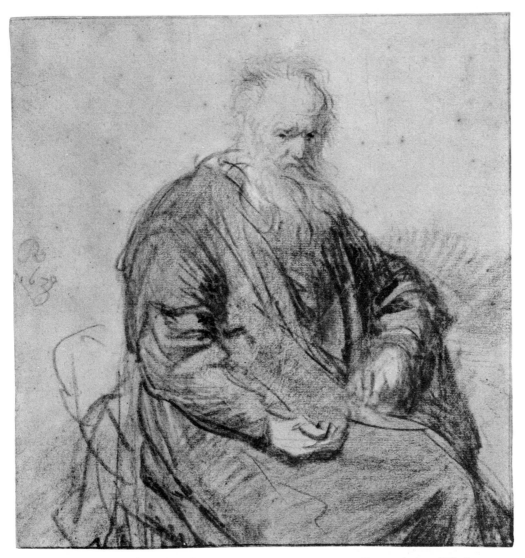

135. REMBRANDT: Seated old man, 1630. National Gallery of Art, Washington, D.C., Rosenwald Collection.

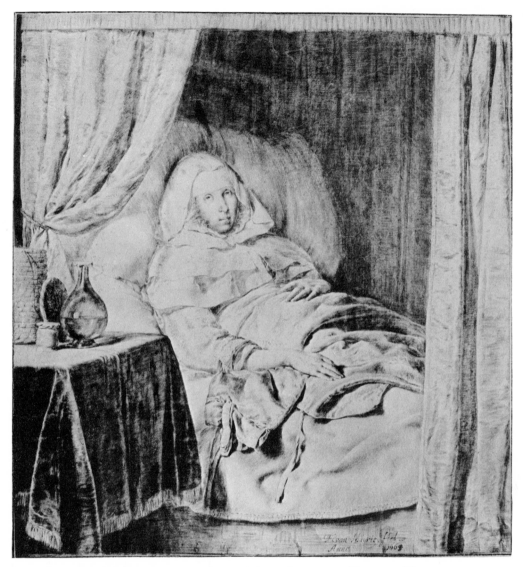

136. FRANS VAN MIERIS: The sick woman. Vienna, Albertina.

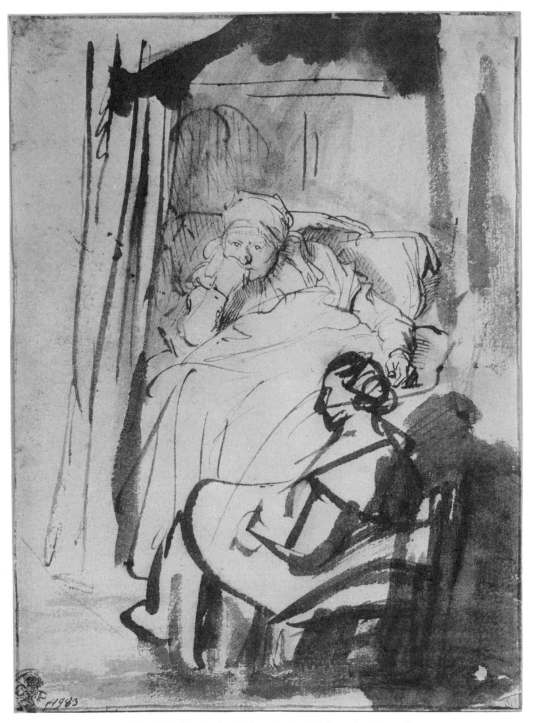

137. REMBRANDT: Saskia in bed. Munich, Print Room.

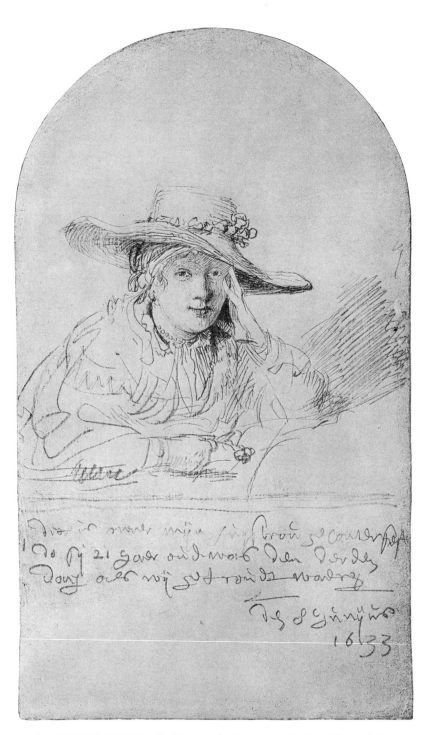

138. REMBRANDT: Saskia as a bride, 1633. Berlin, Ehemals Staat-
liche Museen Berlin, Kupferstichkabinett,
Museum Dahlem.

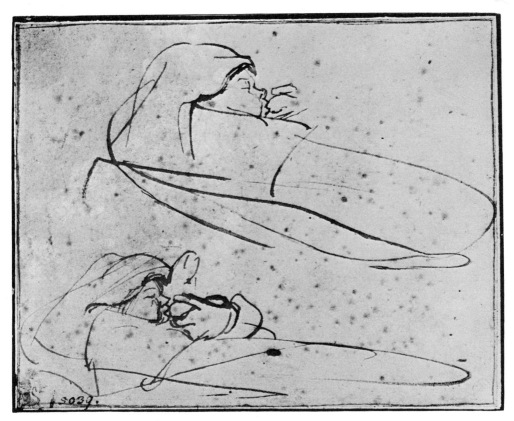

139a. REMBRANDT: Studies of a baby with a bottle. Munich, Print Room.

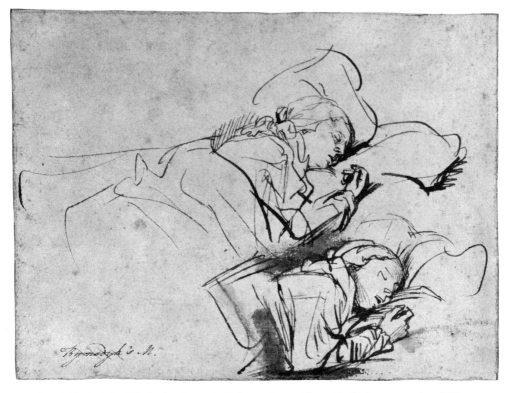

139b. REMBRANDT: Studies of Saskia asleep. New York, by courtesy of Pierpont
Morgan Library.

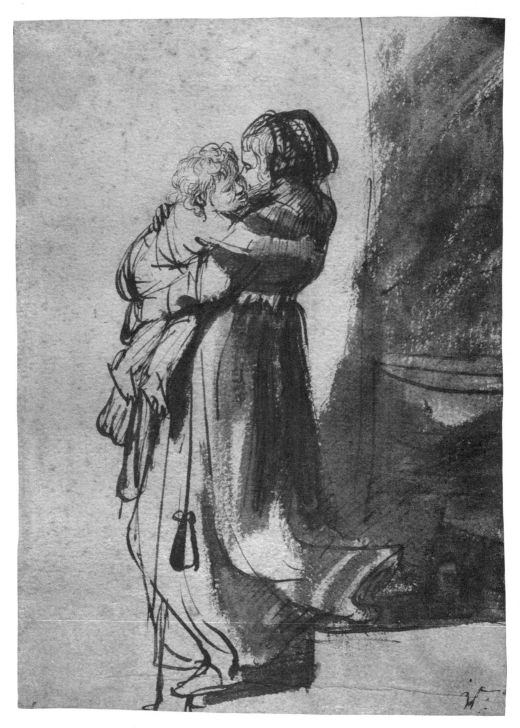

140. REMBRANDT: Mother with child on a staircase. New York, by courtesy of Pier-
pont Morgan Library.

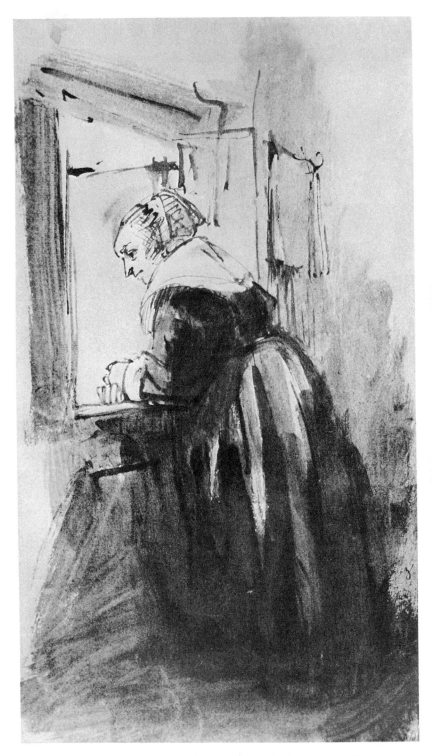

141. REMBRANDT: Woman at a window. Paris, Louvre.

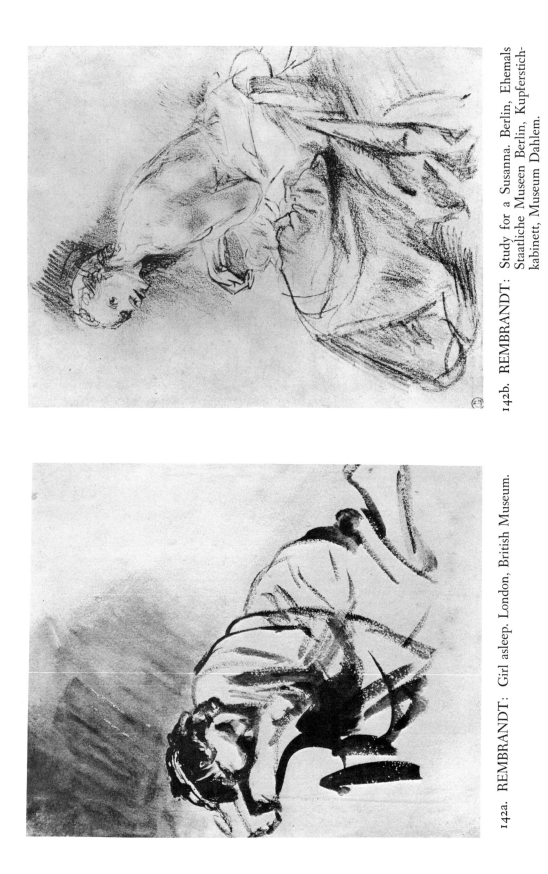

142a. REMBRANDT: Girl asleep. London, British Museum.

142b. REMBRANDT: Study for a Susanna. Berlin, Ehemals Staatliche Museen Berlin, Kupferstich-kabinett, Museum Dahlem.

143b. REMBRANDT: Two women teaching a baby to walk. London, British Museum.

143a. REMBRANDT: Studies of beggars, etc. Berlin, Ehemals Staatliche Museen Berlin, Kupferstichkabinett, Museum Dahlem.

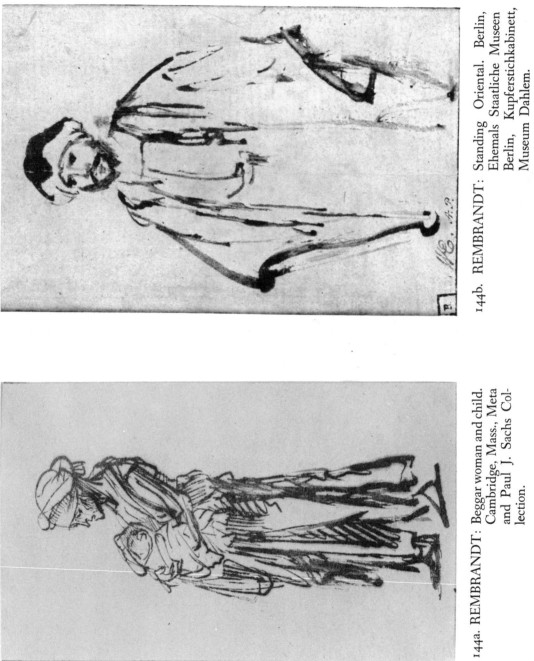

144a. REMBRANDT: Beggar woman and child. Cambridge, Mass., Meta and Paul J. Sachs Collection.

144b. REMBRANDT: Standing Oriental. Berlin, Ehemals Staatliche Museen Berlin, Kupferstichkabinett, Museum Dahlem.

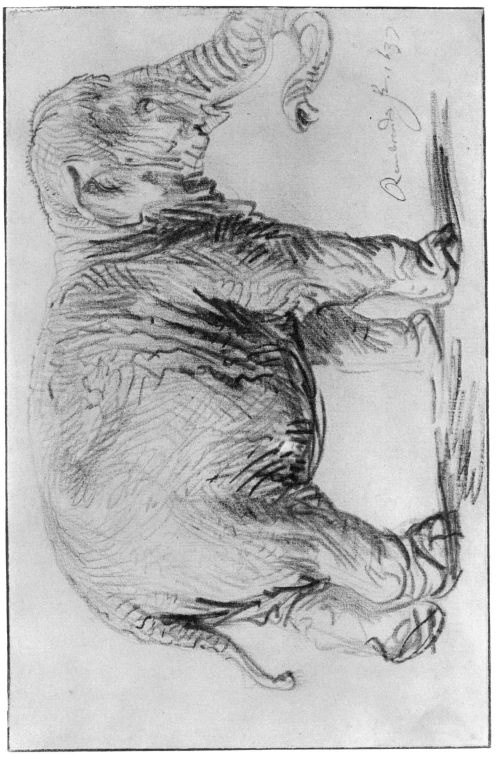

145. REMBRANDT: Elephant, 1637. Vienna, Albertina.

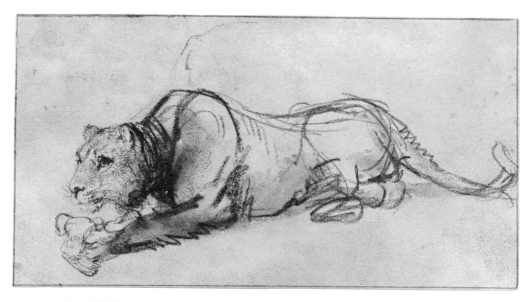

146a. REMBRANDT: Lioness devouring a bird. London, British Museum.

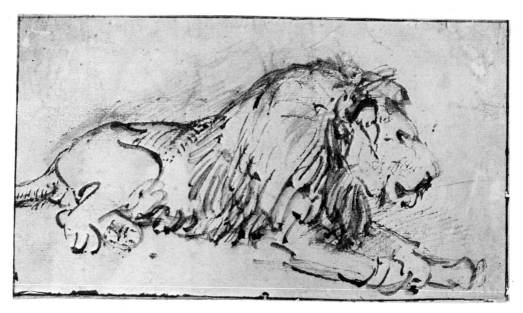

146b. REMBRANDT: Crouching lion. Amsterdam, Print Room.

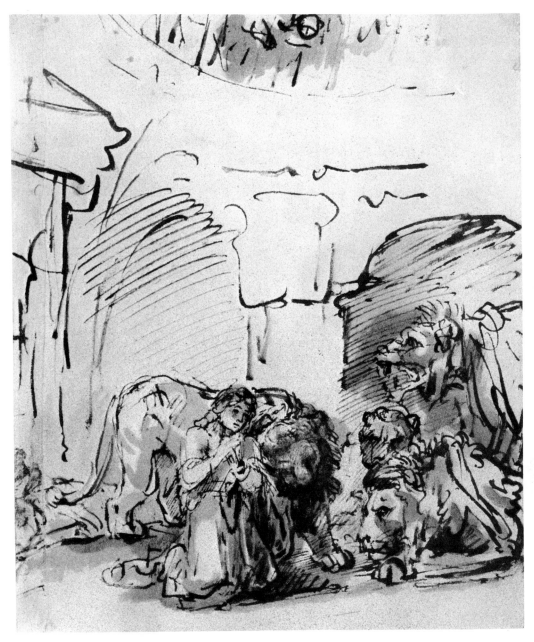

147. REMBRANDT: Daniel in the lions' den. Amsterdam, Print Room.

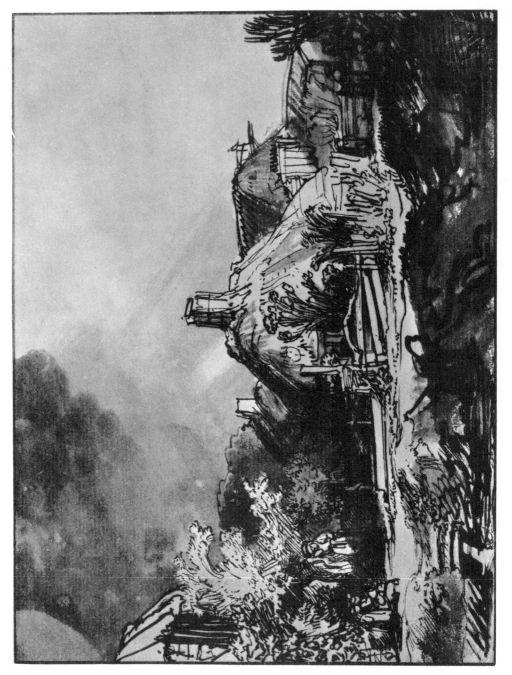

148. REMBRANDT: Stormy landscape. Vienna, Albertina.

149. REMBRANDT: House among trees on a canal. London, British Museum.

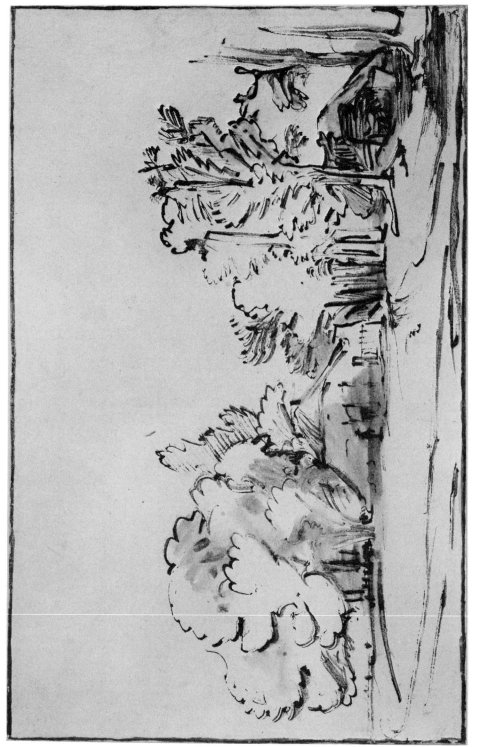

150. REMBRANDT: Cottages among trees. Berlin, Ehemals Staatliche Museen Berlin, Kupferstichkabinett, Museum Dahlem.

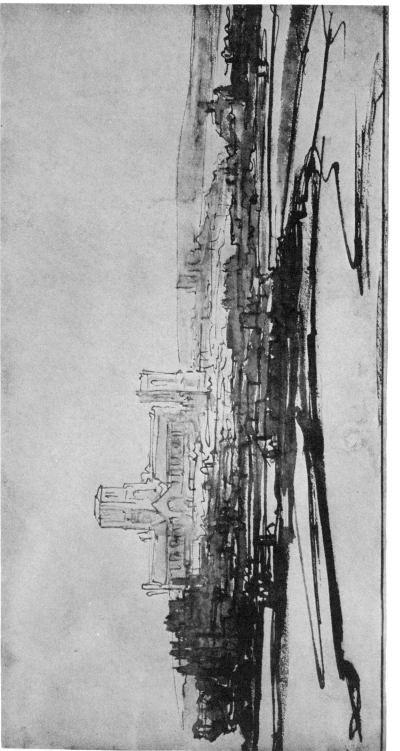

151. REMBRANDT: View of London with Old St. Paul's. Berlin, Ehemals Staatliche Museen Berlin, Kupferstich-kabinett, Museum Dahlem.

152. REMBRANDT: Christ in the house of Mary and Martha. Haarlem, Teyler Museum.

153. REMBRANDT: Christ healing a sick person. Berlin, Ehemals Staatliche Museen Berlin, Kupferstichkabinett, Museum Dahlem.

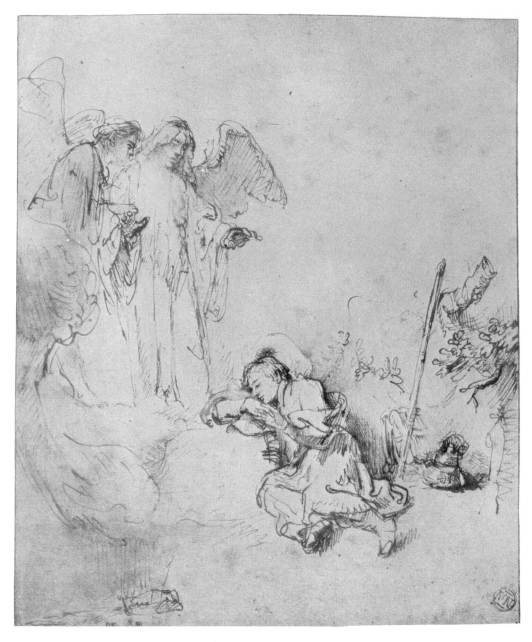

154. REMBRANDT: Jacob's dream. Paris, Louvre.

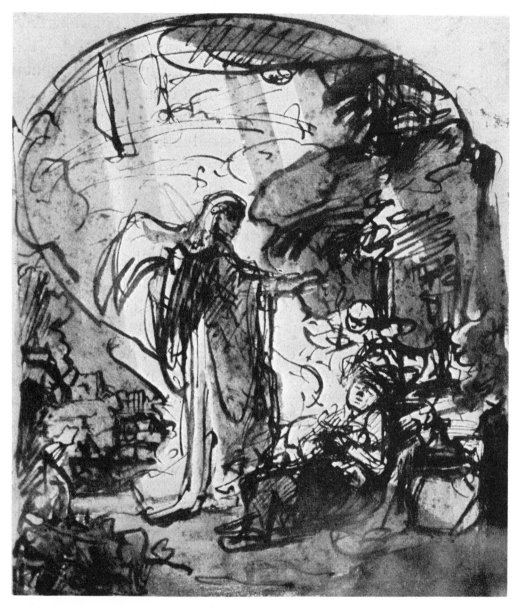

155. FERDINAND BOL: Jacob's dream. Besançon, Museum.

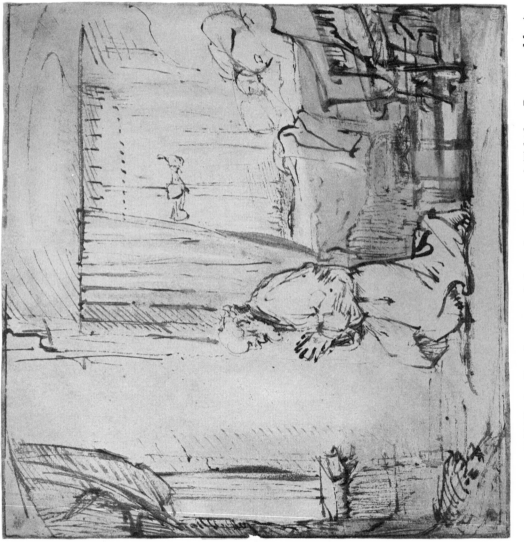

156. REMBRANDT: St. Peter's prayer before the raising of Tabitha. Bayonne, Musée Bonnat.

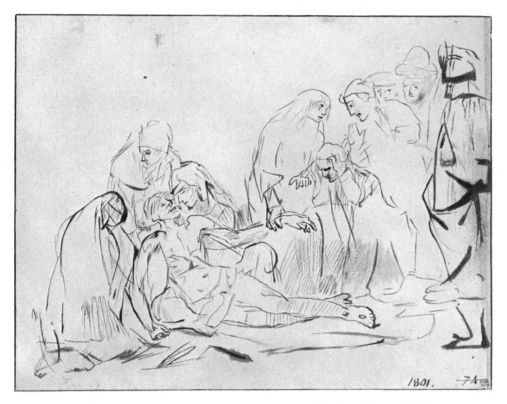

157a. REMBRANDT, copy: Lamentation. Stockholm, National Museum.

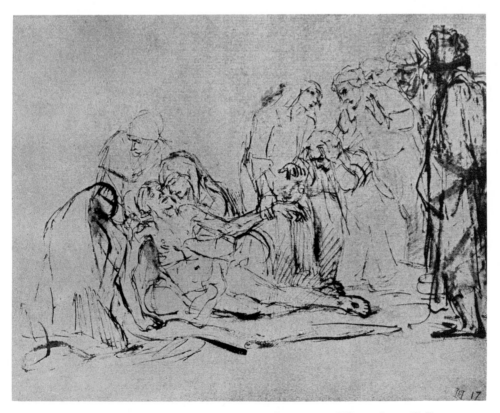

157b. REMBRANDT: Lamentation. Constance, Wessenberg Gallery.

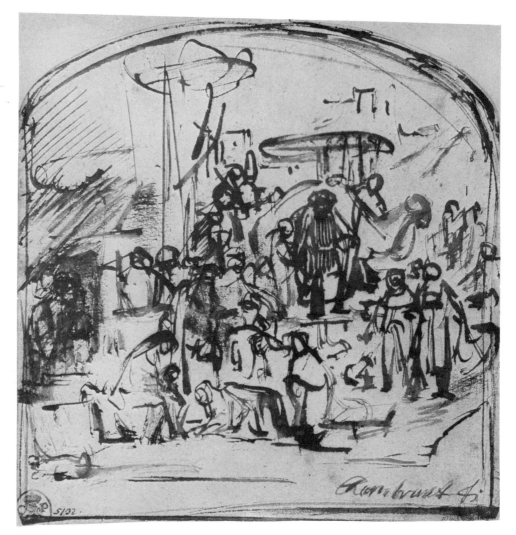

158. REMBRANDT, FORGERY: Adoration of the Magi. Munich, Print Room.

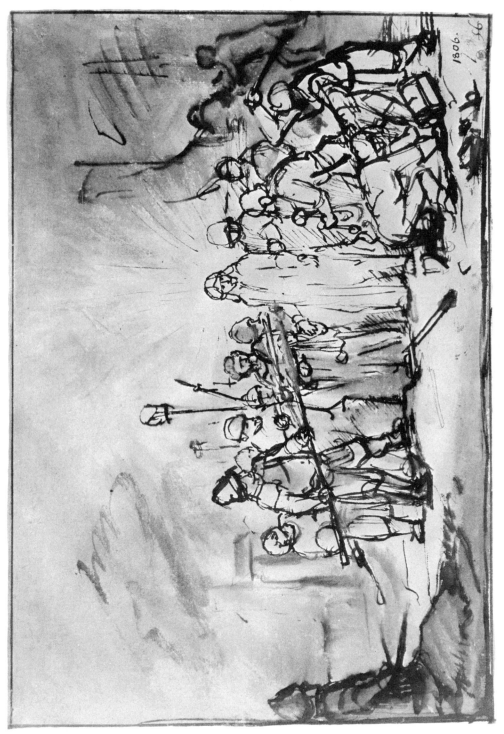

159. REMBRANDT: Arrest of Christ. Stockholm, National Museum.

160. REMBRANDT: Self-portrait in studio attire. Amsterdam, Rembrandthuis.

WATTEAU

161a. CLAUDE GILLOT: Scene from Italian comedy. Paris, Louvre.

161b. WATTEAU: Troupe of comedians. Stockholm, National Museum.

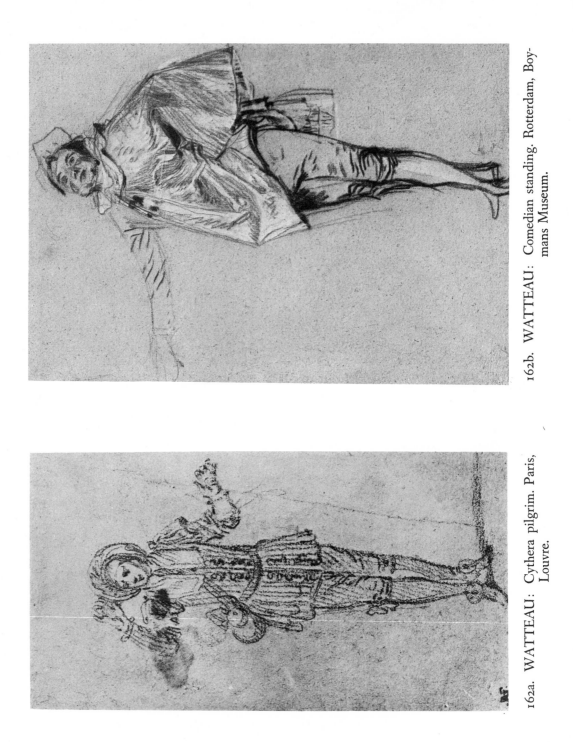

162b. WATTEAU: Comedian standing. Rotterdam, Boymans Museum.

162a. WATTEAU: Cythera pilgrim. Paris, Louvre.

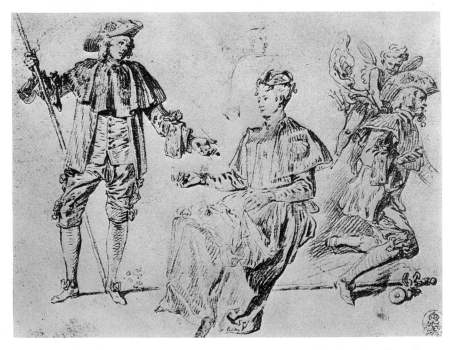

163a. WATTEAU: Figure studies: pilgrims, seated lady. Dresden, Print Room.

163b. WATTEAU: Study for the Embarkation for Cythera. London, British Museum.

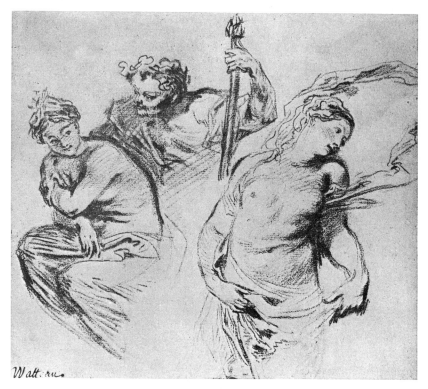

164a. WATTEAU: Studies after Rubens: Ariadne, Bacchus, and
Venus. Paris, Louvre.

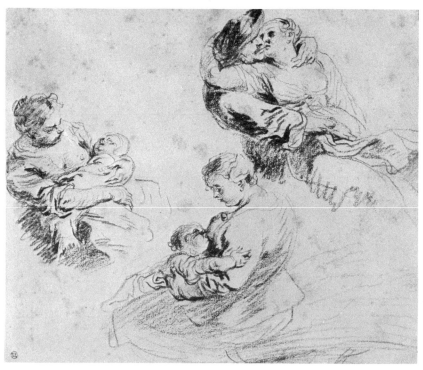

164b. WATTEAU: Studies after Rubens: figures from the Kermesse.
Paris, Louvre.

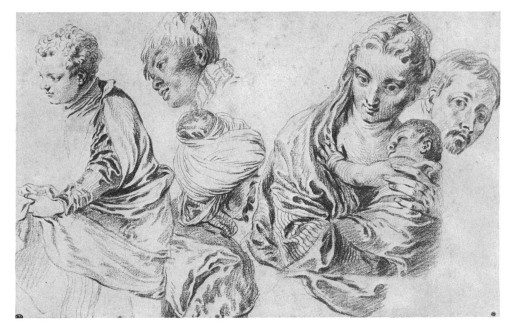

165a. WATTEAU: Studies after Veronese. Paris, Louvre.

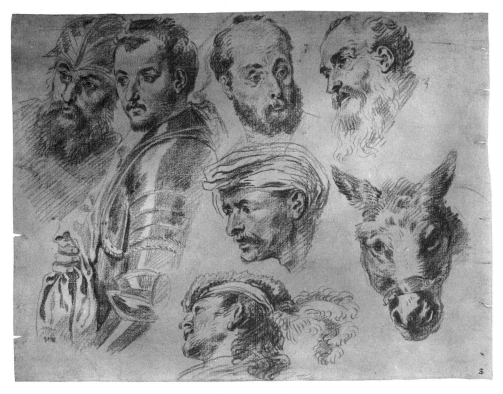

165b. WATTEAU: Studies after Veronese. New York, by courtesy of Pierpont Morgan Library.

166. RUBENS: Head of a young woman. London, British Museum.

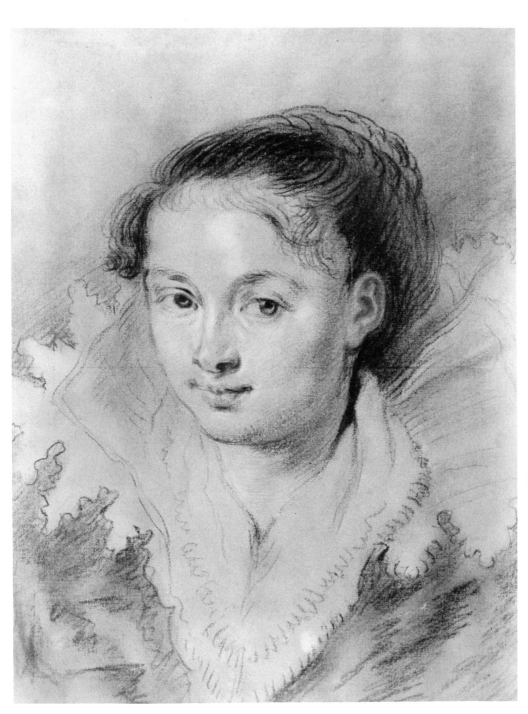

167. WATTEAU: Study after Rubens: head of a young woman. New York, S. Kramarsky Collection.

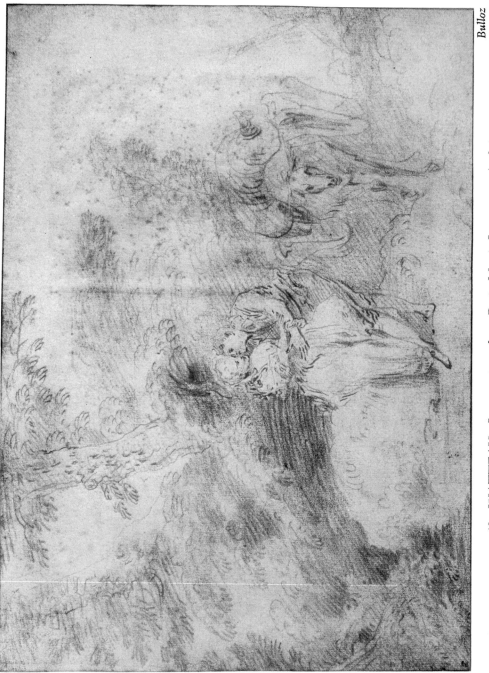

168. WATTEAU: Le meunier galant. Paris, Musée Jacquemart-André.

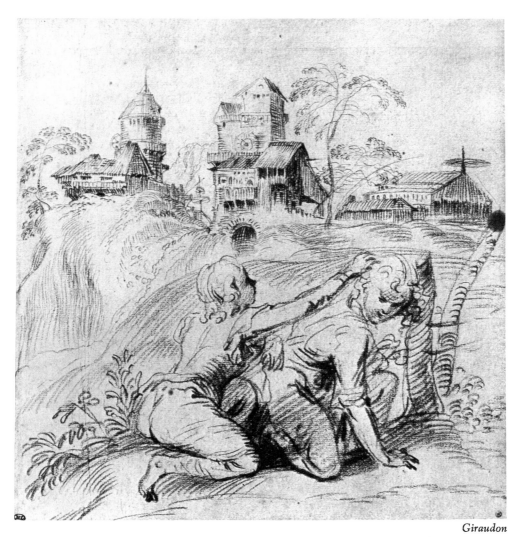

169. WATTEAU: Study after Titian: landscape with two youths. Paris, Louvre.

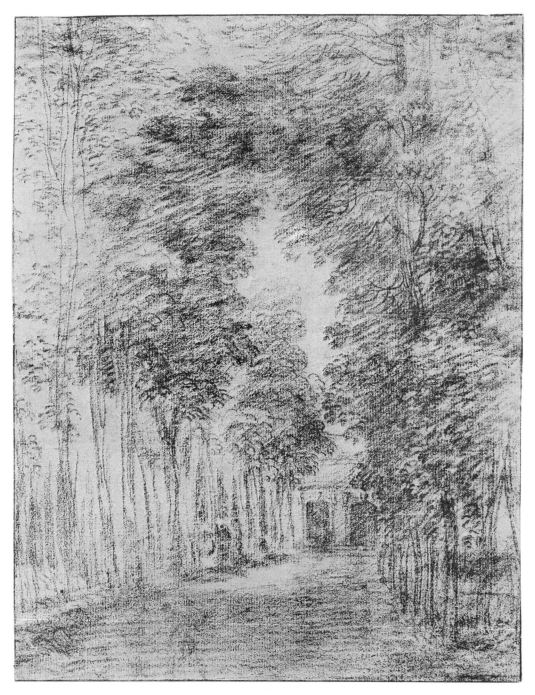

170. WATTEAU: Vista down an alley of trees. Leningrad, Hermitage.

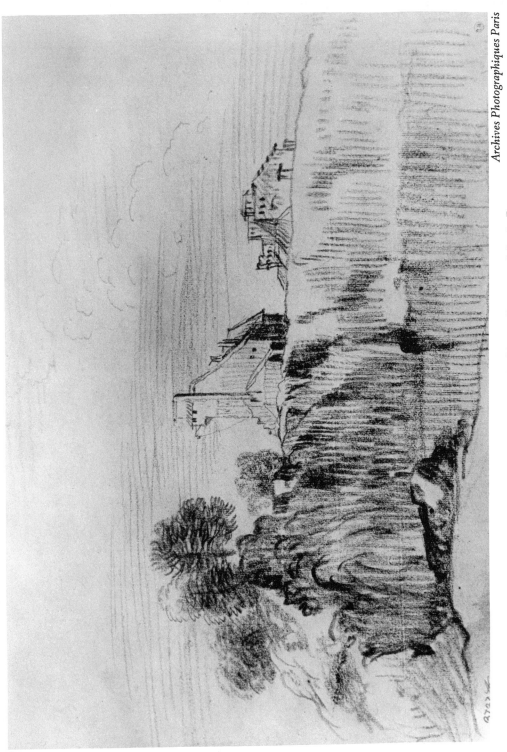

171. WATTEAU: Landscape with buildings. Bayonne, Musée Bonnat.

172. WATTEAU: Ornamental design. Formerly Leningrad, Hermitage.

173. WATTEAU: Ornamental design: le berceau. Paris, P. Bordeaux-Groult
Collection.

174. WATTEAU: Design for interior decoration. Florence, Uffizi.

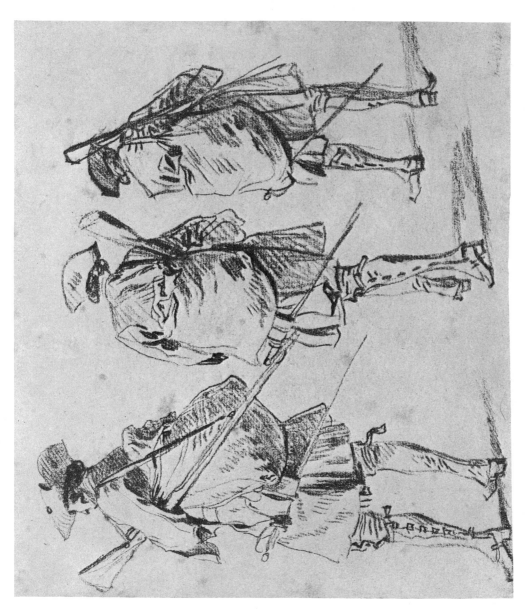

175. WATTEAU: Three soldiers. Berlin, Ehemals Staatliche Museen Berlin, Kupferstichkabinett, Museum Dahlem.

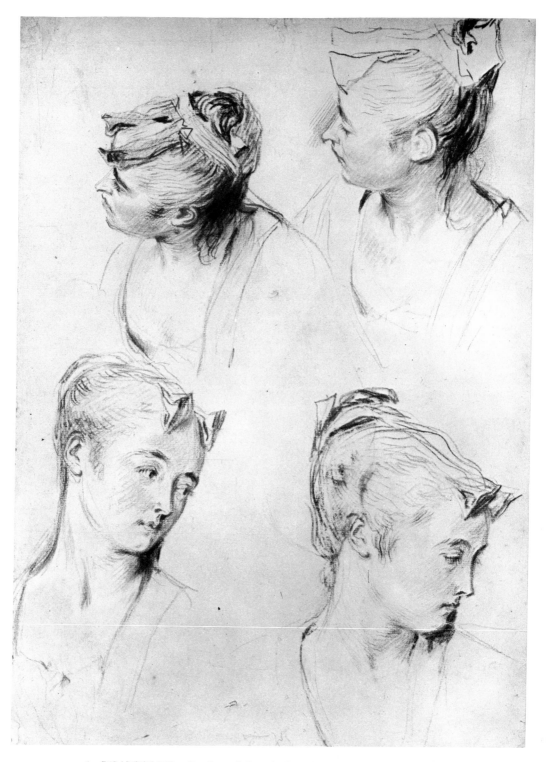

176. WATTEAU: Studies of female heads. London, British Museum.

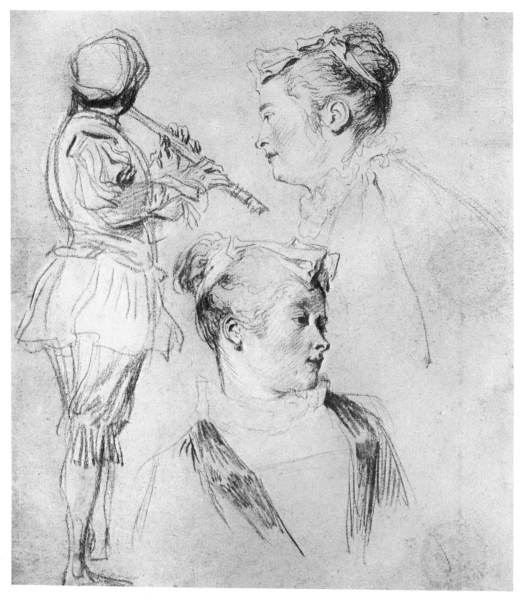

177. WATTEAU: Flute-player and studies of female heads. New York, H. N. Strauss
Collection.

178. WATTEAU: Studies of head of a Negro boy. Paris, Louvre.

179. WATTEAU: Two studies of a little girl. New York, by courtesy of Pierpont Morgan Library.

181. WATTEAU: Studies of a guitar player. London, British Museum.

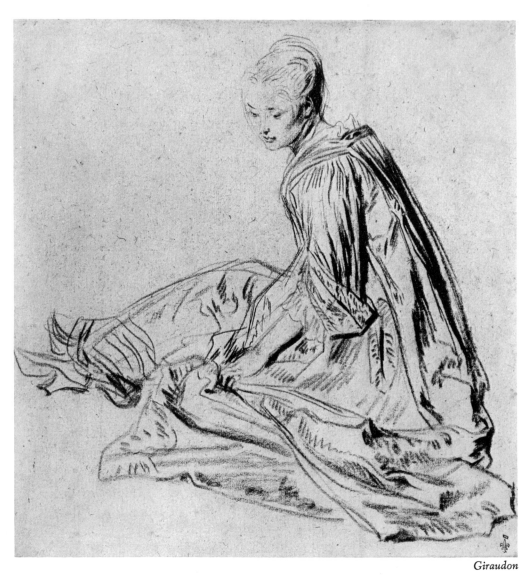

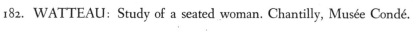

182. WATTEAU: Study of a seated woman. Chantilly, Musée Condé.

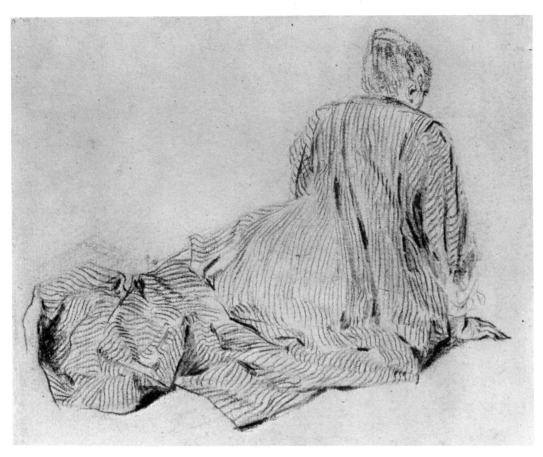

183. WATTEAU: Woman seated on the ground, seen from the back. London, British Museum.

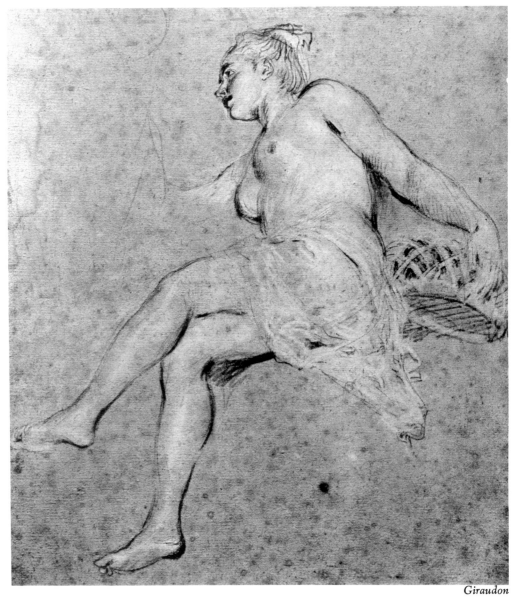

Giraudon

184. WATTEAU: Study for Spring. Paris, Louvre.

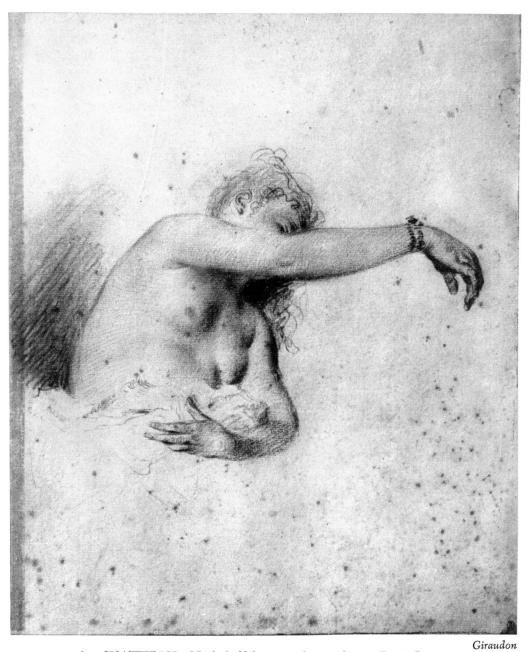

185. WATTEAU: Nude half-figure with raised arm. Paris, Louvre.

186. WATTEAU: Reclining nude asleep. New York, S. Kramarsky Collection.

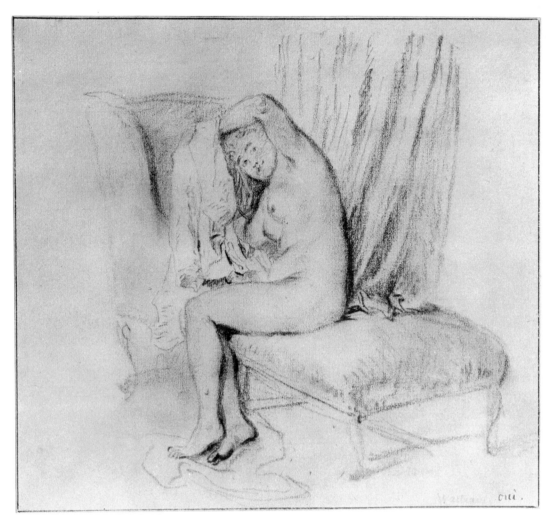

187. WATTEAU: Woman at her toilet. London, British Museum.

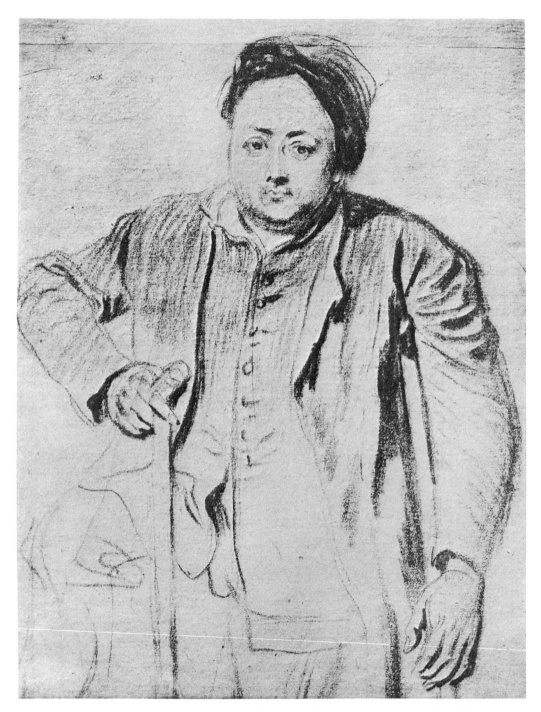

188. WATTEAU: A man on crutches (Antoine de la Roque). Reproduced by permission of the Syndics of the Fitzwilliam Museum, Cambridge.

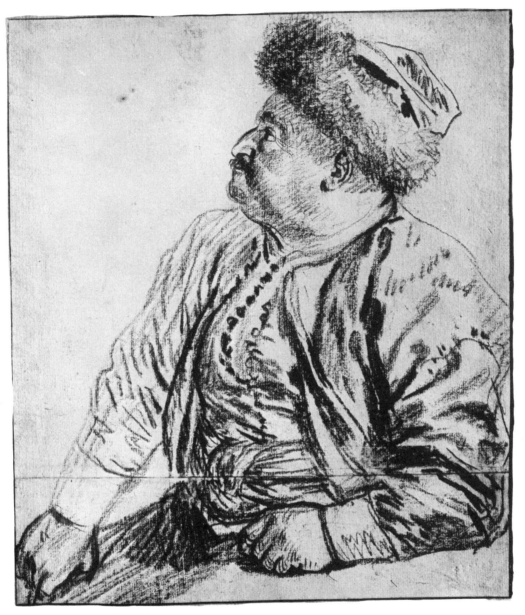

189. WATTEAU: Portrait of an Oriental. Haarlem, Teyler Museum.

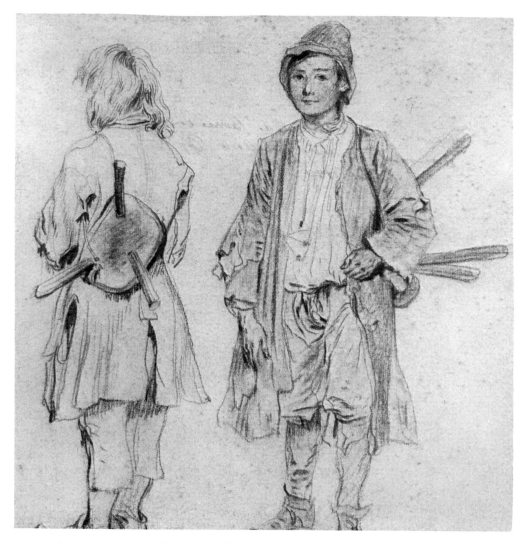

190. WATTEAU: Bootblacks. Rotterdam, Boymans Museum.

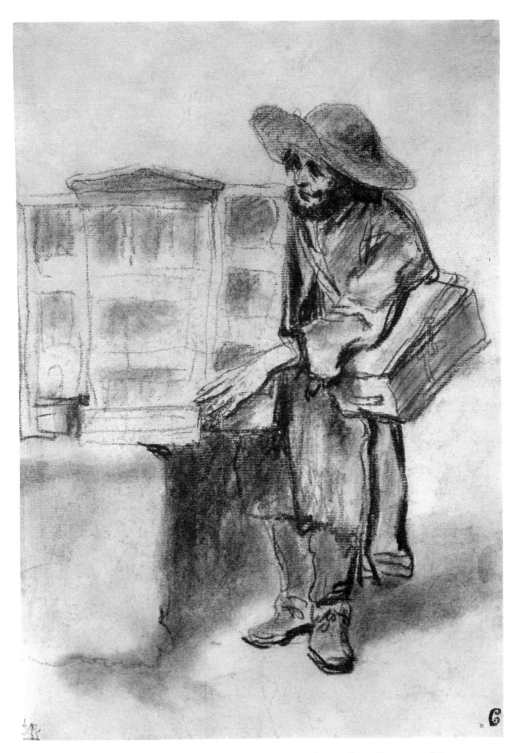

191. WATTEAU: Savoyard with curiosities. Rotterdam, Boymans Museum.

192. WATTEAU: Les Plaisirs d'Amour. Paris, R. de Billy Collection.

DEGAS

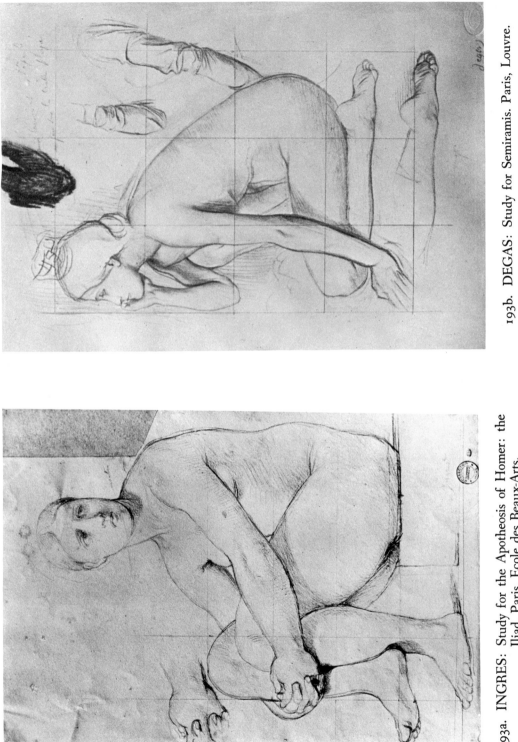

193a. INGRES: Study for the Apotheosis of Homer: the Iliad. Paris, Ecole des Beaux-Arts.

193b. DEGAS: Study for Semiramis. Paris, Louvre.

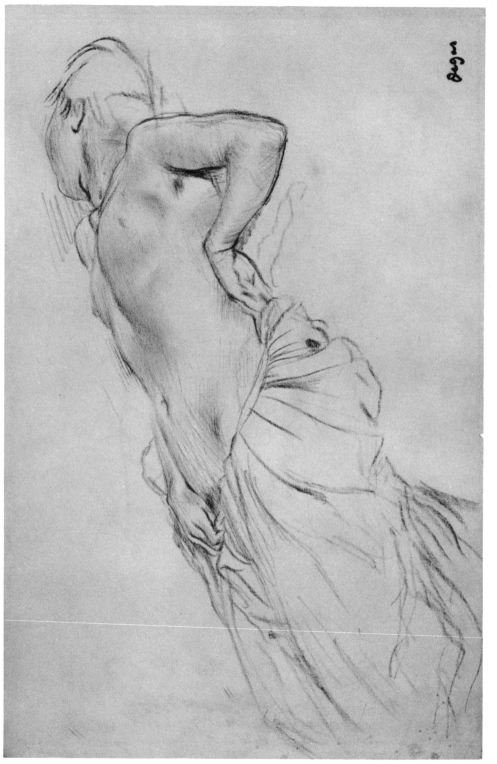

194. DEGAS: Reclining nude, study for Les Malheurs de la Ville d'Orléans. Paris, Louvre.

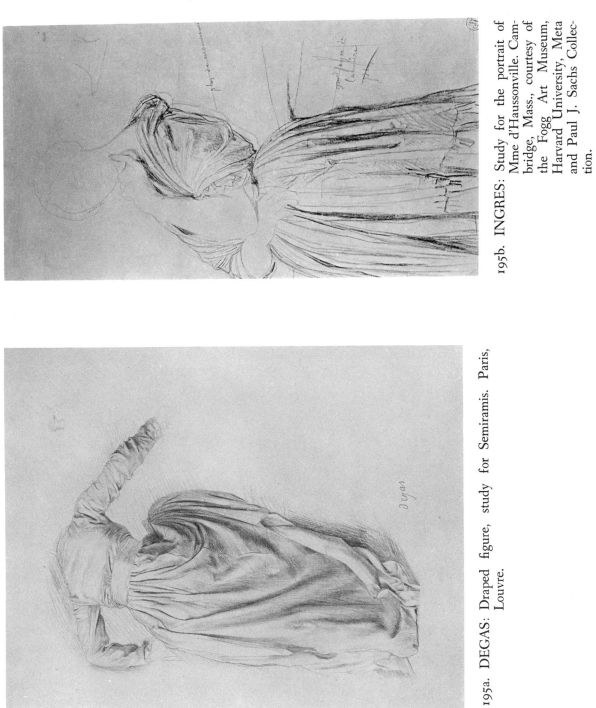

195a. DEGAS: Draped figure, study for Semiramis. Paris, Louvre.

195b. INGRES: Study for the portrait of Mme d'Haussonville. Cambridge, Mass., courtesy of the Fogg Art Museum, Harvard University, Meta and Paul J. Sachs Collection.

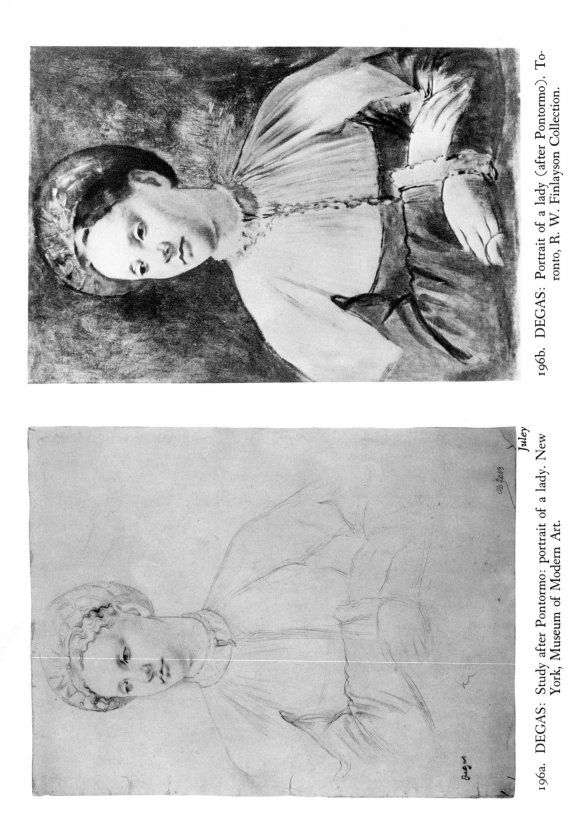

196b. DEGAS: Portrait of a lady (after Pontormo). Toronto, R. W. Finlayson Collection.

196a. DEGAS: Study after Pontormo: portrait of a lady. New York, Museum of Modern Art.

Juley

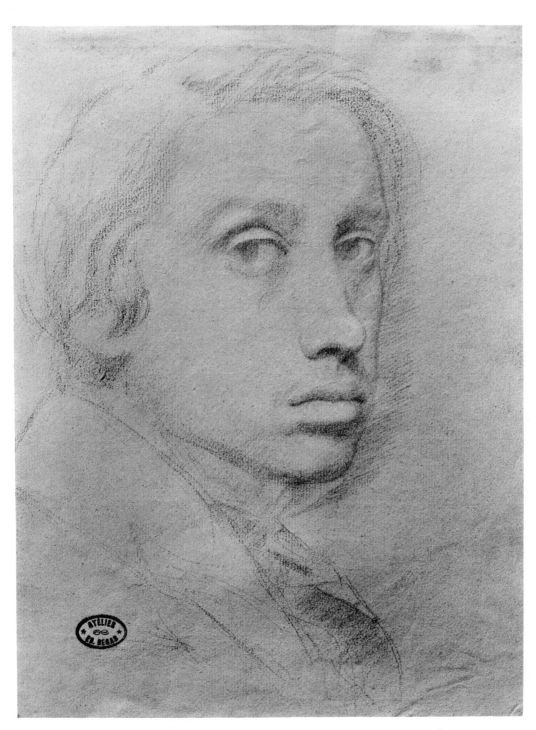

197. DEGAS: Self-portrait. Providence, John Nicholas Brown Collection.

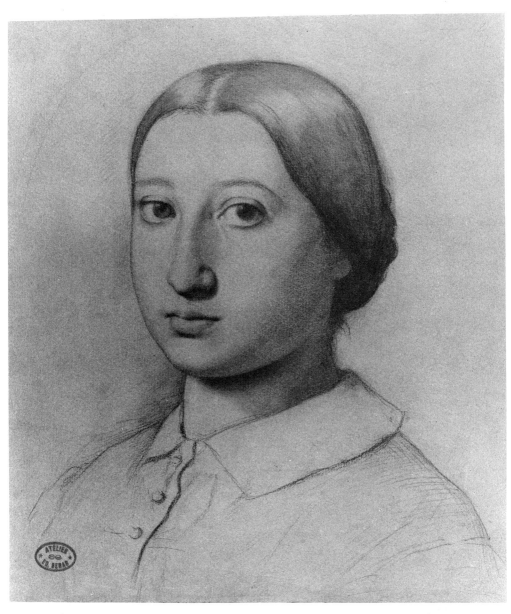

198. DEGAS: Portrait of Thérèse de Gas, later Mme de Morbilli. Courtesy Museum of
Fine Arts, Boston.

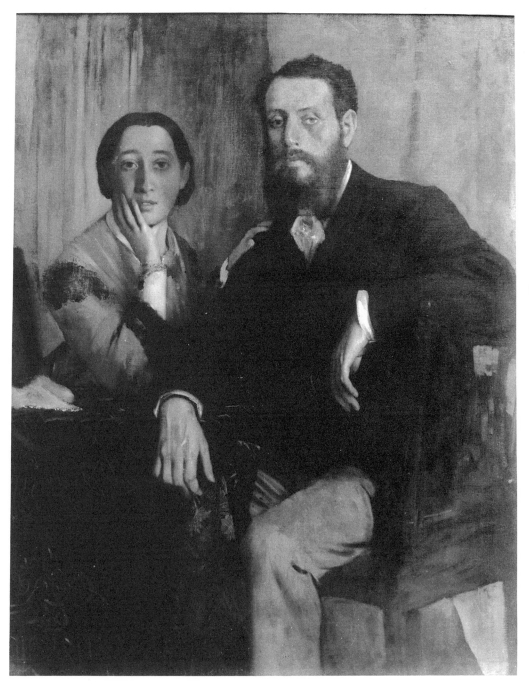

199. DEGAS: The Duke and Duchess of Morbilli. Courtesy Museum of Fine Arts, Boston.

200. INGRES: Mme Flandrin. Paris, Flandrin Collection.

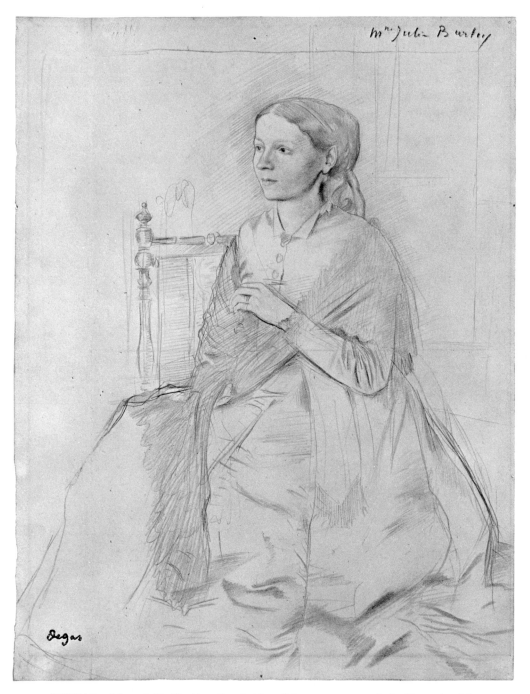

201. DEGAS: Mme Julie Burtin. Cambridge, Mass., courtesy of the Fogg Art Museum, Harvard University, Meta and Paul J. Sachs Collection.

202. DEGAS: Mme Hertel. Cambridge, Mass., courtesy of the Fogg Art Museum, Harvard University, Meta and Paul J. Sachs Collection.

203b. DEGAS: Studies of Manet. Paris, Mme Rouart Collection.

203a. DEGAS: Study for the portrait of James Tissot. Cambridge, Mass., courtesy of the Fogg Art Museum, Harvard University.

204. DEGAS: Lady tying her hat (Mary Cassatt). Paris, Marcel Bing Collection.

205. **DEGAS**: Diego Martelli. Cambridge, Mass., courtesy of the Fogg Art Museum, Harvard University, Meta and Paul J. Sachs Collection.

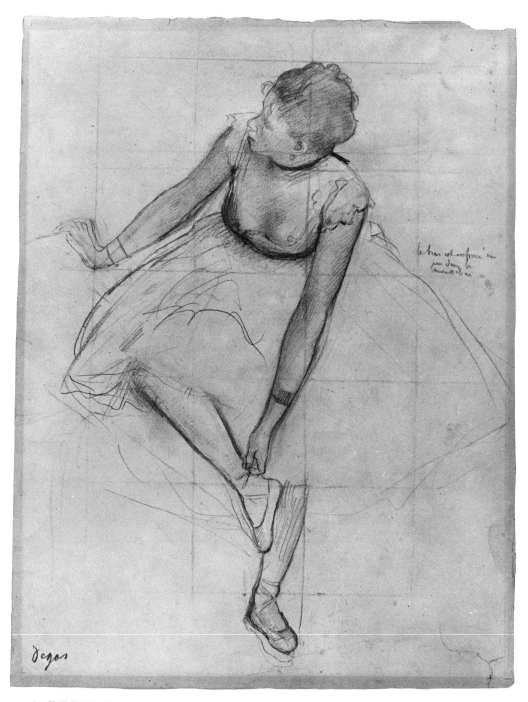

206. DEGAS: Dancer adjusting her slipper. New York, courtesy of The Metropolitan
Museum of Art, gift of Mrs. H. O. Havemeyer, The H. O. Havemeyer
Collection, 1929.

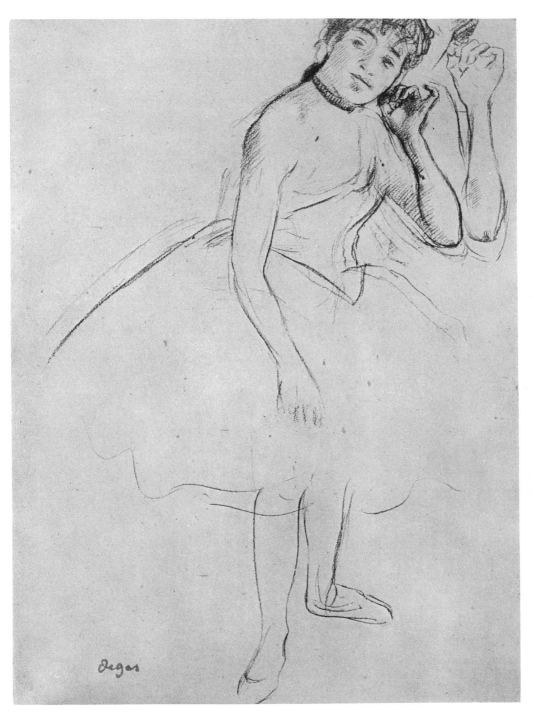

207. DEGAS: Dancer touching her earring. Paris, Louvre.

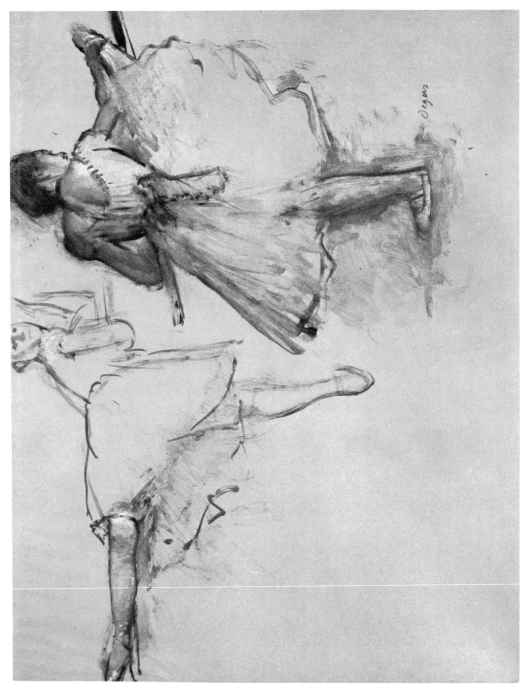

208. DEGAS: Dancer at the bar. New York, César de Hauke Collection.

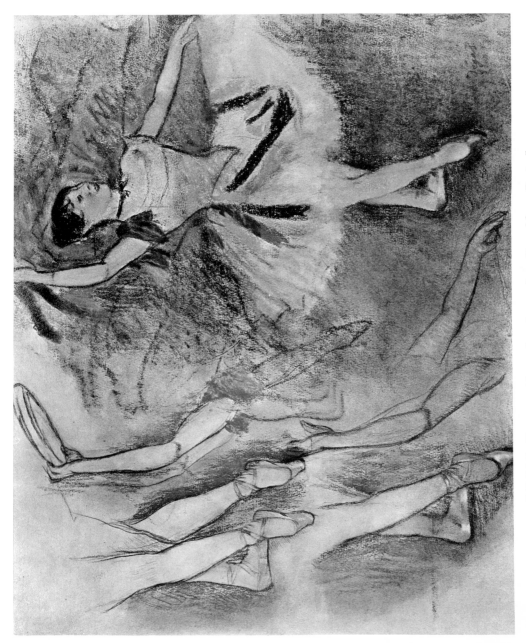

209. DEGAS: Dancer with tambourine and studies of legs. Paris, Louvre.

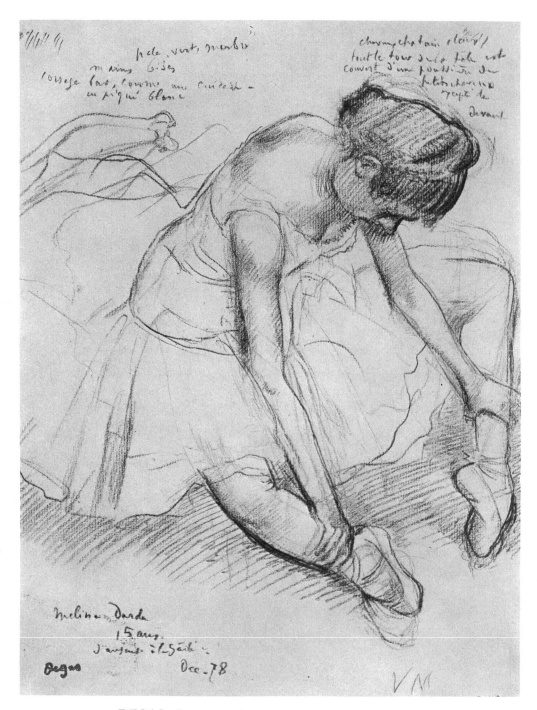

210. DEGAS: Dancer Mélina Darde. Paris, Mathey Collection.

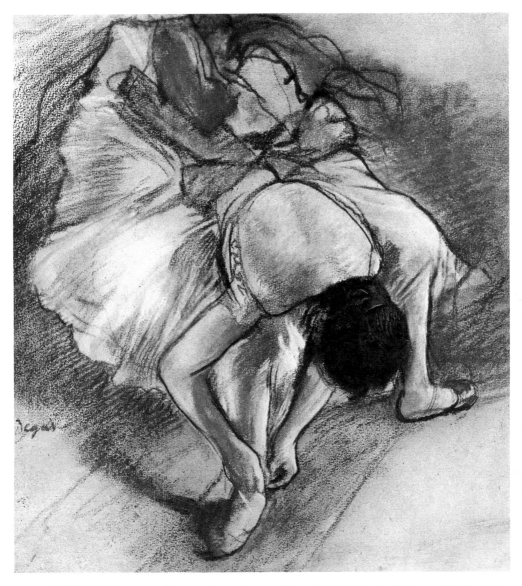

211. DEGAS: Dancer adjusting her slipper. New York, Mrs. J. Watson Webb Collection.

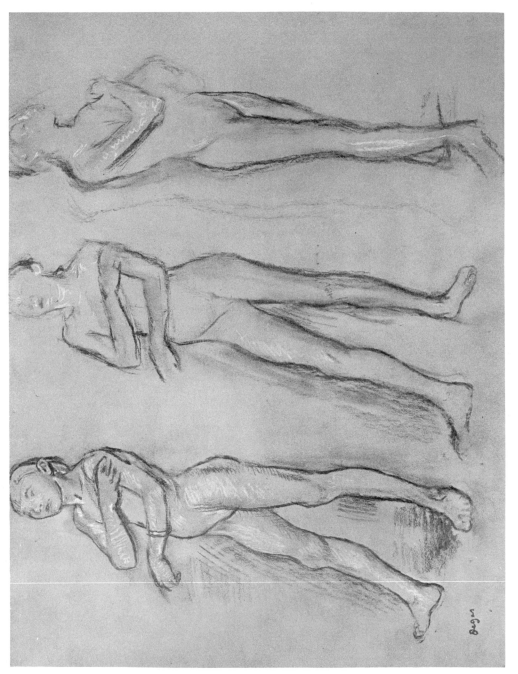

212. DEGAS: Three nude dancers. Paris, Demotte Collection.

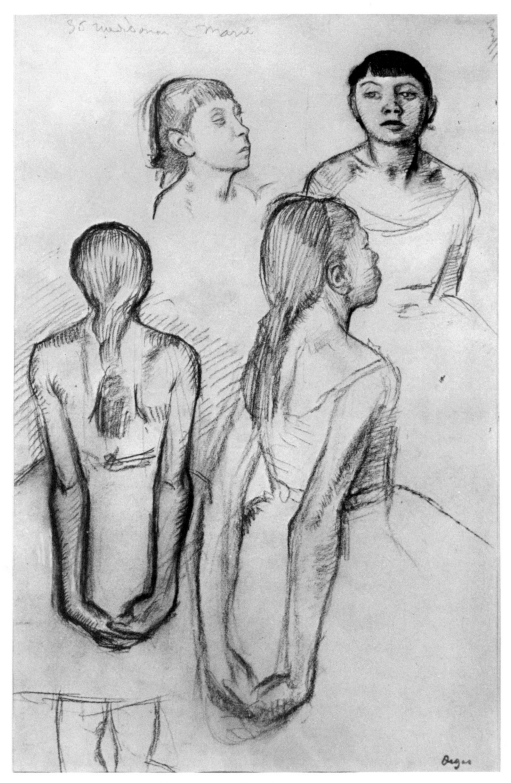

213. DEGAS: Four studies of a dancer. Paris, Louvre.

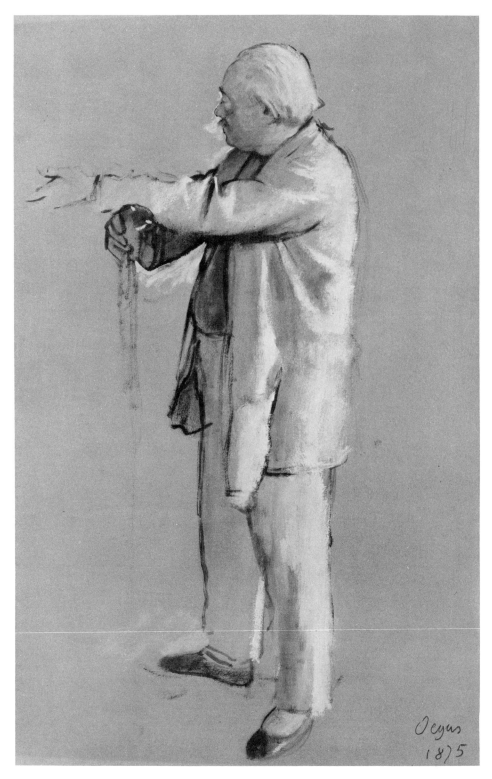

214. DEGAS: The ballet master. Philadelphia, Henry McIlhenny Collection.

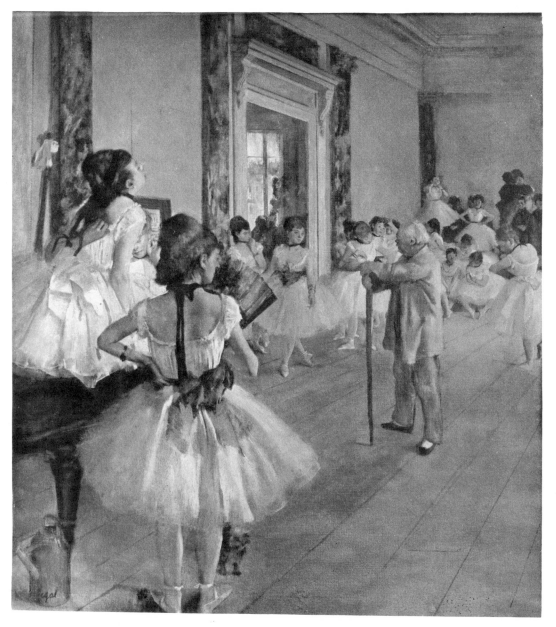

215. DEGAS: The dancing lesson. Paris, Louvre.

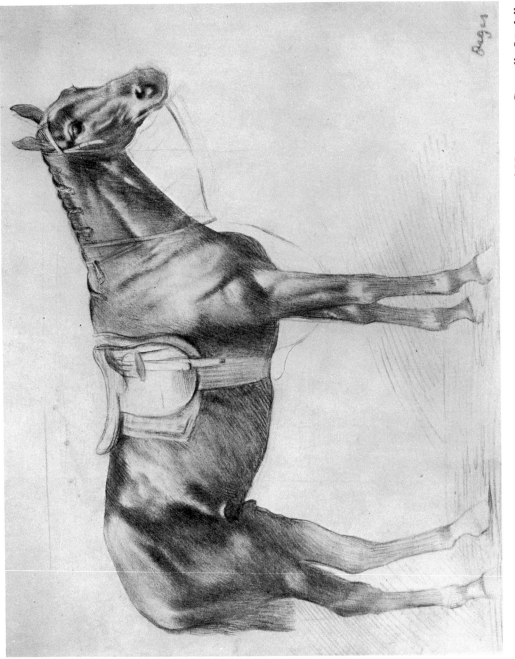

216. DEGAS: Horse. Cambridge, Mass., courtesy of the Fogg Art Museum, Harvard University, Grenville Lindall Winthrop Collection.

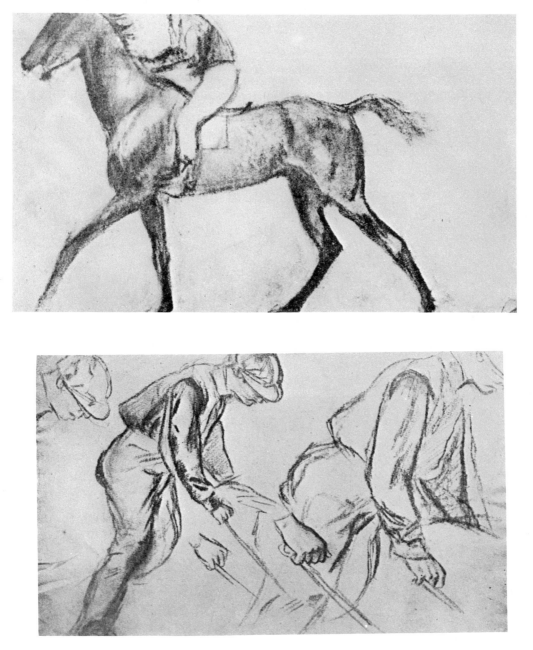

217. DEGAS: Jockey in profile — Two jockeys. Location unknown.

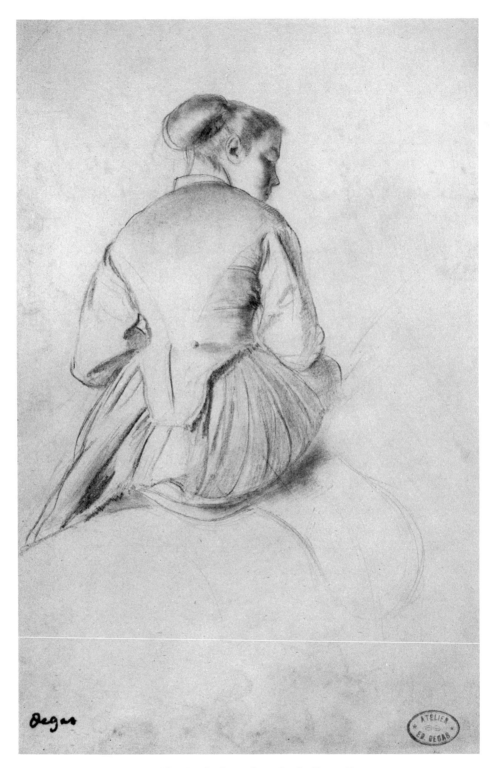

218. DEGAS: Lady on horseback. Paris, Louvre.

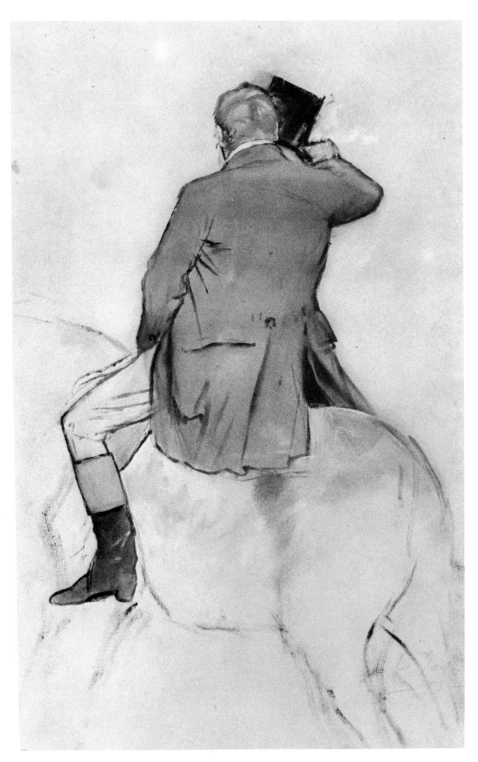

219. DEGAS: Gentleman on horseback. Paris, Louvre.

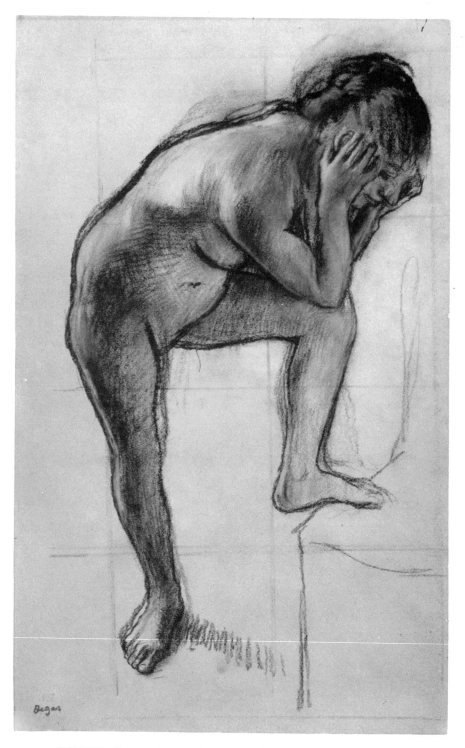

220. DEGAS: Study of a nude woman. Paris, Georges Viau Collection.

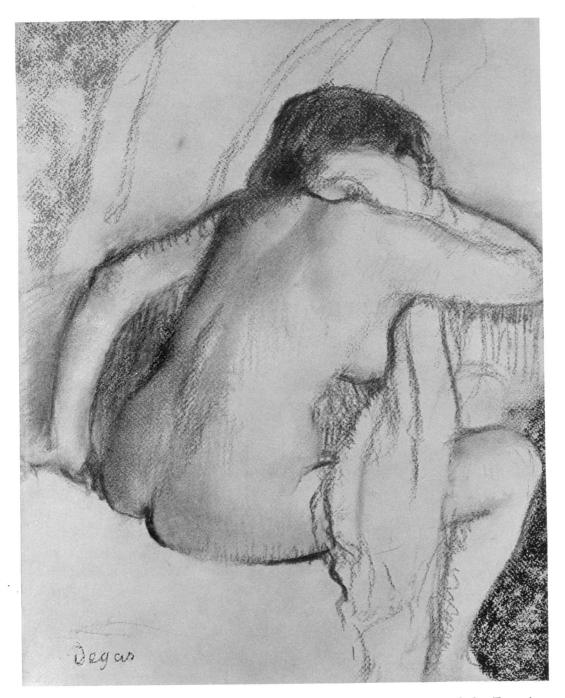

221. DEGAS: Seated nude, drying herself. Cambridge, Mass., courtesy of the Fogg Art Museum, Harvard University, Meta and Paul J. Sachs Collection.

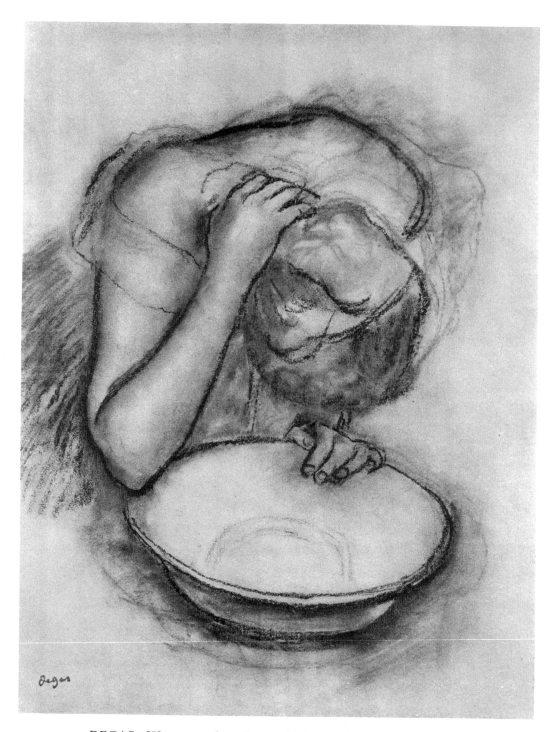

222. DEGAS: Woman washing her neck. Paris, André Noufflard Collection.

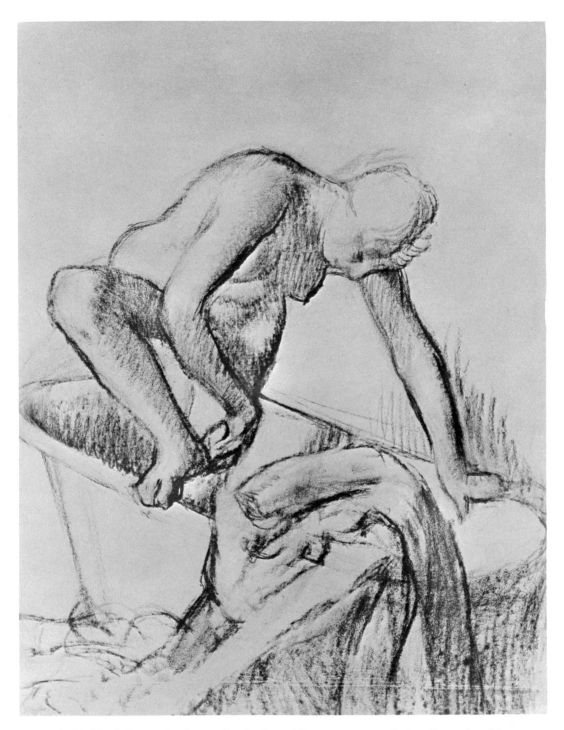

223. DEGAS: Woman bathing. Cambridge, Mass., courtesy of the Fogg Art Museum, Harvard University, Meta and Paul J. Sachs Collection.

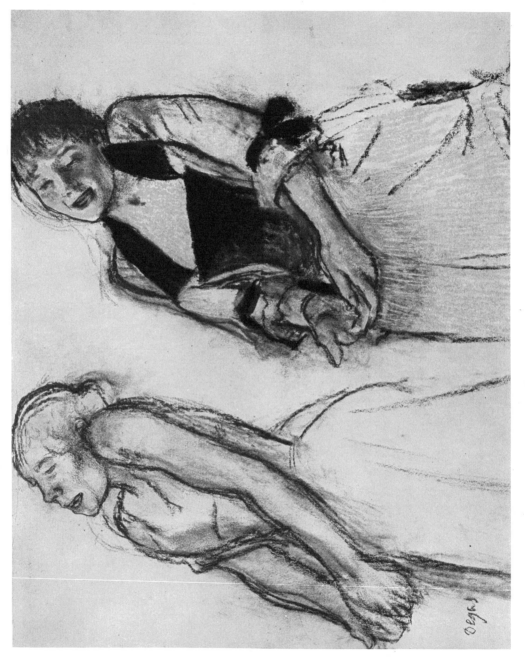

224. DEGAS: Two café-concert singers. Philadelphia, Mrs. John Wintersteen Collection.

PICASSO

225. PICASSO: Page of studies. Seattle, Ivan L. Best Collection.

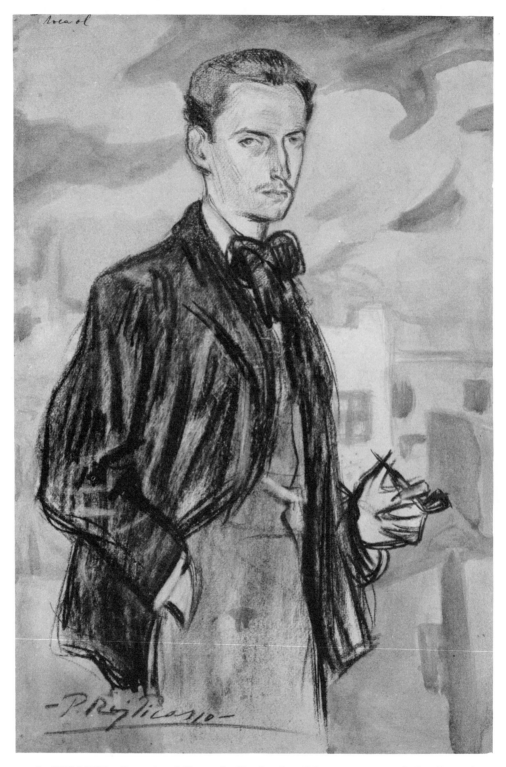

226. PICASSO: Portrait of Rocarol. Cambridge, Mass., courtesy of the Fogg Art Museum, Harvard University.

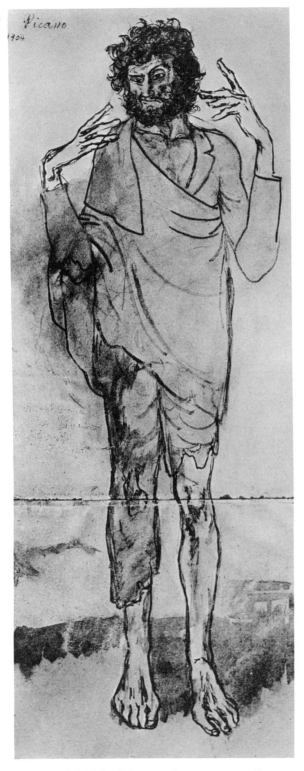

227. PICASSO: The madman, 1904. Barce-
lona, Museum of Modern Art.

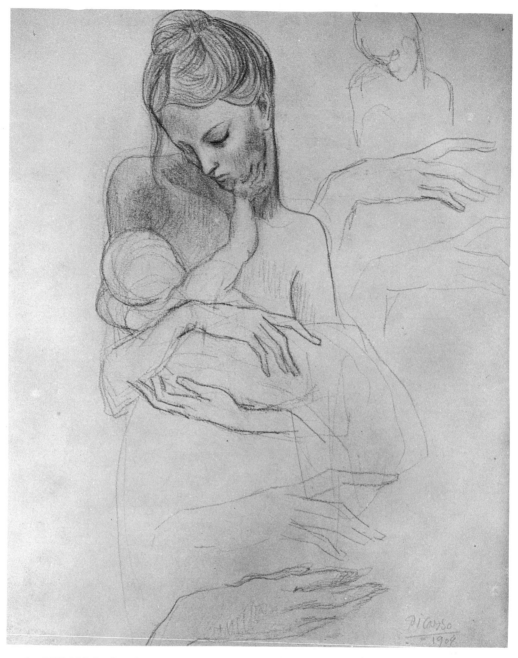

228. PICASSO: Mother and child. Cambridge, Mass., courtesy of the Fogg Art Museum, Harvard University, Meta and Paul J. Sachs Collection.

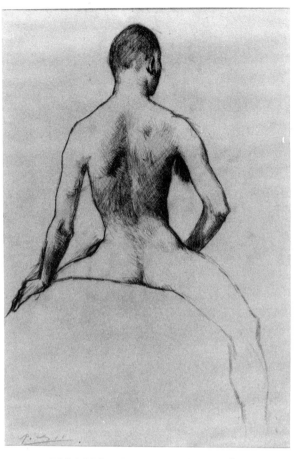

229a. PICASSO: Boy on a horse. Cincinnati,
John W. Warrington Collec-
tion.

229b. PICASSO: The watering place. Courtesy of the Fogg Art Museum, Harvard
University, Cambridge, Mass.

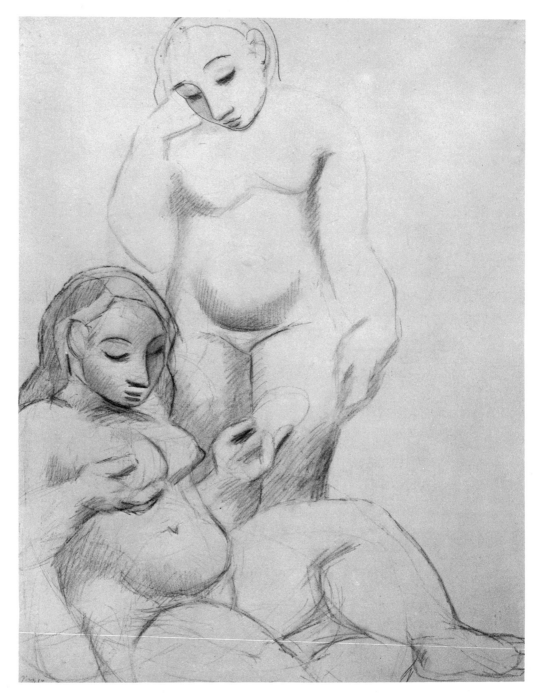

230. PICASSO: Two nude women. Wayzata, Minn., Richard S. Davis Collection.

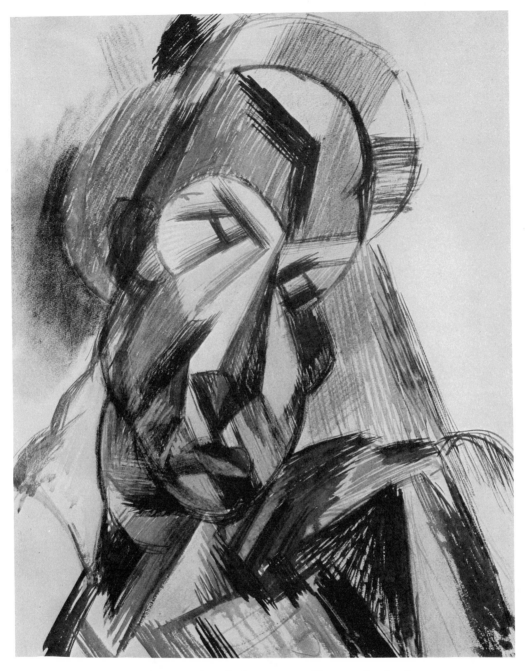

231. PICASSO: Head of a woman. Chicago, Art Institute.

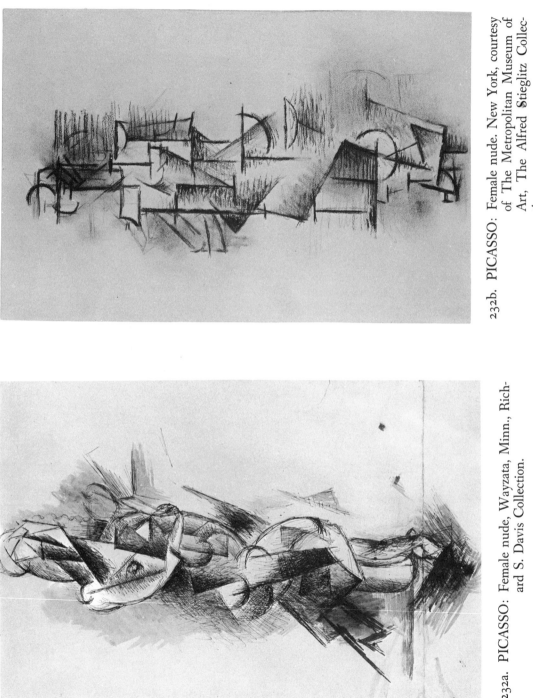

232b. PICASSO: Female nude. New York, courtesy of The Metropolitan Museum of Art, The Alfred Stieglitz Collection, 1949.

232a. PICASSO: Female nude, Wayzata, Minn., Richard S. Davis Collection.

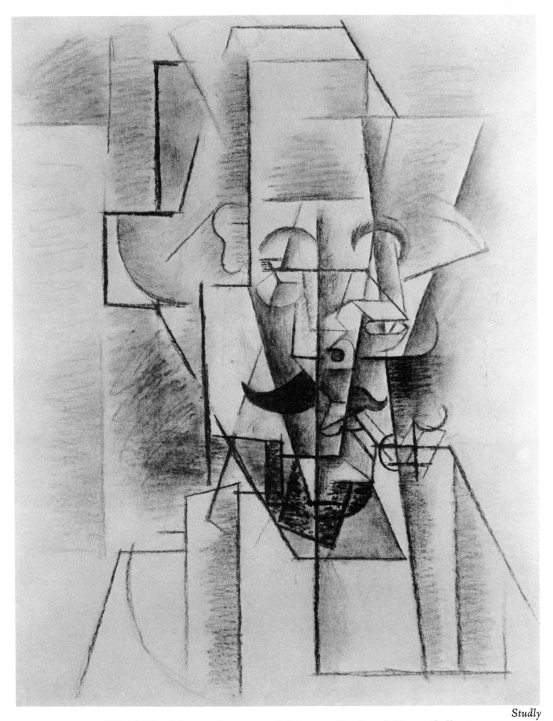

233. PICASSO: Man with a pipe. Baltimore, Dr. Israel Rosen Collection.

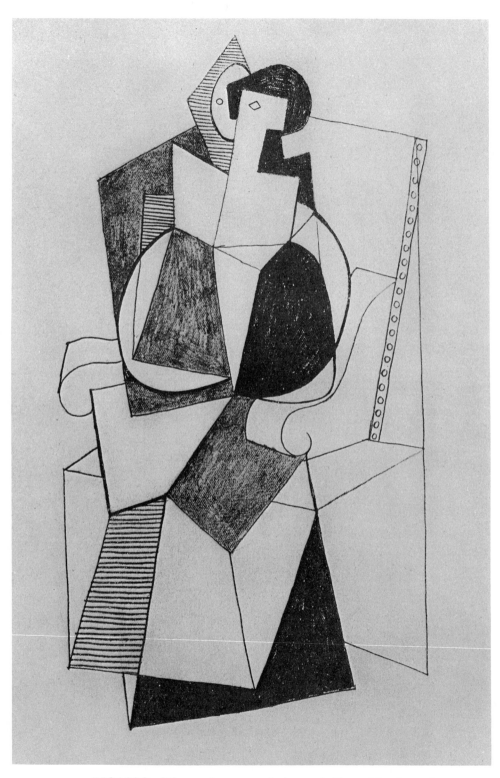

234. PICASSO: Woman in an armchair, 1916. Owned by the artist.

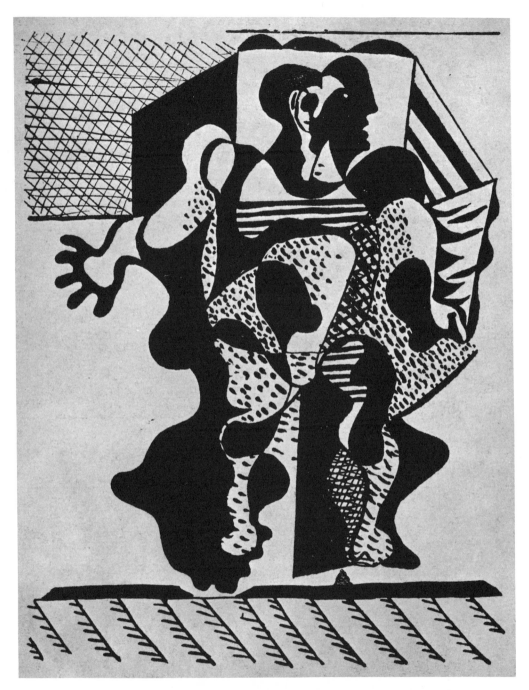

235. PICASSO: Abstract figure in motion, from a sketchbook of 1925. Owned by the artist.

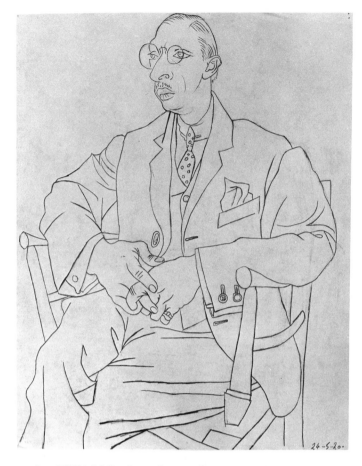

236a. PICASSO: Igor Stravinsky, 1920. Owned by the artist.

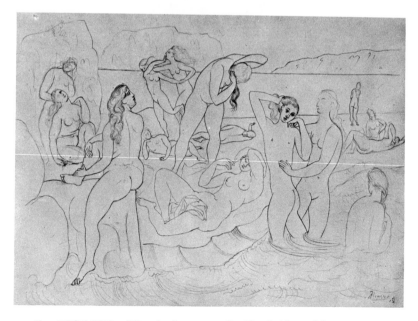

236b. PICASSO: The bathers, 1918. Cambridge, Mass., courtesy of the Fogg Art Museum, Harvard University, Meta and Paul J. Sachs Collection.

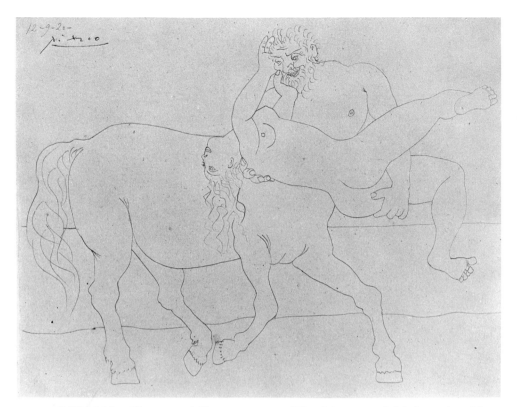

237a. PICASSO: Nessus and Dejanira, 1920. The Museum of Modern Art, New York, acquired through the Lillie P. Bliss Bequest.

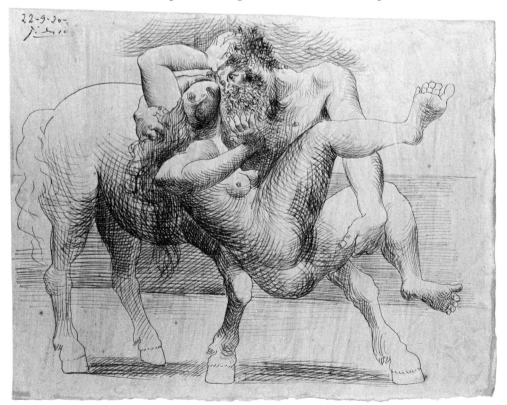

237b. PICASSO: Nessus and Dejanira, 1920. New York, private collection.

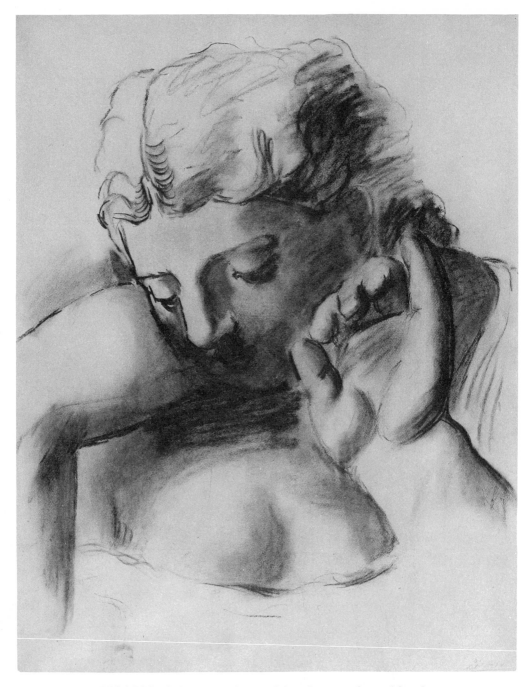

238. PICASSO: Woman with raised hand, 1921. Owned by the artist.

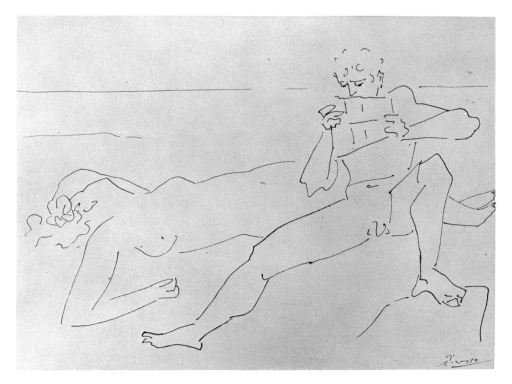

239a. PICASSO: Pipes-player and reclining nymph. Providence, John Nicholas Brown Collection.

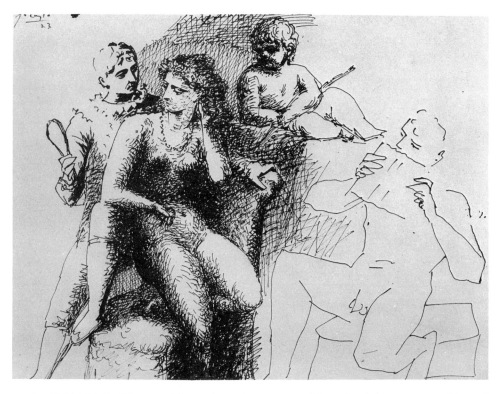

239b. PICASSO: Venus with a pipes-player, a cupid, and a Pierrot, 1923. Owned by the artist.

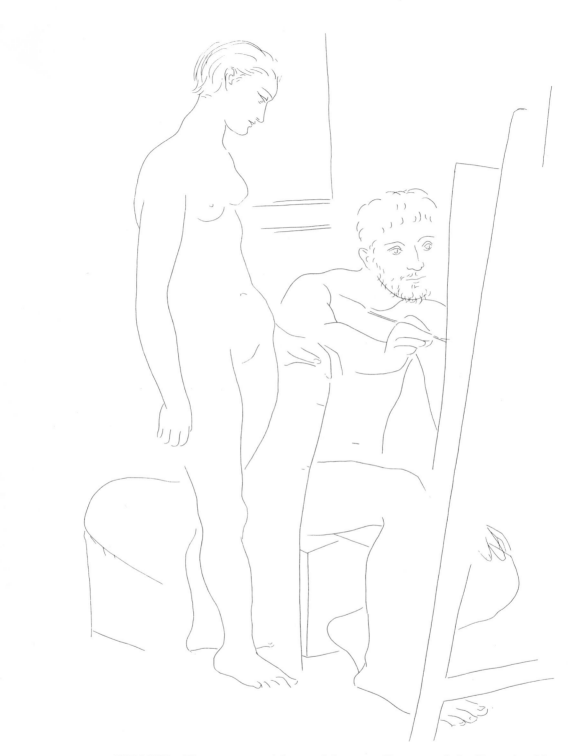

240. PICASSO: The painter and his model, 1927. Courtesy of the Fogg Art Museum, Harvard University, Cambridge, Mass.

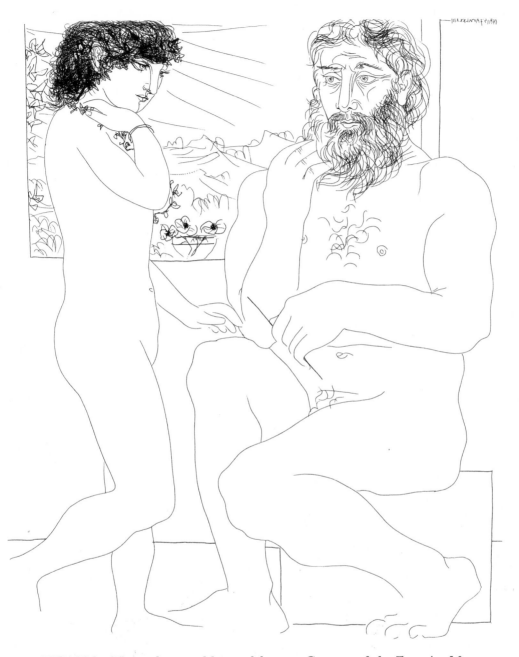

241. PICASSO: The sculptor and his model, 1933. Courtesy of the Fogg Art Museum, Harvard University, Cambridge, Mass.

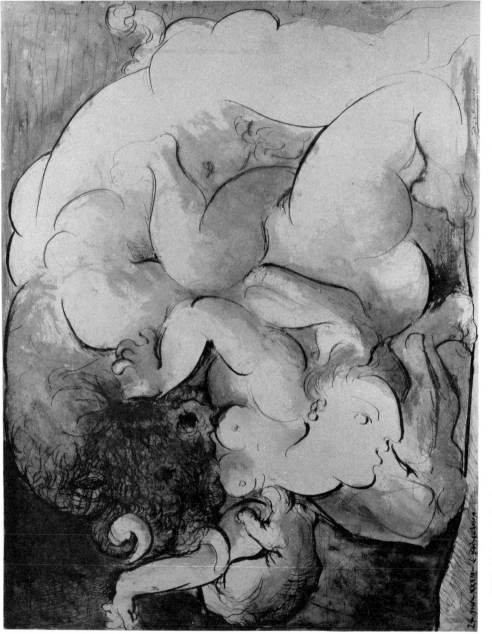

242. PICASSO: The Minotaur attacking a woman, 1933: Hobe Sound, Florida, Sylvester W. Labrot, Jr., Collection.

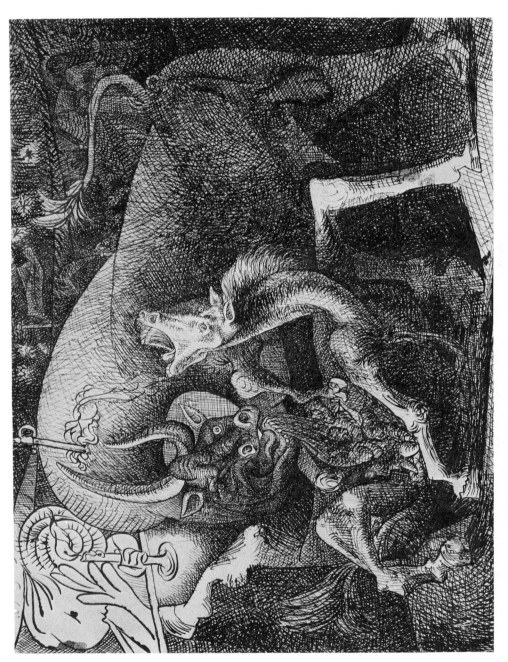

243. PICASSO: The bull and the wounded horse. Owned by the artist.

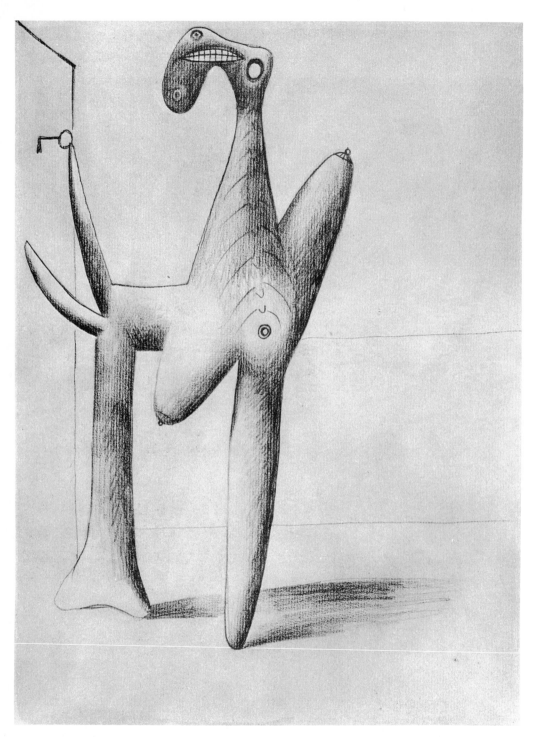

244. PICASSO: Bather at a beach, opening her locker, from a sketchbook of 1927. Owned by the artist.

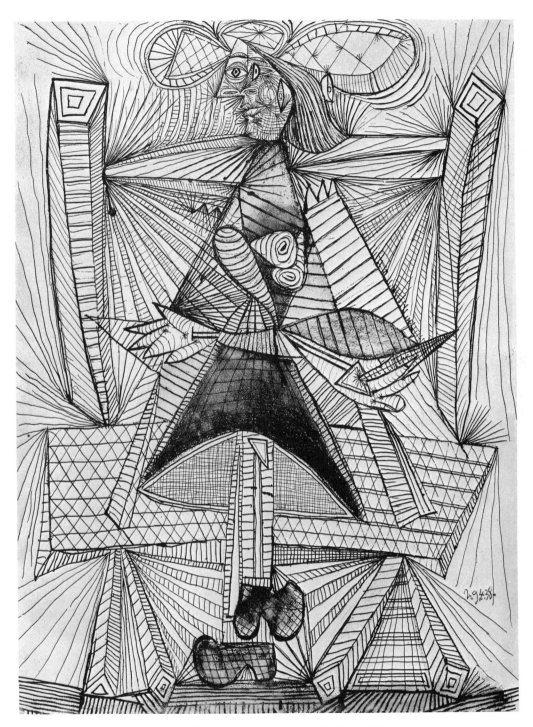

245. PICASSO: Woman in a chair, 1938. Owned by the artist.

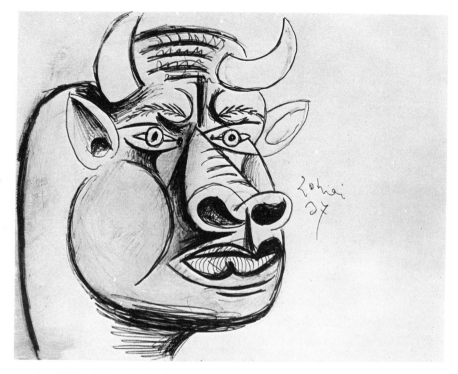

246a. PICASSO: Study for Guernica: head of a bull, 1937. Owned by the artist.

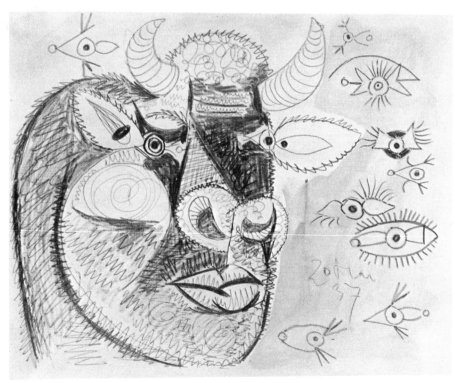

246b. PICASSO: Study for Guernica: head of a bull, 1937. Owned by the artist.

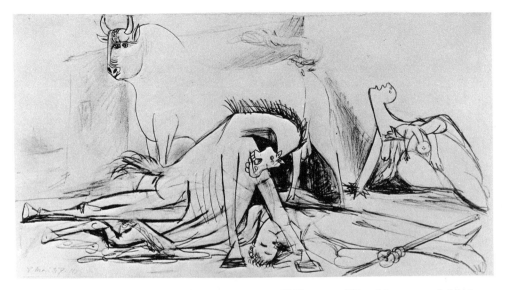

247a. PICASSO: Study for Guernica, 1937. Collection, The Museum of Modern
Art, New York.

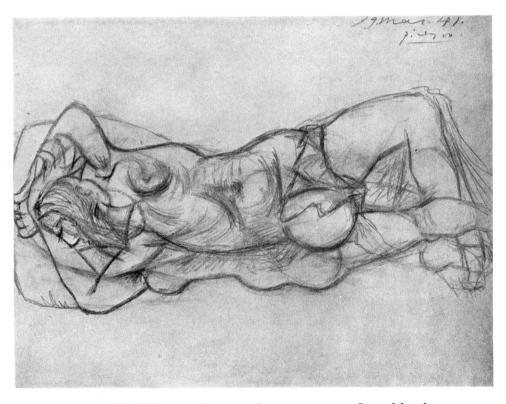

247b. PICASSO: Reclining nude woman, 1941. Owned by the
artist.

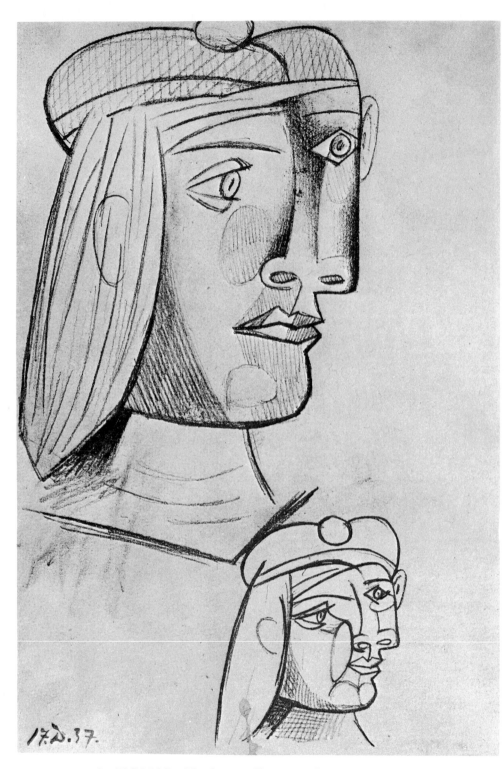

248. PICASSO: Head in profile, 1937. Owned by the artist.

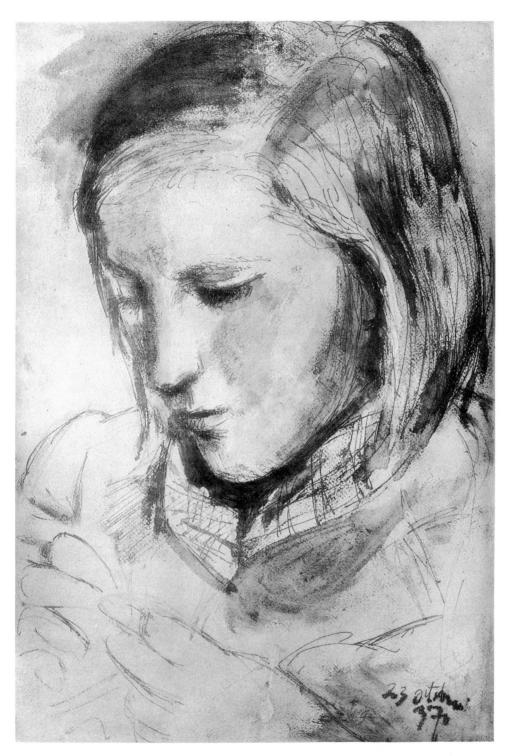

249. PICASSO: Girl looking down and sewing (?), 1937. Owned by the artist.

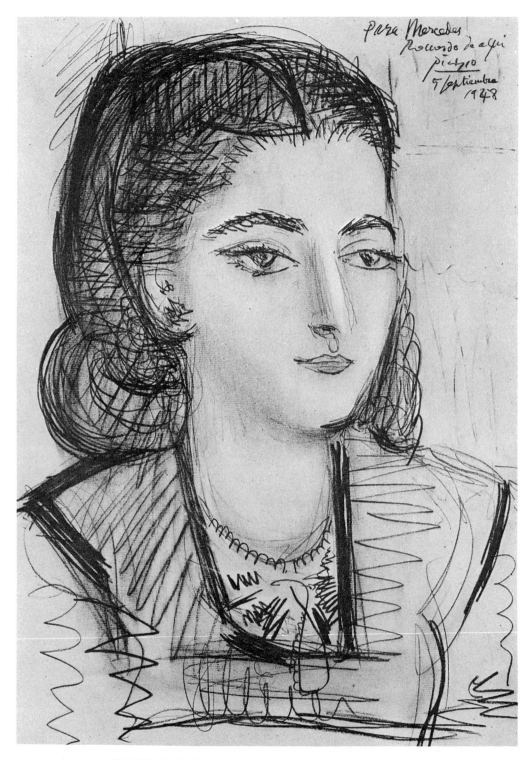

250. PICASSO: Mlle. Mercedes Arcas, 1948. Owned by the artist.

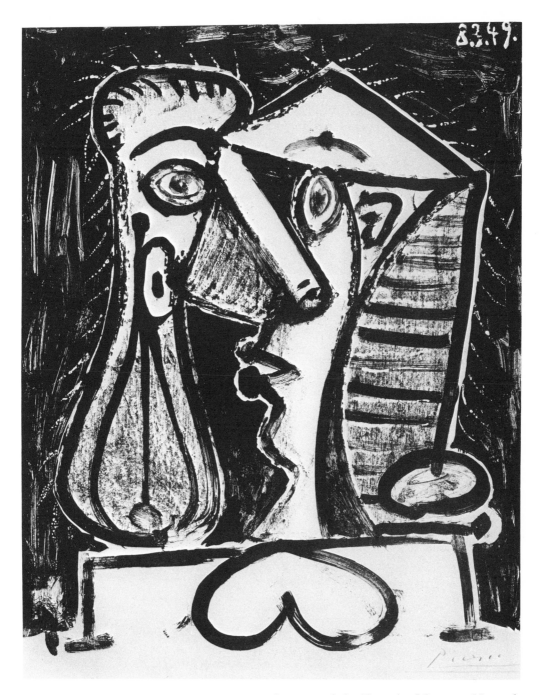

251. PICASSO: Head of a woman, 1949. Courtesy of the Fogg Art Museum, Harvard
University, Cambridge, Mass.

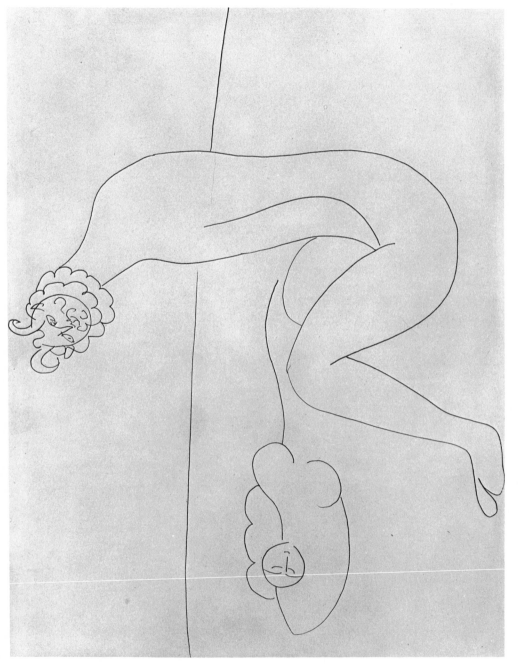

252. PICASSO: Satyr and reclining nymph, 1946. Antibes, Museum.

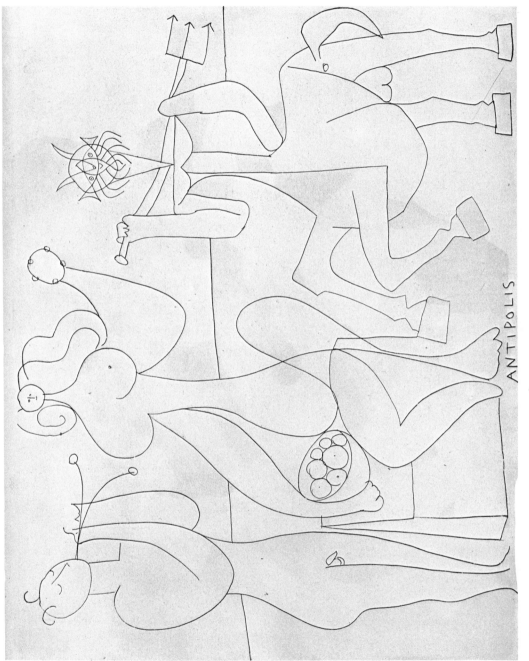
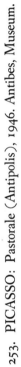

ANTIPOLIS

253. PICASSO: Pastorale (Antipolis), 1946. Antibes, Museum.

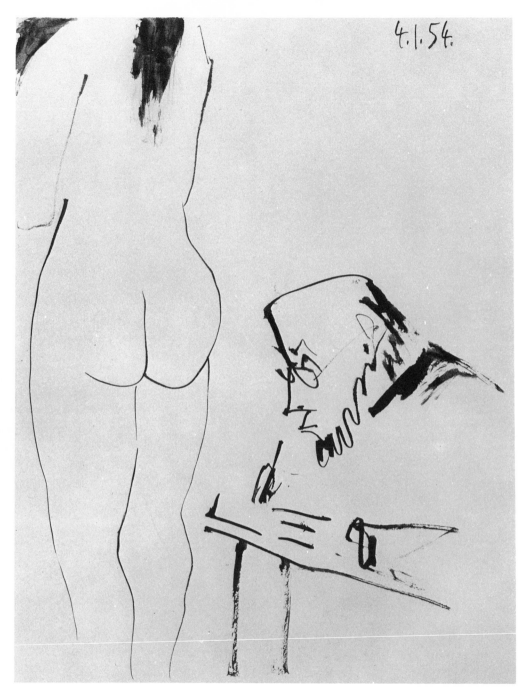

254. PICASSO: The painter and his model, 1954, from the "Suite de 180 dessins." Location unknown.

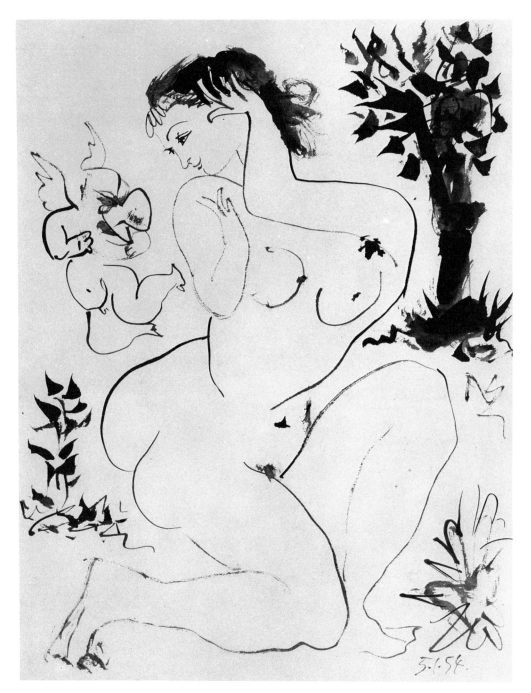

255. PICASSO: Female nude playing with a masked cupid, 1954, from the "Suite de 180 dessins." Location unknown.

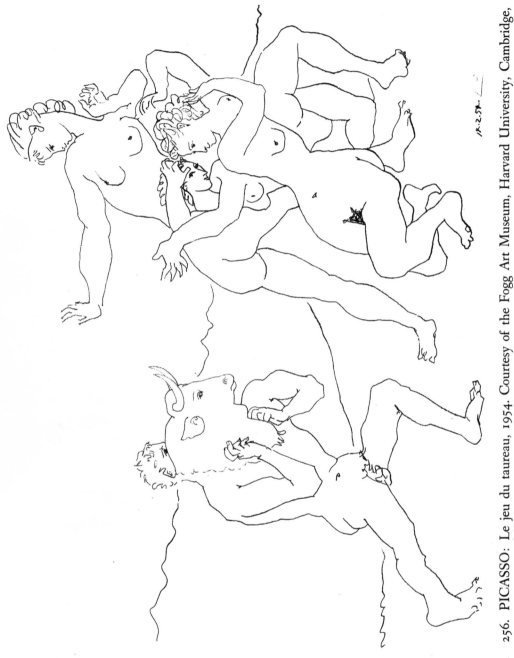

256. PICASSO: Le jeu du taureau, 1954. Courtesy of the Fogg Art Museum, Harvard University, Cambridge, Mass.